Photojournalism

*Content
and
Technique*

D1399152

Photojournalism

*Content
and
Technique*

Greg Lewis
California State University, Fresno

WCB **Wm. C. Brown Publishers**

Book Team

Editor *Stan Stoga*
Developmental Editor *Jane F. Lambert*
Production Editor *Harry Halloran*
Designer *Laurie J. Entringer*
Art Editor *Jess Schaal*
Photo Editor *Carrie Burger*
Visuals Processor *Joseph P. O'Connell*

 Wm. C. Brown Publishers

President *G. Franklin Lewis*
Vice President, Publisher *George Wm. Bergquist*
Vice President, Publisher *Thomas E. Doran*
Vice President, Operations and Production *Beverly Kolz*
National Sales Manager *Virginia S. Moffat*
Senior Marketing Manager *Kathy Law Laube*
Marketing Manager *Kathleen Nietzke*
Executive Editor *Edgar J. Laube*
Managing Editor, Production *Colleen A. Yonda*
Production Editorial Manager *Julie A. Kennedy*
Production Editorial Manager *Ann Fuerste*
Publishing Services Manager *Karen J. Slaght*
Manager of Visuals and Design *Faye M. Schilling*

Cover photo by John Murphy

Table of Contents photos
Page vii top: Stephen J. Pringle; p. vii bottom: © Copyright 1990
Bill Hess; p. viii top: Sarah Fawcett; p. viii bottom: Stephen J.
Pringle

Library of Congress Catalog Card Number: 89–82089

ISBN 0–697–04292–8

Printed in the United States of America by Wm. C. Brown Publishers,
2460 Kerper Boulevard, Dubuque, IA 52001

10 9 8 7 6 5 4 3 2

This book is dedicated to my family, who put up with so much during its preparation; to my students, from whom I have learned so much; and to the memory of Earl Theisen. Some day I hope to be at least half the teacher he was.

Table of Contents

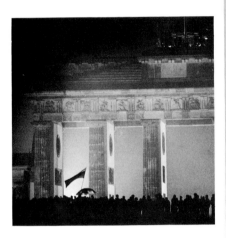

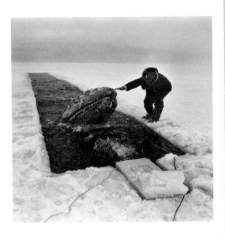

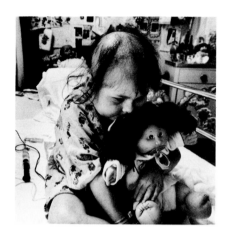

Preface

This book is intended for first- and second-semester courses in photojournalism. It is organized into four sections, the first being an introduction to the medium. The introduction attempts a definition of photojournalism and explains the differences between pictures made for publication and those made for personal purposes.

Part II is for those who are learning the tools of photography: cameras, film, lenses, darkroom procedures, light, and color. Classes starting from ground zero will have the information they need right up front. For programs that require students to take a basic photo course elsewhere, this information can be a handy review.

For the beginner, I believe it is important to start shooting right away; therefore, I have presented cameras, film, and exposure before taking up the topic of lenses. Because darkroom time is at a premium in a beginning course, the new photographer can at least start shooting as early in the course as possible, saving the details of lenses for a few weeks. Instructors will note that I placed the all-important section on push processing in the Appendix. The purpose is to avoid confusing beginners with too many options at once. I strongly believe that conventional methods should be mastered before trying these techniques. Part II closes with an introduction to color, an element of increasing importance in photojournalism.

Second-semester courses will more than likely start at Part III, which begins with some thoughts on composition, a topic that is as important to the photographer as syntax is to the writer. These basics are followed by specific approaches used in the major areas of photojournalism: news, features, sports, studio, the photo story, and finally, editing the picture. The editing chapter, however, is intended to be only an introduction to a subject that could be an entire book in itself.

Finally, those elements of photojournalism that go beyond the details of making the photo are presented in Part IV: ethical and legal questions, education and careers, history, and a look to the electronic future.

One thing I learned from preparing this book is that it is impossible to create a work that will fit the structure of every course. It was my goal to make the chapters independent so an instructor could switch the order of reading to fit his or her program. Some instructors might prefer to mix the material from Part II ("Tools") with Part III ("Techniques"). Others believe, for example, that cameras and lenses should be studied together.

Most photojournalists will not go to exotic places and shoot unusual events; therefore, I have tried to balance contest-winning photos with the kinds of pictures and situations a photojournalist will deal with on a daily basis. I think that every photographer should strive to do the best job possible, and

sometimes the best job is a straight-forward one. I agree with Rich Clarkson, who recently said: "[R]outine visual reporting is called for in some cases—every potential picture cannot and should not be a dramatic and graphic masterpiece. Simple reporting is sometimes the best solution to informing the reader." Where appropriate, case histories are used to illustrate the application of a concept.

Although this book contains considerable technical information, it is important for the student to remember that technique is only a means, not the end, of photojournalism. When photographers gather, they often talk about cameras and lenses, yet as photo editor Sandra Eisert says, you must know the reason why you are making pictures and what you are trying to say. This book does not pretend to be the last or most complete word on this subject, and as I have written in the chapter on education and careers, I encourage all students to broaden their knowledge by taking as many courses in the liberal arts as time and finances will allow.

I owe a great deal to the many generous photographers who have loaned photographs. Without their help, this book would have been impossible. I wish there was space here to name each one individually, but you will find their names adjacent to their work. Almost one-third of the photos are the work of students or recent graduates. Photos not credited are by the author.

A special thank you is due Robert Hanashiro for his help with the chapter on sports. I would also like to thank my contributors for the chapters on law, electronic imaging, and the history of photojournalism. I drove John Zelezny mad with my requests that the law chapter be as specific as possible in spite of his protestations that the law is never absolute. I thank him for an excellent chapter. Mike Morse had the difficult task of writing about electronic photography and image processing, a field that is changing so rapidly that some of his predictions are sure to become old news long before the life of this book expires. And Beverly Bethune faced the almost impossible task of compressing 150 years of history into so few pages. She agonized over what to cut in order to keep the chapter within our space limits. I think she did an exceptional job.

Finally, I want to apologize to my family for all they put up with during the preparation of this book. A textbook is the Mount Everest of the journalist's profession, and I thank them for waiting so patiently while I climbed it.

Photojournalism

Content
and
Technique

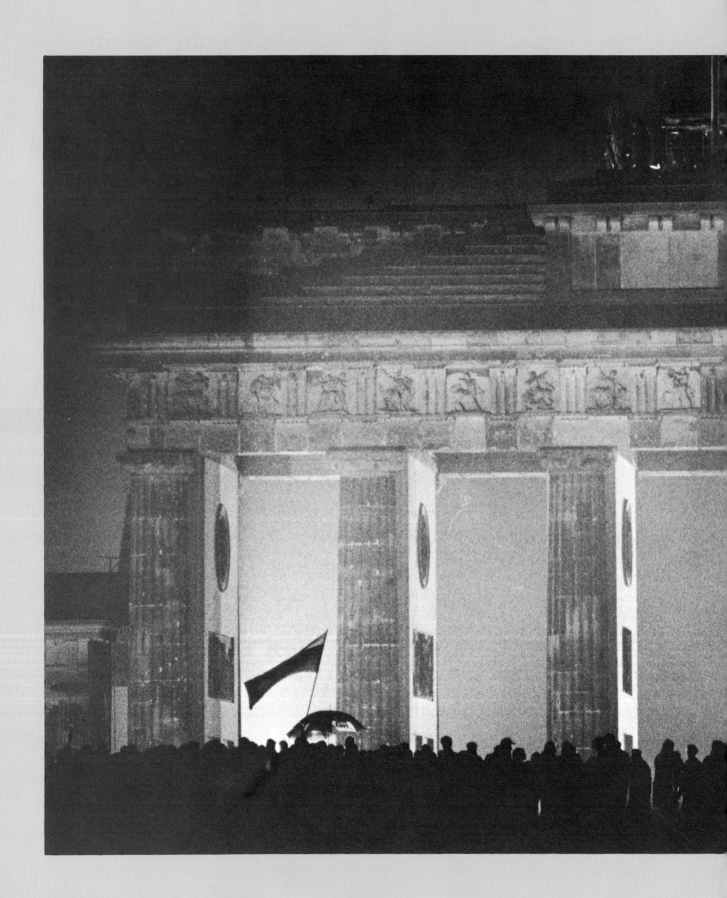

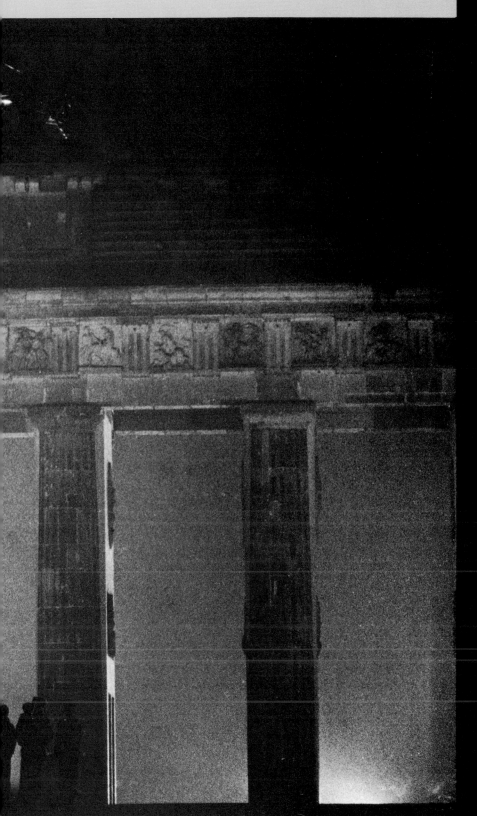

Part I
Introduction

Opening the Brandenburg Gate,
Berlin, December 22, 1989. *(Stephen
J. Pringle)*

Chapter 1

Photojournalism: A Visual Mass Medium

"There were two things I wanted to do. I wanted to show the things that had to be corrected. I wanted to show the things that had to be appreciated."

—Lewis Hine

"The art of photography is a dynamic process of giving form to ideas and explaining man to men."

—Edward Steichen

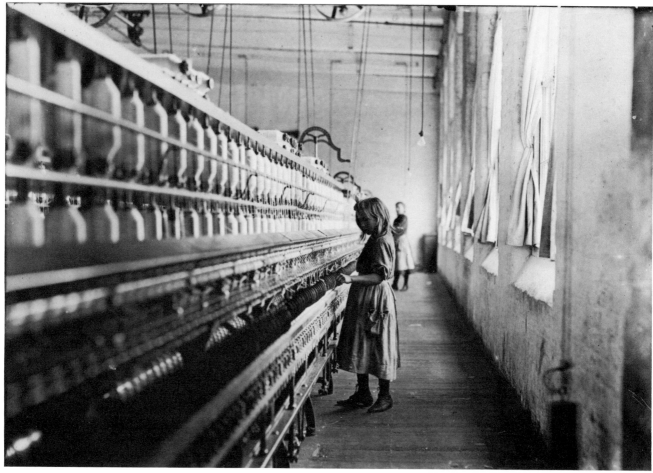

Figure 1–1 In 1908 Lewis Hine made this photo as part of an extensive study of child labor abuses. His pictures contributed to the passage of child labor laws. *(Lewis Hine, from the International Museum of Photography at George Eastman House.)*

The Nature of Photojournalism

Although neither Lewis Hine nor Edward Steichen, quoted on the previous page, were photojournalists as we use the term today, their ideas, when combined, lead us toward a definition of photojournalism. Hine began his career as a social reformer who used the camera to expose child labor abuses just after the turn of the century. And Steichen, whose achievements in photography are many, presided over the creation of the Family of Man exhibit in the mid-1950s. It was quite possibly the most successful photo exhibit in history.

Hine used photography as an instrument of social change, and his comments imply an advocacy role for photojournalism.* But more often, the medium tries to

be objective—as Steichen said, it tries to explain and clarify, and to give us another look at ourselves.

Both men would probably agree that photojournalism is a medium of communication that uses a universal visual language to convey facts and information.

That photographs are a medium of communication should need no proof. Hine's photos convinced many people of the need for child labor laws. An example from an earlier era is William Henry Jackson's photographs of the Yellowstone region of Montana. Those pictures, when displayed to Congress, were instrumental in creating the nation's first national park. On a more commercial level, you can see countless advertisements that are loaded with visual information. The images might be of the product, but they might also convey feelings the advertisers want you to associate with the product—happiness, success, satisfaction, and social acceptance.

In fact, so much of our information comes from visual sources that images are an integral part of society. What do we, each of us individually, know of the world because of photographs? How many of us have been to

*Hine's quote implies using the camera for a social agenda, which is what he did. But this does not mean using the camera to distort the truth, which he did not. I believe pure objectivity is impossible, as you'll learn by the time you finish this book, but honesty is a different thing, certainly attainable, and the goal that I hope you'll set for yourself in all your journalistic endeavors.

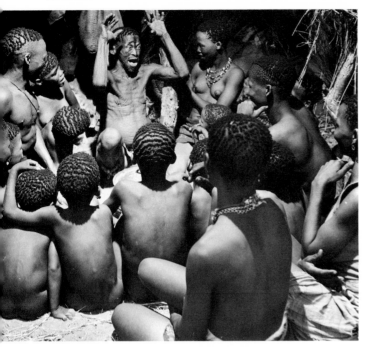

Figure 1-2 In this image from the Family of Man exhibit, we see symbols of humanity that cross cultures and time. It is the way photography captures these symbols that makes it a universal language. (N. R. Farbman, Life Magazine © Time Inc.)

the Egyptian pyramids, the Antarctic, or the surface of the moon? Most of us, however, are familiar with these places and could describe them reasonably well because of our visits to them via photographs.

But the communication of facts is not the only function of the photograph. I'm sure you can recall an instance when your emotions were triggered by a photo, whether it was a warm feeling elicited by an image of happiness or a feeling of horror caused by a picture of tragedy. Maybe a photo of a loved one calls up the feelings between the two of you, or an image in your scrapbook may bring back romantic memories of times past.

The stimulation of these feelings is evidence that photography is a language, an emotional language that speaks to us through our eyes, and in a way that often can't be translated into words. When you see that photo of your loved one, can you describe the feelings completely and accurately?

Photography Is a Universal Language

When humans first started painting on cave walls, they used a visual language. The marks left behind probably were not representations of verbal expression, but images that directly resembled the reality of the time. And the earliest records of organized civilization are picture-symbols that represent ideas—the hieroglyphs and pictographs of the Egyptians, Aztecs, and others. These symbols suggest that visual communication is fundamental to our species.

If visual language reaches to our core, then photography is a universal tool of that language. The medium is one of the few methods of communication that transcends cultural barriers. The Family of Man exhibit, for example, was shown throughout the world to record crowds, and its universal message was understood regardless of the verbal language of the viewers. More recently, the *Day in the Life* series of books has taken us to places such as Australia, Canada, and Russia, and given us a good look at ourselves as well. Photographs of a mother and baby or a smiling child contain messages that do not need translation. Unlike words, there is no problem of shared meaning, because the meaning and the language are the same for everyone.

The Word Photojournalism

It is important when defining this visual language that the term is photojournalism and not news photography, publications photography, or a hyphenated version of photo and journalism. "Photojournalism" is a compound word coined in 1942 by Frank Luther Mott, dean of the journalism school at the University of Missouri.[1] In the previous decades, news photography was a stepchild to the written word. *Life* magazine and others were some notable exceptions, but the bulk of news photographs were made just to show that the newspaper had someone on the scene. Artistic quality had little value, and the intense competition among newspapers meant that the goal was to get a picture and get it into the paper to beat the cross-town rival.[2]

But Mott's creation meant a change in the importance and respectability of the news photograph. The medium had started to become recognized as more than a craft, and its practitioners could specialize in its study at the university level. Publications began to treat the photograph as more than a space filler or graphic device. Although some of those archaic ideas persist today, publications everywhere are showing their commitment to visual communication by adding management-level positions to deal solely with the visual development and production of the product.

Photojournalism and Personal Photos

There is more to a thorough definition of photojournalism than delineating what it is not. First there is the picture itself. What is a journalistic photo? Just as a pen can be put to many uses, from writing poetry to writing a technical dissertation, so can the camera be put to many uses.

A journalistic photo informs and motivates. It is a nonfiction work that, as much as possible, does not include the inner reaches of the photographer's personality. It is an image that is created in reality, keeps a strong connection with it, and reveals facts and information on the first look.

Figure 1–3 Many personal photos have meaning only for the people involved; the photo triggers their memories of the event. But a good journalistic photo includes story-telling elements that anyone can understand.

But what about so many other types of photos that meet these criteria? You probably have many pictures in your scrapbook that, if we ended our definition here, would qualify. Yet those scrapbook pictures are not photos that would be printed in a news publication for everyone to see. They are personal images, and there is an important difference between these and the ones classified as photojournalism. Personal photos are the ones you take at parties, on vacations, and during family events. They are your records of the occasion. These kinds of photos are visual notes that serve as memory triggers. When you see the photo, you remember what happened at the event, even though those memories may not be represented by something in the photo itself.

Frequently, such pictures mean nothing to anyone else. Perhaps you have had the experience of enduring a friend's vacation slides. I'll bet I can tell you what happened. You sat on an uncomfortable couch for several hours while photos came and went on the screen. You were taken to London one minute, Rome the next and then bounced back to England, which was upside down. And more than likely, each photo included your aunt (or whomever) looking at the camera while standing in front of some grotesque monument. And, of course, each picture required a five-minute explanation. While you were bored out of your wits, the photographer was excitedly reliving the trip.

Now, don't misunderstand. There is nothing wrong with making personal images, as long as you recognize them as such and don't expect them to have the same meaning for others as they have for you.

The Interpretive Statement

Although vacation photos and the like serve more as private visual notes for the photographer, there is another type of personal photo, one intended to communicate. It is an image that represents the maker's inner thoughts or feelings, but it is a private interpretation that the photographer intends to share. Sometimes these photos make obvious statements; sometimes they present us with a mystery or riddle. Perhaps an analogy could be made between these kinds of images and certain forms of literature that explore the depths of the author's mind or personal point of view. These photos, which can be eloquent statements and insightful uses of the medium, are often seen in galleries and museums and represent the application of photography as fine art.

But the images made for others, the ones we label photojournalism, must contain strong story-telling features. They need a main object and a focal point, and should show us something we couldn't ordinarily see for ourselves. These photos reveal new information at first look, and more information on the second. They answer some of the classic questions of journalism: who, what, when, why, where, and how. They go right to the point, without ambiguity. They are not photographs that represent the photographer's inner thoughts, but images of what happened before the lens. They are most frequently, as others have said, pictures of people doing things. And I would add that the things being done should be of interest to others.

But how can you be sure that a photo will be interesting to others? One test is to apply the classic news values that are used to describe the qualities of a newsworthy event: consequence, an event that will affect many people; conflict, a clash between people or institutions; prominence, an event involving the well known; proximity, a happening close to those addressed; timeliness, a current situation; and finally, the bizarre, the unusual, the curious, or the amusing. Not all values need be present in every situation, but if just one is there, chances are good that the event would be of interest to many people.

Pictures and Words Together

But photojournalism is not pictures alone. Photos tell only part of the story. Words must complete the message. Wilson Hicks, executive editor of *Life* magazine almost forty years ago, made clear the connection between these two methods of communication. In his book, *Words and Pictures,* he explained how pictures and words each have a separate, yet important job, and that to reach their potential, they must work together.[3]

Hicks said that pictures deal with what happened at the moment of exposure and can only suggest connections with the past and future. They cannot directly express hidden feelings, the sounds or smells and the details of fact that escape the lens.

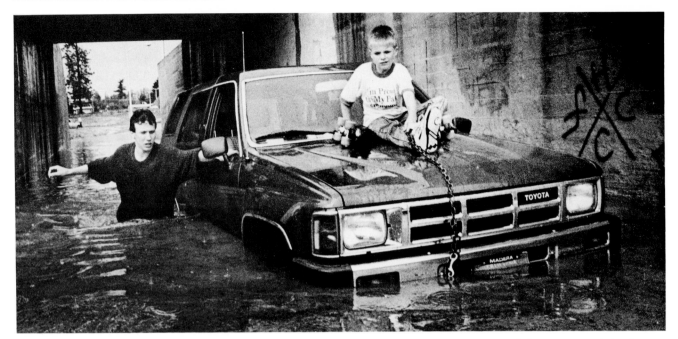

Figure 1–4 Photojournalists try to present facts and information in their photos, and the subject matter is often quite different from what we photograph for our personal visual notebooks. *(Kurt Hegre)*

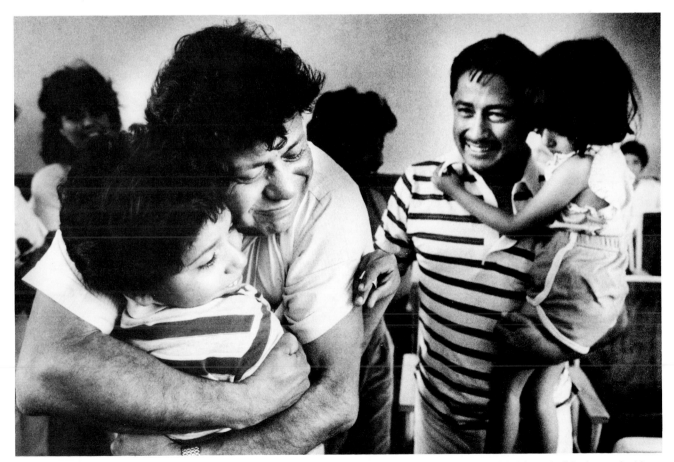

Figure 1–5 Photojournalism is also words and pictures working together. This photo has more impact when you learn that the man in the foreground has just won a low-income home-loan lottery that will enable him to build a house for his family. *(Kurt Hegre/Gilroy Dispatch)*

Unlike words, pictures are read all at once and communicate in a language quite different from words. Words depend upon shared meanings whereas photos have a precision that reaches beyond the culturally based meanings assigned to words. A photo of children playing has universal meaning that transcends the words used by various cultures for spoken communication.

On the other hand, words can tell us many specific things: a person's age, address, or what he or she did yesterday. Words can describe attitudes, put things into a time context, and relate separate events to each other. Hicks said words can deal with cause and effect, whereas the photo deals only with what appeared before the camera. The picture captures time in its own way, and I suspect our ideas about time were greatly altered by the magic little box we call a camera.

Photojournalism, then, is words and pictures, intended for reproduction, that try to produce an honest visual report of what happened, in a form understandable to others. Whereas the personal photo is made for the private use of the photographer, the journalistic photo is made to convey facts and information. The best of these images will arouse the emotions of the viewer and stimulate thought and action.

Uses of Photojournalism

If we also define photojournalism as nonfiction photography, we can find many uses for the medium. Newspapers and news magazines come immediately to mind, but the informative photo with its accompanying text is used in a wide range of publications, including special-interest magazines, books, and even annual reports.

Photojournalism in Newspapers

The largest use of photojournalism today is by the newspaper industry. Almost any paper you pick up on a given day will have at least one photograph on the front page and other pictures inside (the *Wall Street Journal* being a notable exception). Many of these photos are taken by staff photographers, but some of the pictures, usually those about national or overseas stories, are bought by the newspaper from wire services and picture agencies, which are companies that specialize in supplying photos to publications.

The exact procedure for assigning locally produced photos varies, but the photo assignment usually begins with a reporter or an editor. The request for a photographer may go directly to the photo department, but sometimes it goes to a graphics desk where the entire visual presentation of the paper, including photos, artwork, and page design, is coordinated. In the photo department, a chief photographer usually arranges the schedules and assignments of staff photographers.

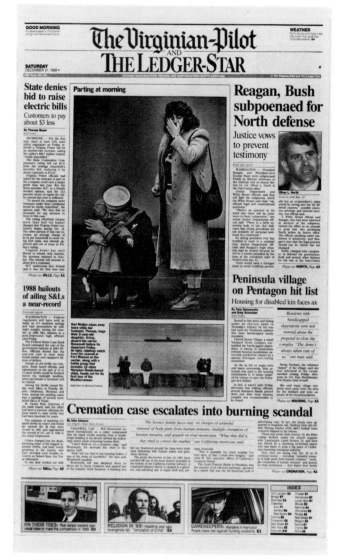

Figure 1-6 The newspaper industry is perhaps the largest user of photojournalism today. *(Courtesy The Virginian-Pilot and The Ledger-Star)*

A typical staff photographer shoots about four assignments per day. The photographer processes the film and selects the shot that he or she believes best tells the story. Sometimes a photo editor will make the decision with input from the photographer.

The photographer then makes a print, which is delivered to the newsroom for captioning and use in planning the page design. The print will eventually find its way to the backshop, the area of the plant where the various elements—advertisements, stories, photos, headlines—are assembled and prepared for the printing press.

Newspapers rely on the photojournalist for caption information, and it is not unusual for the photographer to write the caption used in the publication. On small

Figure 1–7 A wild-art photo is one that could be run any time in the next few days and still be fresh and interesting. *(Glenn Moore)*

papers there may be more overlap between writing and photography; writers may take photos while on assignment, and photographers may be expected to write an occasional story.

On all sizes of newspapers, photographers are encouraged to come up with their own story ideas, and some papers give photojournalists time to pursue these on their own. Further, while traveling to assignments, and on the few slow days when there is spare time, the photojournalist is expected to find feature photos that can be used with only a brief caption. Sometimes called wild art, free art, enterprise or evergreen material, these pictures are the "slice of life" shots that provide a chuckle or an interesting look at something readers can empathize with. Wild art does not mean a crazy shot, although, once in a while, that could be true. Wild art is more like a card player's wild card. It means that, in contrast to the traffic accident picture that must be used today or become outdated, wild art, because it is not connected to a specific story, will stay fresh for several days and can be used any place in the paper.

Versatility Required

On many newspapers, the photojournalist shoots all types of assignments, including news, features, sports, and increasingly, illustrations. News photos include, of course, the traffic accident and the fire, but they also include just about anything that is of immediate interest to the reader. The majority of the story might be told by the photo, with only a few words of explanation, or the photo might enhance or clarify a story that is told primarily with words. The feature photo is a broad category without a concise definition. A feature is just about anything that isn't a news or sports photo. The wild-art shots previously mentioned, as well as fashion, food, personality profiles, and in-depth stories, can be called features.

Illustrations are highly controlled photos in which every element is selected, placed, and lit to convey a specific idea or concept. Illustrations range from food and fashion pictures to images that symbolize complex stories. Illustrative photography is a relatively new area for the newspaper photojournalist although magazine photographers have been using these techniques for years.

Many newspapers also publish their own Sunday magazines and special sections. The Sunday magazine may have an entirely separate staff, including a photographer, who may be assigned to the magazine for varying periods. Special sections vary widely in content. You might find a paper producing one in advance of a major sporting event or community celebration. Special sections are also used when in-depth coverage is needed for a single topic. For example, the section shown in figure 1–9 is about a boy's losing battle with leukemia. The paper's editor believed the story was important enough to warrant its own section.

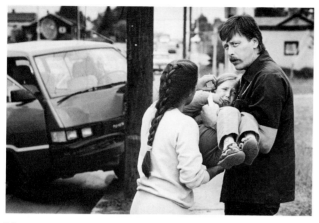
(a)

(b)

(c)

(d)

Figure 1-8 While other professional photographers often specialize in one area of photography, the photojournalist is expected to be able to handle any type of assignment, from fashion and illustration to sports, features, and news. These four photos show some of the versatility of photojournalist Mike Penn. *(Michael Penn/Anchorage Daily News)*

On some papers, photographers are also expected to take photos for advertisements. Large papers may have a staff position or separate department just for ad photos, but the photographer on the small daily or weekly usually handles these tasks along with regular assignments.

Wire Services

Almost all daily newspapers subscribe to wire services for pictures from outside their immediate geographic area. These services supply dozens of photos every day from sources around the world. Originally, the photos were transmitted over telephone wires to special receivers in newspaper offices, hence the name "wire service." Today, nearly the only wire left in the system connects picture transmitters and receivers inside buildings to satellite antennas on the buildings' roofs.

The most common wire service credit lines seen in the United States are Associated Press (AP) and United Press International (UPI). These agencies collect photos from their own staffers as well as newspaper photographers and freelancers throughout the world. Pictures related to major stories are fed through a central editing center where they are retransmitted to client newspapers. Wire services have bureaus in major cities and an extensive network of contacts for photos. European services that are expanding to the United States include Reuters News Pictures Service and Agence France Presse (AFP).

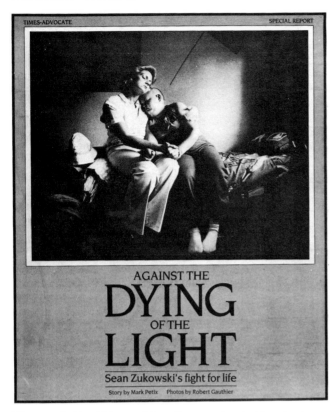

AGAINST THE
DYING
OF THE
LIGHT
Sean Zukowski's fight for life

Story by Mark Peitx Photos by Robert Gauthier

Figure 1–9 This special section was devoted to a boy's losing battle with leukemia. The sixteen-page section was written by Mark Peitx and photographed by Robert Gauthier. *(Escondido Times Advocate)*

Agencies

Agencies are similar to wire services in that they provide photos from worldwide sources, but they differ from the wires in their structure and coverage. Agencies have very small staffs compared to the wire services, and are more like brokers in that they receive material from photographers and sell it to publications, taking a percentage of the sales as their commission. Differences among agencies lie in the types of material they deal with and how they relate to the photographer. Some agencies handle only breaking news. Photographers working exclusively through these agencies use their wits and intuition to keep themselves in the center of major world events. These agencies are in constant contact with clients all over the world, transmitting pictures by wire and overnight mail. Credit lines you may see from some of these agencies include Sygma, Sipa, and Contact Press Images.

Other types of agencies emphasize in-depth stories and follow-ups on events. Still others specialize in stock photos, which are pictures that aren't keyed to a dated news event. There are stock agencies that deal in specific subjects such as agricultural images, animals, or

Figure 1–10 Freelancers often work alone, and must have a sixth sense about what to photograph and where the pictures can be sold. While it may seem glamorous, it is a lot of work and only a few photographers are successful at it.

historical photos. Even the wire services sell photos from their files, for a given photo can sometimes earn more in stock sales than it did for its original use.

Credit lines that you may see with in-depth coverage include Black Star and Magnum. Stock photos might come from agencies such as The Image Bank, Woodfin-Camp, or The Bettman Archive. Because the business is so competitive, agencies tend to specialize in certain types of photos, subjects, or photographic styles. It is impossible to list all of the many agencies here, but you can find picture agencies listed in the Yellow Pages directory of almost every large city.

A very few photographers work exclusively through one agency, with the agency handling sales, billing, filing, and darkroom work for the photographer. The number of photojournalists in this category are few—you could probably assemble them all in one room. On the other hand, freelancers may deal with several agencies, sending pictures of one type to agency A and pictures of another type to agency B.

Whereas wire service photographers receive assignments from the service editors, agency photographers generate almost all their own story ideas. This type of photography is perhaps the most difficult, because the photojournalist must have a sixth-sense ability to anticipate when and where something is going to happen and an understanding about the marketability of the pictures from that event. If a photographer's ideas don't pan out and the pictures don't sell, he or she will soon be looking for a new line of work.

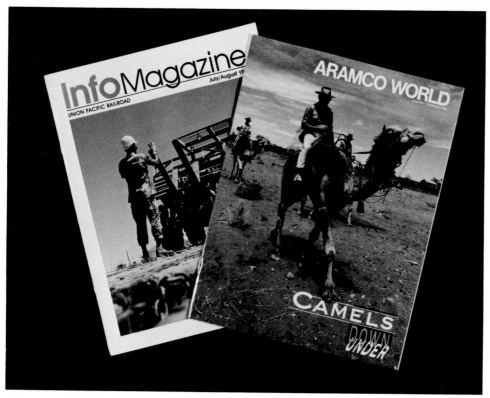

Figure 1–11 Markets for photojournalism extend beyond newspapers and magazines to include annual reports, books, and corporate publications such as these. *(Courtesy Union Pacific Railroad and Aramco Services Company)*

Magazines

There are so many different categories of magazines and their methods of getting photos are so varied that it is hard to generalize. News magazines such as *Time* and *Newsweek* have a few staff photographers, but they also rely upon wire services, agencies, and freelancers for photos. They deal in timely material, use color almost exclusively, and pay fairly well for pictures used. Because of the pay, and the limited space available for photos in the magazines, competition among photojournalists in this market is intense.

A broad category of magazines we could call general-interest magazines might include titles such as *Life* and *National Geographic,* which present a variety of stories to a large general audience. *National Geographic* probably has the largest staff of photographers, and they are well known for their talent. They have the rare luxury of large expense accounts, generous deadlines, and considerable technical support. The freelancer who lands an assignment with this magazine has quite a plum, indeed.

Another category of magazines that uses photojournalism is special-interest magazines. Most of these publications do not use news photos (unless that is their

special area). Examples of large-circulation special-interest magazines include *Sports Illustrated, Ebony,* and *Rolling Stone.*

There are literally thousands of other magazines that use photos, including publications for almost every trade, profession, hobby, or special interest. The *Model Railroader, Home Shop Machinist,* and *USA Gymnastics* are just a few examples. Most of these magazines do not have staff photographers, but rely on freelance submissions and stock photos.

Other Publications

Other uses of photojournalism include books, annual reports, audio visual programs, company newsletters and newspapers, and many public relations publications. Books use many stock photos, and, depending upon the book's topic, may include news pictures. This text is one example.

Annual reports have become a premium vehicle for corporations to display themselves to the public, and some report designers prefer the spontaneous look of photojournalism to show off their company. Annual report photos are sometimes a mixture of photojournalism, illustration, advertising, and public relations.

Another vehicle for photojournalism is audio visual programs, which are very common in industry. These shows are photographed in 35mm slide format and usually include a sound track. Low production costs and ease of updating the programs make them popular. Often, a number of projectors are used to create special effects.

Many companies publish employee newsletters and periodicals intended for their clients and the public. Photojournalism is also used in these publications, some of which reach quality standards as high as any well-known major magazine or newspaper.

Because these special uses of photojournalism are created to promote corporate interests, don't expect to find much investigative journalism. Negative news and any image that might show the company in a bad light will more than likely be rejected. Even so, the spontaneous, direct style of photojournalism is used often enough that photojournalists should consider these uses as potential markets for their work.

Summary

Photojournalism is not a medium that can be defined in one tidy sentence. It is the interplay of words, doing the job only words can do, against the photograph, which speaks to us with a universal visual language. This visual language crosses cultures, political divisions, and time. Whereas words are open to differing interpretations and require a certain level of literacy for their use, photographs can be understood by anyone, regardless of verbal literacy. The power of this photographic language is demonstrated by the fact that taking pictures is restricted more often than taking notes.

The photograph captures time, freezes motion, and reveals the invisible with unmatchable reality. The goal of the photojournalist is to tell the reader what was there, clearly, quickly, and without mystery, confusion, or riddle.

The photographs used in photojournalism are different from those we might take for ourselves. Journalistic photos are intended to convey facts and information, not the personal feelings or inner thoughts of the photographer.

The cultivation of a news sense is important for the photojournalist, and it begins with an understanding of basic news values: prominence, proximity, timeliness, consequence, conflict, and the bizarre.

The pictures we take and the words that go with them are used in many ways. The most common and obvious is the daily newspaper. Papers have staffs of photographers who supply an unending appetite for fresh, timely material. Other users include news magazines, special-interest magazines, and the thousands of other publications that need "nonfiction" photos, from trade magazines to textbooks and company publications.

All of these users depend, in varying degrees, on wire services and picture agencies for material. Wire services have large staffs of photographers, and they supply newspapers with a daily stream of photos from around the world. Picture agencies have smaller staffs and tend to specialize in their coverage.

In conclusion, the word photojournalism also indicates what is required of you. You must be both a photographer and a journalist. You must be a master of the technical and visual means of communicating with a camera, and you must also have the instincts of a reporter for news value, emphasis, and significance. And, ideally, you should be able to use both communicative tools—words and pictures. Although this book will emphasize the development of your visual skills, I urge you to become a total communicator and expand your verbal skills, too. It is extremely difficult to wear two hats while reporting a story, but you should know what is required of both the writer and photographer, the strengths and limitations of words and pictures, and how both elements are created and used.

Notes

1. Clifton C. Edom, *Photojournalism: Principles and Practices* 2d ed. (Dubuque, IA, 1980), 41.
2. Wilson Hicks, *Words and Pictures* (New York, 1952), 26.
3. Ibid.

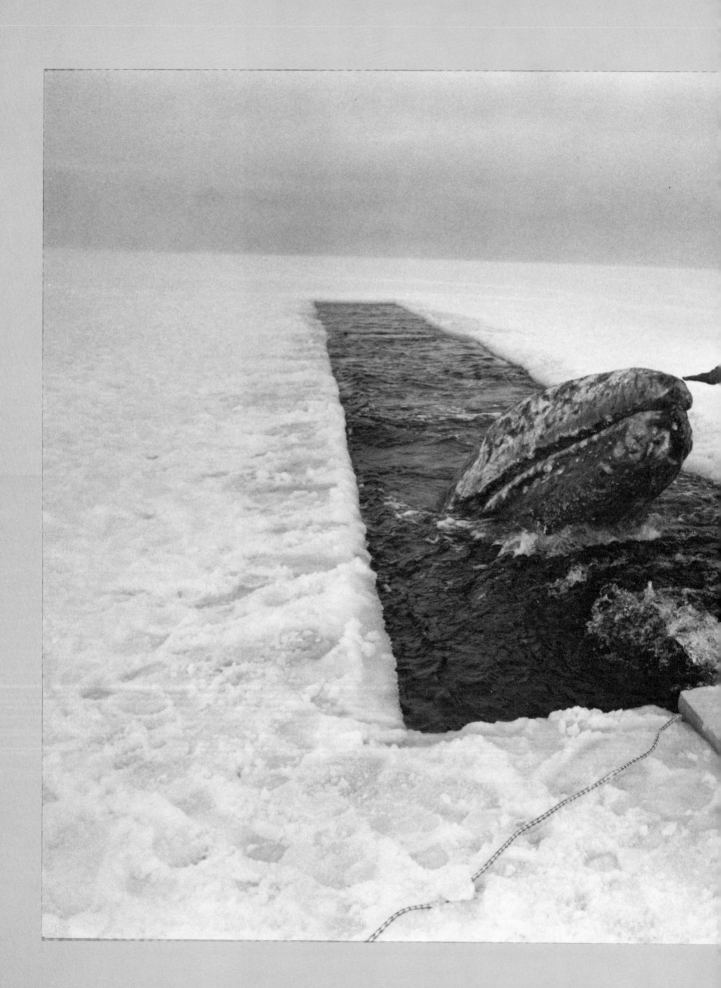

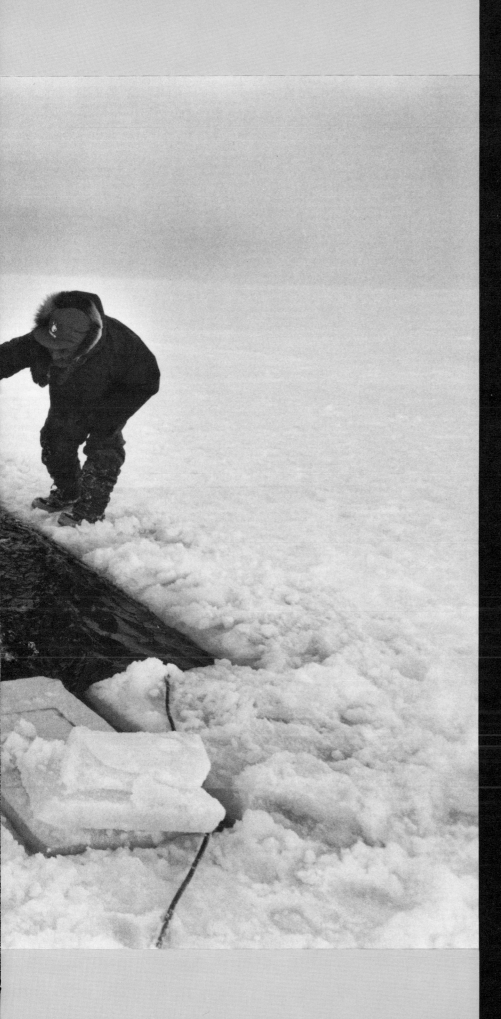

Part II
Tools

A pair of California gray whales were trapped in ice off Point Barrow, Alaska. As a Soviet icebreaker approaches to free them, Malik, an Inupiat Eskimo whale hunter who helped engineer the rescue, bids a final goodbye. (© *Copyright 1990 Bill Hess*)

Chapter 2

Cameras

Outline

To be a photographer: "You need a heart, an eye, a mind, and a magic box."

—Carl Mydans

Understanding the Tools

In the past, considerable technical expertise was required to produce professional quality photos. To be a photographer you also had to be a mathematician, chemist, and mechanic. Today, automation has taken over many of the technical problems, giving photojournalists more time to concentrate on capturing the perfect moment. But just as the computer has not replaced the writer's need for a good vocabulary, I doubt that cameras will ever be so fully automated that photographers can work without making decisions about the tools in their hands. The first order of business in learning photography, then, is to understand the tools and make their operation part of your natural reflexes.

In order to discuss cameras, we must break them down into their components: viewing systems, focusing systems, shutters, the aperture, and related controls.

A Simple Camera

A camera in its simplest form is a box with a pinhole in one side and a piece of film at the other (fig. 2–1). (In fact, you can make a workable pinhole camera out of a shoe box or oatmeal carton. Use a piece of photo print paper instead of film.) But the pinhole camera is to modern photography what Henry Ford's first sputtering little car is to the modern automobile. To make a camera useable for the photojournalist, many refinements must be made.

Viewing Systems

The first of these refinements is a viewing system that will help you aim the camera's lens accurately. There are three common viewing systems: *reflex, viewfinder,* and *direct-view.*

The Reflex System

In a camera equipped with a reflex viewing system, a mirror sits behind the picture-taking lens as in figure 2–2. The image is reflected by the mirror onto a focusing screen. When you press the button to take the picture, the mirror first swings up quickly out of the way so the image can pass through to the film, and then flops down again so you can continue viewing through the lens. Cameras so equipped are called *single-lens reflex* (SLR) cameras.

In modern SLR cameras, the large prism on top of the camera reflects the image on the focusing screen to your eye. In some SLR cameras, the prism is removable so you can look directly at the focusing screen—a handy

Figure 2–1 Pinhole camera.

option when shooting from extremely low angles. Some cameras also have removable focusing screens that can be exchanged for screens designed for special needs.

The single-lens reflex camera is the most popular camera among photojournalists today. Because you use the same lens for both viewing and photographing, you can attach many different lenses without concern for special viewfinders, and there are literally hundreds of accessories available that help the photographer do the best job possible. The most common SLR cameras use film that is 35mm wide, but some SLR cameras take other film sizes such as the fairly common 120 size roll film.

SLRs were once bulkier and noisier than viewfinder cameras, but modern designs have, for the most part, eliminated these drawbacks. For the versatility and quick response needed by the photojournalist, there is no better instrument than a good SLR.

The Viewfinder System

The second type of viewing system is the *viewfinder.* The simplest type of viewfinder is a tube or frame aligned with the camera's lens like a gunsight on a rifle so you can see what is in the lens' field of view. Pocket cameras such as the Instamatic are the most common examples of this type.

Unfortunately, viewfinders do not see exactly what the lens sees. If you look at figure 2–3b, you'll see why—the viewfinder is offset from the lens. The technical term for this problem is *parallax error,* and many of us have suffered the embarrassment of cutting off someone's head in a photo because of this problem. Sophisticated cameras include mechanisms for adjusting the viewfinder as you focus on close objects, but although this adjustment overcomes many parallax problems, most viewfinder cameras have a close-up limit of about three feet.

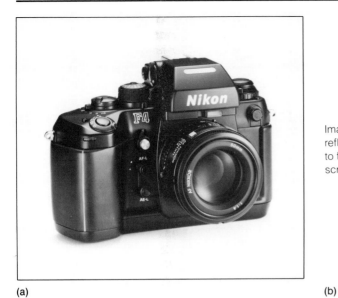

(a)

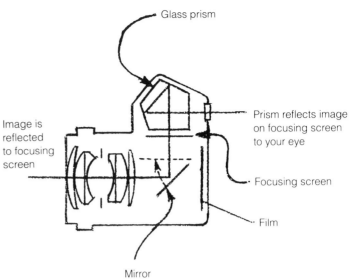

(b)

Figure 2-2 (a) This Nikon F4 has reflex viewing, which permits you to see through the image-forming lens up to the moment of exposure. *(Courtesy Nikon Inc.)* (b) In a reflex camera, the mirror reflects the image up to the focusing screen, and the prism reflects the image from the focusing screen to your eye. The mirror swings out of the way at the moment of exposure so the image can pass on to the film. Not shown is the shutter, which sits just in front of the film plane.

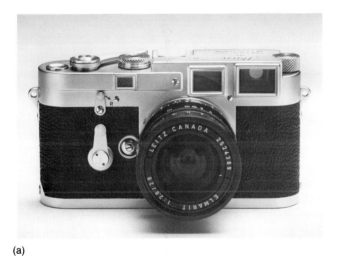

(a)

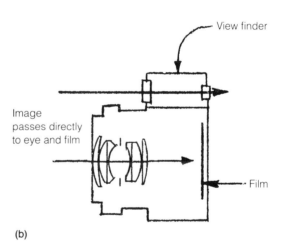

(b)

Figure 2-3 (a) The viewfinder window in this camera is the large one at the right. The center window is for the light meter and the one on the left is for the rangefinder. This is a Leica, a camera that is popular with photojournalists. (b) An illustration of viewfinder viewing. The viewfinder sits atop the camera and works similar to a gunsight. Thus, you do not see exactly what the image-forming lens sees.

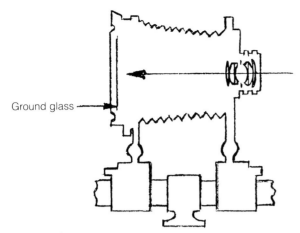

Ground glass

Figure 2–4 In a direct-view focusing system, the image is projected onto a piece of frosted, or ground, glass that sits at the film frame. The film is loaded in special holders that are inserted one shot at a time in front of the ground glass.

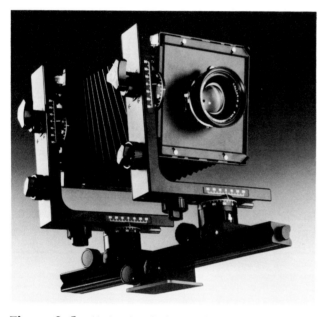

Figure 2–5 Notice that the lens and film back on this view camera can be swung and tilted. This permits the photographer to control distortion and depth of field. *(Courtesy Calumet Photographic)*

An additional problem with viewfinder cameras arises when you attach a wide-angle or telephoto lens. To accurately frame your photos, you must have the equivalent of a wide-angle or telephoto viewfinder. In some cameras, the built-in viewfinder automatically adjusts to certain lenses; in other cases, you must buy a special add-on viewfinder matched to the lens you plan to use. In any event, viewfinder cameras are difficult if not impossible to use with the long focal length lenses frequently used for sports photography. Accurate framing and focusing of fast action requires the ability to see through the picture-taking lens, something that is best done with reflex cameras.

However, there are many advantages to viewfinder cameras, including their light weight, simple construction, and bright viewfinder image. This latter feature makes these cameras a favorite with many photojournalists when shooting in dim light. The Leica is a popular brand because of its quality design, quiet operation, interchangeable lenses, and accurate viewfinder. You may see viewfinder cameras made for any number of film sizes from small 110 cartridges up to 4 × 5-inch sheet film.

The Direct-View System

The direct-view method is the oldest and perhaps the simplest. If you removed the back of a camera and replaced it with a piece of frosted or *ground glass,* you could see the image exactly as it is projected by the taking lens (fig. 2–4).

Direct viewing is useful when extreme accuracy is needed or when the special features of view cameras (to be discussed shortly) are called for. But direct viewing is not practical for most photojournalism because it is slow and awkward. The camera's lens inverts the image so it is seen upside down on the ground glass, and because you must view the image through the back of the camera, the film must be removed and replaced for each shot. Also, you can't be sure what is happening in the lens' field of view after the film has been replaced, so these cameras need to be mounted on a tripod and used for controlled subjects.

The cameras associated with direct-view systems are called *view cameras* (fig. 2–5). If you have seen pictures of nineteenth-century photographers at work, you have probably seen view cameras as these large, bulky cameras that were the primary type of camera used in the early days of the medium.

View cameras are used frequently by commercial and architectural photographers when high-quality images produced by large negatives are needed. Also,

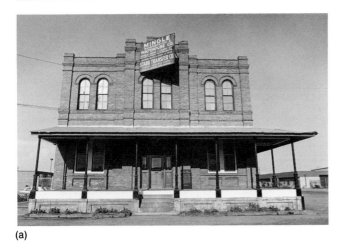

(a)

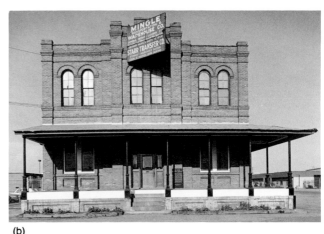

(b)

Figure 2–6 The vertical lines in the left photo seem to converge and the building looks as though it is tipping away from the camera, but in the photo on the right the adjustments of the view camera have been used to keep the building's lines straight.

TABLE 2-1 Advantages and Disadvantages of Viewing Systems

Viewing System	Advantages	Disadvantages
Reflex	Wide variety of lenses and accessories Precise viewing through taking lens	Viewing system blocked out at moment of exposure Hard to focus in low light or with wide-angle lenses
Viewfinder	Quick to operate Bright viewfinder useful in low light Quiet operation useful in sensitive situations	Lens selection limited Parallax problem
Direct View	Precise viewing through lens Control of image distortion Can use many lenses	Heavy and slow to use; must use tripod, cannot be used for moving subjects Image seen on ground glass upside down

view cameras can control distortion, which is important in much architectural and commercial work (fig. 2–6).

Studio illustrations and technical or scientific subjects are the most likely uses of view cameras by the photojournalist. The most common film size for view cameras is 4 × 5 inches, but these cameras are also made for 5 × 7-inch and 8 × 10-inch film. The film is inserted one shot at a time, each piece of film being carried in a special holder about as thick as a slice of bread. Working with a view camera can be fun because there is a certain magic to large negatives. If you ever have the opportunity to use a view camera, I urge you to try it.

Focusing Systems

Although the inexpensive cameras found at variety stores for $20 or less have lenses that are prefocused at the factory, the cameras you are likely to use as a photojournalist will rely on one of two focusing systems: *ground-glass* or *rangefinder.*

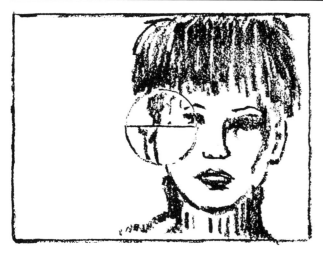

Out of focus

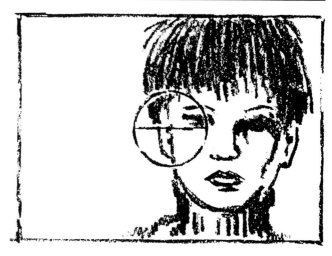

In focus

Figure 2–7a This is a split-image focusing screen. When the subject in the center circle is out of focus, the image halves in the top and bottom of the circle appear offset. When the image is in focus, the image halves match.

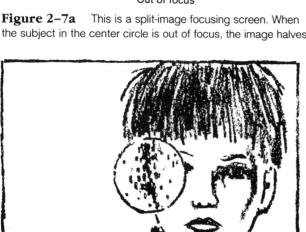

Out of focus

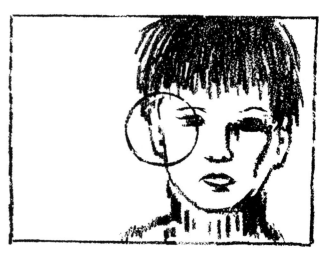

In focus

Figure 2–7b On a microprism focusing screen, the image in the center focusing spot appears to shimmer when out of focus.

Ground-Glass Focusing

Ground-glass focusing is used in view and reflex cameras. When you look at the image projected onto the ground-glass viewing screen, all you need do is focus the lens until the image is sharp.

Modern ground-glass screens in 35mm cameras include focusing aids such as the split image or a microprism or both (fig. 2–7). The illustrations show how your image will look when it is in and out of focus. When looking into the viewing system of a 35mm camera, you may also see various styles of lights, numbers or pointers around the edge of the frame. These are exposure readouts, which will be explained in chapter 3.

Rangefinder Focusing

To understand how to use a rangefinder look at figure 2–8. When you look into the rangefinder window, your field of view is split and you see two images. When the lens is out of focus, the images will be distinctly separate, but when the lens is in focus, the images coincide.

Here's how a rangefinder works: The camera's lens is mechanically connected to the rangefinder. When you focus the lens, gears or levers inside the camera cause the mirrors in the rangefinder to pivot until the two images in the viewing window merge. (In some rangefinder designs, you may see the two images superimposed; in other designs you may see the top half of one image and the bottom half of the other.)

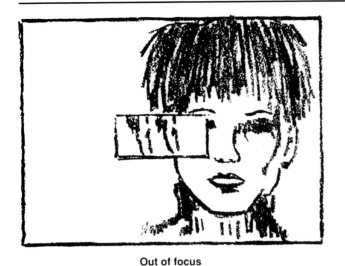

Out of focus

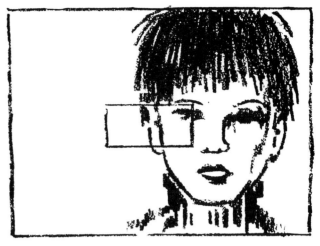

In focus

Figure 2–8 When a rangefinder system is out of focus, you'll see a double image in the focusing spot in the center of the frame. When focused, the images coincide.

Rangefinders are usually used on viewfinder cameras because they can be built into the viewfinder. Be sure not to confuse the term *viewfinder* with the term *rangefinder*. Remember that the former is a viewing system, the latter a focusing system.

Automatic Focusing

Automatic focusing cameras dominate the amateur market and are making inroads in the professional arena as they prove their reliability and accuracy. Controlled by tiny computer chips, these systems use complicated methods for focusing the lens. However, many pros say the auto-focus systems aren't yet fast enough or reliable enough for the exacting requirements of professional work. One problem being attacked by camera designers is slow response. For the fast action of news photography, an auto-focus system must be as quick as human reflexes. Another problem is the area in the viewfinder that is used as the focusing target. If your picture is composed so the subject falls outside of this zone, the camera may not focus correctly. As with any automatic device, there will be times when there is no substitute for human thinking and control.

Shutters

A *shutter* is a device inside the camera that controls the amount of time the film is exposed to light. Shutters open and close in a fraction of a second, the exact time being set by the photographer or the camera's exposure system. There are two types of shutters: *focal-plane* and *leaf*.

Figure 2–9 This focal-plane shutter is partially closed. The bottom curtain is opening while the top curtain is closing a fraction of a second later. At high shutter speeds, the second curtain, made of thin cloth or metal, begins to close before the first curtain has fully opened.

Focal-Plane Shutters

Focal-plane shutters are mounted in the camera just in front of the film. They operate like a pair of window shades, each mounted at opposite edges of the frame. When the shutter release is pressed, one curtain opens, exposing the film. The second curtain closes when the exposure is complete. Figure 2–9 shows a focal-plane shutter in mid-travel. Very high shutter speeds are possible with this type of shutter, and 1/4000 second is not unusual.

TABLE 2-2 Advantages and Disadvantages of Shutter Types

Shutter Type	Advantages	Disadvantages
Leaf Shutter	Use with flash at any speed Quiet compared to focal plane shutters	Top speed limited to 1/500 second Must buy lens and shutter together
Focal-Plane Shutter	High shutter speeds can be used Lenses need not include shutters Allows camera to be used with any lens	Shutter speeds limited when using flash Noisier than leaf shutters

Figure 2–10 A leaf shutter is inside the lens and consists of overlapping blades shaped like shark fins. This shutter is half open.

On the other hand, this design is a disadvantage when using electronic flash. The frame of film is not exposed all at once at high speeds. The second curtain must start to close before the first one is fully open. Thus the shutter is scanning or "wiping" the image across the film; therefore, the light from the flash will have come and gone before the shutter has completed its travel across the frame. Perhaps you have taken pictures with electronic flash and wondered why you got only about half of the picture. Here is your answer: You were using a focal-plane shutter set at too fast a shutter speed for flash.

The solution to this problem is to use slower shutter speeds where the first curtain has a chance to completely open before the second curtain begins to close. At these slower speeds, the flash is triggered when the whole frame is exposed. Virtually all focal-plane shutters will synchronize with electronic flash at 1/60 second. Many cameras will synchronize at 1/125 second and some at shutter speeds of 1/200 and higher.

Leaf Shutters

Leaf shutters consist of a set of overlapping blades like those in figure 2–10. When you press the shutter release, the blades open outward from the center, exposing the entire frame of film at once. When the blades reach the limit of their travel, they quickly reverse direction and close.

Leaf shutters in modern cameras are mounted between the lens elements. View cameras and many viewfinder cameras use leaf shutters.

An advantage of leaf shutters is their compatibility with electronic flash. When the shutter opens, it trips a switch that fires the flash. Because the burst of light from the flash is so short (about 1/1000 second), the flash light passes through the shutter before it has a chance to close. This works even at the fast shutter speed of 1/500 second. As you will see in chapter 6, this is very useful when combining light from an electronic flash with other light sources such as daylight.

Leaf shutters can be a disadvantage to the photographer who must buy several lenses. Because the shutters are mounted in the lenses, the cost of each lens includes the cost of a complete shutter. This problem can be solved by mounting a shutter in the camera body, and the most practical way to do this is to use a focal-plane shutter.

The Iris Diaphragm

The iris diaphragm (fig. 2–11) is a set of overlapping blades inside the lens similar to the blades of a leaf shutter. The iris diaphragm serves the same function as the iris in your eye—it controls light intensity. All cameras beyond the most simple pocket models have adjustable iris diaphragms. The adjustment can be made

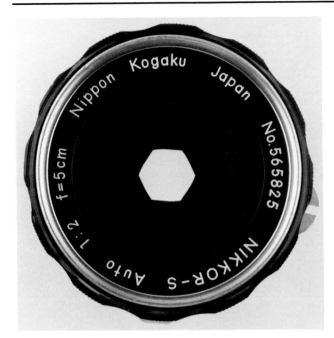

Figure 2–11 The hexagon-shaped opening in the center of this lens is the aperture in its iris diaphragm. The iris diaphragm serves the same light-controlling function as the iris in your eye.

TABLE 2-3 Camera Systems Review

Viewing Systems		
Reflex	*Viewfinder*	*View*
Look through taking lens via mirror	Look through separate viewer	Look straight through taking lens; can control distortion

Focusing Systems	
Rangefinder	*Ground-Glass*
Does not look through taking lens; uses separate mechanism geared to lens	Views image projected on ground-glass lens by taking lens or through special viewing lens

Shutters	
Leaf	*Focal-Plane*
Inside lens; overlapping blades; any speed with flash	Inside camera body; similar to window shades, limited speeds with flash

Aperture
Opening in iris diaphragm inside every lens; operates like iris in your eye to control light. Numbers that indicate size of opening run backwards to common sense.

by turning a ring on the lens, but it is often controlled automatically by the camera's exposure system.

The hole in the diaphragm is called the *aperture,* and the sizes of this aperture are referred to as *f-stops.* Setting the aperture and shutter speed are important for both exposure and creative control.

Controlling Your Camera

Your first look at a full-featured camera may be bewildering. There are any number of dials, rings and windows, all of which contain numbers, pointers, or plus and minus signs. One set of numbers indicates the shutter speed. Another set indicates the lens aperture. Most likely, there will also be controls for the light-metering system and possibly a battery-test indicator. And there is also the depth-of-field scale and the film-speed dial. It isn't hard to learn what these controls are and how they work if you take them on one at a time. Figure 2–12 shows a common 35mm SLR and its major controls.

Shutter Speeds

Shutter speeds control how much light reaches the film by controlling how long the film is exposed—a long exposure will admit more light than a short one.

Somewhere on a full-featured camera, you should see a set of numbers like these:

B, 1, 2, 4, 8, 15, 30, 60, 125, 250, 500, 1000.

You might find these shutter speed numbers on a ring around the lens, or on a small dial on top of the camera near the film-advance lever, as in figure 2–13. Increasingly, shutter speeds are displayed as digital readouts in a tiny window atop the camera.

The numbers represent fractions of a second; however, the numeral 1 means one second. The letter *B* is for time exposures, and you may occasionally see a camera with a *T* setting, which is also for time exposures. Also, many cameras offer shutter speeds of several seconds. On the shutter speed dial these longer speeds are marked with either a contrasting color or style.

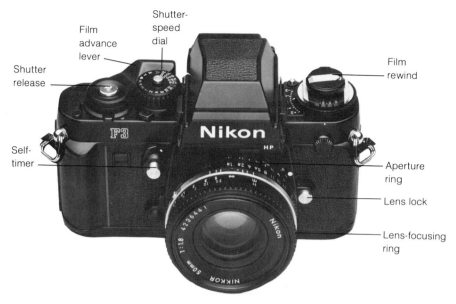

Figure 2–12 The major controls of most cameras are similar. Be sure you can find the shutter-speed, aperture, and focus controls on your camera.

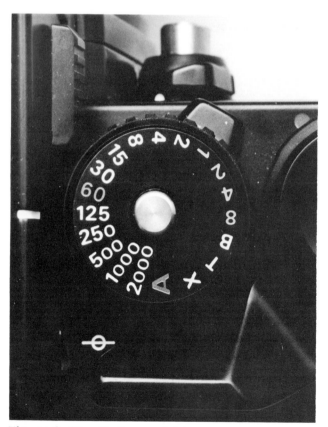

Figure 2–13 Shutter-speed dial.

You'll notice that each listed shutter speed is half as fast or twice as fast as the speed next to it. There are a couple of exceptions: 1/15 second is not quite twice as fast as 1/8, and 1/125 second is a bit more than twice the speed of 1/60, but for practical purposes photographers consider them to have the same relationship as the rest.

Some cameras do not have shutter-speed dials; the shutter speed is set by the exposure system. If you have such a camera, it is still important to understand shutter speeds, as there are times when automatic exposure systems must be overridden, and other times when you may find yourself using a camera without an automatic exposure system.

Exposure will be explained in detail in chapter 3, but for now, concentrate on learning shutter-speed and aperture controls and the meanings of the numbers on them.

The Aperture

In addition to the shutter speeds found on a full-featured camera, you will also see a set of numbers like these:

1.4, 2, 2.8, 4, 5.6, 8, 11, 16, 22.

These f-stop numbers will, in almost all cases, be on the lens barrel, but they may also appear in the view-finder window or as a digital readout. The numbers indicate the sizes of the opening in the iris diaphragm inside the lens.

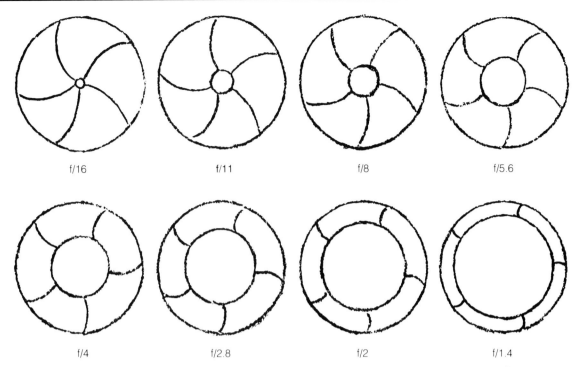

f/16 f/11 f/8 f/5.6

f/4 f/2.8 f/2 f/1.4

Figure 2–14 A small f/stop would be f/16, while a large one would be f/1.4. Don't get confused; the relationship between the numbers and the aperture sizes seems to run counter to common sense. Memorize this illustration if necessary.

Remember, in a lens, the aperture in the iris diaphragm regulates the intensity of the light reaching the film. As with shutter speeds, each adjacent aperture setting admits either half as much light or twice as much light as the f-number next to it. This concept is important in understanding exposure, and because the f-numbers don't have a logical sequence like the shutter speeds, be sure you understand this half-as-much/twice-as-much relationship (fig. 2–14).

At first, you may be confused because the f-numbers seem to run backwards to common sense. When dealing with f-stops, the larger numbers refer to the smaller apertures and vice versa. It might be a good idea to memorize figure 2–14. It is important to remember that f/22 refers to a small aperture and f/2 refers to a large one. Avoid the trap of thinking of 2 as a small f-number and 22 as a large f-number. Professional photographers never refer to them this way. You'll confuse others if you use this incorrect terminology, and you may confuse yourself. Learn to think of these f-stops correctly: 2 is large and 22 is small. When a photographer says "Stop down," it means adjust the aperture toward f/22. When a photographer says "Open up," it means move the aperture toward f/2.

Here is a tip to help you remember: Think of f-stops as devices for stopping the light entering the lens. F/22 stops more light than f/2. In fact, in the early days of photography, metal slides were inserted into a slot in the barrel of the lens. The slides had various-sized holes in them and, quite logically, because they were used to stop light, the term "stop" was used. It may also help to remember the f-numbers if you note that every other one is a double. The only exception is the jump from 5.6 to 11.

When you look at a particular lens, you may see a different f-number for the maximum aperture. F-numbers 1.2, 1.8, 2.5, and 3.5 are not uncommon. These numbers indicate the widest aperture available on that lens and are not full f-stops—that is, they do not admit twice the amount of light as the next stop on the lens barrel. The reason lens makers mark their lenses this way is so you will know the maximum light-gathering power of the lens, an important feature when shooting in dim light.

F-numbers are determined by dividing the diameter of the aperture into the focal length of the lens. Here is the formula:

$$\text{f-number} = \frac{\text{focal length of lens}}{\text{diameter of aperture}}$$

The numbers, which represent the *diameter* of the aperture, increase or decrease by a factor of about 1.4. Yet in order to double the amount of light passing through the aperture, you must double the *area* of the opening, and when you double the area of a circle, the diameter changes by a factor of about 1.4. Therefore, each doubling of the size of the aperture increases its diameter by roughly 1.4.

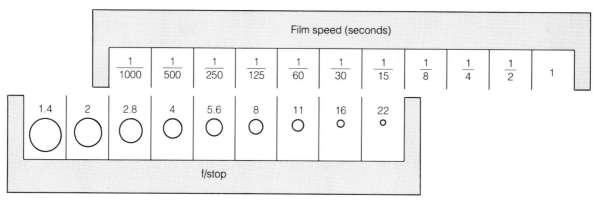

Figure 2–15 This diagram shows the various shutter speed and aperture combinations that are possible in one particular light situation. As the aperture becomes smaller, the time must increase in order to achieve the same exposure.

If the mathematics of f-stops confuses you, don't worry. There are many successful photographers who aren't skilled mathematicians. You will be able to master the concept if you memorize the numbers and their relative aperture sizes and remember that each stop doubles or halves the transmitted light.

The Shutter, Aperture, and Exposure

The shutter and aperture must work together to provide the correct amount of light needed by the film. Remember, the shutter controls how long the film is exposed and the aperture controls the volume of light reaching the film. If you increase the time by using a longer shutter speed, or increase the volume by opening the aperture, more light will strike the film. Of course, decreasing the time or aperture will decrease the exposure.

It is also possible to change the shutter and aperture in such a way that they counteract each other and the total amount of light reaching the film remains the same. If you increase one and decrease the other, the exposure can be kept constant. This concept is important for using the shutter and aperture as creative controls, which is discussed in the next section.

Here's a useful analogy: Think of light as water and the aperture as a valve. You can open the valve and fill a bucket in a certain amount of time. If you open the valve wider, less time is needed to get the same amount of water. If you open the valve twice as wide, you'll fill your container in half as much time.

In your camera, each smaller aperture reduces the intensity by half, so doubling the amount of time is the perfect counteraction to keep the total exposure constant. For example, suppose the meter recommended an exposure combination of 1/125 second at f/8. Any of the equivalent combinations in figure 2–15 will provide the same exposure. The technical term for this relationship is *reciprocal exposure* or the *law of reciprocity.*

The Shutter and Aperture as Creative Controls

In addition to controlling exposure, the shutter and aperture each contribute to the photographer's visual vocabulary. The creative photojournalist knows when to bypass automatic systems and use shutter speeds and apertures to increase the story-telling value of the photo.

The Shutter and Motion

In addition to controlling the amount of time the film is exposed to light, the shutter also influences how motion is captured by your camera. It should be fairly obvious that a one-second exposure will allow moving subjects to blur, and that a 1/1000 second exposure will stop motion. In figure 2–16a, the motion is stopped, and the shot catches the peak moment of this event. On the other hand, the blur of figure 2–16b captures the feeling of motion, and is intended to convey the atmosphere and the idea of movement. Although the subjects of most news photos must be sharp and blur-free, you should learn how to create blur when it would be the best way to report the event.

To create a stop-action photo such as figure 2–16a, choose an f-stop and shutter-speed combination that includes a speed of 1/250 second or faster. The blurred image in figure 2–16b was created by choosing an f-stop and shutter-speed combination that included 1/30 second.

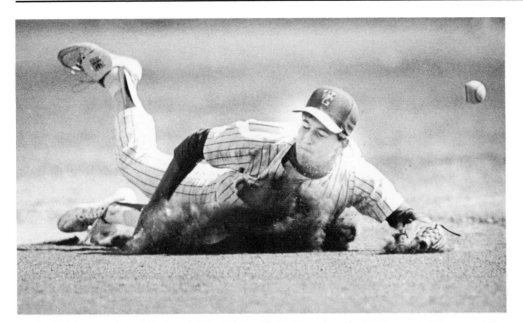

Figure 2–16a A high shutter speed such as 1/1000 of a second freezes this player, the ball, and even the bits of dirt. *(Glenn Moore)*

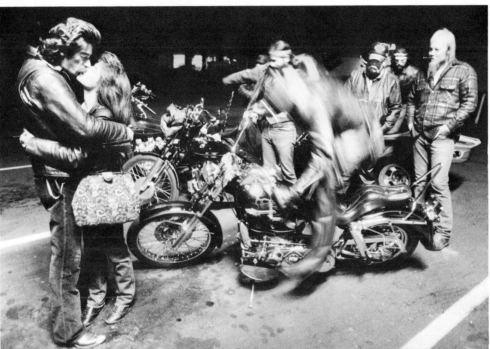

Figure 2–16b Photographer John Walker used a slow shutter speed for this shot so the biker kick-starting his bike would blur. *(John Walker/The Fresno Bee)*

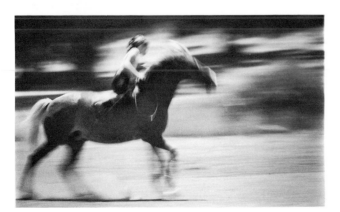

Figure 2–16c By using a slow shutter speed and panning with the subject, the background becomes blurry.

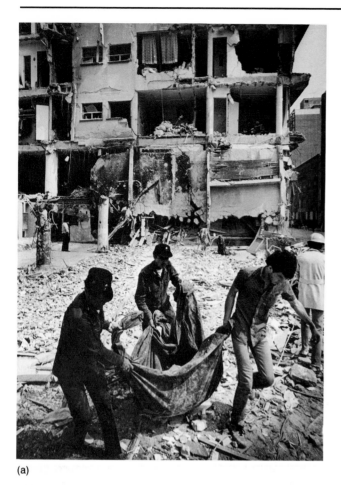

(a)

(b)

Figure 2–17 (a) To keep both the workers in the foreground and the quake-damaged building in the background sharp, photographer Lane Turner used a small aperture, f/16. The photo was taken in Mexico City after an earthquake in

1986. *(Lane Turner)* (b) A wide aperture combined with a telephoto lens will result in narrow depth of field. Notice how the background is thrown out of focus. *(Robert Gauthier/Escondido Times-Advocate)*

Blur is not limited to the subject, however. In figure 2–16c, you'll see that the subject is somewhat sharp but the background is blurry. This technique is an effective way to tell your audience that the subject is in motion. You can create this effect by selecting an aperture and shutter-speed combination that includes a slow shutter speed. If you follow the subject with the camera as you take the picture, the subject will be sharp but, because you are moving the camera relative to the background, the background will be blurry. This technique is known as *panning*. Panning works best when you are close to your subject or use a telephoto lens.

When you try these techniques, write down your exposures. Then check your notes when looking at the results to get an idea of which shutter speeds best contribute to the final effect.

The Aperture and Depth of Field

In addition to its role in controlling light, the aperture also controls *depth of field.* Nearly all photos have depth from close to the camera to some distant point. Depth of field, often mislabeled depth of focus, refers to the spread between the closest object in focus to the most distant object in focus.

This option is an important creative control for the photojournalist. Small apertures such as f/16 produce more depth of field; large apertures such as f/2 produce less depth of field. Figure 2–17 shows two extremes of depth of field. The example in figure 2–17b is sometimes called selective focus.

To get this minimum depth of field, check your exposure meter and select an f-stop and shutter-speed combination that includes a large aperture. On the other

hand, maximum depth of field is created by selecting an exposure combination that includes a small aperture. Once again, keep the terminology straight. Small apertures are those such as f/22, and large ones are those such as f/2.

Some cameras have a depth-of-field preview button or lever. By pressing this button, the lens is stopped down to the taking aperture and you can see the depth of field produced by that aperture. It is hard to see this effect when using small apertures, however, because the image on the focusing screen becomes quite dark.

Other Controls on Your Camera

On most modern cameras there is some way to connect a flash. You may find a tiny socket, a flash shoe or both. The flash shoe allows you to slip a small electronic flash onto the camera. The flash unit will have a matching foot that fits snugly into the camera's shoe. Because the flash must be fired at precisely the right instant, the shoe and foot will usually include the electrical connections needed between the camera and flash. As you will see in later chapters, many lighting effects require you to use the flash away from the camera. In this case, you must connect the flash to the camera by means of a wire that plugs into a tiny socket on the camera body.

There may also be a self-timing feature on your camera, which delays the tripping of the shutter by twenty seconds or so. This gadget will give you time to run around in front of the lens and get into the photo, and it is also useful in helping prevent camera movement when making time exposures. Just set the camera on a firm support, start the self-timer and let go of the camera.

Also found on most modern cameras are light-meter controls. A dial or button may be used to set the meter to match the film's sensitivity. There may also be a dial or window with + and − indications which are used when you intentionally want to over- or underexpose the film. Chapter 3 will explain these controls and how to use them.

Camera Accessories
Some of the most popular accessories today are *motor drives* and *auto winders*. Auto winders advance the film quickly so you are ready for the next shot, whereas motor drives will keep making pictures automatically as long as you hold the button down.

Be careful using a motor drive, though. Don't expect it to take the place of good timing on your part. Too often, beginners press the button on a motor drive with the idea that one of the resulting frames will be good. But chances are good that the peak moment will come when the motor is cycling the camera, and you'll miss the shot. Furthermore, I see an increasing amount of film

Figure 2–18 A monopod, which is nothing more than a single leg from a tripod, is a great camera-steadying device when you must move quickly from place to place.

from beginners who hold down the button on a motor and shoot five or six frames of every image. This method not only wastes film but also results in poor coverage. Beginning photographers may be misled into thinking they shot a lot of film on a subject, yet many frames are duplicates. Invest first in a telephoto and a wide-angle lens and learn to use them well before adding a motor to your inventory.

Tripods and *monopods* are camera-steadying devices. Tripods are useful for holding the camera in exact position, either for long time exposures or remote operation. When using a camera on a tripod, a *cable release* can be attached to the shutter release to prevent your hand from moving the camera.

Monopods (fig. 2–18) are a bit more portable than tripods and are useful for reducing camera shake, particularly when using heavy telephoto lenses of the type often needed on sports assignments.

Figure 2–19 When loading film, be sure the sprocket holes are engaged in the drive gear at the far right before closing the camera back.

Camera Handling

When loading film in the camera, first be sure the film chamber is clean. Get a rubber ear syringe from a pharmacy and use it to blow out dust or chips of film. When threading the film through the camera, be sure the film end is caught securely by the take-up spool (fig. 2–19). Click the shutter and wind the film once before closing the camera back, just to be sure the end is caught. Then close the camera and advance the film twice to get past the leader that was exposed during loading. Double-check that the film is winding through by watching the film rewind knob when you advance each frame. If the knob doesn't turn, the film is not going through the camera. Open the camera and re-attach the leader to the take-up spool.

Some photojournalists have said they wish they could merely thread a roll of film through their ears and blink their eyes to make pictures. Although camera handling isn't that easy, figure 2–20 shows how to hold a 35mm camera for comfort and steadiness. When the camera is held this way, you can operate the aperture ring and the focus ring with your left hand while your right hand operates the film advance lever and the shutter-speed dial. The camera sits in the palm of your left hand, and you should tuck your elbows into your sides for firm camera support. Squeeze the shutter release slowly. Punching it quickly could jerk the camera and cause unintentional blur.

Operating your camera should be a reflex action. Learn how to change lenses and reload without unnecessary delay. Practice shooting "dry" with an empty camera until you can operate all the controls without looking at them. When you carry your camera with you,

Figure 2–20 How to hold a 35mm camera.

watch for that fleeting photo that may last for only an instant. You may have no time to prepare, so avoid form-fitting cases that slow your response, and keep your camera loaded and the shutter cocked. Adjust your shutter and aperture for average conditions or set your exposure system on automatic and focus the lens on about twelve feet.

Camera Maintenance

A photojournalist can't risk losing a shot because of equipment failure. Keep your lens clean. The oil from your fingers leaves greasy marks that can decrease sharpness in your photos and may even eat into the lens coating. Use an ear syringe to blow dirt and dust off the lens. Then use a soft cotton cloth or special lens tissue to wipe the lens clean. (Be sure the cloth is pure cotton. Synthetic fabrics may feel soft yet the fibers may have sharp, abrasive edges.) Stubborn smears may be removed by placing a drop or two of lens cleaner on the lens tissue, then wiping with a circular motion from the center to the edge of the lens. Do not put the cleaning fluid directly on the lens. It may run down inside and cause more problems. Be sure to use photographic lens fluid, not cleaners made for eyeglasses or windows.

Because a photojournalist's equipment is subject to rough handling, you should protect the front elements of your lenses with *skylight* or *haze filters*. These filters

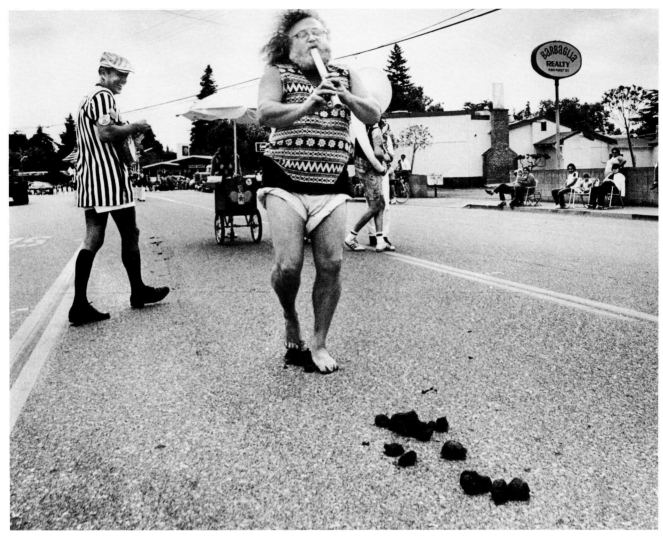

Figure 2–21 Shots like this moment at a small-town parade won't wait, so you must be able to react in a fraction of a second. Keep your cameras set to average conditions and learn to operate the controls by reflex action. *(Kurt Hegre/Gilroy Dispatch)*

look like clear glass and are cheap insurance against a damaged lens. Clean them as you would a lens.

Use the ear syringe to blow dust out of the inside of the camera. Look in the back of the camera for film chips that could land on the rear lens element or jam the mechanism, and get rid of any dust or grit that could scratch the film. The metal blades in some shutters are so thin that they can be bent by the slightest touch, so keep your fingers away from them.

If the lens is removable, take it off and blow out the front chamber of the camera, too. Never touch a reflex mirror with anything—including lens tissue. The reflective coating on the front surface is extremely delicate; any dirt that won't blow off with the syringe is unlikely to cause a problem. Extremely dirty mirrors should be cleaned by a camera technician. If you turn a reflex camera upside down, you can look inside the front cavity and see the bottom side of the focusing screen. Blow the dust off the screen with the syringe.

Your camera probably uses batteries for its various systems. Be sure to check these batteries and replace them at least once a year. If you just bought a new camera, consider how long it may have sat on a warehouse shelf, the batteries losing power all the while. There may be a battery test indicator on your camera, but if not, take the batteries to a camera store for testing. Clean the ends of the batteries and the contacts inside the battery compartment with a pencil eraser.

Finally, check the tiny screws visible on the camera and lens. If necessary, tighten them with a jeweler's screwdriver. Any problem more involved than tightening screws should be referred to a camera repair service.

The Professionals' Choice

In photojournalism, the 35mm single-lens reflex is most popular because of its versatility. Professionals seem to prefer Nikon and Canon although there are many other brands of equal quality. If you use the same brand that professionals in your area use, you may be able to rent or borrow a special lens or accessory locally. On the other hand, if you are the only person in town using a particular brand of camera, you might find it difficult to get accessories you need. This drawback is no small consideration for those who occasionally shoot a sporting event, where a special telephoto lens might be called for. These lenses can cost several thousand dollars; renting or borrowing is sometimes the only practical way to get them.

When looking at specific camera models, be sure to choose one with manually adjustable f-stop and shutter-speed controls. Automatic exposure is fine, but as you'll see in chapter 3, there will be times when you'll need to override the meter system.

Also, be sure the camera you choose accepts interchangeable lenses. You'll soon want to add telephoto and wide-angle lenses to your inventory, and in photojournalism some assignments can't be properly covered without these lenses.

Higher prices generally mean more features and increased durability, and the busy professional may need the extras offered by the top-of-the-line camera. But for the price of a top-of-the-line camera you might be able to get a lower-priced camera body and a couple of lenses, too. This option would give you extra tools for expanding your photographic vision. Auto-focus cameras may be worth considering, but automatic focusing is not fool-proof. As with any automatic feature, be sure it can be overridden manually.

Sometimes you can find a good deal on a used camera, and there is no reason to shy away from used equipment if it is in good condition and not obsolete. Check for visible signs of damage or abuse, test all of the controls, and shoot a test roll if possible.

The Importance of Backup Equipment

Although your first experiences in photography will probably be with limited equipment—one lens and one camera—professionals never embark on an important assignment without backup equipment. If you ever go on an important assignment with only one camera, flash unit, or flash sync cord, fate will catch up with you and you'll have a breakdown at the worst possible moment. The weakest item in a photojournalist's bag is the flash sync cord. The connection between the wire and the moulded plug usually breaks inside the insulation. The only cure is to bury the cord. They are not expensive, so you should have at least two spares handy.

Other weak spots are flash and camera batteries that die without warning. Always keep spares handy. If you are being paid to cover the assignment, you had better think carefully about carrying backup equipment, including at least one extra camera body and lens, and complete flash unit. If you can't borrow something from a friend, you can sometimes rent gear from camera stores. Most major cities have rental shops that will even ship equipment to the hinterlands. Be sure your backup gear is working, particularly if it is borrowed or rented and you don't know it's history.

Finally, regardless of the camera you use, your equipment should be transparent. That is, it should not interfere with the relationship between you and your subject. Don't get so caught up in equipment that your photos are meaningless. Equipment is the means, not the end of photojournalism.

Summary

The simplest camera is nothing more than a light-tight box with a pinhole in one end and a piece of film inside opposite the hole. Practical cameras, however, have viewing systems, focusing systems, shutters and iris diaphragms, all of which give the photographer control over the final image.

Viewing systems help you to accurately frame and compose the image. The most accurate viewing system, direct-viewing, allows you to see the image on a piece of ground glass exactly as it is projected by the image-forming lens. A second type of viewing system, the viewfinder, is a separate viewer that may include lenses of its own. It is aligned parallel to the camera's lens, yet is not very accurate at close camera-to-subject distances. A third type is the reflex system. When looking into a single-lens reflex (SLR) camera, your line of sight is reflected by a mirror through the image-making lens. A great advantage of this viewing system is that you can attach many different types of lenses to the camera yet always see the lens' effects.

There must also be some way to focus the lens, and your quest for sharp pictures is aided by either rangefinder focusing or ground-glass focusing. The rangefinder is vaguely similar to a viewfinder (beware of

confusing these two similar terms) except that it presents two images. By focusing the lens, the two images can be made to coincide. On the other hand, ground-glass focusing projects the image onto a piece of ground glass or matte plastic, and focusing is simply a matter of adjusting the lens until the image is sharp.

Shutters are like small doors that control the light entering the camera. Leaf shutters are inside the lens, where they open outward from the center to expose the film all at once. These shutters can be used with flash at any shutter speed and are commonly found in low-priced pocket cameras as well as some of the most expensive professional gear. Focal-plane shutters are inside the camera just in front of the film. They are similar to a set of window shades, one rolled at the top of the window and one rolled at the bottom. One shade is pulled closed, and when the shutter fires, it opens, revealing the film. It is quickly followed by the other, which closes over the film. Focal-plane shutters are capable of much higher speeds than leaf shutters, but, because they scan across the film, they cannot be used at high speeds with electronic flash.

The iris diaphragm is inside the lens where it does the same job as the iris in your eye: controlling light intensity. The lens' iris opens and closes as you turn the f-stop ring on the lens; but in some cameras it is also controlled automatically by the camera's exposure system. The opening in the diaphragm is called the aperture, and the sizes of the opening are called f-stops. The f-stops are numbered in an unexpected way, f/2 being a large opening and f/22 being small. The progression of numbers does not seem to make sense, but it is based on the doubling of the area of the opening.

Remember, each f-stop change doubles or halves the amount of light entering the lens. Be sure to learn the terminology—photographers "open up" their lenses to wide apertures such as f/2 and "stop down" their lenses to small ones such as f/22.

Controls on the camera include those that set the shutter speed and aperture. Whereas the shutter controls how long the film is exposed, the aperture controls the brightness of the exposing light. These two settings work together to control the total amount of light that reaches the film. The analogy of filling a bucket with water is useful to help form a mental picture of what happens during exposure. If the water faucet is open wide, the bucket fills in a short time, whereas if the faucet drips, the bucket will take a long time to fill. Transferring this analogy to your camera, a wide aperture will allow a short exposure time, whereas a small aperture requires a longer exposure time.

The shutter is also responsible for the control of motion in the photo, short times freezing action and long times permitting moving subjects to blur. The aperture also contributes by controlling depth of field. Depth of field is the range of sharpness from close up to far away. Small apertures produce great depth of field whereas wide apertures produce very narrow depth of field.

The most versatile camera for photojournalism is the 35mm single-lens reflex. Useful accessories include motor drives, skylight filters (to protect lenses), and steadying devices such as tripods and monopods. You never know when a photo may present itself, so keep your camera clean, loaded, and ready to use at a moment's notice.

Chapter 3

Film and Exposure

"Good photographs start with perceptive minds rather than with merely perceptive eyes."

—David Yarnold

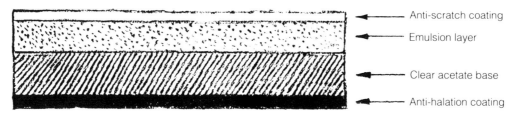

Anti-scratch coating
Emulsion layer
Clear acetate base
Anti-halation coating

Figure 3–1 Film cross-section.

Film

For a photographer in the last half of the 1800s, making photographs was a bit of an ordeal. Photographic film did not exist as we know it today. Sheets of glass had to be sensitized on the spot with messy liquid chemicals, then exposed and processed before the emulsion coating dried. Today, the roll of film you put in your camera works on the same basic principles, but technological changes have increased efficiency, quality, and ease of use a thousandfold.

Instead of a plate of glass, modern film is a plastic strip coated by the manufacturer with light-sensitive silver salts. When the film is exposed, the silver salts affected by the light form an invisible *latent image.* When the film is developed, the latent image is converted to crystals of metallic silver. Figure 3–1 shows a cross-section of a typical piece of film.

Characteristics of Film

Photographic film is a very complex product, and the scientists concerned with its manufacture can spend entire careers delving into its mysteries. For us, however, only a few characteristics are important.

Film Speed When photographers use the term *film speed,* they are talking about how fast the film reacts to light. High-speed films react very quickly, and therefore require relatively little light to record an image. Conversely, slow-speed films react very slowly and need much more light for proper exposure.

Film speeds are marked on film packages and may be preceded by three letters (ASA, ISO, or DIN). The initials stand for various standards and testing associations. The photo industry is converting to the ISO designation, so for the next several years you may see any of these initials associated with film speed.

Films rated at ISO 400 or higher are considered high-speed films. Medium-speed films are rated between ISO 100 and 400, and slow-speed films are rated at ISO 100 or less. For most assignments shot in black and white, photojournalists use ISO 400 film because this film can be used easily for photographing both bright outdoor scenes and dimly lit interiors. For color film, the options depend on many factors, including the type of lighting at the scene and the processes used by the publisher to prepare the photo for the printing press.

Each time film speed doubles, the rating number doubles also. An ISO 100 film is twice as fast as an ISO 50 film. An ISO 1600 film is twice as fast as an ISO 800 film, and four times as fast as an ISO 400 film. In the last few years, some fabulous new films in both black and white and color have been introduced that have speeds of ISO 3200. Under special circumstances, Kodak's P3200 black-and-white film can be used with an ISO rating of 12,500, a speed photographers only dreamed about just a few years ago. These extremely fast films are great for photographing in places where light is weak, and have opened up many new opportunities for photojournalists.

Grain Notice the speckled look of figure 3–2. This effect is called grain, and the specks are the clumps of silver that form the image in the negative. High-speed films have coarse grain when compared with slow-speed films. Compare the coarse grain in figure 3–2 to the almost invisible grain in figure 3–3.

Although fast films have coarse grain and vice-versa, other factors influence the appearance of grain. One of these is the degree of enlargement. When you make an 8 × 10-inch print from a 35mm negative, you enlarge the image roughly eight times. Because the grain is part of the negative, it will be enlarged also. Other factors affecting grain are the choice of developers and processing techniques, discussed in chapter 5. Generally, care in processing will minimize grain.

Contrast In photography, the term *contrast* means the number of intermediate gray tones between black and white. At one extreme, the highest contrast image is one that contains only black and white (fig. 3–4). At the other extreme, a low-contrast image may contain only gray tones (fig. 3–5).

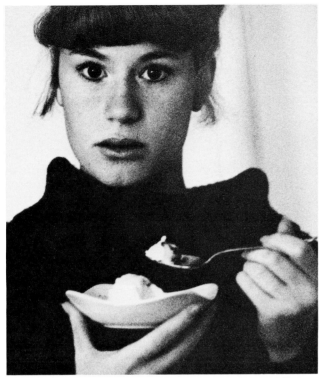

Figure 3-2 This photo was shot with a high-speed film and enlarged considerably in the darkroom. The clumps of silver in the negative are large enough to be visible as specks in the middle tones.

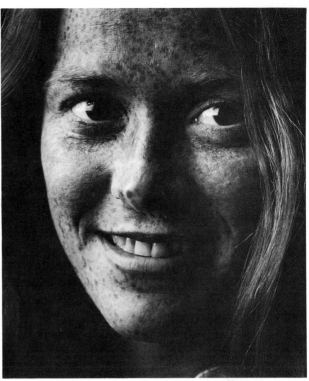

Figure 3-3 Compare this portrait with the one in figure 3-2. This image was shot on a fine-grain film, and the grain is nearly impossible to see.

Figure 3-4 This silhouette is a high-contrast image—it contains only black-and-white tones. *(Glenn Moore)*

Figure 3-5 Lacking strong black-and-white tones and a full range of mid-tones, this low-contrast image emphasizes the story: these people were evicted from their home on this foggy winter day and are moving their things to a pile across the street. *(Paul Kuroda/The Fresno Bee)*

These contrast extremes, and various levels of contrast in between, can be partially the result of the film. Many special films used in the printing industry, for example, are extremely high contrast. These materials are not used for normal photography, but if you photographed an ordinary scene with this type of film, the tones would be recorded by the film as either black or white, as in figure 3–4. Your photo dealer may have one of these high-contrast films (a common one is Kodalith) in 35mm, which are useful for photographing pen-and-ink drawings or lettering for slide shows.

On the other hand, films commonly used by photojournalists produce more realistic results. The contrast in these films varies, although you may find it hard at first to see the difference. In general, high-speed films are lower in contrast than slow-speed films. Other factors are involved in the contrast of the negative, however, and in the section on printmaking you'll see why film contrast is important to photojournalists.

Figure 3–6 Because infrared film records infrared light, the results are always unusual. Foliage appears light while blue skies turn quite dark.

Color Sensitivity Although you expect color film to be color sensitive, black-and-white films are also sensitive to color, but in different ways.

Panchromatic films are the ones most used by photojournalists and are sensitive to all colors of light. *Orthochromatic* films are not sensitive to red light, and, therefore, can be handled in the photo lab under a red safelight. Because they are rarely used in conventional photography it is unlikely that you will encounter orthochromatic films unless you specifically ask for them. Many of the special-purpose, high-contrast films mentioned in the last section are orthochromatic.

Color sensitivity can also vary in subtle ways. For example, Kodak makes two varieties of Tri-X film in 120 size, one labeled Tri-X Pan and the other marked Tri-X Professional. The latter film has extended red sensitivity for use under studio floodlights, which emit more red light than sunlight does. You'll have to look closely to see it, but this slight difference is important to portrait and other studio photographers.

Infrared film has a special sensitivity to infrared light. When used for ordinary photography the results are often unpredictable, and the photos are always a surprise. Infrared film is used only rarely by photojournalists, but it is used widely by medical and scientific photographers, who can learn about their subjects by the way the subjects reflect infrared light. Scientific uses include astronomy, plant pathology, and aerial surveys. The example reproduced in figure 3–6 was made through a red filter, which emphasizes the infrared effect. If you try infrared film, remember that you cannot measure the exposure as the film will record it, so use the exposure guidelines packed with the film, and be sure to make several exposures at different settings. Both black-and-white and color infrared films are available.

Color Rendition Color films vary in their color rendition. Some films favor reds, some favor blues. Some are higher in color saturation than others. For example, Ektachrome traditionally has been on the cool side, whereas Kodachrome has been praised for its vibrancy and fidelity. Fujichrome has gained popularity with photojournalists because of its high color saturation. The ISO 1600 to 3200 films have been noted for softer colors. Color rendition is much a matter of taste, so try a variety of films and rely on your own preferences.

Exposure Latitude The capacity of film to produce a usable image over a range of exposures is known as *exposure latitude*. For example, Tri-X, the old standby, can be over- or underexposed by several stops and still yield a usable negative. On the other hand, Kodachrome 25, the standard by which most color films are judged, has a very narrow latitude. Exposures made on this color transparency (slide) material should be within a half-stop range.

Generally speaking, negative films have more latitude than transparency materials, and high-speed films are more forgiving than slow-speed ones. And color is fussier than black and white. Although there is no substitute for the correct exposure, the importance of film latitude is not lost on photojournalists, who may not have time to set exposures accurately during a fast-breaking news event.

Film Size There are many film sizes; the most common one used by photojournalists is 35mm wide. This format was introduced in the early twentieth century with the idea of using motion picture film in still cameras. Photos made on 35mm film measure 24mm × 36mm or about 1 × 1½ inches. Another common film size is

120 roll film. This film is about 2¼ inches wide and comes in a paper-backed roll. Image format depends upon the camera; some are 2¼ inches square, others are 6cm × 4.5cm and 6cm × 7cm. You might also encounter sheet film. Loaded in special holders, these sheets are inserted one at a time into the camera. Common professional sizes measure 4 × 5 inches and 8 × 10 inches.

Films for Photojournalism

When shooting black and white, most photojournalists use ISO 400 film because it can be used easily both indoors and out. It can also be developed in special chemicals that help the film capture images under very dim light (see Appendix). I suggest you start with these ISO 400 films and learn their characteristics thoroughly. Kodak's Tri-X is the standard, although their T-Max 400 is also popular. Ilford's entry in this category is HP-5, and Fuji offers Neopan 400.

An important black-and-white film is Kodak's P3200. This film has a speed of 3200 and can, with special processing, be used at speeds of 12,500. This capability is extremely valuable for low-light photography. At sports events held at night, the high film speed permits faster shutter speeds.

In color photography, both print and slide films with ISO speeds from 25 to 3200 are used. Your exact choice will depend upon a number of factors, including the nature of the assignment and the processes that will be used to prepare the photo for publication.

Color print films are usually called *negative films,* whereas films for slides are called *transparency films.* Most of these films can be processed quickly and without special equipment; but Kodachrome, an excellent film, requires elaborate processing that is not suited to short-deadline work. Check the film package for the processing required. If you see the phrase "Process E6," (used for transparency films) or "Process C41," (used for negative films), the film can be processed by many newspapers and local processing labs. Obviously, if you have an assignment in color, you must check with the editors to see what type of film should be used.

Polaroid instant-picture films are available in a wide variety of sizes, including 35mm. They are used frequently in studio situations to check lighting and composition, but are rarely used by photojournalists to produce the final image.

When choosing film, be sure you select one that is readily available. Some less-popular brands may be hard to find if an assignment should send you to an out-of-the-way place. Use only one or two films until you fully understand what they will do for you, and never shoot an important assignment on film you haven't previously tested. Don't get too worked up over film brands and types. You'll hear photographers talk about which film is best, but in the end it is the content of your pictures, not the film they are made on, that counts. There is a brief discussion of popular films in the Appendix.

Storing and Handling Film

Film is quite durable, and it is amazing that it will record images under conditions ranging from the hot, humid tropics to the frozen arctic. Nevertheless, heat can damage film, and you should avoid leaving it in your car on a hot day. Although the film won't be completely destroyed in one afternoon, grain and contrast will be affected. In extreme cases, heat can cause fog or odd-looking streaks to appear in the processed emulsion. Objectionable color shifts can occur in color film. I once had a box of film damaged during a cross-country trip because the film was on the floor of the car, right over the muffler. I hadn't realized how warm that spot could get after a few hours' driving.

A small picnic cooler is a handy place to keep film when you are shooting in hot weather, but if you plan to store film for a long time, keep the rolls (in their original factory packages) in a refrigerator or freezer. Be sure to let the packages warm up to room temperature before opening them. Otherwise, condensation could form on the film, causing its own type of damage. Cold weather poses no threat to the image-recording abilities of film, but under extreme conditions the film can become brittle. If you find yourself shooting in the freezing cold, operate the film advance and rewind slowly and avoid the use of motor drives if possible.

Some color films have the word "professional" as part of their name. Intended for critical work, these films are designed for precise color rendition when used and processed promptly and should be kept in a refrigerator. Films not marked this way are made so they will "ripen" by the time they find their way to your camera. There is no reason not to use these films under normal circumstances.

Airport X rays are another hazard to avoid. In spite of some claims to the contrary, radiation from baggage screening equipment can cause damage. Keep film in a separate carryon bag and ask for a hand search. Airports in the United States are required to handsearch bags if so requested, but foreign airports are a different matter. Some use high-level X-ray equipment, and it has been said that some foreign airport inspectors will not pass any object through the boarding gate without a successful X ray. At camera stores you can get lead-lined bags that are made to protect film from X rays, but they are not fail-safe. The best solution is to keep film away from X-ray machines.

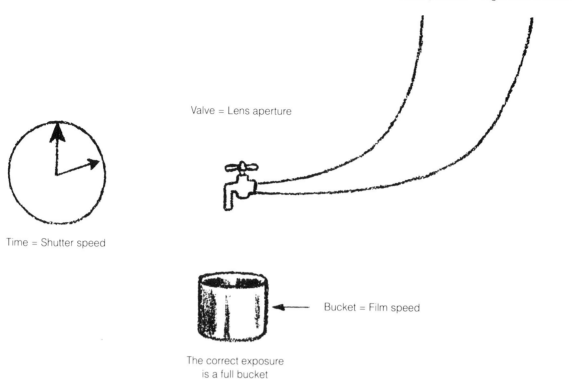

Water pressure = Light level of scene

Valve = Lens aperture

Time = Shutter speed

Bucket = Film speed

The correct exposure
is a full bucket

Figure 3–7 The bucket of water analogy. See the text for an explanation.

Exposure

Understanding exposure is an important part of becoming a photojournalist, because photography depends upon both content and technique. Without the correct technique, the content will be lost. If the negative is not correctly exposed, image quality will suffer; if the exposure is too far afield, there will be no usable image at all. Furthermore, understanding exposure can help you improve content, because the camera features that control exposure also contribute to important depth-of-field and motion effects that carry messages about the subject. Although you may be tempted to let automatic systems set exposure for you, you should know how these systems work so you won't be stranded when they fail, and so you, not a machine, can make the creative decisions.

The Bucket of Water Analogy

In order to record an image properly, the film must receive exactly the right amount of light. As discussed in chapter 2, both the shutter and aperture control the amount of light reaching the film. I recommended then that you memorize the aperture and shutter-speed numbers, particularly the idea that a small f-number, such as 2, is a large aperture setting, and a large f-number, such as 22, is a small aperture setting. Review that section now if necessary.

The easiest way to understand exposure is to think of light as water. Other factors such as aperture, shutter speed, film speed, and the light level of the scene become parts of your water system (fig. 3–7). Think of:

- the aperture as the valve on a water line;
- the shutter speed as the time the valve is left open;
- the light level of the scene as the water pressure in the line;
- the film speed as the size of the bucket to be filled.

In figure 3–7, you have a bucket of a specific size (film speed). You must fill the bucket with just enough water. The correct exposure is a full bucket. It can't overflow by one drop, or be less than full by one drop. To fill the bucket, you must set the proper valve opening, and hold it open for the proper amount of time.

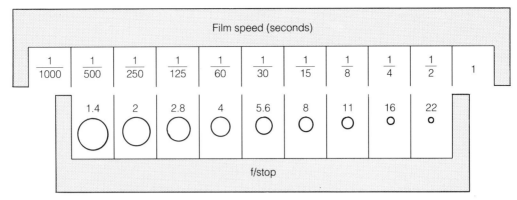

Figure 3–8　The top strip represents shutter speeds and the bottom one represents f/stops. The ruler can be used to find equivalent exposures as explained in the text.

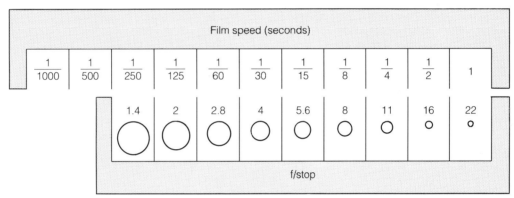

Figure 3–9　If your light meter recommended an exposure of 1/8 second at f/8, any of these f/stop and shutter-speed combinations will pass the same amount of light through to the film.

In filling the bucket, you have some choices. You could open the valve just a small amount, say, just enough to let the water drip through. If you hold the valve open for a long time the bucket will eventually fill. On the other hand, you could open the valve all the way and hold it open for a short time and also fill the bucket.

When making photographic exposures, the same principles are true. You can use a small aperture and a long time, or a wide aperture and a short time, and either combination will provide the correct exposure. As with the bucket of water, if you increase one factor (such as the aperture), you must decrease the other (shutter speed) to keep the total effect the same. This relationship is the law of reciprocity that was introduced in chapter 2.

The Exposure Ruler

The exposure ruler presented in figure 3–8 will help you work with this concept of reciprocity or *equivalent exposure.* You can make your own exposure ruler by copying these two strips and pasting the copies on separate pieces of file card. You can use the ruler to figure almost any combination of equivalent exposures. The top strip shows all the common shutter speeds, whereas the bottom strip shows common f-stops. Some shutters and lenses may go beyond what's shown in this example.

Using the Exposure Ruler

Light meters are devices that measure the brightness of the light and then calculate f-stops and shutter speeds. Light meters will be thoroughly covered in the next section, but for now, assume that you took a light-meter reading and the recommended exposure was 1/8 second at f/8. If you align the exposure ruler so that 1/8 second is opposite f/8, as in figure 3–9, the ruler will show you a complete range of exposure combinations, all of which will result in the same exposure. One second at f/22 fills the bucket just as well as 1/250 second at f/1.4.

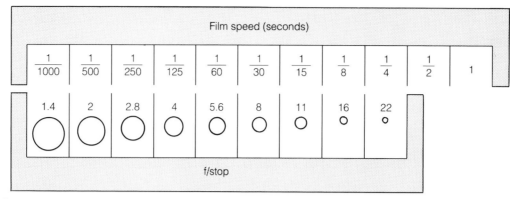

Figure 3–10 Here are the combinations that result if the meter recommends 1/30 second at f/8.

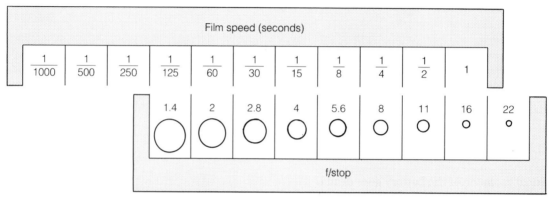

Figure 3–11 In this example, the meter recommended an exposure of f/8 at 1/4 second. Note that there is no shutter speed that matches f/22 and no apertures that match speeds over 1/125.

Here is another example: Assume you took a meter reading of a different scene, and the recommended exposure was 1/30 second at f/8. There is more light in this new scene, and in terms of our water-system analogy, the water pressure is higher. Therefore, you need either a smaller valve opening or a shorter time to prevent the bucket from overflowing. In figure 3–10, the ruler shows you all shutter and aperture combinations that are correct for this particular scene.

Moving in the other direction, assume that the scene has less light, and the meter recommended an exposure of f/8 at 1/4 second. The exposure ruler in figure 3–11 shows all exposure combinations that will result in a correct exposure for this hypothetical scene. Notice that f/22 is too small an opening for the speeds available on the ruler. Also, 1/1000 second is too fast for the widest opening available. You are always limited to f-stop and shutter-speed combinations that are paired on the ruler. If you were to use 1/1000 second anyway, the film would be incorrectly exposed. If you choose a shutter speed and f-stop that do not match up on the ruler, you will get an incorrect exposure.

At this point, you may be wondering how to decide which exposure combination to use. The answer stems from chapter 2 where we discussed how the shutter speed controls the appearance of motion in the photo, and the aperture controls depth of field. An exposure combination with a small aperture will increase depth of field, whereas a combination with a wide aperture will decrease depth of field. Fast shutter speeds stop action; slow ones permit blur. Review those sections on motion and depth of field in chapter 2, if necessary.

You can see by looking at the exposure ruler that compromises must be made in many exposure situations. In figure 3–11, the exposure combination with the fastest shutter speed is 1/125 second at f/1.4. This combination is not quite fast enough to stop most fast-moving subjects, yet it will permit minimum depth of field. At the other extreme, you could use 1 second at f/16. This combination would provide maximum depth of field, yet any moving objects would be very blurred at this slow shutter speed. At a news event, the need for blur-free photos limits your practical choices to combinations with higher shutter speeds.

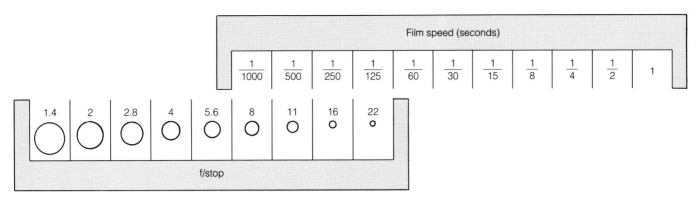

Figure 3–12 A typical sunny-day exposure for 400-speed film is 1/500 second at f/11. In this case, you are quite limited as to shutter speed and f/stop combinations.

In the previous example, you could have used any one of eight f-stop/shutter-speed combinations, but many times you will have fewer choices. For example, a common exposure for ISO 400 film in daylight is 1/500 second at f/11. Figure 3–12 shows the options available, and there is no exposure combination that will produce extremely narrow depth of field.

If you are confused by the concept of equivalent exposure, make an exposure ruler, flash cards, or any other devices that will help you. Avoid relying solely on automatic exposure systems, which may let you down at a critical moment. If the battery goes dead or you are faced with one of the meter-fooling situations discussed in the next section on light meters, you could lose the shot. (I have a friend who went on a three-month tour of Europe. He did not know how to control exposure, and his camera's battery was dead. He came home with forty-four rolls of blank film!) Also, if you leave the creative decisions about depth of field and motion control to an automatic exposure system, you forfeit important aspects of visual communication to a machine. Learn about exposure and expand your photographic vocabulary.

Film Speed and the Term Stops
As you have learned, the term *stops* means the sizes of the aperture in the lens' iris diaphragm. But this term is also used when talking about any change in exposure. As you remember from chapter 2, if you open your lens, say from f/8 to f/5.6, you have increased the exposure by twice as much, or one f-stop. But if you shifted to a slower shutter speed, you would also have doubled the exposure by the equivalent of one f-stop. Photographers commonly refer to any means of changing exposure in terms of "stops" regardless of how the change was made. "Give it one more stop" could mean use either a wider aperture or a slower shutter speed.

Differences between film-speed ratings can also be referred to by the word *stops*. A film with an ISO rating of 200 requires twice the exposure of a film rated at 400. Because twice the exposure requires either one more f-stop or the next slowest shutter speed, the 200-speed film is one stop slower than the 400-speed film.

Light Meters

A light meter is a device that measures the brightness of the light and translates that into f-stops and shutter speeds for the correct exposure. Most cameras have light meters built in, but there are also separate handheld meters.

Meters in Cameras
The light receptors for meters in cameras are usually arranged so they can see right through the picture-taking lens. When the camera's exposure system is set on automatic, the shutter speed, aperture, or both may be set by the meter. When you look into the viewfinder, you will see some sort of exposure indicator that will tell you when the exposure is correctly set. Figure 3–13 shows some typical viewfinder displays.

Using In-Camera Metering Systems There are four types of metering systems in cameras: *manual, aperture-priority, shutter-priority* and *programmed*. To find out what type you have, check your camera's instruction manual.

Before using your metering system, first check the battery, which you should do from time to time anyway. A weak battery could result in incorrect readings. Second, get in the habit of setting the meter to match your film speed as soon as you load the film. This step might be done with a small dial on top of the camera

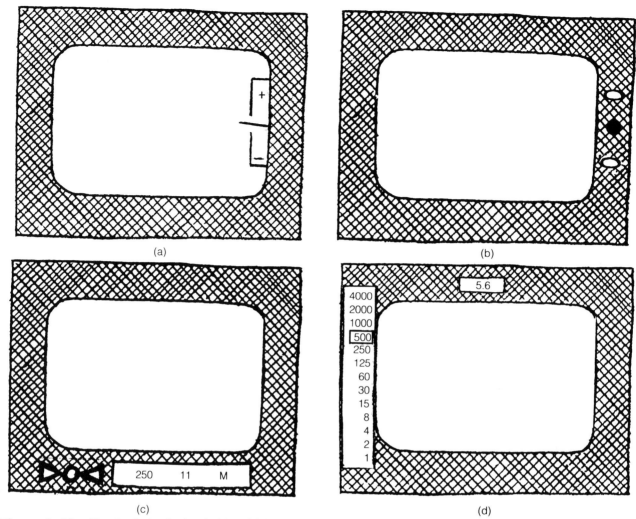

Figure 3–13 The viewfinder displays in (a) and (b) are typical of older cameras with manual exposure systems. The displays in (c) and (d) are similar to what you will find with an automatic exposure system. There are many varieties of exposure readouts; the viewfinders in highly sophisticated cameras are likely to contain much more information.

or by setting a digital readout. Check your camera's instruction manual for details. Increasingly, modern cameras include sensors that read the speed coding on the film cartridge, but you should know how to set this feature manually. Then aim the camera at your subject and use one of the following methods depending upon your system.

Manual System In manual systems the meter simply provides a readout in the viewfinder that tells you when you have set the correct aperture and shutter speed. Select a shutter speed, and look at the viewfinder display. Turn the aperture ring on the lens until the display indicates that you have the correct setting. You can, of course, set the aperture first and then adjust the shutter speed.

Automatic System Operation of automatic systems depends upon the system you have.

1. *Aperture-priority:* You choose the aperture; the meter automatically sets the corresponding shutter speed.

2. *Shutter-priority:* You choose the shutter speed; the meter sets the corresponding aperture.

3. *Programmed:* Both shutter and aperture are set by the meter. These systems are designed to make exposure-ruler choices for you by striking a balance between high shutter speeds for reduced blur, and small apertures for maximum depth of field. In some cameras, the program favors higher shutter speeds; in others, small apertures are given preference. Top-of-the-line cameras may have several options.

Remember that on the exposure ruler discussed earlier, your exposure combinations are sometimes limited. Auto-exposure cameras warn you if you go past this limit. The warning will be some sort of indication in the viewfinder (a red light, or a small plus or minus sign telling you that you have asked for a shutter speed or aperture that cannot be matched with an appropriate counterpart). There are too many types to list here, but your instructor can help you if you are not sure how to read your viewfinder display.

Controlling Motion and Depth of Field with Auto-Exposure Systems

Although auto-exposure systems set f-stops and shutter speeds for you, the system may not select exactly what you want for depth of field or motion control. If you always let the system decide what settings to use, you may get more or less depth of field than you need, or blur may appear when you don't want it. This situation can be compared to a word processor that insists you use only certain words in your writing. To use the camera to its fullest, you must be able to select an exposure that will match your creative needs.

Aperture-Priority Systems Controlling depth of field is a simple matter with aperture-priority systems. Because the aperture controls depth of field, just set the aperture you want and the meter will select the correct shutter speed. It bears repeating, however, that you must watch the viewfinder display for indications that the aperture you have chosen can be mated with an available shutter speed. And be sure that shutter speed isn't so slow that unwanted blur will occur.

When controlling motion with an aperture-priority system, your goal is to make the camera select the shutter speed you want. You can do this by changing the aperture and watching the exposure readout. Opening the aperture will result in a higher shutter speed; closing the aperture will cause the shutter speed to slow down.

Shutter-Priority Systems Controlling motion with shutter-priority systems is easy. Set the shutter for the speed you want and watch your viewfinder to be sure the system can match your choice with the correct aperture. If you want to create minimum depth of field, use a high shutter speed to force the meter to set a wide aperture. For maximum depth of field, a slow shutter speed will force the exposure system to select a narrow aperture. Again, watch the viewfinder window to be sure you have not exceeded the span of possible exposure combinations.

Figure 3–14 This handheld light meter can be used as an incident meter or, by sliding the tiny dome at the top out from in front of the light receptor, as a reflected meter. *(Courtesy Bogen Photo Corp.)*

Handheld Light Meters

Handheld light meters are about the size of a large electronic belt-pager. Figure 3–14 is a photo of a typical handheld meter. All meters have a receptor cell that receives the light, which is read on the meter's scale. Digital meters provide exposure information directly in f-stops and shutter speeds. Analog meters (ones with needles that point on a scale, like the one illustrated) have a calculator dial that translates the meter reading into f-stops and shutter speeds.

Handheld light meters measure light in one of two ways. The first is by measuring the light falling on the scene; the second is by measuring the light reflected back to the camera from the subject.

Figure 3–15 Commercial photographer Richard Eissler is making an extreme close-up of a pair of wire cutters. He holds an incident light meter just in front of the cutters and aims the meter's light receptor dome toward the light source. The front of his view camera is just visible in the lower right.

Incident Light Meters You can recognize an *incident light meter* by the small white dome that is the light receptor. Incident meters measure the light as it comes from its source (fig. 3–15). Hold the meter in front of the subject and aim the meter's light receptor toward the light source. Be sure you don't cast a shadow on the meter's receptor dome. If you can't place the meter near the subject, you can take a reading from some other position as long as the light falling on both the meter and the subject is the same.

Because incident meters measure light as it comes from its source, they are not affected by bright or dark subjects or the other abnormal scene conditions discussed in the following sections. For this reason, incident meters are favored by many professionals. But incident meters can't be conveniently built into cameras, and their chief drawback is that you must carry them as separate tools in what may be an already crowded camera bag. Often, there is not time to juggle a meter and a camera, too.

Reflected Light Meters *Reflected meters* measure the light reflected back from the scene (fig. 3–16). This type of meter is used in cameras, where it often sets the shutter speed or aperture (or both) for you. To use a handheld reflected meter, simply aim the meter at the subject.

Using Handheld Light Meters

1. *Check the battery.* There may be a battery-test button or switch. If the battery check shows the battery to be low, remove the battery and clean it

Figure 3–16 A reflected meter is aimed at the subject from the camera position.

and the contacts in the meter with a pencil eraser and test again. Some handheld meters do not have batteries, but if yours does, don't expect it to last forever—treat your meter to a new one once a year.

2. *Set the meter for the correct film speed.* Before using any light meter, you must tell it what film speed you are using. On meters with calculator dials, you will find a small window or index mark on the calculator dial labeled ASA or ISO or both. Set the film speed opposite the index mark, or rotate the dial so that the film speed number shows in the window. Digital meters are set by pressing a button until the film speed readout is correct.

3. *Aim the meter and note the reading on the scale.* Remember, reflected meters are aimed toward the subject; incident meters are held at the subject and aimed toward the light source. The meter reading will be on a scale underneath the pointer needle. (If your meter uses a digital readout, you won't have a scale. The reading you get will be in f-stops and shutter speeds. Displays vary, so be sure to check the meter's instruction manual.)

4. *Set the meter's calculator dial.* (Digital meters need not be set.) Set the reading from the pointer's scale into the calculator dial. There should be a window or index mark on the dial where this reading is to be set.

5. *Note the recommended f-stops and shutter speeds, and set the camera.* Decide which f-stop and shutter speed combination to use based on your needs for depth of field and motion control. If neither of these is particularly important, use an exposure combination that includes a blur-reducing shutter speed of 1/250 second or higher.

If the shutter speeds don't match up perfectly with the f-stops, you can set your camera for in-between aperture settings even though the f-stop ring on the lens wants to click into place at each stop. Shutter speeds, however, must be set at the specified speeds.

Because it is impractical to illustrate every possible style of meter display, you may need to read your meter's instruction manual or ask your instructor for help with an unfamiliar meter.

Metering Abnormal Scenes

When working with incident meters, you'll have little problem with the abnormal situations discussed here. As mentioned above, incident meters measure the light as it comes from its source and are not affected by variations in the brightness or reflectance of the subject. But reflected meters, including those installed in your camera, can be fooled by subject variations as well as by unusually bright or dark backgrounds.

Here's why: Light meters don't see specific details the way a camera does. Meters only see a conglomeration of brightnesses, and their makers calibrate them for average conditions. If you added up the brightnesses of all the tones in a typical scene, they would average out to be a medium gray. If the scene contains large bright or dark areas around your primary subject, or if the subject is unusually light or dark, the meter is likely to be confused and give you the wrong information.

For example, in figure 3–17 the subject's face is in the shadows, although the background is very bright. If you used the exposure recommended by the meter, the skydiver's face would be too dark. A similar problem would arise with an extremely dark background, such as a performer on a dark stage lit by a spotlight. In these cases, take a close-up reading of your subject if you can. Just be sure you don't get so close that you cast a shadow on the area you are metering. As you can't take a close-up reading of the skydiver, you could just make an educated guess and open up the lens two or three f-stops.

Figure 3–17 This photo was a difficult exposure problem because the man's face was in deep shadow yet the background was extremely bright. The text discusses possible solutions. *(John Murphy)*

This method would probably work fine in black and white, but color film requires more precise exposure. In that case, you must take a substitution reading, or use the backlight switch, both of which are discussed in the next section.

Another common meter-fooling situation is a wide view that contains a lot of sky. Skies that are hazy but bright are particularly troublesome. Aiming the meter slightly downward will prevent the sky from being too dominant in the meter's calculations.

Your meter may also be fooled when your subject is unusually light or dark. A bride in a white dress against a white wall is one example. Because the meter thinks it is seeing gray, the exposure settings recommended to you by the meter are for a gray subject, not a white one. In this case, you must take a *substitution reading.*

Substitution Readings A substitution reading is simply a light meter reading taken from something other than the scene you are photographing. You could take a substitution reading to avoid the problems explained in the previous section. Camera stores sell special gray cards that are designed to be used as targets for substitution readings. But it is hard for fast-working photojournalists to use gray cards, and there is a convenient alternative readily available at the end of your arm. The palm of your hand can be used as a target for substitution readings. Hold your hand about a foot away from the meter (or camera if using an in-camera meter—it's not necessary to focus the lens) and open up the lens one f-stop from the reading obtained. This extra exposure is needed because your hand is not the same brightness as the gray card.

Substitution readings are also useful when you need to make a close-up reading but can't get close to the subject. You can take a reading from a similar object as long as that object is in the same type of light as your subject.

Be careful when making substitution readings with an automatic exposure system in a camera. Unless you bypass the automatic system, the camera will reset itself when you step back to your shooting position. You'll see how to override in-camera meters in the next section.

Overriding In-Camera Meters When taking substitution or close-up readings, f-stop and shutter-speed settings must be locked in or the meter system will change them when you step back to your shooting position.

If your metering system is manual only, you'll have no problem because the meter doesn't change the cameras settings—you do. Just make the reading, set the camera and ignore the viewfinder indications when you step back to shoot.

Automatic exposure systems in cameras usually have one or more of the following control devices.

Exposure Mode. With this feature, a switch allows you to choose between manual and automatic exposure control. It is a simple matter to override the automatic modes by using the manual mode. Then you can take a close-up or substitution reading, set the camera, step back to your original shooting position and shoot.

Backlight Switch. If your camera is so equipped, pressing this button when shooting backlit scenes such as figure 3–17 increases the exposure to compensate for the backlight.

TABLE 3-1	Meter-Fooling Situations
Problem	**Solution**
Bright or dark background	Take close-up reading of subject
Unusually light or dark subject	Take reading from palm of your hand
Wide-angle view including lots of sky	Aim camera down slightly, set exposure and recompose

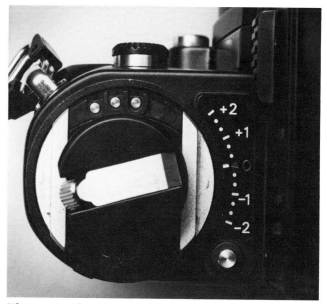

Figure 3–18 Underneath the rewind knob on this camera is the exposure compensation dial. The plus and minus numbers to the right of the knob indicate the amount of exposure change in f/stops. For example, +1 is one additional stop of exposure.

Memory Lock. This override method allows you to lock in aperture and shutter-speed settings by pressing a button on the camera. Take your close-up or substitution reading, press the memory-lock button on the camera, and the settings are locked in until you release them. Then just move to your shooting position and fire away.

Exposure Compensation Dial. On the top of your camera body, you may find a dial marked +1, +2, −1 and −2 . Turning this dial will allow you to change the exposure that is automatically set by the meter (fig. 3–18). The + numbers increase the exposure; the − numbers decrease it.

TABLE 3-2 Rule-of-Thumb Exposure Guide

Scene	Change from Basic Exposure
Bright sun	Basic exposure = Set shutter to match ISO and use f/16
Backlight	+ 2–3 stops
Sidelight	+ 1/2–1 stop
Slight overcast	+ 1 stop
Heavy overcast	+ 2–3 stops
Dark storm	+ 4 stops
Open shade (such as under a large tree)	+ 2 stops
Extra bright	− 1–2 stops
Office interiors (fluorescent light)	+ 8 stops

Film-Speed Dial. If you must use a camera with none of the previously listed override features, you can still control the exposure system by lying to the camera's light meter. That is, you can force a change in exposure by changing the meter's ISO setting. If you cut the film speed in half, you increase the exposure by one stop; if you double the film speed, you decrease the exposure by one stop.

Bracketing Bracketing is a form of exposure insurance that you can use in difficult situations. To bracket, make one shot at the meter's recommendation, then make one or more shots with increased exposure, and one or more shots with decreased exposure. With black-and-white film, bracketing by one full f-stop over and under the meter reading is usually adequate. With color transparency film, bracketing is usually done in half-stop intervals.

The Rule-of-Thumb Exposure

There may be times when you just can't take a meter reading. Perhaps the meter quit working, or you need a substitute reading but can't take one, or maybe there just isn't time. In these cases, you can use the rule-of-thumb exposure system. It starts with a basic exposure, which you either use as is or modify, depending upon the conditions. Table 3–2 lists a complete rule-of-thumb exposure system. It might be a good idea to copy the chart and tuck it in a pocket of your camera bag—just in case.

The basic exposure is found by using the shutter speed closest to the film's ISO number. Then, in the bright sun the aperture will be f/16. For example, the ISO for Tri-X is 400. Because shutters do not have a setting of 1/400 second, use the next closest speed—1/500. The basic exposure then is 1/500 at f/16. To use another example, if you were using T-Max 100, which has an ISO of 100, your basic exposure would be 1/125 at f/16.

From this basic exposure, increase or decrease your exposure depending upon the conditions. As table 3–2 shows, darker lighting conditions or backlit subjects require increasing the exposure, sometimes as much as four f-stops or their equivalent. Extra bright conditions, such as at the beach or on concrete pavement on a sunny day, require decreasing the exposure.

The basic exposure can also be used as a rough means to test a light meter. Take a meter reading of a subject in bright sun. If the recommended settings are more than one f-stop away from the basic rule-of-thumb exposure, have the meter accurately tested by a camera repair shop.

Summary

Film has several characteristics that are important to photojournalists. Film speeds, called ISO ratings, tell us how fast the film will react to light. An ISO 400-speed film is considered high speed, ISO 200-speed films are considered medium speed, and films slower than 100 are called slow-speed films.

Grain is another important characteristic. Slow-speed films have extremely fine grain, and the grain is sometimes hard to see. In high-speed films, however, grain is usually easy to see as a speckled look in the middle gray tones. In spite of this effect, photojournalists usually use ISO 400 or faster films because these films can be used both indoors and out, in bright light or dim. Choosing which color film to use can be difficult and depends on the lighting available at the scene and the printer's requirements. Although film is quite durable, it should be kept away from heat and X rays.

Getting the right exposure is the major technical goal in photography. If the scene is not recorded on the film, no magic can save the photo. Exposure is a lot like filling a bucket with water. The aperture in the lens is similar to the water faucet, the light level in the scene is like the water pressure in the pipe, and the size of the bucket is like the film speed. The shutter speed is equal to the time the water valve is open. You can fill the bucket quickly by opening the valve wide, or you can

take a lot of time by letting the water drip from the faucet. Photographic exposure works the same way, but you can't let your photographic bucket, the film, overflow or come up short, not by a single drop. However, you can change the time and the valve opening any way you want as long as the bucket is filled perfectly.

This idea is important, because the camera controls that affect exposure, the shutter and aperture, also affect visual aspects of the photo. The shutter can stop motion or let it blur, and the aperture can increase or decrease depth of field.

For accurate exposures, you must use a light meter to tell you which f-stop and shutter-speed settings to use. The meter takes into account the film speed and the brightness of the light at the scene, and gives you exposure combinations of aperture and shutter speed that will result in a correct exposure.

Light meters are of two types. Incident meters measure the light falling on the scene, whereas reflected meters measure light that is reflected back to the camera from the subject. Incident meters aren't fooled by variations in the scene, but they must be held at the subject's position, which often can be a difficult task in photojournalism. Reflected meters can be simply aimed at the subject, but they can be fooled if the subject includes very bright or dark backgrounds, or light- or dark-colored subjects. In these cases, you must take a substitution or close-up reading so the meter won't be fooled by the unusual brightnesses.

Meters in cameras are always reflected meters. They may help you set the lens aperture and shutter speed yourself, or they may be mechanically connected to one or both of these controls. In order to maintain control over depth of field and motion in your photo, you can force these automatic systems to use the shutter speeds or apertures that you need. The exact method depends upon the specific exposure system, but basically you must operate one of the controls while watching the exposure readout until it displays the setting needed.

Regardless of the meter you use, handheld or in-camera, be sure you set it to match your film's ISO rating, and that the meter's battery is in good condition.

In case of meter failure, the rule-of-thumb exposure system can be a useful estimating method. Just set your shutter for a speed that matches the film's ISO number, and use f/16 in the bright sun. For other lighting conditions, increase or decrease the exposure as necessary.

Chapter 4

Lenses

"I find it hard to believe that there is anyone fully unable to say something about the world that is imaged in his mind and heart."

Ansel Adams

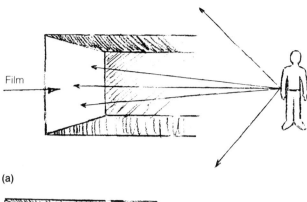

(a)

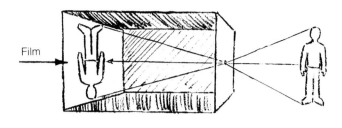

(b)

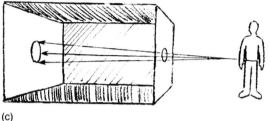

(c)

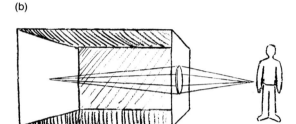

(d)

Figure 4–1 (a) No image would be formed on the film in this camera with its front end cut open. Light rays bouncing from all parts of the image would strike all over the film. (b) A small pinhole in the front of this camera would admit just a few light rays from each point on the subject, and an image would form on the film. (c) If the pinhole was enlarged to admit more light, the image would blur. Adjacent points would create overlapping circles on the film. (d) If a lens is installed in the camera, it will collect more light rays and focus them on the film to create a sharper image.

Why Lenses Are Needed

Although you can make photos with pinhole cameras like the one shown in chapter 2, lenses increase your photographic vocabulary. They offer you a way to edit the photo, allowing you to include or exclude subject matter, magnify or diminish objects, and control what your viewer sees.

The primary purpose of a lens is to gather the light rays being reflected by the subject and focus them onto the film. In order to understand how this concept works, let's start with the pinhole camera from chapter 2. If you were to make a camera like the one in figure 4–1a, you would not get a recognizable image because light is bouncing off every point on your subject and hitting every point on the film. But if you made a pinhole camera like the one in figure 4–1b, only a few light rays would pass through the hole and strike the film. The extraneous rays would be blocked by the front panel of the camera.

But the big drawback to a pinhole camera is that the tiny hole doesn't admit enough light for the fast shutter speeds needed by a photojournalist. Using 400-speed film in bright sunlight, an exposure for such a tiny aperture would be somewhere between 2 and 6 seconds—useless for the photojournalist.

To shorten this exposure time, you could increase the size of the hole. But figure 4–1c shows what happens then. All the points of light reflecting from the subject become overlapping circles on the film, and the image becomes blurry.

But if a lens was inserted into an even larger hole, the lens would bend the light rays together and more of the light rays could be collected and directed to the same spot on the film. A brighter and sharper image would result (fig. 4–1d).

How Lenses Work

Lenses work because light bends when it passes at an angle from one transparent medium to another. You have seen this effect if you have ever stuck a stick into a pool

Figure 4–2 When a light ray passes from one medium such as air into another medium such as glass, it is bent. This is the fundamental principle on which lenses bend light rays to form images on film.

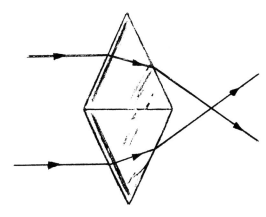

Figure 4–3 If two prisms were placed base-to-base, the light rays passing through them would converge.

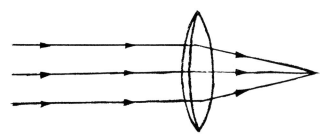

Figure 4–4 If the surfaces of the two prisms in figure 4–3 were smoothed out to form a convex lens such as this, all the light rays from a particular source could be made to converge at the same point.

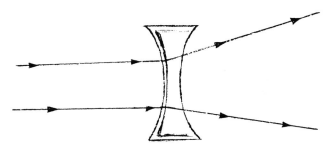

Figure 4–5 Concave lenses cause light rays to diverge. They are used in combination with convex lenses to correct aberrations in the convex lenses that would otherwise degrade the image.

of water and noticed how the stick appears to bend where it enters the water. Physicists like to demonstrate this *refraction* with a prism, as in figure 4–2. When light passes into the prism it is bent, and it is bent again upon leaving the prism.

If two prisms are placed base to base, the light rays can be made to converge, as in figure 4–3. Expanding on this idea, we can curve the sides of the prisms and blend their bases together to create a lens, as in figure 4–4.

This convex shape is a *positive lens*. The simple magnifying glasses you can buy in a variety store are positive lenses. When light rays leave a positive lens, they converge and can be focused on a surface such as a piece of film. There are also *negative lenses,* which have concave surfaces and cause light rays to diverge, as in figure 4–5. Images from negative lenses cannot be focused on a surface.

Although a variety store magnifying glass could be used in a homemade camera, the image projected by a single lens is not perfect. These imperfections, called *aberrations,* can be reduced by grouping several individual lens elements together, some positive and some negative, so that their aberrations cancel each other out. For this reason, all photographic lenses consist of several elements.

Lens Characteristics

When you look at a lens, you may first notice its size and weight, but two other characteristics are more important to photographers. One is the lens' focal length; the other is its widest aperture.

Figure 4-6 This is a good example of space distortion. Photographer David Grubbs found this scene as school was about to open in the fall. He said the man at the far right was carrying a dictionary. *(David Grubbs/Corvallis Gazette-Times)*

Focal Length

The *focal length* of a lens is the distance from the optical center of the lens to the film plane when the lens is focused on infinity. You can find the focal length of a simple lens such as the variety store magnifier mentioned in the last section by taking it outside and focusing the sun's rays on the pavement. Then measure the distance from the lens to the spot of focused light. That is the focal length.

You can't do this with complex lenses because the optical center of such a lens may not be at the physical center. Anyway, we need not measure focal lengths because lensmakers engrave them on the lens barrels, usually on the ring that surrounds the front element. The engraving may simply read "50mm," but it may also read "f=50mm." In this case, the *f* stands for focal length, not f-stops, and the *mm* stands for millimeters.

In photography, lenses are classified as normal, short or long focal length. You will hear short focal length lenses called *wide-angle lenses* and long focal length lenses called *telephoto lenses*. Technically, the terms wide angle and telephoto are not as accurate as short and long focal length, but photographers commonly use the terms interchangeably, which I will do here.

Space Distortion

Space distortion is an interesting and useful phenomenon associated with lenses. Compare figures 4-6 and 4-7. Figure 4-6 was made with a wide-angle lens, whereas figure 4-7 was made with a telephoto lens. Notice how the objects near the camera in the wide-angle shot seem so much bigger than the objects in the background, and there is a great distance between them. Also notice how the foreground seems to curve down toward the camera. The letters on the pavement seem to lean toward each other, even though they are parallel on the pavement.

Yet in figure 4-7, the skateboarder and the Santa seem to be stacked right on top of the background, even though the background is slightly out of focus. Notice the size of the car behind the skateboarder. Overall, the wide-angle shot seems to be more three-dimensional, whereas the telephoto shot has a flat, pancaked look.

Figure 4-8 is also a good example of the compression of space that can occur with telephoto lenses. In figure 4-8a, you can see that the woman is about 12 feet from the car, but in figure 4-8b, shot with a telephoto lens, she looks as though she is sitting much closer to the car.

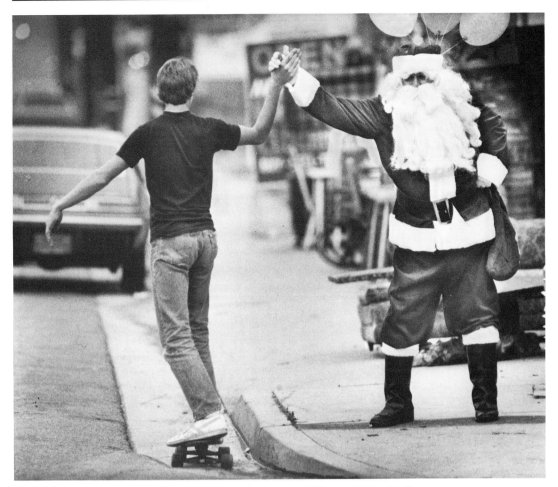

Figure 4–7 This photo was made with a telephoto lens. When compared with figure 4–6, the spatial relationships between the subject and the background are completely different. *(John Walker/The Fresno Bee)*

(a)

(b)

Figure 4–8 (a) Here we can see that the woman is about 12 feet from the car, but in (b) she seems quite close to it. *(Robert Gauthier/Escondido Times-Advocate)*

Figure 4-9 A 21mm wide-angle lens was used to create the distorted lines in this building.

Shape Distortion

Another type of distortion, one that is particularly evident with wide-angle lenses, could be called *shape distortion*. Notice how the building in figure 4-9 appears smaller at the top, almost as though it were falling over backwards. Figure 4-10 shows another type of shape distortion from wide-angle lenses. Some extreme wide-angle lenses create barrel distortion, as in figure 4-19.

Sharp readers will notice that I qualify many of my statements with the words "appears" and "seems." Technically, perspective and depth of field aren't distorted by these lenses, but they appear that way because of how we use the lenses. If you held the finished print at the proper distance from your eye, the scene would appear normal. (Photos made with wide-angle lenses would need to be held quite close to your eye, whereas shots made with telephoto lenses would have to be held away from your eye.) But because we rarely look at photos this way, distortion occurs and we ascribe that to the lens.

You can see this distortion with your own eye. If you hold your thumb about an inch from your eye, you'll notice that it is grotesquely larger than the background objects (even though your thumb is blurry)—an effect similar to the one in figure 4-10b. And if you look off into the distance at two objects, you'll see a spatial relationship similar to that shown in figure 4-7. We aren't normally aware of this distortion because our brains keep providing interpretations of what we see.

Normal Focal Length Lenses

A *normal focal length* lens is one that produces an image that looks very much like what you see with your eyes. Perspective seems normal, and there is very little space and shape distortion.

A normal focal length is determined by measuring the distance across the diagonal of the image on the film. For example, the diagonal of a piece of 4 × 5 inch sheet film is about six inches, so a normal focal length lens for this size film would be six inches or 152mm. A normal focal length lens for 35mm cameras is about 50mm. There is some leeway in focal lengths, and you might find normal lens' focal lengths anywhere from 42mm to 55mm. Most photographic optics are measured by the metric system, but you may find a few older lenses for view cameras whose focal lengths are measured in inches.

Because the 35mm camera is the predominant tool in photojournalism, the focal lengths mentioned below and in the accompanying illustrations are for that film format, but the principles are the same for any film size.

Wide-Angle Lenses

Any lens with a focal length shorter than normal is a wide-angle lens. Common wide-angle lenses for 35mm cameras include 35mm, 28mm, 24mm, and 20mm. Wide-angle lenses have a wide field of view, which you can see compared with other focal lengths in figure 4-12.

Compared with normal lenses, wide-angle lenses make subjects seem smaller and farther away, with much distance between foreground and background. Depth of field appears much greater. Shape and space distortion is quite pronounced, and objects at the very corners of the image can become quite distorted (fig. 4-11).

Photojournalists use wide-angle lenses when they need to include a wide angle of view, emphasize the subject in its environment or provide wide depth of field. The extreme depth of field allows you to show elements in the foreground and background with equal sharpness, and the wide angle of view enables you to make overall views when working close to your subject.

A prime example of the latter is when you're shooting in a crowd, such as at a press conference, rally or even a traffic accident. The wide-angle lens allows you to get in front of the spectators for an unobstructed view of the action. If you had only a normal lens, you might need to step back to show the overall scene, and other people would end up between you and the center of interest. Then all you would have in your photos is the backs of the spectators' heads.

Telephoto Lenses

Any lens with a focal length longer than normal is a telephoto lens. Common telephoto lenses include 85mm, 105mm, 135mm, 180mm, and 300mm. Telephoto lenses have a narrow field of view, as illustrated

Figure 4–10 The shape distortion in the photo on the right is quite evident when you compare it to the one on the left. The distorted image was made with a wide-angle lens while the other was made with a medium focal length telephoto lens. *(Steve Pringle)*

Figure 4–11 A man known as the phantom curb painter painted the curb at Fresno city hall during a controversy over the size of the numbers used for house numbers on curbs. The photo was made with a wide-angle lens, which makes the vertical lines tip inward and the parking meter seem to loom over the building. *(Ryan Miles Marty/The Fresno Bee)*

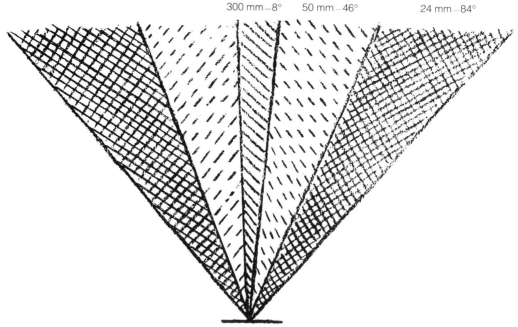

300 mm—8° 50 mm—46° 24 mm—84°

Figure 4–12 Fields of view with various focal length lenses on 35mm format.

Figure 4–13 When used at wide apertures, telephoto lenses blur backgrounds. *(Glenn Moore)*

in figure 4–12, and they tend to compress space. Their shape distortion is more subtle, giving the image a flat, two-dimensional look, and they can have a very narrow depth of field.

Perhaps one of the most common uses of the telephoto lens is in sports photography. Here, the photojournalist must reach out visually to magnify the action

so we can see the peak moment and the expressions on the players' faces. But there are many other times when you can't get close to the action, and a telephoto lens is the only way to get an image on the film that is large enough to see.

However, eliminating a confusing or distracting background is also a reason for selecting telephotos. Their limited depth of field helps blur the background, and when used at wide apertures, backgrounds sometimes can be dropped out completely, as in figure 4–13.

Maximum Aperture and Lens Speed

The maximum aperture of a lens is very important to photojournalists. Because many news events happen in low light levels, we need lenses that will capture as much of that light as possible. In terms of the water analogy mentioned in the last chapter, the pressure in the pipe is low, and we need the widest valve opening we can get so the bucket won't take too long to fill.

When shooting in low light, photojournalists prefer lenses whose widest apertures are at least f/2.8, although f/2 or even f/1.4 are better. Check back to your exposure ruler and assume that you are shooting a basketball game in a high school gym. Let's say the meter recommended an exposure of 1/60 second at f/4. This shutter speed is way too slow to use for the fast action of a basketball game. But if your lens has a maximum aperture of f/2, you could use that aperture at 1/250 second, which would be fast enough to stop the action.

Figure 4–14 We feel closer to the subjects in a photo made with a wide-angle lens. Compare this with the telephoto effect in figure 4–15. *(Robert Gauthier/Escondido Times-Advocate)*

Sometimes you will hear a photographer talk about lens speed, or say that a particular lens is a "fast lens." The photographer is talking about the lens' maximum aperture. A fast lens has a wide maximum aperture. "Fast lens" is an odd phrase, to be sure, but the lens' wide aperture lets light in quickly, so there is some logic to the term.

The "Look" of the Lens

The lens characteristics discussed so far—field of view, image size, space distortion and depth of field—all add up to a concept that is visually precise but verbally elusive. We could call it the "look" of the lens. There is a certain feeling to photos made with long lenses and those made with short ones. For example, there is a feeling of closeness between the subject and viewer in figure 4–14, whereas there is a feeling of distance in figure 4–15. The subject isolation created by the long lens makes a different statement than the inclusive view of the wide angle. Deciding which approach to take is but one of the many creative decisions a photojournalist must make.

Figure 4–15 In a photo made with a telephoto lens, there is a feeling of distance between the camera and the subject. Compare this photo with figure 4–14. *(Diana Baldrica/The Fresno Bee)*

TABLE 4-1 Lens Characteristics and Uses (35mm Format)

	Wide-Angle	Normal	Telephoto
Focal Length	Up to about 40mm	40mm–55mm	85mm and up
Space Distortion	Increases distance between near and far objects. Makes foreground objects seem bigger. Creates strong three-dimensional look.	Distortion not readily apparent.	Decreases distance between near and far objects. Foreground and background objects seem similar in size. Creates two-dimensional look.
Shape Distortion	Causes lines to tilt and shapes to bend or bulge	Distortion not readily apparent.	Keeps lines straight; causes shapes to flatten.
Depth-of-Field	Maximum	Moderate	Minimum
Uses	To include background; create feeling of being close to subject; capture wide field of view.	For normal perspective	To isolate subject from background; reach out to distant subjects; compress depth perspective.

Figure 4–16 As you move closer to your subject, depth of field decreases. Compare the sharpness of the background in these two photos. *(John Kril)*

Depth of Field

As you will recall from chapter 2, depth of field is the spread between the closest object in focus to the most distant object in focus. Depth of field is such an important creative tool that all of its controlling factors—aperture, lens focal length, and lens-to-subject distance—should be considered together.

The aperture's role in depth of field was explained on page 32. A wide aperture decreases depth of field whereas a small one increases it. But remember, the aperture also controls exposure. If you change the aperture to control depth of field, you must find a shutter speed that will complement your new f-stop, otherwise your exposure will be incorrect. Review the exposure ruler in chapter 3 if necessary.

Focal length is the second factor that affects depth of field. As shown in figures 4–11 and 4–13, wide-angle lenses seem to increase depth of field, whereas telephoto lenses seem to decrease it.

The third factor affecting depth of field is the distance from the camera to the subject. As you move closer to your subject, depth of field decreases. When making extreme close-ups, depth of field can be so narrow that only one point in the image is perfectly sharp (fig. 4–16).

When studying depth of field, you'll notice that it is a continuum. You won't find a point in the image where sharpness suddenly ends; instead, things appear to lose sharpness as they advance or recede from the point of critical focus. The exact depth of field under any situation is dependent upon what your own eyes will accept as sharp.

Sometimes you have little choice about the depth of field. As explained in chapter 3, the exposure required may force maximum or minimum depth of field upon you. Other times, it may be the lens or camera-to-subject distance that does not provide the depth of field you would prefer. In still other cases, it seems as though all three factors combine to prevent you from getting the result you want.

Yet, I cannot overemphasize the importance of depth of field as a part of your visual vocabulary. It is a primary means of controlling what your reader sees in the photo. You can use it to emphasize a foreground object and connect it with its environment, or to allow your reader to see all elements of a scene with equal emphasis. On the other hand, you can isolate an object or event, separating it from a confusing or distracting background. This technique is known as *selective focus.* Study the photos in this book and elsewhere to see how this technique contributes to the photographic message.

Focusing Techniques: Using Depth of Field

In photojournalism, your subject is often on the move. Getting sharp pictures is always a challenge, and on some assignments there is little time for focusing. However, certain techniques can increase your chances of getting your subject in focus. By focusing your lens so the action will fall somewhere in the middle of the depth of field, you'll have some leeway for error and your chances of getting a sharp picture will be increased.

To check depth of field, look for a *depth-of-field scale* on the barrel of your lens, which has index marks or numbers that match the f-stop numbers on the aperture ring (fig. 4–17). This scale shows you the depth of field for any given aperture and focus setting. This scale, which is explained below, is very handy when you know how to use it.

Hyperfocal Focusing Simple pocket cameras usually have lenses that are prefocused at the factory. Because the focus can't be adjusted by the photographer, the manufacturer sets the lens' focus to encompass the greatest depth of field. This distance is called the *hyperfocal distance.* You can easily set manual-focus lenses to the hyperfocal distance.

On the focusing ring is an infinity symbol (a sideways numeral 8). Rotate the ring so this symbol is opposite the depth-of-field mark for the aperture you are using. Then, the distance shown on the focusing ring opposite the lens' large index mark is the hyperfocal distance. The other f-stop mark on the depth-of-field scale will be opposite the close limit. Anything that falls within this zone will be in focus. This is a good spot to set your lens when you may not have time to focus carefully. Things may be happening too fast, or perhaps you

need to concentrate on timing your shot for the peak moment. Remember, because the aperture is also a factor in depth of field, the exact hyperfocal distance depends on the f-stop you are using (fig. 4–18).

Zone Focusing Zone focusing is a modification of the technique described above and is used for events that happen closer to the camera and do not require sharpness to infinity. Focus your lens on the spot where you expect the action to happen. Then check the depth-of-field scale to see what the safe limits of the depth of field are. Remember, the depth of field will vary depending upon the aperture you choose. You'll notice that one-third of the depth of field extends in front of the subject and two-thirds lie behind it.

Another tactic to remember when shooting fast-moving subjects is to follow-focus—that is, keep adjusting the focus as the subject moves, trying to keep the image sharp. If your focus should be a bit off when you shoot, depth of field may save the shot for you.

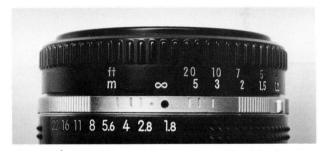

Figure 4–17 The small lines on either side of the focusing mark on this lens are depth-of-field indicators. On this brand of lens, they are color-coded to match f/stop numbers; on other brands, the marks may be tiny f/stop numbers.

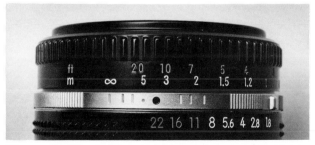

Figure 4–18 This lens is set for maximum depth of field at f/22. The infinity mark on the focusing scale is placed opposite the f/22 mark on the depth-of-field scale. The hyperfocal distance is opposite the focusing index mark, and the near limit of the depth of field is opposite the other f/22 mark on the depth-of-field scale.

Depth-of-Field Preview The aperture of an SLR lens must stay wide open during focusing so you can see through it, but at the moment of exposure, the aperture stops down to the f-stop you have called for. Therefore, the depth-of-field you see when focusing is always the minimum. But you can see the depth of field you will get at other apertures by using the depth-of-field preview lever or button, which stops the lens down to the taking aperture. The lever is usually on the front of the camera. It takes a bit of practice to see the depth of field at small apertures because the focusing screen gets quite dark.

Zoom Lenses and Special-Purpose Lenses

Zoom lenses are lenses with variable focal lengths. By turning a ring on the lens barrel, you can shift the focal length to any point within the range of the lens. Common zooms seem to fall into two categories: wide angle to telephoto, and medium telephoto to long telephoto. In the first category, you can find focal length ranges that zoom from 28mm at the wide end to 135mm at the telephoto end. In the telephoto range, focal lengths that zoom from 75mm or 80mm up to 300mm are available. In addition, many zooms offer close focusing (often erroneously called macrofocusing), which allows extreme close-ups of small objects.

Zooms are useful when you want to reduce your equipment load as much as possible. By carrying one or two zoom lenses, you can have almost any focal length you are likely to need for common assignments. You can also zoom to frame your photo precisely.

A true zoom lens will maintain focus as you zoom from one end of the range to the other. There is another type of lens that is often called a zoom, but it is really a variable focal length lens. It is the same as a zoom except that you must refocus this lens after any adjustment of focal length.

Zoom lenses have some drawbacks, however, and aren't used by professionals as often as you might think. For details, be sure to read the Professionals' Choice section that follows.

Fisheye Lenses
These special optics are extreme wide-angle lenses that produce results like those in figure 4–19. The distortion

Figure 4–19 Fisheye lenses produce an interesting type of distortion. Because of their short focal length, depth of field can range from a few inches in front of the lens to infinity.

caused by these lenses is bizarre and can be used to advantage when the effect contributes to your visual message. Fisheye lenses are used regularly in industry for jobs such as inspection of pipe interiors and horizon-to-horizon weather photos.

Lens Extenders

These accessories fit between the lens and camera body and double or triple the focal length of the lens. For example, an 85mm lens could become a 170mm lens if coupled to an extender. There is a trade-off, however. The extender reduces the light transmission of the lens by two or three stops, and sharpness often suffers. There are some high-quality extenders that produce sharp images when matched to specific lenses, but the light

Figure 4–20 Bellows attachments (left) and extension tubes fit between the lens and the camera body. Extreme close-ups, such as pictures of bugs, can be made with these accessories.

loss makes extenders almost impossible to use in low-light situations. In spite of this drawback, extenders do offer an inexpensive way to add more focal lengths to your lens inventory.

Close-Up Lenses

If you want to make photos of small objects, such as postage stamps, coins or even bugs, a close-up lens is the tool to use. There are two types of close-up lenses. The first is a complete lens with a focusing ring and iris diaphragm. These lenses are often called macro lenses, although the term is technically correct only when the lens can be focused to produce a life-size image on the film.

The second type, supplementary lenses, are sometimes called plus or diopter lenses. They look similar to a magnifying glass, and they simply screw on the front of your normal lens. They produce results similar to macro lenses, but at a much lower cost; however, they are recommended only for those assignments where optical perfection is not necessary.

Extension Tubes and Bellows Units

These devices are not lenses, but close-up accessories that are appropriate to mention here briefly (fig. 4–20). By attaching your lens to one end of the bellows or tube and the camera to the other, you can make greatly magnified images, as much as ten times life-size. Whereas bellows units can be expanded or collapsed to adjust the image size, extension tubes offer only limited degrees of magnification. A photojournalist might find this equipment important when illustrating a technical, medical, or scientific story.

Lens Hoods

Lens hoods prevent stray light from striking the front element of the lens and causing flare, as in figure 4–21.

Figure 4–21 The bright spot in the upper right corner is caused by lens flare. In this case, a lens hood would not prevent the flare since the light source is in the picture. Lens hoods can be effective against similar flare caused by light sources just outside the field of view. (Lloyd Francis/The Fresno Bee)

Sometimes flare is more subtle, and the result is a mysterious loss of contrast in the negative. I recommend you use lens hoods at all times. Be sure the hood you use is designed for the focal length of your lens, because a telephoto hood used on a wide-angle lens will show in the corners of the pictures.

The Professionals' Choice

For the beginner, the plethora of lenses available can be overwhelming. If you already have a normal focal length lens, it will serve you well while you learn the basics of technique and content. Thousands of photographers have made outstanding photos with normal lenses. It is image content, not special optics, that is the key to a successful photo. When it comes time to move beyond the normal focal length lens, however, decisions about which lenses to use can be difficult. As with choosing a camera, ask local professionals what lenses they have found useful. Their choices are based on practical need and experience, rather than advertising claims.

Because selecting lenses is also quite personal, I make recommendations knowing that they may produce screams from those who disagree. But these recommendations are based upon experience as well as discussions with a number of working professionals. To resolve the question for yourself, borrow or rent a lens of the focal length you are considering and give it a good workout before you commit money to it.

Your first two lenses should probably be a 24mm wide-angle and an 85mm or 105mm telephoto lens. The former is a favorite among news photographers because it enables them to work in very tight quarters, and it has tremendous depth of field. You can focus this lens on about eight feet and, at f/11, everything will be sharp from about four feet to infinity, which is a great asset when shooting spot news. Be sure to get a lens with a maximum aperture of at least f/2 for shooting in low-light situations.

For a moderate focal length telephoto, opinion among those I consulted is split between the 85mm and the 105mm. These lenses are useful for portraits, and I prefer the 85mm as it allows you to work closer to your subject. The results from the 105mm are just as good, however. Both are useful when shooting basketball from behind the basket (some photographers prefer the normal lens for this position), and they can be used to drop out backgrounds and create the compressed telephoto effect discussed previously. Again, you should consider at least an f/2 or faster.

After you have added a wide angle and a moderate focal length telephoto, your next step should probably be a lens in the 180mm range. This lens is extremely useful for shooting close-ups of speakers and isolating subjects from backgrounds. It can be used for many types of sports and news shots as well. For serious sports photography, you will also want a 300mm. This lens is commonly used for baseball and football because it brings the action closer and isolates it from confusing backgrounds. In photojournalism, the 180mm and the 300mm are possibly the most frequently used telephoto lenses.

Zooms are very popular among amateur photographers, but do not seem to be used heavily by photojournalists, primarily because of the limited maximum aperture, f/3.5 to f/4 being common. F/4 is just too slow for many of the poor lighting conditions a photojournalist will face. Also, because of the many optical elements and the mechanics needed to focus and zoom, zooms are easier to damage and not always as sharp as their fixed focal length brethren. When professionals do use zoom lenses, they use a top brand. Cheap zooms you can buy for a hundred bucks just won't deliver. You get what you pay for. Save your money and buy a good fixed focal length lens.

A final word on lenses: rushing out and buying a bagful of optics will not make you a great photographer. I suggest that, unless you have a specific need, you learn what each lens will do before adding to your inventory.

Filters

Filters are discs of glass that attach to your lens. They are called filters because they filter the light passing through the lens on its way to the film. In doing so, filters remove some colors of the light while transmitting others. The result is a change in the way various tones are recorded on the film and in the subsequent print.

For example, you might photograph a scene that includes puffy clouds set off against a bright blue sky. Yet in the print, the clouds and sky appear as similar dull shades of gray. This effect occurs because black-and-white film does not transform every color into a different shade of gray; it sees some colors the same. In this case, the film saw the blue sky and the white clouds as almost the same shade of light gray. But a red filter placed over the lens will cause the sky to darken, emphasizing the white clouds, as in figure 4–22.

To understand how filters work, we must first look at the nature of the light these filters are going to change. White light is made up of three *primary* colors: red, blue and green. (You'll notice that yellow is not a primary color of light, although it is a primary for pigment.)

Plate 23 shows these three primaries in relation to three other colors known as *secondaries*. The secondaries are yellow, cyan and magenta. Cyan is a light blue that looks slightly greenish, and magenta is a purplish red that you might be tempted to call hot pink.

(a)

(b)

Figure 4–22 (a) Compare the differences between the tones in the sky, the truck, and the skin of the man in the foreground in these two photos. This shot was made without a filter, while (b) was made through a red filter.

One of the peculiarities of light is that a filter of a particular color will block, or filter out, its complementary color. In plate 23, the primaries are placed opposite their complements on the diagram. Any color along the wheel, even those between the ones named, will block the color on the opposite side of the wheel.

An easy way to see how filters work is to look at the Sunday comics through pieces of deeply colored acetate. Don't stare at the page through the filters. Hold the filters close to your eye and move them quickly in and out of your field of view so your eye won't have time to adapt to the color of the filter. The extent of the effect will depend upon the strength of the colors in the filters you use. You will notice that certain colors on the comics page lighten and appear the same or almost the same as the white newsprint. Some colors may even disappear, yet other colors darken. The basic rule is that a filter lightens its own color, and darkens its complementary color. The colors on the comics page that lighten are the same, or almost the same, as the color of the filter, and the colors that darken are that filter's complements.

Let's return to our scene with the blue sky and puffy white clouds. The red filter blocks the light from the blue sky. If the light is blocked from the film, that part of the image will record darker than normal. The white clouds, however, contain red light, which is easily passed by the filter and is seen by the film as white.

Darkening skies is a common task for filters. If skies are too light, the top edges of the print might not show in the finished publication, creating an awkward blend between the photo and other elements on the page. For this reason, I often use a yellow or orange filter to darken skies when shooting overall views outdoors. These filters produce less dramatic effects than the red filter, which can make skies almost black.

Filters are also useful when photographing colored objects that must appear different in the print but, without filtration, will be seen as the same shade of gray

(a)

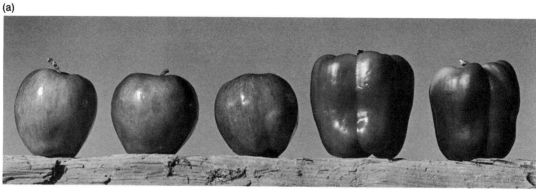

(b)

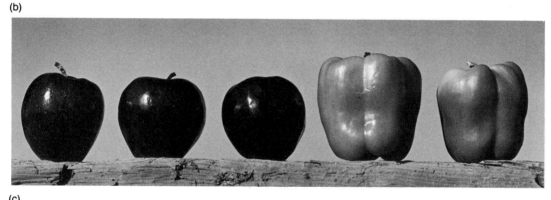

(c)

Figure 4-23 These three shots show how subject tones can be changed by the use of filters. In (a), no filter was used. In (b), a red filter was used. Notice how the apples are lightened, the peppers and the hazy light blue sky darkened slightly, while the gray wood remains the same. The photo in (c) was made through a green filter that lightened the peppers and darkened the apples.

by the film. For example, if you had a fashion assignment to photograph a red blouse, a green jacket, and a gray skirt, you could use filters to prevent the three items from appearing the same shade of gray. A red filter would lighten the red blouse and darken the green jacket, whereas a green filter would do the opposite. The gray skirt would not be affected because gray is really only dark white, and contains all three primary colors.

Therefore, some of every filter's color is present, which will be passed through the filter and recorded on the film (fig. 4-23).

You can find out which color filter to use for any situation by checking the color wheel in plate 23. Remember, a filter lightens its own color and darkens its complementary color.

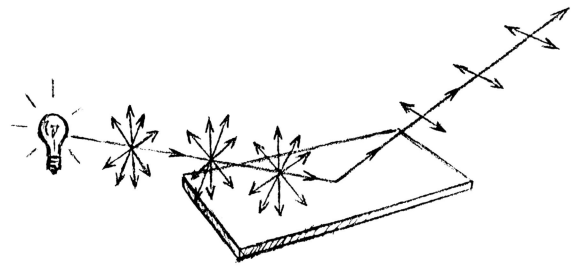

Figure 4-24 When light rays leave a source, they are vibrating in all directions. When the light rays are reflected by a smooth surface, the vibrations are polarized, or limited to vibrating in one direction.

Haze and Ultraviolet Filters

Haze is a common problem with distant landscapes. Because haze is bluish, a light yellow *haze filter* blocks that blue light while allowing yellow light from distant objects to be recorded by the film.

There can also be a great deal of ultraviolet (UV) light in distant scenes. Although you can't see this light, film is highly sensitive to it. *Ultraviolet filters,* which look like clear glass, reduce some of the ultraviolet light that both black-and-white and color film will record. Also, many photographers keep UV filters on their lenses at all times to protect the front lens element from damage.

Unfortunately, there is no smog filter. The yellow-brown murk that hangs over so many of our cities often includes small particles of smoke or dust. These particles block and scatter light, and because they are physical obstructions, they can't be optically filtered away.

Neutral-Density Filters

Neutral-density (ND) filters do for film what sunglasses do for your eyes: They cut down on the light entering the lens without affecting the color of the image.

In practice, this effect allows you to use large apertures or slow shutter speeds in bright light. For example, a common exposure for Tri-X film in sunlight is 1/500 second at f/11. This exposure will stop motion and produce a relatively wide depth of field. But a neutral-density filter that reduces the light by three f-stops would let you shoot at 1/500 second at f/4 (or 1/1000 at f/2.8) to reduce depth of field. You could also create blur by shooting at 1/30 second at f/16. Check this information on the exposure ruler you made when studying chapter 3.

If you have a camera with an automatic exposure system, your camera's light meter will compensate for the ND filter automatically. If you don't have an in-camera meter, look at the engraving on the filter ring to see how much additional exposure is needed. An ND2 requires one extra f-stop, an ND4 needs two extra stops, and an ND8 needs three stops additional exposure.

Polarizing Filters

Polarizing filters block light just as other filters do, but they have an interesting effect on light reflected from smooth surfaces. Polarizers block the reflective glare, enhancing the colors underneath.

This glare is polarized light, which is created when light is reflected at an angle from a surface. When light rays leave a source, they vibrate in all directions. When the light rays are reflected by a smooth surface, the vibrations are limited to one direction, and this light is now polarized (fig. 4-24). This light is the kind that reflects back off the pavement into your eyes when you are driving toward the sun. All sorts of surfaces can polarize light, including leaves, glass, wood, and plastics.

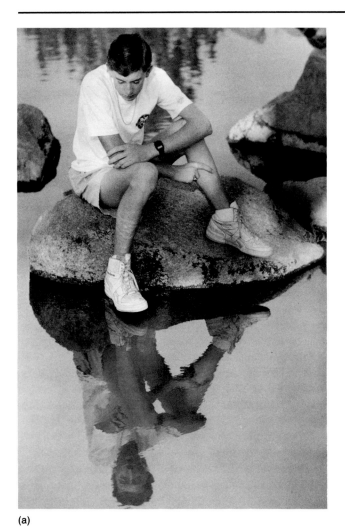

(a)

(b)

Figure 4–25 Polarizing filters cut glare and reflections caused by polarized light.
Photo (a) was made without the filter, photo (b) was made through the filter.

Polarizing filters block this polarized light. Think of the filter as a set of optical jail bars. When the bars are at right angles to the vibrating light rays, the rays are blocked. But if the bars and the rays are both oriented in the same direction, the light rays will pass through.

Polarizers are simple to use because you can see the effect with your eye. The filter is usually in a rotating mount that can be turned once it is on the lens. All you need do is look through the finder and rotate the filter until you get the effect you want. Figure 4–25 is an example of reflection control with a polarizing filter. Because almost every scene contains some polarized reflections, polarizing filters increase color saturation by reducing these stray reflections. Polarizing filters also darken skies if the camera is aimed at about 90° to the

sun. Exposure with polarizers can be determined by metering through the filter or by increasing the exposure by one and a half to two stops.

Filters for Color

Both polarizing and neutral-density filters are useful when working in color, but there are also some special filters designed solely for color film. They will be discussed thoroughly in the chapter on color, but briefly, these filters are designed to match the color of the light to the film. This matching is required when shooting indoors under tungsten light (from regular light bulbs) as well as fluorescent (long tubes such as those found in classrooms) and other artificial light sources because these lights are not the same color as daylight. Your eye does not notice this difference but color film will see it and, if not corrected, off-color photos will result.

Filter Factors

A *filter factor* is a number that tells you the exposure increase needed by a particular filter. Although you can rely on your camera's exposure system to compensate for the light loss in ND and polarizing filters, it is not a good idea to take meter readings through other types of filters. The meters do not respond to color changes the same way film does, and an erroneous reading could result. Instead, take a meter reading before placing the filter on your lens, then increase the exposure by the filter factor.

To use filter factors, multiply your exposure by the factor. A factor of 2 means double the amount of exposure. As you recall from the section on exposure, doubling the exposure would mean opening the lens one stop or using the next slowest shutter speed. If the factor was 4, you would need two stops more; a factor of 8 requires *three* stops additional exposure. If you are confused by this last step in the progression, remember that each increase doubles the exposure. Opening one stop provides twice as much as the original exposure, opening two stops provides four times as much, opening three stops provides eight times as much, and opening four stops provides sixteen times as much. If you opened the aperture one more time, it would be a total of thirty-two times the original exposure!

Summary

Lenses are to the photographer what paint brushes are to the artist. Different features offered by different types increase your creative options as well as your technical flexibility. The fundamental task of a lens is to collect the light rays into a coherent image and project it onto the film.

The focal length of a lens is the distance between the optical center of the lens and the film when the lens is focused on infinity. Lenses with normal focal lengths produce images similar to what we see with our eyes.

Shooting through a telephoto lens is similar to looking through a telescope—distant objects are magnified. But telephoto lenses also create interesting visual effects, compressing depth perspective and reducing depth of field. Wide-angle lenses have the opposite effect, providing a wide angle of view and making things look farther away. They also create some interesting shape and size distortions, tilting vertical lines and, in extreme cases, distorting shapes in a bizarre fashion.

You can use these lens characteristics—angle of view, space and shape distortion, and depth of field—to add to the visual impact of the photo. When wide-angle lenses are used close to the subject, they tend to

TABLE 4-2 Filter Factors

Filter	Effect	Factor	Stops Increase
Yellow	Cuts haze slightly; natural rendition of tones	2	1
Orange	Darkens skies, makes clouds stand out, emphasizes texture of snow and sand	4	2
Red	Darkens skies dramatically (almost black)	8	3
Polarizing	Removes reflections, darkens skies, increases color saturation	2.5	1½–2

make the viewer feel close to the action. Wide angles are also a means of including as much of the scene as possible, an important consideration when the various elements of an event must be related to each other.

On the other hand, telephoto lenses isolate subject matter, sometimes separating it from the background while compressing the space between objects in the scene. Although telephoto lenses can bring the subject close to the viewer, the feeling is not as intimate as it is in the same situation shot at close range with a wide-angle lens.

The maximum aperture of a lens is its widest f-stop. The maximum aperture is an important consideration when selecting a lens for an assignment, because photojournalists often shoot under low-light conditions. Thus, the lens must gather as much light as possible. When referring to a lens that has a wide maximum aperture, photographers often use the term, *fast lens.*

Although depth of field is controlled by the aperture, two other factors influence this variable: lens-to-subject distance and focal length. As you reduce lens-to-subject distance by moving closer to your subject, depth of field decreases, and close-ups may have extremely narrow depth of field. But depth of field is also changed when focal length changes. Depth of field appears to decrease with telephoto lenses and increase with wide-angle lenses. If you combine all three factors, focal length, aperture, and lens-to-subject distance, you have

considerable control over depth of field. A 300mm tele-photo, used to make a close-up at a depth-of-field-reducing aperture of f/2.8, would cut the depth of field to almost nothing. Only the point of focus would be acceptably sharp. On the other hand, a wide-angle lens, used at f/16 and at some distance from the subject, would produce a sharp image from several feet away to infinity.

Depth of field can also be used to your advantage by using hyperfocal and zone focusing, which increase your chances of getting a sharp photo. Hyperfocal focusing provides the greatest depth of field for the aperture in use, whereas zone focusing provides a closer area of sharpness.

Filters can change the final photo by influencing which colors of light reach the film. Even in black and white, tones can be emphasized or de-emphasized by the use of a filter. There are also special purpose filters that reduce haze and ultraviolet light, and polarizers that are useful for reducing reflections. Because filters cut down the light entering the lens, an exposure increase is necessary. Although you can take light meter readings through polarizers and neutral-density filters, filter factors should be used to figure exposure when using other types of filters.

Chapter 5

Darkroom

Outline

"The ultimate end, the print, is but a duplication of all that I saw and felt through my camera."

—Edward Weston

The darkroom is where the magic of photography takes place. In the nineteenth century, Native Americans were suspicious of the mysterious goings-on inside the darkened tents of frontier photographers. Many cultures still believe that a photographic image captures one's soul. And scientific analysis notwithstanding, I'd like to think there is a bit of magic behind an image that suddenly appears on a blank piece of paper while you watch under the glow of a dim yellow light. Although the darkroom is being challenged by electronic substitutes, its magic will remain.

If you can follow the directions on a box of cake mix, you shouldn't have any problems processing film. Printmaking is a little more involved because subjective decisions must be made—decisions that are guided only by experience.

Film Processing

Film processing is a simple procedure that can be done almost anywhere, and the equipment and chemicals are so inexpensive that you can easily equip yourself for this basic operation.

Processing begins by loading the film into a processing tank. Then a *developer* is poured in, which converts the exposed film into a visible image. After development, *stop bath* stops the development action, and *fixer* removes the undeveloped silver halide. The film is then washed, treated in a wetting agent to reduce water spots, and hung to dry.

Although the steps of film processing are simple, you must strive for accuracy and consistency. Most processing problems are due to simple mistakes or chemical contamination caused by sloppy lab procedures. Monitor solution temperatures, keep your equipment clean, follow the procedure exactly, and standardize every detail.

Chemicals for Film Processing

The three most important chemicals used in black-and-white film processing are: developer, stop bath, and fixer. These are normally followed by a wash and a wetting agent, the latter to prevent water spots when the film dries.

The job of the developer is to convert the latent image on the exposed film into a visible one. Many brands of developers are available, and choice of a developer is often based on personal preference. In a school or professional lab, you will probably use the developer supplied by the lab or be told what formula to buy. If you must buy your own, stick with one developer until you have the skill to recognize the differences between various brands. A good choice is Kodak's common D-76 formula.

In use, a developer loses strength. Therefore, it should either be used only once, or brought back to strength by the addition of a solution called *replenisher*. A half ounce or so of replenisher should be added to the used developer after the film has been processed. If your lab replenishes film developer, be sure to follow their replenishment procedure. D-76 is a typical replenishment developer.

Many labs use *one-shot* developers, which are mixed just before use and poured down the drain afterward. This method guarantees fresh chemicals. If you are buying your own chemicals, I recommend one-shot developers. D-76 mixed with an equal amount of water is commonly used, as are Edwal's FG-7 and many others. Although one-shot developers are slightly more expensive than replenishing developers, the guarantee of fresh developer is worth the small additional cost.

Stop Bath

The purpose of the stop bath is to stop the development action. Plain water works fine for film processing. Although I don't think it is necessary, you may use a weak acetic acid solution, and there are a number of commercial stop bath formulas available. Length of time in the stop bath is not critical—a minute or so will do, but keep it at the same temperature as the developer.

Fixer

Fixer (sometimes called *hypo*) removes the undeveloped silver salts from the emulsion, thus making the image insensitive to light. Fixer also removes the opaque backing layer found on most films. When fixing is complete, the edges and other unexposed areas of the film will be clear, and the image will be visible.

As a general rule, fix your film for twice the time it takes the film to clear. If the unexposed area at the end of the roll turns clear in one minute, fix the film for two minutes. Kodak's T-Max films require longer fixing times and more agitation in the fixer than other films. Three to five minutes in a rapid fixer with frequent agitation is recommended. After fixing, check to see if the film has a pinkish color in the clear areas. If so, it needs more fixing. Fixing baths can be saved and reused for many rolls of film—you should be able to fix about a hundred rolls of film in a gallon. The silver compounds that are removed from the film build up in the solution, and this silver can be reclaimed. The Appendix provides directions for reclaiming silver from used fixer.

Wash

You must wash away the fixer that has been absorbed into the emulsion or the film will stain and fade with time. When on tight deadlines, photojournalists often skip the wash and just rinse the fixer off the film and dry it. No harm will be done if the film is washed properly after the prints have been made. If you have one of the plastic washing devices shown in figure 5–2f, the washing time is about four minutes. Although conventional wisdom calls for 20-minute wash times, the 4-minute wash time for the plastic film washers is recommended by one of their makers, as well as the author of a technical manual published by Ilford. I have twenty-year-old negatives washed this way that show no signs of fading, and chemical tests bear out this recommendation. If you don't have such a gadget, wash the film in the processing tank by letting the stream of water from the sink faucet flow down through the center of the processing reel. With this method, a half hour wash is recommended for maximum permanence.

If you prefer, washing aids can speed the removal of fixer and therefore shorten wash times. The film is rinsed, placed in the washing aid, and then given a final wash. Exact times vary from brand to brand so refer to the instructions provided with the product.

Wetting Agent

The last chemical step is the wetting agent. Its job is to prevent water spots from forming as the film dries. Mix the wetting agent carefully; too strong a solution will leave streaks on the film. I prefer to mix it to half the manufacturer's recommended strength. Also, dirt in the water will stick to the film as it dries, resulting in white specks or streaks in the final print. If you have problems with grit or minerals in your tap water, consider mixing the wetting agent with distilled water.

Equipment for Film Processing

Surprisingly little equipment is needed for film processing. You will need at least a thermometer, timer, film processing tank and reel, and a couple of jugs to hold chemicals.

Temperature influences both development time and negative quality, so be sure to get an accurate thermometer. Processing is usually done between 65° F and 80° F, so select an instrument that shows each degree clearly.

Any timer that will accurately measure ten minutes or so will do. There will probably be a timer in the lab you are using, but you can use your watch if the minutes are graduated on the face. Digital watches are ideal processing timers.

There are several varieties of processing tanks, but the ones most used by professionals are the stainless steel ones shown in the processing illustrations in this section. Stainless steel resists rust and corrosion and transfers heat quickly.

The processing reels used in stainless steel tanks are spirals of wire, as shown in figure 5–1. When the film is loaded on the reel, the wire spirals separate each layer of film from the next as it wraps around the reel, allowing developer to flow through and reach all parts of the film.

Loading Spiral Processing Reels Before you start to load the film on the processing reel, be sure the reel is not bent. Check to see that the spirals are flat and parallel to each other. Practice loading the reel with some scrap film until you are confident you can do it when the lights are out. When loading film, there can be no darkroom safelights on and no light leaking under the door. The glow from darkroom timers is not bright enough to damage 400-speed films, but Kodak recommends turning the face of the timer toward the wall when loading their T-Max P3200 high-speed film.

Open the film cassette by prying off the end with a bottle opener as in figure 5–1a. Pull the plastic spool out of the cassette and cut or tear off the end so it is straight (fig. 5–1b). Then, holding the film in one hand and the reel in the other, make sure the end of the wire spiral is pointing toward the hand that is holding the film (fig. 5–1c). The film is wound on the reel from the center out. Bend the film so it arcs slightly, as in figure 5–1d, and slide it under the center clip. Feel the edges of the film as in the illustration to be sure the film is centered between the two spirals of the reel. Then set the reel on the counter and turn it as shown in figure 5–1e, allowing the reel to pull the film onto itself. When you get to the end, cut or tear the film to remove the plastic spool (fig. 5–1f).

The most common error in loading these reels is allowing one layer to skip off the spiral and touch the layer underneath. You can check for this problem as you turn the reel by listening carefully. If you hear a popping noise as you turn the reel, the film has skipped to the track below. You can also feel the film pull to one side with the hand that is guiding it. Unwind a few inches and try again. When you are done, another check is to feel the sides of the reel as in figure 5–1g. If you feel the sharp edges of the film sticking out from the spirals, that is a sure sign the film is off track.

When you finish, drop the reel into the tank and put the cap on. Then you can turn on the lights and start processing.

(a) Open the film cassette with a can opener and remove the film.

(b) Cut the end of the film square so it can be fitted into the processing reel.

(c) Be sure you are holding the processing reel so the end of the wire spiral points toward the hand holding the film. In this example, the photographer is holding the film in his right hand.

(d) Squeeze the edges of the film slightly so it will fit between the wire spirals and insert the end of the film into the clip at the center of the reel.

(e) Turn the reel with one hand while guiding the film onto the reel with the other hand. Use your thumb and first finger exactly as shown to guide the film.

(f) When the end of the film is reached, cut off the plastic spool.

(g) To check for misthreaded film, feel the sides of the wire spirals. If you detect any sharp edges protruding beyond the flat spirals, back the film off the reel and try again. If the film becomes kinked at the first few turns, start from the spool end.

Figure 5–1 How to load a spiral film processing reel.
(Randy Dotta-Dovidio)

Processing Film

Although the illustrations in figure 5–2 present a basic processing procedure, you may find variations in individual photo labs. Some photographers prefer different brands of chemicals, which may require different processing times, and other types of processing equipment may be in use. Further, you may encounter shortcuts that seem to go against the procedures described here, but I must emphasize that there is almost always some compromise with quality when shortcuts are taken. Learn these standard techniques and the reasons behind them before you try to cut corners.

Development Time and Temperature Development time depends upon the developer temperature. The common processing temperature for black-and-white film is 68° F. As temperature increases, processing time decreases. The Appendix includes time/temperature charts for several common film/developer combinations. A mistake in development time can have a noticeable effect on the negative, so be sure to check the developer temperature and use the correct processing time.

The temperature of all the processing solutions, including the wash water and the wetting agent, should be the same. Aim for a difference of no more than one degree. By keeping all solution temperatures the same, you'll help guarantee consistent results and minimize the appearance of grain in the negative.

Agitation As the film develops, the developer that touches the film becomes contaminated with processing byproducts and loses its strength. To get even results and keep fresh developer in contact with the film, you need to agitate the film during processing—a simple matter of turning the tank upside down two or three times every so often. I agitate by inverting the tank three times every 30 seconds. Agitation does influence development, so try not to vary your procedure from roll to roll. You should also agitate during stop bath and fixer treatments. After the wash, a 10- to 15-second dip in the wetting agent is adequate.

Drying After the film has been dipped in the wetting agent, it should be hung to dry in a dust-free place. Airborne dust that lands on the film will stick and show up as white specks in the print. You can use clothespins to hold the film to a piece of wire or string stretched out like a clothesline. Put a clothespin on the bottom end of the roll to keep it from curling while it dries. Be sure the film is completely dry before handling it. If the film is bent in a large arc from top to bottom as it hangs, it is still slightly wet and must not be touched.

In many news situations, there is not time to wait for film to air dry, therefore various drying devices are used. Cabinets with blowers that push filtered hot air past the film are common. A variation is a device similar to an oversize hair dryer. The film reel is put into the end of the tube where it gets hot air from a blower. As an alternative to this special equipment, simply hold the processing reel in your hand and aim an ordinary hair dryer at it. Be sure to let the dryer run for a minute to blow the dust out before using it on the film, and keep the heat set on low or medium. Don't overdry the film or it will take on the curl of the processing reel. Four or five minutes under a hair dryer is about right.

Negative Handling and Filing Handle your negatives with great care. Damaged negs are often not repairable, and scratches, fingerprints, and dirt on the negatives will show up in the prints. Be sure to hold negatives by the edges only, and keep them in special negative envelopes, which are available in a variety of styles from camera shops.

A convenient way to file negatives is to make a contact sheet (see page 85), attach the negative envelope to it, and file them together in old print paper boxes or file folders. Newspapers often file news photos by the date of the event, sometimes cross-indexing by type or category of event and photographer's name. I file news events by date, but file personal photos by subject matter: family, Yosemite, railroads, and so on. Use any filing order that makes sense to you, but avoid the tendency to let negs pile up because, as fate will have it, the ones you lose will be your favorites.

Checking Negative Quality A crude way to check the technical quality of your negatives is to lay them on a piece of newsprint. You should just barely see the printing underneath. But if the negs are almost clear, or so dark that you can't see the printing through them, something went wrong.

It is difficult to show the subtle differences in negative quality in a book because of the variables of the printing press, but I have tried to illustrate some of the most common problems in figure 5–3. The most common problem I have found in beginners' negs is underexposure. Seriously underexposed negatives look somewhat faint or almost clear, as in the top strip in figure 5–3a. This problem is caused by insufficient light reaching the negative; either the f-stop was too small or the shutter speed too high, or both. To the beginner, underexposed negatives look similar to underdeveloped ones, so be sure to ask your instructor to check your negs. The second strip is properly exposed as a comparison.

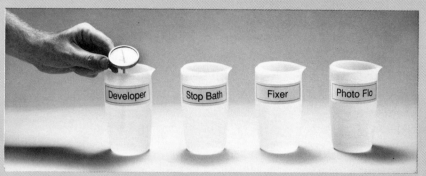

(a) First, set out all the chemicals you will need: developer, stop bath (water is adequate for film processing), fixer, and a wetting solution such as Photo Flo. Be sure the temperature for all solutions, including wash water, is the same.

(b) Pour in the developer. Use the processing time required by your film and developer combination as listed in the Appendix.

(c) Agitate the film in the developer by inverting the tank. Agitate continuously for the first minute; then for five seconds every thirty seconds thereafter. When the time is up, pour the developer down the drain.

(d) Pour in the stop bath. Agitation is the same as for developer. When using water for a stop bath, give several rinses.

(e) Pour in the fixer. Be sure to agitate the film while it is in the fixer. With rapid fixers, three minutes in fresh solution is enough time for most films; T-Max films may take longer. The rule-of-thumb is to fix for twice the time it takes for the film to turn clear.

(f) After fixing, wash the film to remove the fixer. If a washer such as this is used, a four-minute wash is sufficient.

(g) After the wash, soak the film in a wetting agent for a few seconds. The wetting agent prevents water spots from forming on the film as it dries. Then hang the film in a dust-free place to dry.

Figure 5–2 Film processing procedure. *(Randy Dotta-Dovidio)*

Figure 5–3(a) Although it is extremely difficult to show the variations in negative quality within the limits of textbook reproduction, these examples represent some of the common errors. See the text for a complete explanation.

Figure 5–3(c) The crescent-shaped mark in this enlarged portion of a negative was caused by squeezing the film so much that it kinked as it was threaded on to the processing reel. The white squiggles are dust and lint on the negative.

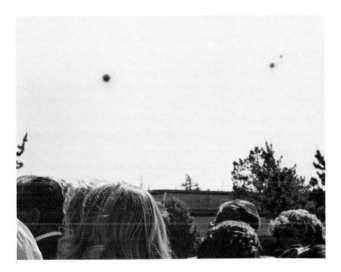

Figure 5–3(b) The dark spots in the sky may look like UFOs, but they are the result of air bubbles that clung to the film during development. To prevent this, tap the tank with the heel of your hand right after adding developer.

The third strip is overexposed, which looks similar to overdevelopment. Again, get an expert interpretation of your work. The blotch on the fourth strip is the result of cross-threading the processing reel. The fifth strip has edge numbers but no images, which means the film was processed but no images were on the film. More than likely, the roll was not properly threaded on the camera's take-up spool and did not go through the camera. If your film comes out blank with no edge numbers, as in the sixth strip, the film was not developed at all before it was placed in the fixer. Either the developer was defective or the chemicals were poured into the processing tank out of the proper sequence.

Figures 5–3b and 5–3c show two negative defects that are easier to see after a print is made. The dark circles in figure 5–3b are caused by air bubbles clinging to the film during development. Be sure to dislodge these bubbles by tapping the bottom of the tank with the heel of your hand several times as soon as you have poured

in the developer. The light mark that looks like a crescent moon in figure 5–3c is caused by kinking the film when loading the processing reel. Don't squeeze the film so tightly between your thumb and first finger when loading processing reels.

The white squiggles in figure 5–3c are bits of lint on the negative. If they landed on the film after it was dry, they can be blown off with an ear syringe. If they landed on the film while it was wet, more than likely they are stuck to the film. The only remedy is to retouch the print with spotting dye and a 6–aught brush.

The Print

Making the print gives you considerable control over the image. Many aspects of printing are similar to editing a written story: deciding what to include or exclude, and what to emphasize or de-emphasize. Basically, print-making involves projecting the image of the negative onto a piece of photo paper, which is then processed in chemicals that are similar to film processing chemicals.

Photographic Paper

Like film, photographic paper is coated with light-sensitive silver salts, and also like film, there are many varieties. Paper characteristics include the base paper itself (resin coated [RC] or fiber), surface, contrast, and image tone.

Two types of paper bases are used for print paper. The first type is coated with a polyethylene resin. This waterproof plastic coating keeps chemicals out of the paper core, which makes RC papers ideal for the rapid processing required in photojournalism. Some brands have development chemicals added and can be processed completely in minutes. The second type of base, the more traditional fiber-based paper, is not waterproof and therefore requires longer processing times because of chemical absorption by the paper. The chemicals must be washed out, and wash times approach one hour. Fiber-based papers have been used by photographers for over a hundred years, and the look of fiber papers is preferred by most photographers when printing for a portfolio or display.

Print paper is also available in several surface finishes. Glossy is very common, but matte, pearl, and luster finishes are available as well. When printing for reproduction, use a glossy or pearl surface unless you are asked to use another type; heavily textured papers should be avoided because the texture can show up in the reproduction.

Image tone is a combination of the color of the paper's base and the subtle color of the emulsion. Some papers are a neutral black-and-white, whereas others have a cream or ivory base and a brownish image. In photos for reproduction, papers with tones other than clean black-and-white are not used because they can complicate the reproduction process. Nevertheless, these papers can do exciting things to an image, and I urge you to try some of them for your personal photos.

Paper Contrast Contrast is a difference between the lightest and darkest shades of gray. If most of the image is gray, it is said to be low contrast. However, if the image is mostly blacks and whites, with few middle grays, it is said to be high contrast (fig. 5–7).

Photographic contrast is the result of a number of factors, including the contrast of the scene and its lighting, the exposure and development of the negative, and the print paper used. The goal is to make a print with a full range of tones from black to white. To do so, you must find the print paper contrast that complements the contrast of the negative. If your negative is low contrast, you must offset that by using a high-contrast paper, and vice versa.

The contrast of print papers is changed in two ways. One is by using paper made to a specific contrast level. This type of paper is known as *graded paper*. The contrast of graded paper is commonly numbered from 1 to 5. A number 1 contrast paper is low contrast and is used when printing high-contrast negatives. A number 5 paper is very high contrast and is used when printing low-contrast negatives. The disadvantage of graded paper is that you must have a box of each grade available when printing.

The second way to control print contrast is with *variable-contrast paper*. One box of paper can be used for all levels of contrast, and contrast is controlled by using filters in the enlarger. The filters are numbered from 1 to 4 (or 1 to 5 depending on brand) in half steps. When using either graded or variable-contrast paper, the best place to start is with a number 2 paper or filter.

Print Size The most common size for print paper in photojournalism is 8 × 10 inches. This size is easy to handle, is close to the common reproduction sizes, and fits conveniently into standard filing systems. On occasion, prints are made on 11 × 14-inch paper, particularly if the photo is likely to be reproduced much larger than 8 × 10. Another common paper size is 16 × 20, but that is usually used only for display prints. If you are on a tight budget, you might try 7 × 9- or 6½ × 8½-inch paper. These sizes are available by special order and can save you considerable money: 7 × 9 paper is about 30 percent less expensive than 8 × 10 yet might fill your needs just as well.

In conclusion, unless you are told to buy a specific paper, I recommend resin-coated, glossy or pearl finish, variable-contrast paper in either 8 × 10 or 7 × 9-inch size. Be sure to shop for the best price, and consider the savings in sharing a 250-sheet box with a friend.

Print Chemicals

Print chemicals are basically the same as film processing chemicals: developer, stop bath, fixer, and wash. Sometimes a washing aid is used, but it is not necessary with resin-coated papers.

A common print developer is Dektol, which should be kept in a closed container and diluted with water just before use. Developer that has been sitting out in a tray for more than a day is surely oxidized and will not deliver top-quality prints. The temperature of print chemicals is not as critical as it is for film processing. If the print chemicals are at a room temperature that is comfortable for you, they are suitable for printmaking.

Although water is recommended as a stop bath for film processing, an acid stop bath should be used for prints. The acid stop bath is important in printmaking because the print paper is more likely to absorb and retain developer. If the developer is not neutralized by a stop bath, inconsistent processing could result, and developer could be carried into the fixer, spoiling its acidity. One ounce of glacial acetic acid (available at camera stores) added to a gallon of water makes an inexpensive stop bath. Be careful—glacial acetic acid is strong. Do not breathe its fumes, and be sure to add the acid to the water—*never* add water to concentrated acid. Stop bath formulas are available that change color when exhausted: however, acetic acid is so cheap that I recommend it and suggest making fresh stop bath for each print session.

Fixer for printmaking is essentially the same formula used for film, but it is usually diluted to about half the film concentration. Exact mixing depends on the brand. In many newspaper photo labs, fixer intended for printing is mixed to the strength used for film. This concentration shortens fixing time to about 30 seconds compared to the typical two- to five-minute treatment; however, you must not overfix prints in such a strong bath or the image may bleach out. There is some question about the longevity of prints fixed this way, but one paper manufacturer recommends this method for archival permanence. If you work in a lab where chemicals are provided, be sure to find out what fixing times should be used.

Resin-coated papers need only a two-minute wash. In fact, longer wash times are not recommended. RC papers can be heat or air dried in minutes, and a variety of drying machines are available. But because fiber papers absorb chemicals, they must have about an hour's worth of washing unless a washing aid is used. Fiber papers are most often dried with specially designed print dryers, although they can be air dried if you are willing to wait a day for the paper to dry. Beware: some types of print dryers designed for fiber papers will melt resin coatings, ruining the print and possibly the dryer.

A final note about print chemicals: be very careful about contaminating the print developer with stop bath or fixer. Very small amounts of either stop bath or fixer can reduce the alkalinity of the developer and cut its strength. The process moves from the developer to the stop bath and fixer. *Never* take anything from the stop bath or fixer and move it to the developer, including your hands, which should always be rinsed in water and dried before returning to the enlarger.

Machine-Processed Paper and Chemicals

An alternative to the above method is machine processing. Some resin-coated papers can be processed in large machines, which are usually found only in professional photo labs where they are cost-effective. Machine-processed resin-coated prints are considered as permanent as conventionally processed resin-coated prints.

In small labs, stabilization machines are common. About the size of a stereo receiver, these machines feed special stabilization paper into an activator bath and then into a stabilizer. The print is not washed, but is squeegeed by a set of rollers before it emerges from the machine. These damp-dry prints are ready for use in seconds, but because they still contain a lot of chemicals, they will not last more than a few months. Stabilized prints, which are printed on a fiber base, can be fixed, washed, and dried using the procedures for fiber paper if permanence is needed.

Printing Equipment

Equipment for printmaking includes an enlarger and a timer, an easel to hold the paper, trays for the chemicals, a safelight, and dodging and burning tools. The enlarger is the basic printmaking tool. It works like a slide projector, except that it is attached to a vertical column and is aimed down at the counter instead of against the wall. And, as with a projector, you can make the image bigger or smaller by moving the enlarger head closer to or farther from the counter top. Figure 5–4 shows a typical enlarger.

Exposing print paper is similar to exposing film; you must control both the f-stop of the lens and the exposure time. Therefore, while you could control print exposure times by watching a stopwatch, an enlarging timer is the only practical way to work. The enlarger plugs into the timer, which in turn plugs into the wall outlet. Typical enlarger timers have a range from one second to a minute or more.

The print easel is a simple device similar to a picture frame. It holds the paper in place under the enlarger. There are several types of easels, some with adjustments for any size print, and some that will take only one size (fig. 5–4).

Figure 5–4 Basic printmaking equipment: enlarger, timer, safelight, easel, and dodging and burning tools. *(Randy Dotta-Dovidio)*

Safelights are special colored lights that do not affect print paper. Be sure to use the correct bulb wattage. The use of too bright a bulb can cause fogging of the paper and possible heat damage to the safelight or its filter. Also, no safelight is totally safe, and your paper can fog after too much safelight exposure. Therefore, don't leave a stack of paper on the counter; keep it in its original box until you are ready for it. This habit is also good insurance against loss if someone accidentally opens the door or turns on the room lights.

Dodging and burning tools, easily made from scraps of thin cardboard, are used to make local changes in print exposure. You can see what they look like and how to use them in figure 5–6g and 5–6h.

Making a Print

The basic steps in printmaking begin with a *contact sheet,* a print that shows all the shots on the roll. By looking at the contact sheet, or *proof sheet,* you can choose the shot you want to enlarge. You'll then put that neg in the enlarger and project its image onto a piece of print paper. After processing the paper, you'll examine the print for exposure and contrast corrections and make a corrected print if necessary.

The Contact Sheet

Briefly, a contact sheet is made by putting all the negs from one roll of film on a piece of photo paper. The negs are pressed against the paper with a sheet of glass, and this sandwich is exposed to light from the enlarger. The paper is then processed and dried. A sample contact sheet and the steps in making one are shown in figure 5–5.

To make a contact sheet, either get a piece of glass a little larger than 8 × 10 inches, or use a contact printer, as in the illustration. Lay a piece of photo paper on the baseboard under the enlarger or on the foam side of the contact printer, emulsion side up. (The emulsion side is the shiny side of glossy surface paper. With other papers, you may need to sacrifice a piece to find the emulsion side under normal lights.)

Then put your negative strips on the paper, emulsion side down. The emulsion side of the film is the dull side, and film almost always curls toward the emulsion side. Put the glass over the negs to press them against the paper. Stop the enlarging lens down about two stops and expose for about 8 to 10 seconds.

Then put the paper face up into the developer tray. Get it under the developer quickly and evenly. The development time for rapid-processing, resin-coated paper in common print developers is one minute. (Some non-rapid processing papers require two minutes. Check the data sheet inside the paper box.) During this time, agitate the print by rocking the tray slightly. Agitation in print processing is important for the same reason it is in film processing. Don't be tempted to pull the print out of the developer before the minute is up. Prints often look fine under the safelight, but show the effects of improper processing when examined in normal light.

After one minute, drain the developer off the print by holding it by one corner, and then move it to the stop bath tray. About five seconds is enough time to stop development in RC prints. Drain again and transfer the print to the fixer.

Fixing time for RC paper is about two minutes in ordinary paper fixer, but some labs use film-strength fixer, which fixes paper in 30 seconds. After about half the fixing time has passed, you can examine the print under white lights, but be sure to return the print to the fixer to complete the process. When the fixing time is up, wash the print for two minutes in a tray of running water, wipe it off and dry it, either by hanging it from a line or using a print dryer. If the finished contact sheet is too dark, make another with less exposure; if it is too light, use more exposure.

(a)

(b)

(c)

Figure 5–5 (a) To make a contact sheet, place a piece of print paper face up in a contact print frame, then put the negatives on the paper with the negative's emulsion (dull) side down. (b) After the negatives are in place, press the glass down on the negs to hold them tight against the paper and expose the contact sheet for about eight seconds at f/8. If the developed sheet is too light or dark, make another with more or less exposure. If you don't have a contact frame like this, a piece of window glass will do. Just set the paper on the enlarger baseboard, put the negs on top and cover them with the glass. (c) The finished contact sheet. *((a) & (b): Randy Dotta-Dovidio)*

(a) Put the negative in the negative carrier, then blow the dust off the neg with an ear syringe and put the carrier in the enlarger.

(b) Open the enlarger lens all the way before focusing.

(c) Adjust cropping and carefully focus the enlarger.

Figure 5–6 Making a print. *((a)-(e), (g), & (h): Randy Dotta-Dovidio)*

(f) The finished test print should look like this. The lightest stripe is the shortest exposure.

If you are using fiber-based paper, the procedure is the same except the processing times are longer. Development is typically two minutes, stop bath is 30 seconds, and fix is about five minutes (except the extra-strength mixture, which fixes fiber papers in the same 30 seconds as RC paper). Wash times for fiber papers approach one hour, but you can use a washing aid, which helps remove the fixer from the paper base, reducing wash times to 20 minutes or so.

When looking at the images on contact sheets, check your shots for message content, composition, and major technical errors. Do not reject a shot merely because it looks slightly light or dark—slight density variations on a contact sheet may be well within normal limits.

Making an Enlargement

Noted photographer Ansel Adams said that the negative is similar to a composer's musical score, and the print is the performance. It is true that, as with music, there are many ways to interpret a particular negative, and it is also true that, just as learning to play an instrument takes practice, so to does learning to print. Although the illustrations here will help you get started, there is no substitute for time spent at the enlarger.

First, be sure your enlarger is fitted with the correct lens. A 50mm lens is needed for enlarging 35mm film, and a 75mm or 90mm lens is used for 120 size film. Put the negative in the negative carrier emulsion side (dull side) down, and dust it off with a large ear syringe or negative brush. Put the carrier in the enlarger and turn on the enlarger lamp. Open the enlarger lens all the way and focus the lens. Adjust the enlarger height for the image size you want, moving the print easel under the enlarger to crop out distracting areas of the image.

Cropping is a form of visual editing that allows you to cut irrelevant material from your photo, much like deleting unnecessary paragraphs from a written story. In

(d) Stop the lens down two or three stops.

(e) Make an exposure test.

(g) Dodging is a means of lightening a small area of a print. Dodging is done during the main exposure.

(h) Burning is a way to darken a specific area of a print. It is done by giving additional exposure to the area after the main exposure is complete.

the darkroom, cropping is done by moving the easel under the enlarger so only certain parts of the image fall on the paper. Deciding what to crop is a creative decision that is made to enhance the message. Eliminate everything from the photo that does not contribute: distracting foregrounds, unnecessary material at the sides, and excess sky. Crop also to improve the graphic aspects of the image, including composition and balance.

Next, you must find the right print exposure. Exposure is controlled by a combination of f-stop and time, just as it is with film. But, although light meters help you set exposure in the camera, meters are rarely found in photo labs. The best way to find the right print exposure is to make a *test print*. As figure 5–6f shows, a test print is a series of stripes made by moving a piece of cardboard across the paper as a series of short exposures is made. As a starting place, stop the enlarging lens down two stops and set the timer for three seconds. If you use

graded paper, start with a grade number 2. If you use variable-contrast paper, put a number 2 contrast filter into the enlarger.

Give the paper a 3-second exposure and cover about 1½ inches of the edge of the print with the cardboard. Then give the paper another 3-second shot. Repeat this procedure until you have worked your way to the other side of the print. The exposure will build in each stripe. In the illustration, the last stripe to be exposed received four 3-second shots for a total of 12 seconds.

Then process the exposure test the same way you processed the contact sheet. After the test is in the fixer, you can turn on the lights and check the results. Find the stripe that looks the best, set the time on the enlarger timer accordingly, and make a trial print.

This first print is called a trial print because you'll probably have to make some minor adjustments to exposure and contrast after seeing the entire image.

Too light Correct density

Contrast
too high

Correct
contrast

Contrast
too low

Figure 5–7 This series of photos shows differences in contrast and density. The center image is correct. The top row is too contrasty while the bottom row is too flat. The column on the left is too light; the column on the right is too dark.

Improving the Trial Print When you look at your trial print, check the overall range of grays, comparing them with the examples in figure 5–7. If the print is low contrast, increase the contrast by using a higher-numbered paper or contrast filter. With some older contrast filters, you may need to make a new exposure test with each change of filter. Contrast can be hard to recognize at first. Most beginners print too light and too

flat. For your first few prints, it's best to have an experienced printer look at your work in progress.

You might find that the print is fine except for a few small areas that are too light or dark. *Burning* and *dodging* are methods used to correct these local defects. Burning is most often done to darken the corners of the print as shown in figure 5–8, but you can also use the technique to shift emphasis away from distractions. Dodging is used to lighten areas that are too dark. Faces in shadow are common areas that need dodging. Dodging

Too dark

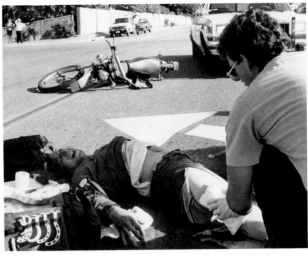

(a)

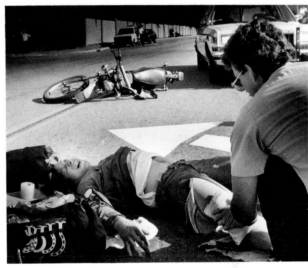

(b)

Figure 5–8 (a) This is a straight print (no dodging and burning) of the photo in (b). Notice how dodging and burning changes the impact of the image. (b) The main exposure in this print was set for the victim on the ground. His face was dodged slightly, then the fence in the upper right was burned in, as was the arrow on the pavement, the light area on the medic's shoulder, the highlight on the victim's leg and hand, and the medic's bag in the lower left. *(Kurt Hegre/Gilroy Dispatch)*

is only to lighten an area slightly; it won't put sunshine where it did not exist in the original scene.

How to burn and dodge is illustrated in figures 5–6g and 5–6h. The technique is quite simple. By using the burning and dodging tools mentioned above, or your hands (which many printers prefer), you cast shadows on the print during the exposure. By shielding a specific area of the print, you can make the spot lighter, and by giving additional exposure to certain areas of the print, you can make them darker.

Almost all prints need some burning in the corners. When a photo is reproduced on a printed page with headlines, type and other graphics, it needs borders that identify where it begins and ends. A very light sky, for example, might not show up at all on the page, and the main subject would appear to be floating about in that space. In many other cases, the edges are burned to give extra emphasis to the subject or to reduce visual distractions. Figure 5–8 is an example of a photo that has been improved considerably by good burning technique.

The final step is to make a print with the appropriate contrast and burning and dodging, wash it for two minutes (RC paper), and dry it. Then check it for small white spots caused by dust specks on the negative. These spots are retouched with spotting dye and a fine 4–aught or 6–aught spotting brush (available from a camera store). Find a reject print to practice on. I prefer to put the dye on dry. Put a drop of dye on the inside of a plastic film can lid and let it dry. Then, using a brush that is just barely damp, pick up a minute amount of dye and touch it to the white speck on the print. Make little dots with the brush, working your way across the speck. Don't paint the dye on. Just use a polka-dot technique, building the dye up slowly until the density matches the surrounding area.

Checking Print Quality Aside from spots, other problems that may appear in the finished print include yellow or brown stains. These stains are the result of sloppy darkroom technique—chemicals on your hands while handling dry paper, failure to get the paper completely under the chemical bath, splashing chemicals on the print, or some similar cause. Gray or black areas around the edges of the print (or overall) suggest fogging, exposure of the paper to extraneous light. Perhaps the box top was not seated tightly when you last had the paper box in white light. Light may have leaked around the lid and struck the paper. Another cause could be excessive exposure to the safelight. Prints that fade or stain after processing did not get enough fixing or washing. These and other print problems are outlined in table 5–1.

Darkroom Cleanliness and Safety

Although the details of processing may change from lab to lab, some basic procedures are universally important. High on the list in every lab should be cleanliness. Keeping the lab and equipment clean is important for more than aesthetic reasons. Spilled chemicals leave a residue that can contaminate other chemicals, damage your film and paper, and stain your clothes. Fixers, for example, are corrosive and can damage metal items around the lab. Some developers can cause skin reactions in persons with sensitive skin, and wetting agents

TABLE 5-1 Problems in Prints

Problem	Cause
Print Too Light	Not enough exposure—use larger aperture or increase exposure time
Print Too Dark	Too much exposure—decrease aperture or use less time
Overall Gray Look	Contrast too low—use higher number contrast filter or paper
Harsh, Soot and Chalk Look	Contrast too high—use lower number contrast filter or paper
Brown or Yellow Stains	Chemicals splashed on print; exhausted or contaminated chemicals
Fingerprints Appear on Print after Processing	Chemicals on hands when handling paper
Print Fades after Drying	Inadequate fixing
Print Paper Has Black Edges after Processing	Light leaked into paper box when room lights were on
Image Reversed Left to Right	Negative wrong side down in enlarger

leave a sticky residue on processing equipment. When cleaning your work area, be sure to use a clean sponge and make a second wipe-down after rinsing the sponge thoroughly with plain water. A quick once-over will not remove all traces of chemicals. When the liquid evaporates, a powdery residue will remain that can be spread throughout the lab and even find its way into your lungs. *Always* rinse your hands in water before drying them on a towel. If you dry them without rinsing, chemical residues will remain on your hands, and you'll have contaminated the towel as well.

Also, every darkroom has a wet side and a dry side. The wet side is where the processing takes place; the dry side is reserved for the enlarger and related items. Never take wet prints, print trays, or other materials to the dry side of the darkroom. Wet chemicals in the enlarger area are sure to get on your negatives, print paper, and equipment, and cause stains, spoiled materials, and wasted time.

Mixing Chemicals
When mixing chemicals, follow the package directions exactly. If they instruct you to pour the contents slowly,

do so. Dumping the whole package at once could result in undissolved material. Stir until the material you have added is dissolved, then add another small amount and stir again. When stirring, avoid creating a whirlpool that draws air into the mixture, and don't mix chemicals by pouring the ingredients into a bottle and shaking. Shaking is a sure way to mix air into the solution, which can cause oxidation of the chemicals.

Using a waterproof marker, label containers with their contents and date mixed. Be sure to use clean bottles, and never use old food or cleanser containers, which could be contaminated with residue that could affect the photo chemicals. Worse yet, someone could think an apple juice jug still contains its original contents.

Developers should be stored in full, tightly capped bottles to reduce oxidation. Stop baths and fixers are less fussy, but don't leave them out where evaporation can change their composition. Our lab has had some problems with mixed wetting agents spawning foul-smelling growths, so I recommend keeping wetting agents as stock solutions, mixing them just before use.

Stock and Working Solutions

A stock solution is a concentrated mixture that is diluted before use to make the working solution. Stock solutions are a space-saving way to store chemicals. Also, some developers must be kept as stock solutions because they will not keep when mixed to working dilutions. Be sure to clearly label stock and working dilutions.

Chemical Safety

Photo chemicals should be handled with the same respect you would give any other common laboratory chemicals. Although the immediate hazards are few, evidence is still being gathered about the consequences of long-term exposure to photo chemicals.

As mentioned previously, some persons are allergic to one of the common developer components. The skin rash that results is temporary, but if you are afflicted, use rubber gloves and a barrier cream available from a pharmacy. When mixing chemicals from powdered stock, always wear a dust mask. Follow the package directions exactly, and wear goggles if there is a chance of getting chemicals into your eyes. Use common sense and keep direct contact with photo chemicals to a minimum.

Summary

Many photographers find much satisfaction (and frustration!) in darkroom work. It is here that the image takes its final form. You have more control at this stage than you may at first realize. The process begins by developing the film. The exposed film is loaded onto a processing reel and put in a tank. Developer is added, which converts the latent image to a visible one. The development is stopped by a stop bath, and the image is made permanent by the fixer. The film is then washed, treated with a wetting agent, and dried.

Two important considerations in film processing are time/temperature and agitation. The temperature of all solutions should be the same, and the development time depends upon developer temperature. Agitation during processing is needed to bring fresh developer in contact with the film, and you should use the same agitation technique every time for consistent results.

Your negatives can't be replaced, so handle them with care. Physical damage such as scratches and fingerprints will most likely show up in the print. Recognizing problems in negatives takes some practice. A quick way to see if your neg is printable is to lay it over a piece of newsprint. If the copy underneath is just barely visible, the neg should be within limits for printmaking.

The main characteristics of photographic paper are base material, contrast, and surface finish. Paper bases are either resin coated or fiber. Resin-coated papers are waterproof, and can be completely processed in less than four minutes, but fiber papers require long wash times, up to an hour for maximum permanence.

Print papers are either graded to a specific contrast or are made with variable contrast. In either case, contrast levels are numbered from 1 to 4 or 5, higher numbers being higher contrast. Always start printing with a number 2 filter or paper and adjust as needed to get the best result. Although print paper is available in many surface finishes, glossy finish is universally accepted for reproduction prints.

The three challenges to the beginning printmaker are: cropping to improve message content, recognizing correct print exposure and contrast, and learning to dodge and burn to emphasize local areas within the print.

The first challenge requires careful analysis of what the photo is trying to say. All extraneous parts should be cropped out. The second challenge is to match the paper contrast to the needs of the negative, and exposing so the final print will have a full range of tones from maximum black and deep, detailed shadows to textured highlights and bright whites. Learning to see correct print exposure and contrast will come from studying the examples in this chapter, having your work evaluated by an expert, and practice. Dodging and burning, which are used to lighten or darken certain areas of the print, are done by casting shadows on the paper during the exposure with your hands or home-made cardboard tools. This useful technique can direct your readers' attention toward the subject and away from distractions.

Finally, darkroom housekeeping should not be approached casually. Chemical contamination can spoil your work and damage equipment, and carelessness with chemicals can be a health hazard.

Chapter 6

Light

"Whether of a board fence, an eggshell, a mountain peak or a broken sharecropper, the great photograph first asks, then answers, two questions. 'Is that my world? What, if not, has that world to do with mine?"

—*Dorothea Lange*

Light: A Fascinating Phenomenon

Most of the beauty of a particularly pretty sunset or the view out your window after a storm is created by light, that mysterious phenomenon of nature we too often take for granted. But light is more to the photographer than sunsets and storms. Learning to see it in all its forms and understanding what it will do for your subject are important keys to making pictures that communicate. After all, the word *photography* literally means "light writing." And to learn to write with light, you must know what it will do to your subject and how it will evoke responses from your reader.

Scientists have puzzled about light for centuries. Early thinkers believed that light traveled from the eyes of the observer to an object and back again. But more modern scientists, beginning with Sir Isaac Newton and his contemporaries, have shown that light is a part of the electromagnetic spectrum, and that it behaves in some ways like particles and in some ways like waves.

Newton theorized that light consisted of streams of particles that shot out from the source like bullets from a machine gun. This theory seemed logical because light sometimes behaves as energy, aiding photosynthesis in plants and reacting with the film and print paper we use in photography. But light also behaves like waves, spreading around the edges of opaque objects. Perhaps you have noticed this *diffraction* when looking at the blurry edges of shadows cast on a sunny day. The way sunlight can be transformed into a rainbow of colors by a glass prism is additional evidence of wavelike behavior. The various wavelengths are bent differently by the prism, therefore individual colors can be seen. Light also behaves like waves in our camera's lenses, which are, in a sense, modified prisms that bend light rays so they form an image on film.

Light and the Spectrum

Unlike waves on the surface of water, which move only up and down, light waves also move sideways. The distance between the crests of each wave is the *wavelength*. Wavelengths in the electromagnetic spectrum span almost unimaginable extremes, from the miles between some radio waves to the miniscule distance between gamma rays, which is about 1/2,500,000,000,000 inch. The wavelengths of visible light are about 1/4,500,000 inch.

At the long end of the visible section of the electromagnetic spectrum are infrared rays, which can be photographed on infrared-sensitive film. Next to infrared rays are red, yellow, green, cyan, and blue rays. The shortest rays are ultraviolet. You may remember from chapter 4 that in views of distant landscapes ultraviolet rays contribute to haze.

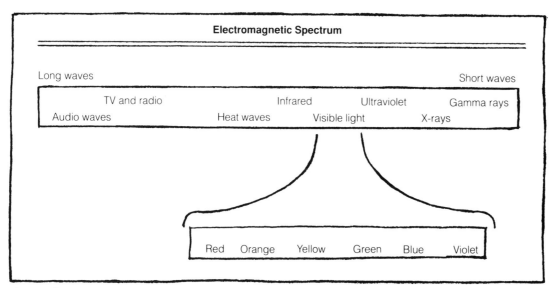

Figure 6–1 Visible light is slightly toward the high end of the electromagnetic spectrum. Red light consists of the longest waves while violet rays are the shortest.

White light from the sun is a mixture of all these colors, and a rainbow is evidence of that. The water droplets act as prisms and break the white light into its constituent colors. The dominance of red or blue in what appears to be white light is known as *color temperature,* and can be measured. A tungsten light bulb, for example, emits much more red than the light from the sky, therefore, color photos made under tungsten light will appear overly red or orange.

But some light sources, such as fluorescent lights in a classroom or vapor lights in a parking lot, don't contain a full spectrum. If you could create a rainbow from one of these sources, you would see gaps in the spectrum where certain colors are missing. Because of these missing colors, it is hard to get natural-looking color photos under these types of lights. Color temperature will be discussed in more detail in chapter 7.

Light from Source to Film

As light rays leave a source, such as the sun, they depart headed in all directions. The individual rays travel in straight lines, and when they hit an object, they can be reflected, absorbed, or refracted (bent).

We frequently think of reflection as coming only from shiny objects, such as a mirror or chromed auto part, but light is reflected from almost every surface. In the case of a mirror, the light rays are so perfectly reflected that we can see an image of the source. But when light is reflected from a textured surface, such as a piece of cloth, the rays are scattered and no image of the source is visible.

Regardless of the surface, light rays are reflected at the same angle as they are received. For example, if you threw a tennis ball straight at a wall, it would bounce straight back. If you stood to the side and threw the ball at an angle to the wall, it would bounce off the wall at an equal angle. Scientists say it this way: The angle of incidence (incoming light) equals the angle of reflectance. Keep this idea in mind when using the bounce flash techniques discussed later.

Although some light rays are reflected, some are absorbed. The color we see depends on which rays are reflected and which are absorbed. For example, if an object absorbs all colors except red, the object appears red.

You can conduct an interesting experiment in color reflectance and absorption in a photo lab lit by the safelights used for black-and-white printmaking. Assemble some small items of different colors: blue, orange, yellow, red, and green, or write on a piece of white paper with a red or orange marker. Then go into the lab and see what colors the items appear to be under the lab safelight. See if two items of different colors look the same color under the safelight.

Refraction is the bending of light rays. Anytime a light ray passes at an angle from one medium, such as air or glass, into another medium, it is bent. You have seen this effect if you have ever noticed how a pole sticking out of a pool of water appears to bend where it enters the water. Although we don't have to think much about refraction when making pictures, this property of light is what enables lenses to focus light rays onto film.

Light as a Creative Tool

Regardless of whether we classify light as energy or particles, it is of major importance to our photographic vocabulary. Light is to the photographer what words are to the writer. Light illuminates, but light is also darkness; and shadows are as important as highlights. Light isolates, blends, emphasizes, de-emphasizes, reveals or reduces shape, enhances or hides texture, creates atmosphere and mood, and can direct or distract the viewer. Whereas a feature writer listens to his subject, intent on finding the salient quote, the photographer looks at her subject, intent on finding the most appropriate light. If you learn to see what light does to your subject, you will have almost limitless control over the image.

Characteristics of Light

In everyday photography, the most important characteristics of light are intensity, quality, and direction. Whereas intensity is a primary concern when figuring exposure, the quality and direction of light create highlights, shadows, and texture, which provide clues about the subject's three-dimensional features.

Intensity

The intensity of light is simply its brightness. Of course, intensity is a factor in exposure, but it also influences your options for depth of field and motion control. Under low light levels, you must use slower shutter speeds or wider apertures or both; bright light may require high shutter speeds and small apertures. Under these conditions you may have few choices regarding depth of field or motion. Remember the information in previous chapters about depth of field—wide apertures limit you to selective-focus techniques, and slow shutter speeds may result in unwanted blurry images.

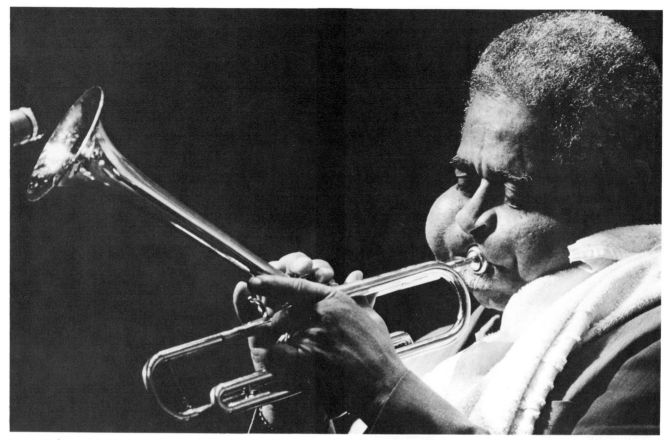

Figure 6–2 Hard light is characterized by the sharp line between highlight and shadow. *(Gary Kazanjian)*

Intensity, however, does not directly influence two other characteristics of light—quality and direction. These two are the photographer's main tools for transferring information about a three-dimensional subject onto two-dimensional paper. Light quality and direction create the highlights, shadows and texture, which are visual clues to shape and surface.

Quality

The quality of light ranges from hard to soft. Hard light comes from compact, point-light sources such as the sun, a light bulb, or even headlights on a car. It creates a sharp line between highlights and shadows, and emphasizes texture and specular reflections.

On the other hand, soft light comes from broad sources such as the sky on a foggy day, skylight (not sunshine) coming in a window or the fluorescent light panels in an office ceiling. It creates a broad, soft line between highlights and shadows, and it tends to diminish texture, creating a smooth, even look. Figures 6–2 and 6–3 show examples of hard and soft light.

Hard light can suggest feelings of firmness, strength, power, tension, shock, drama, excitement, and extreme cold or heat. Soft light can suggest feelings of calm, dullness, peacefulness, blandness, boredom, sensuousness, and warmth. Although the main concept of a photo is more often determined by image content, feelings can be created or reinforced by the quality of light.

Direction

The direction of light emphasizes the shape of the subject. You can discover the direction of the light by looking at the shadows, which always point away from the light. Front light comes from near the camera position, and as figure 6–4 shows, it reduces shadows and the resulting feeling of three dimensions. This is the type of light created by the small flash units that attach to (or are included in) many popular pocket cameras.

As you move the light to the side, shadows increase. The light placed as in figure 6–5 is sometimes called Rembrandt lighting, even though the light in the famous painter's works did not always come from this direction.

Figure 6–4 Front light comes from the photographer's position. *(James Kinney)*

Figure 6–3 The light in this photo is so soft that the transition between highlight and shadow is almost impossible to find. *(Tom Spitz/Reno Gazette-Journal)*

Figure 6–5 Sometimes called Rembrandt light, this light comes from about 45 degrees to the side of the camera position. *(Lane Turner)*

Figure 6–6 Texture and detail is emphasized by side light. *(Akemi Miyama)*

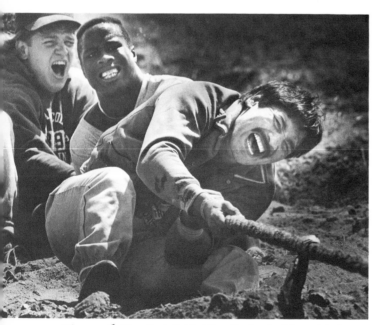

Figure 6–7 Back light strikes the back of the subject, creating a highlight that tends to outline the subject against the background. *(Gary Kazanjian)*

When the light is at the side as in figure 6–6, the subject is said to be side-lit. When light falls on the part of the scene opposite the camera, the subject is back-lit. Back lighting creates rim light, as in figure 6–7, which helps separate the subject from the background. Most television news programs are lit this way. The lighting on the newscaster usually includes a strong back light that creates highlights along the hair and shoulders.

Light in the Photograph

When a scene is full of light tones, bright highlights, and minimal shadows, as in figure 6–8, it is called high key. The converse, as in figure 6–9, is called low key. High key is a useful way to suggest feelings of heat, goodness, warmth, innocence, delicacy, and vibrancy in a photo. Low key contributes feelings such as mystery, evil, darkness, cold, seduction, and death. As with light quality, the image content of the photo also influences

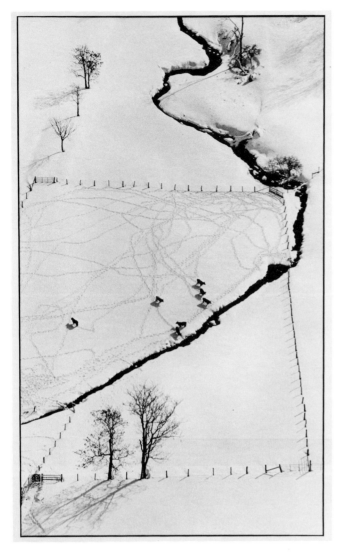

Figure 6–8 In high-key photos, light tones dominate. *(Dan Marschka/Lancaster, PA, Intelligencer Journal)*

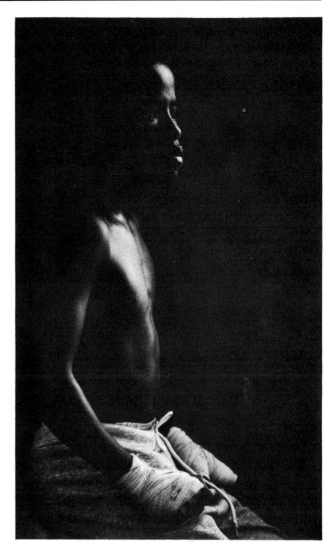

Figure 6–9 A low-key photo is dominated by dark tones. *(Tony Olmos)*

the nature of the light's contribution, and many examples of feelings opposite from those listed could be found. My purpose here is not to list absolutes, but to encourage you to think about the psychological effects of light on your message.

The Importance of Highlights, Shadows, and Texture

All the characteristics of light contribute to creating highlights and shadows in your photograph. And these two elements are the major way of communicating shape, texture, and surface information to your reader.

Photographs can convey this information because your readers' memories contain a lifetime collection of information about objects and how they have perceived

them—their shape, texture, and surface qualities and how those qualities look. When you see an object, you can recall the shape and feel of similar things and make assumptions based on the visual clues created by the highlights, shadows, and texture.

Texture is really nothing more than many small points of highlight and shadow. Visible texture in a photo is the most significant clue to the nature of a surface—the shine of a smooth piece of marble or the coarseness of a piece of sandpaper tell your viewer something about these objects. Carrying this idea a step further, we associate certain surfaces with certain ideas. Chrome and glass, for example, seem modern and businesslike, while wood and earth tones often seem homey and casual. And with people, we tend to subconsciously

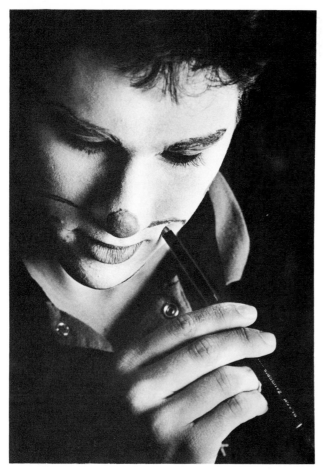

Figure 6–10 Shadows always fall away from the main light. In this shot, the main light is coming from the right. *(Tony Olmos)*

group personality types partially by the clothes they wear. One particular type would more likely be found wearing a smooth satin shirt or blouse, while another would more often be found in a soft, bulky sweater.

Types of Lights: Main, Fill, and Accent

In any given scene, there are at least two different lights, and sometimes a third. The first one, the ***main light,*** is the one that seems to illuminate the scene, and there will always be a main light in every photo. Outdoors on a sunny day, the main light comes from the sun, whereas in a photo studio, the main light is the brightest light. In figure 6–10, the main light is coming from the right.

The second light is the *fill light,* which illuminates shadows. There is always some fill light in every scene, although it could be of such low intensity that the film would not record it and the shadows would photograph black. On a sunny day, fill light comes from the sky, but

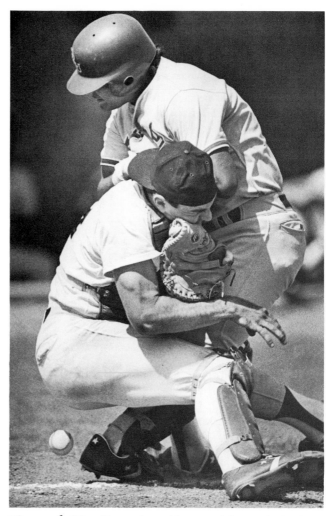

Figure 6–11 These players' faces and the catcher's glove are lit by fill light that is coming from the sky and bouncing back up from the infield dirt. *(Gary Kazanjian)*

it can also be light reflected into the shadows by other objects, such as walls, floors, pavement, trees, and so on. In a studio, the fill light is often a second lamp placed near the camera so it will light the shadows seen by the lens. You may not be aware of fill light, and that is as it should be (fig. 6–11).

The third type of light, *accent light,* is an extra that adds highlights to a scene. You won't find accent lights in every photo, but they are often found in studio photography when a light is used to create a special highlight. In figure 6–12, the highlight that outlines the people's heads is coming from automobile headlights in the background.

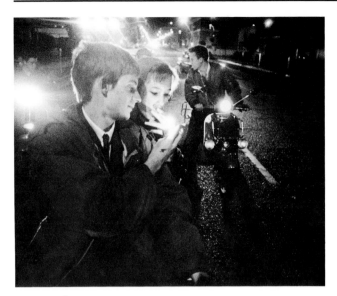

Figure 6-12 The back light that outlines these people's heads is called an accent light. *(Thor Swift)*

Using Light: Natural, Available, and Artificial

Natural light comes from the sun or the sky. Light from the sun is hard light; light from the sky is soft. Instruction manuals for the simplest cameras may have told you to shoot only in strong light and keep the sun at your back. But if you look carefully, you'll see that the light is different depending upon the time of day and season, offering many creative options to the photojournalist.

In some locations, morning light is clearer because photochemical smog doesn't have a chance to form until the sun has been up for some time. In other areas, haze is strongest in the early hours, and will burn off by midday. Yet haze and heavy air pollution, which scatter light into the shadows, actually help some photos.

When photographers have a choice, they often prefer to avoid shooting at midday. In the hours around noon, the light comes from directly overhead (particularly during the summer), and the shadows and highlights created are neither complimentary nor dramatic. Early and late in the day, the sun strikes subjects at an angle, casting interesting shadows, and when shooting with color, the sunlight is a warm color.

Overcast days provide marvelous soft light that is great for portraits, whereas fog can help create very moody photos. Ernst Haas, a photographer well known for his unique color work, said there is never a time when the light is bad: "When it rains, you think, 'Well

how wonderful. I have no shadows.' When the sun shines, you say, 'How great, my colors are brighter.' "

I must add, however, that fog is a serious problem when the assignment is not to create a moody picture, but to catch the action at a football game! Not much can be done to penetrate the fog if it makes it hard to see the field.

In the winter, the sun sits lower in the sky, and it seems there is less dust and haze in the air. Stormy weather can provide dramatic light, and if you live in an area that has volatile weather, watch what happens to light during storms.

Natural light also reaches indoors, and window light is a marvelous, soft light that, in contrast to the unidirectional light of a fluorescent-lit classroom, has shape and texture-emphasizing direction. If you try making a window-light portrait, you'll see how much better the result looks compared with harsh sunlight or direct electronic flash.

Available Light

Any light that is not from the sun or under the control of the photographer is called available light, and includes both interiors and exteriors that are lit by man-made lights. Available light can include sources such as long fluorescent tubes, which are found in classrooms, offices, and stores; vapor lamps, which are used in parking lots, street lamps, and stadium lights; and tungsten lamps, which are the bulbs commonly found in table and ceiling lamps in most homes. Available light can be hard or soft depending upon the size of the source, and it can come from any direction.

Shooting under available light is an easy way to work, because you don't have to carry and set up lighting equipment, and the subjects aren't bothered by abnormal lighting conditions. On some sensitive stories you'll want to avoid distracting the subject or disturbing the natural flow of events. When contrasted with attention-getting flood lights or electronic flash, available light is often the best choice.

But available light is often of low intensity, forcing you to use wide apertures and possibly slow shutter speeds. This combination works against extended depth of field and stopping motion, and the latter is particularly important when shooting sports. For example, many high school gyms are poorly lit. With 400-speed film, some of these dark dungeons require a shutter speed of 1/250 second or less and the widest lens aperture available. This situation puts a heavy burden on the photographer to focus carefully and shoot at the peak of the action, when everything momentarily stops. Also, if you

shoot color under available light, you may get color shifts because of the various colors of the light sources. One common example is the green cast caused by fluorescent lights.

Another problem with available light is that it is often too flat or too contrasty. Although I don't want to overgeneralize, it seems as though Murphy's law is at its best when we must rely solely on available light. Too often we find ourselves shooting under flat, shadow-destroying office fluorescents or the impossible contrast of theatre spotlights.

Artificial Light

Some photographers have said that they only use available light—*any* light that is available! They will use any light, from any source, if it will help them get a picture. And as newspaper photojournalism shifts to color, which requires a strong main light and plenty of fill, photojournalists bring additional artificial lights to the scene more frequently than ever before.

Artificial light, which is light that the photographer controls, most often comes from floodlights or electronic flash. An advantage of floodlights is that you can see what the light does to your subject. But size for size, floodlights don't have the output of flash, and must be plugged into a power source. Yet electronic flash, although more powerful and portable than floods, comes and goes in an instant, leaving the photographer to rely on experience and perhaps a dim modeling light attached to the flash to estimate the final result. Setting and controlling artificial light is covered in chapter 11, but it is important to warn you now about one common mistake: Don't set the main light below the subject's eye level unless you want an unusual effect.

Using Electronic Flash

I suspect that every person reading this book has had at least one experience with artificial light—the little flash that sits atop so many pocket cameras. But there is much more to flash than this shadow-destroying front light. And although early flash work required bulbs that were good for only one picture, modern professionals depend almost exclusively on electronic flash.

When working with flash, conventional light meters can't measure the sudden flash of light, so you must calculate your exposure mathematically, or use a special flash meter, or use a flash unit that has an automatic exposure system. Keep in mind that shutter speed is not a factor in flash exposure. The burst of light from the flash is anywhere from 1/300 second to 1/5000 second or less, and as long as the shutter is open when the flash fires, the film will be exposed.

Exposure with Manual Flash Units Almost all handheld flash units include devices that control the flash exposure, but even with these modern tools you'll sometimes need to calculate an exposure on your own. If you understand the principles behind flash exposure, you'll be ready when that unconventional situation arises.

With any light source, exposure depends upon the distance from the light source to the subject. To understand this concept, imagine yourself driving down a dark road at night. As you look into the distance, the brightness of your headlights diminishes and the objects farthest away receive the least amount of light.

In theory, this fall-off happens at a fixed rate. Suppose that the panel closest to the candle in figure 6–13 is receiving one unit of light. If the distance is increased to two feet, the light spreads out to cover four panels, and the intensity is only one-fourth the original brightness. If you move the subject back three feet, the light spreads out to cover nine panels and the intensity is only one-ninth of the original brightness.

This phenomenon is known as the inverse square law of light, and it means two things to the working photographer. First, it means that light falls off quite rapidly, and you cannot count on a small hand-held flash unit for usable light much beyond twenty or twenty-five feet from the subject. Many factors influence the effective range of an electronic flash, including the presence of walls and other reflecting surfaces. If you shoot outdoors at night, the effective range of the flash unit will be less than if you shot inside a room that has white walls.

Second, the inverse square law of light means that you can mathematically calculate the f-stop needed if you know the film speed and the distance from the flash to the subject. Here's how:

1. Set the flash unit's exposure calculator dial for the appropriate film speed.
2. Measure or estimate the distance from the flash (not the camera) to the subject.
3. Check the calculator dial for the correct f-stop and set your lens aperture accordingly.

If your flash does not have an exposure calculator dial, you'll need to consult the instruction manual for a guide-number chart. This chart provides a guide number for each film speed. Find the guide number for the film speed you are using and divide by the distance from the flash to the subject. The result will be the f-stop you should use.

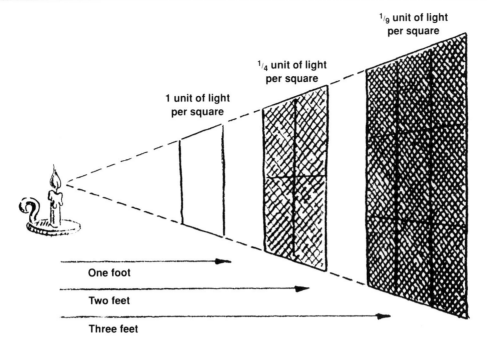

Figure 6–13 When light falls on a surface, its brightness falls off rapidly as the distance between the source and the surface increases. Imagine aiming a flashlight at a wall and backing away. If the distance between the light and the surface doubles, the brightness of the light is cut by one-fourth. If we extended the distance in this illustration to four feet, the intensity of the light would be reduced to one-sixteenth of its original level.

For example, the following chart lists guide numbers for the Vivitar 283, a small flash unit used by many photojournalists:

Film Speed	25	64	80	100	125	160	200	400	800
Guide Number	60	96	108	120	135	150	170	240	340

Suppose your film speed is 100. By checking the chart, you'll see that guide number for that film speed is 120. If you were shooting at a distance of fifteen feet from your subject, your calculations would be:

$$15 \text{ feet} \overline{)120 \text{ (guide number)}}^{\,8 \text{ (f-stop to use)}}$$

Exposure with Auto-Exposure and Dedicated Flash Units It is not necessary to calculate the f-stop with auto-exposure and dedicated flash units, because these units contain tiny light meters that figure the exposure for you. When the flash is fired, light is reflected back from the subject and is measured by the flash's meter. When the meter senses the correct amount of light, it sends a signal that shuts off the flash tube. This action takes place faster than the blink of an eye, yet this method is quite reliable.

Auto-exposure units can be used with any camera. All you need to do is set the flash exposure system for the film speed you are using, and it will control the light output and tell you what f-stop to use.

Dedicated units are similar to auto-exposure units, but they are designed to fit specific camera models. Like auto-exposure units, they have metering systems built in. But when a dedicated unit is attached to the camera, the shutter speed and sometimes the aperture are set by the flash unit. Sophisticated systems can even read film-speed information encoded on the film cassette, so all you need to do is load the film, attach the flash unit and shoot.

Because the special meters in both auto-exposure and dedicated units read reflected light, exposure errors can happen, and usually for the same reasons that things go wrong with regular reflected light meters. Watch for differences in brightness between small subjects surrounded by large backgrounds, and large bright or dark subjects, and make the same kinds of aperture adjustments to compensate for meter error that you would when shooting without flash.

Because of their fast, convenient operation, auto-exposure and dedicated units are the types most used by photojournalists. The exact operation of different brands varies, so be sure to read carefully the instruction manual for your particular brand.

Shutter Speed and Electronic Flash

Although shutter speed is not a factor in flash exposure, it is important for mechanical reasons when using cameras with focal-plane shutters. Think back to the discussion of shutter types in chapter 2. At high speeds, a focal-plane shutter does not expose the film all at once, but scans the image onto the film as the second curtain chases the first across the frame. Thus, the burst of light from the flash is so short that it has come and gone before the shutter curtains can complete their trip, and only part of the frame will be exposed to the light from the flash. At slower speeds, however, the first curtain completely opens before the second one starts to close. The fastest such speed is usually marked on the shutter-speed dial. In older cameras, this speed was commonly 1/60 second, although many newer shutter designs can synchronize at speeds up to 1/250 second. To find the fastest flash-compatible shutter speed on your camera, look for a symbol such as a lightning bolt, or a shutter-speed number in red, or possibly a small dot between two shutter-speed numbers on the shutter-speed dial. If the camera has two flash connections, use the one marked *X*. Any time you see the letter *X* on flash connections or shutter-speed controls, it indicates electronic flash. A letter *M* indicates the connection to use with flash bulbs, but some cameras no longer have this option.

Leaf shutters do not cause synchronization problems because the entire film frame is exposed at once, regardless of shutter speed. When the shutter blades have opened, the flash is tripped, and the light strikes the film before the shutter closes.

Using a Single Flash

The most common way amateurs use a flash unit is to attach it to the flash shoe on the camera and fire away. Although this method is still sometimes the only way a photojournalist can get the photo, it is a technique to be avoided if at all possible. The flat, front light created by this on-camera light removes the all-important shadows and adds a feeling of artificiality to the scene. The most likely times when on-camera flash is unavoidable are at spot news situations where there is inadequate available light and no time to use alternate methods. A prime example would be outdoors at night, as shown in figure 6–14.

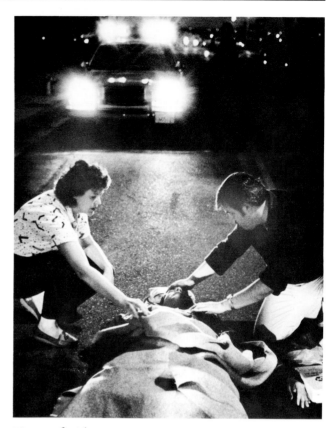

Figure 6–14 The headlights of the police car provide backlight, but the light that is illuminating the faces of the two people comforting the victim is coming from a flash unit attached to the photographer's camera. *(Gary Kazanjian)*

When working close to your subject, you can avoid flat, front light by holding the flash at arm's length, as far overhead and to the side as you can manage. When the light is held in this position, some shadows are created, and the light doesn't have quite the hard, frontal look of on-camera flash. To trip the flash when the shutter fires, you'll need a sync extension cord between the flash and the camera.

You can also soften the light when using direct flash by covering the flash head with a facial tissue, handkerchief or other thin translucent material. Some flash units have special diffusion caps that fit right over the unit.

Bounce Flash In contrast to the stark effects of direct flash, a natural look can be created by bouncing light off a ceiling or wall. If the flash unit has automatic exposure control, swivel the flash head so the flash tube is aimed at the ceiling or wall while the metering sensor remains aimed at the subject. This way, the exposure system will compensate for light absorption by the bounce surface.

Figure 6–15 This humorous view of the relationship between an elderly woman and her pet was taken on a routine portrait assignment. The woman allows the dog to sleep in an oven she rarely uses. The scene was lit by bouncing a flash off the ceiling. *(Judy Griesedieck/San Jose Mercury-News)*

Figure 6–16 Fill-in flash helped light up the parts of these girl's faces that were in the shadows caused by their cap visors. You can see the catchlights from the flash in the girls' eyes. *(Tina Etheridge)*

If you can't orient the flash as in the last paragraph, set the unit's exposure control for manual exposure. Then estimate the distance from the flash to the wall or ceiling and back to the subject, find the suggested f-stop on the flash's calculator dial, and open the lens up two f-stops to compensate for light absorption by the bounce surface. The two-stop correction will work with most light-colored surfaces.

Because dark-toned surfaces absorb light, they don't work well for bounce flash. If you shoot in color, beware of bouncing light off strongly colored surfaces. The light coming back will take on that color and might create an unwanted color shift in the photo.

Using Flash Outdoors You may have seen photographers using flash outdoors on sunny days and wondered why the extra light was needed. Bright, direct sunlight casts strong shadows, and the detail in these dark shadows is often lost, particularly when shooting color film or when the photo is reproduced in a newspaper or magazine. With a technique sometimes called *synchro-sunlight* photography, an electronic flash used at the camera as a fill light can bring these shadows up to a level that will preserve the detail and improve reproduction quality. (Note that this is one time when a flash used direct from the camera is appropriate.)

The difference between highlight and shadow should be somewhere between one and two f-stops if important shadow detail must be preserved. This difference is known as the *lighting ratio*. If you remember our discussion of f-stops in chapter 2, you'll realize that a difference of one f-stop between highlight and shadow would mean that the highlights are twice as bright as the shadows. This lighting ratio is 2:1. A difference of two f-stops produces a lighting ratio of 4:1.

Here's how to set your auto-exposure flash for use as fill light:

1. Set the camera's controls as if you were making the picture without flash fill, but be sure your f-stop and shutter-speed combination includes a shutter speed that will synchronize with the flash.
2. For a 2:1 ratio, set the flash's exposure system for an f-stop that is one stop *wider* than the one you will use. For a 3:1 ratio, set the flash's controls for a difference of one and a half stops.

At first this procedure may seem a little odd, but think carefully about what is happening. The fill light should be less intense than the main light, so the flash must be set to put out less light than what is already falling on the scene. By setting the flash exposure for a wider aperture than the one in use, you have lied to your flash. Because the flash thinks you are using a wider aperture than you really are, it will put out less light, which is what you want. See figure 6–16 for an example of fill-in flash.

Figure 6–17 A flash unit is a necessity in heavily back-lit situations. The flash becomes the main light, while the sun is an accent light. *(Thom Halls/Fresno Bee)*

You'll notice that the technique can also be used with heavily back-lit subjects, as in figure 6–17. In this case, the flash becomes the main light, because it does the primary job of lighting the subject, and the f-stop on the lens should be the one called for by the flash. When shooting against the sun, particularly early or late in the day, flash lighting such as this is often a necessity.

Mistakes with Flash

One common error with electronic flash is using the wrong shutter speed with a focal-plane shutter. Although slower speeds will work, if you get only half (or

Figure 6–18 On-camera flash at dusk adds to the bizarre nature of this image. *(Steve Lokie)*

less) of the image, you used a speed that was too fast. Another common problem is called red-eye, the red-eyed pupils that you see in some flash photos. The cause is the light from an on-camera flash bouncing off the subjects retinas and back to the lens. Remember what was previously said about reflection of light. The solution is to move the flash away from the lens so the light will reflect at an angle. Turning up the room lights, which causes the subjects' pupils to contract, sometimes helps.

Another common problem occurs when an on-camera flash reflects back to the lens from a shiny background such as the glass in a window or picture frame, or even a glossy, painted wall. Again, place the flash at an angle so the reflection will bounce away from the lens.

Ghosting
An example of ghosting is shown in figure 6–19. This combination blur and stop-action image results when the photographer decides to use flash, yet the ambient light is bright enough to record a separate image on the film. When the shutter speed is slow, the moving subject creates a blurred image, but the burst of light from the flash is about 1/1000 second, which freezes the motion. In this example, the technique was skillfully used to create a feeling of motion, but in many cases the blur is an unwanted distraction.

To avoid this problem, you must increase the difference between the brightness of the ambient light and the flash. Solutions include turning off the room lights, increasing the power output of the flash, or using a higher shutter speed (provided it will synchronize with the flash).

Figure 6-19 By using a slow shutter speed and moving his camera during the exposure, photographer Mike Penn has skillfully used the phenomenon of ghosting to create a feeling of motion. Except for special illustrations such as this, ghosting is something to avoid. *(Michael Penn/Anchorage Daily News)*

Although not usually recommended, direct flash can sometimes add an unusual feeling, as in this photo by Steve Pringle. In this case, the light is as much a part of the image as the arrangement of the subject matter. *(Steve Pringle)*

Summary

Traveling at 186,282 miles per second, light is the photographer's primary tool. Its place in the electromagnetic spectrum is between X-rays and heat rays. It behaves like particles when it strikes film, but acts like waves when it passes through lenses. Because photography literally means "light writing," you must build a visual vocabulary based on this medium and learn what it does to subjects that appear before the camera.

Three important characteristics of light are intensity, quality, and direction. The intensity must be high enough for an exposure. The quality of the light adds emotional values to the image. Hard light, such as bright sunlight, creates sharp lines between highlights and shadows. At the other extreme, soft light, such as skylight, produces diffused divisions between highlights and shadows.

The direction of the light is what creates highlights and shadows, which reveal shape and texture and provide information about the subject's three-dimensional features. One way to sharpen your lighting skills is to practice watching shadows. Light coming from the camera position is called front light, whereas light coming in at 90° to the camera position is called side light. Light that strikes the side of the subject that faces away from the camera is called back light.

In any given scene, there are always two lights, a main light and a fill light. The main light is the one that seems to do all the work, but the shadows are lit by the fill light, which contributes more subtly. Without some fill light, the shadows would photograph black. In the studio, fill is usually added by placing a light near the camera, but in nature, fill light is reflected toward the subject from nearby objects. A third light is sometimes used to accent specific areas of a scene, such as the back light often seen on television news programs.

These lights, main, fill, and accent, can be natural, available, or artificial. Natural light, which comes from the sun and sky, and available light, which is man-made but not under the photographer's control, are the easiest to work with because you need not carry and set up lighting equipment. But since you can't control natural and available light, your task under these conditions is to find the best of what is there.

Exposure with flash can't be measured by regular light meters, so you must figure it out mathematically, use a flash meter or use an auto-exposure flash unit. Be sure the flash's exposure system is set for the film speed in use, and that the f-stop called for by the flash is set into the lens. Most important, be sure the shutter is set to a speed that will synchronize with the flash.

Although the most common placement of a single flash unit is on top of the camera and aimed directly at the subject, this type of flash produces hard, flat light that destroys the all-important shadows. Whenever possible, use bounce techniques, aiming the flash at the ceiling or wall, or take the flash off the camera and hold it at arm's length above the camera so at least some shadows are created.

One time when flash is used on-camera is when it is needed to fill in shadows in bright sunlight. Fill-in flash is easy with auto-exposure units. Just set the flash's exposure control for an f-stop that is wider than the one in use by the lens. Fill flash is particularly needed when important details, such as faces, are in deep shadow.

Because the light from a flash is so brief, you can't see what it is doing, but you'll gain confidence with practice. In the meantime, avoid common errors such as forgetting to use the right shutter speed, using on-camera flash that results in red-eye or reflections from the background, and expecting the flash light to carry more than 25 feet or so.

Chapter 7

Introduction to Color

"Don't overload your picture with color just because you have paid for color. A lot of color does not necessarily make a good color picture."

—Eliot Elisofon

Color in Photojournalism

There is no question that color has become a major element in news publications today. Magazines have been using color for decades, and newspapers have been switching to color as fast as they can afford it. Readers want color, and the discussions about the aesthetic differences between black-and-white and color are somewhat moot in our market-driven business.

But color is more difficult for publications to print than black and white. Changes in color film, prepress techniques, printing presses, and paper stock were required before newspapers could print high-quality color on a regular basis. Although black and white is still the logical starting place for the beginning photographer, knowledge of color is a requirement for anyone who wants a complete understanding of photojournalism.

Light and Color

For a thorough understanding of color, let's start with light. As explained in chapter 6, white light is a mixture of many colors, from red to violet. Chances are you've seen a prism splitting a light beam, or at least, the spectrum created by a rainbow. The idea that white light is a composite of all other colors is important, because much of your control over color is based on removing selected colors from the assortment.

Actually, all colors including white can be created by mixing only three: red, green, and blue. These are the *primary* colors of light. The primary colors are used in *additive* color processes, where three separate, colored light sources are added together to create a variety of colors. You can see a crude example of this additive process in your own home. Turn on your TV and look at the screen with a magnifying glass. You'll see that the image is made up of a series of primary-color dots, which are lit by three separate sources inside the picture tube. When you step back from the screen, the dots seem to blend together, creating different colors as the individual dots change brightness.

Although useful for TV screens, the additive system isn't common in photography today. A much more practical system is the *subtractive* system. Instead of adding from separate light sources, the subtractive method removes unwanted colors from a single white light to produce the final result. Like the additive process, subtractive color is also accomplished with three colors, which are known as *secondary* colors. The secondaries are yellow, magenta, and cyan. By placing filters of these colors over a white light source, specific colors are subtracted from the light, leaving those desired.

Primary and secondary colors work together in pairs known as *complementary* colors. An understanding of complementary colors is useful when reducing a particular color cast in a scene or in a print. Complementary colors are opposite each other on the color wheel in plate 22. A filter in any color on the wheel will allow its own color to pass through yet block its complement.

The Color Wheel

The color wheel mentioned in the last paragraph is useful in solving many color problems, so I suggest you memorize it. The primaries are placed opposite their secondaries around the wheel. When drawing the wheel, I usually start with yellow and move clockwise, using this nonsense sentence as a memory device: Young Geeks Could Be Moose Ropers. That may be dumb, but it works for me. By the way, here's how I remember the complementary colors: General Motors; Race Cars; Burn Yogurt.

As you move around the color wheel, any primary color can be created by combining the two adjacent secondary ones. For example, blue can be created by placing cyan and magenta over the light source. This knowledge will come in handy when making color prints, so keep it in mind.

Color Temperature

Besides the color wheel and its primary and secondary colors, another feature of light important to color photography is *color temperature,* which is a way of describing the predominant color of light. A candle flame or a camp fire is very heavy in red, with a low color temperature. Tungsten light, which comes from the bulbs commonly used in household lamps, is a bit higher, followed by the color of special photoflood bulbs. Daylight could be considered the dividing point between warm light sources and cool ones, such as skylight or electronic flash tubes.

Color temperature is important because your brain compensates for the differences in the color of light, and you won't ordinarily see the changes. But photographic film is not so flexible. It expects to find the specific color temperature it was designed to record. If you use a film designed for daylight conditions under tungsten light, the film will record the scene as orange-yellow. Photos shot under fluorescent light will be a sickly green. You probably have some snapshots in your family album that are off-color because of this problem. See plates 4 through 7 for examples of color temperature.

TABLE 7-1 Light-Balancing Filters

Film Type	Light Source	Filter	Exposure Increase
Daylight	Shade or overcast	81A, 81B[a]	⅓ stop
	Incandescent or floodlights	80A	2 stops
	Photofloods	80B	1⅔ stops
	Fluorescent lights	CC30M or FLD[b]	¾ stop (30M); 1 stop (FLD)
	Vapor lights	CC20 − 50M + 20 − 50Y[c]	½ − 1 stop
Tungsten	Daylight	85A or B	⅔ stop
	Fluorescent lights	FLB	1 stop

[a]The 81A is also used with some studio flash systems when the images are consistently too blue.

[b]The CC30M is most popular with the photographers I know, although the FLD is specifically formulated for best results. In an emergency, you can also use a number 2½ variable-contrast printing filter.

[c]There are many types of lights in use; a test should be run first in critical situations. Many news photographers now shoot daylight-balanced negative film without filtration and make corrections in the lab when printing.

Dealing with Color Balance

The first solution to the problem of color temperature is matching the film to the light source. The most common color film is balanced for daylight, and when this film is used outdoors, colors appear normal. Most of the time you'll use daylight-balanced film, and in fact, that is what you'll get at the camera store unless you ask for tungsten-balanced film, which is designed to record correct color in scenes photographed under tungsten light. This film is useful when you are on an assignment that has been lit by a TV crew, since TV lights are tungsten balanced.

Unfortunately, not all lights fall into daylight or tungsten categories. Some artificial light sources don't emit a continuous spectrum, and if you split the light apart with a prism, there would be an uneven distribution of colors, with some colors possibly missing. Fluorescent and vapor light sources are typical examples. Fluorescent lights are the long tubes found in classrooms, offices, and stores. They are deficient in red, and photos made under fluorescent light have a green cast. Vapor lights are used in parking lots, industrial sites, stadiums, and many arenas. There are a number of types of vapor lights, some of which emit a very narrow band of colored light. The problem in correcting these light sources is that some colors needed for natural-looking images are missing.

Correcting Color Balance with Filters

In some cases, corrections can be made with filters, either over the lens or the light source. To correct such a color shift, use a filter of the complementary color. If you refer to the color wheel, you can estimate what filters would be needed to correct daylight/tungsten mismatches. To tungsten-balanced film, daylight would appear too blue, so the correction calls for a filter that falls somewhere between yellow and red. Daylight film

shot under tungsten light results in an orange cast, which can be corrected by using a bluish filter. When using filters, don't forget to make any exposure corrections required by the filter. (Note: Be sure to use the exposure-increase values in the chart. Light meter readings taken through filters are not reliable, because of differences in color sensitivity between meters and film.)

There are two types of color correction filters: *conversion* filters and *color-compensating* filters. Conversion filters are rather deeply colored and are used to match daylight film to tungsten light and vice versa. The most common are the 80B, which is a blue filter that matches tungsten light to daylight-balanced film, and the salmon-colored 85 filter, which matches daylight to tungsten-balanced film.

Color-compensating filters are more subtle and are used when only a slight correction is needed. They are identified by a series of numbers and letters that indicate color and density. For example, a CC30M is a magenta filter with a density of .30. CC filters are also used to correct color balance in color printing and slide duplicating. The CC30M just mentioned is a handy filter for correcting the excessive green cast caused by fluorescent lights.

Although most filters intended for black-and-white film are made of glass, CC filters are made of thin sheets of gelatin, somewhat like cellophane. Three-inch-square gelatin filters are less expensive than glass and can be cut with scissors to fit as needed.

Because filters can only remove those colors that are excessive, they can't create color where there is none. Some parking lot lights emit such a narrow band of color that they are almost impossible to correct. The chart in Table 7–1 lists filters that can be used for various types of lights. When photographers find themselves faced with narrow-band lights, they usually have little choice but to bring in their own floodlights or flash units.

Color temperature meters can measure the color temperature of a light source, and the data from the meter can be used to determine the filter needed for correct color rendition. Color temperature meters are expensive but useful for critical work.

In practice, photojournalists often shoot color negative films without correction, relying on adjustments in the printmaking process to produce normal-looking results. Although this method is common for the pros, it is risky business for the beginner; experiment first and don't try it on must-have pictures. Keep in mind that some color shifts are so great that they cannot be corrected in the lab. The best results come from solving color balance problems when the photo is taken. When shooting transparency (slide) film, corrections should be made when shooting because this type of film is almost impossible to correct after the fact.

Color Films for Photojournalism

In the earliest days of color photography, film speeds were in the range of ISO 10 to 25, paralyzingly slow for news photography. Speeds gradually increased, and in the last ten years, new technology has produced negative films with speeds up to ISO 3200 and transparency films with speeds of 1600. As a general rule, use the slowest film that lighting conditions will allow. As film speed goes up, grain increases and sharpness and color saturation decrease (see plate 4). Color film can be push-processed but there is always some quality loss. (Push processing is a technique that allows you to use a higher ISO than the film's official rating. See the Appendix for details.)

Positive or Negative

I suspect that clerks at film counters don't get many questions about color balance, but hear instead, "Is this film for prints or slides?" Films that result in prints are negative films, as are the black-and-white films you have been using. Films for slides are reversal films; the slide you hold in your hand is the same piece of film that was in the camera. Both types of film are used in photojournalism, the decision usually being determined by the publication's reproduction methods. Films whose names end in "color" are negative films; those that end in "chrome" are transparency films. Although we often call transparencies "slides," you'll also hear professionals call them "chromes."

By the way, because chromes are the actual film from the camera, there is no backup in case of damage. The emulsion layer is quite fragile, and one fingerprint can prove fatal to a transparency. Protect your photos by keeping them in plastic file pages or holders of some sort. Because chromes are one-of-a-kind items, commercial photographers have collected damages amounting, in some cases, to hundreds of thousands of dollars for lost or damaged chromes. If you are ever entrusted with transparencies from another photographer, handle them with extreme care.

From the photographer's viewpoint, negative films are easier to shoot. Negatives don't need the careful exposure and color balancing when shooting that transparencies require. Exposure variations in transparency films should be kept to about a half stop, whereas negative films can be as much as one stop under- or one to two stops overexposed and still yield a usable print. (Push processing is possible for both films, but there is always a quality loss.) Also, negatives allow you to correct overall color balance and burn and dodge when making a print. When transparencies are used, prints are rarely made; the chrome is sent directly to the production department and such corrections are much more difficult, if not impossible, to accomplish.

The main advantage of color negative films, the control offered when making the print, is at the same time a disadvantage. A color printing darkroom must be maintained, and there must be both time and technical skill available for printmaking. Also, it takes practice for a photographer or editor to evaluate a color negative on the light table. Fortunately, these drawbacks are rapidly being overcome by electronics. Devices are available that can transfer an image from a color negative directly to an editor's computer screen for cropping and color correction, and then to machines that make color separations or printing plates. One example is the Leafax machine used by the Associated Press.

Transparency film, however, reveals its color immediately, so it is much easier for an editor to know how the final image will look. But when shooting transparency film, exposure is critical, and extra lighting such as fill-in flash is more often needed. In the editing process, the original transparency is subject to damage if it is passed around in the production process, whereas a negative can be printed and filed safely away. Some newspapers make black-and-white prints from the transparency to be used just for editing purposes. Although the prints are reversed in tone, they can be used for cropping and so on without risking the original chrome.

Some consumer photo magazines run articles from time to time comparing various brands of color films, the headline usually being a variation of, "Which color film is best?" But all the materials on the market work well, the differences being more a matter of personal taste. Professional photojournalists most often use films made by Fuji and Kodak because of their quality, availability, and reliability. I wanted to include a list of photojournalists' favorite color films here but the market has

changed so much in the last few years that anything I'd say would probably be out of date by the time you read it. (There is an additional discussion of films in the Appendix.) At the moment, photojournalists seem to be using a wide variety of materials, but the brand of film you use is far less important than what you do with it.

Because color can shift in film stored too long or in hot conditions, be sure the film you use comes from a reliable source. If you must store it for more than a week or two, keep it in the refrigerator in its own plastic container. Don't open the container until the film has warmed up to room temperature. And avoid leaving color film in your car on a hot day. Always process color as soon as possible.

Another important note about brands: There is one well-known color transparency film—Kodachrome—that must be processed by a specially equipped lab. Although Kodachrome has been hailed by many photographers as the best color film on the market, its complex processing makes it a poor choice for deadline news. If you have the time to send film off to a lab, try it. Otherwise, stick with films that can be processed in C-41 (for negatives) or E-6 (for transparencies) chemicals. Check the film package for the processing requirements.

Processing Color Film

I don't want to sound like your parents giving you another lecture about being neat and clean, but the chemicals used in color work are much stronger than those used in black and white. I've been in some darkrooms where sloppy workers have splashed black-and-white chemicals all over; this practice must not be used with color. Some color chemical ingredients can cause burns to skin and eyes, and the fumes can be highly irritating. Read the warnings on all packages and take them seriously. Also, color materials are very sensitive to contamination. Everything must be kept clean.

Furthermore, there are many more variables in color lab work than in black and white. To keep these variables under control, be consistent. Chemical mixing and storage, time and temperature, agitation and so on must be kept exactly the same, down to the smallest detail, for consistent, repeatable results. Be extremely careful about the slightest bit of cross-contamination between color chemicals. Also be sure your thermometer is accurate and that developer temperature is held to within a half a degree of the required temperature.

Finally, be sure your chemicals are fresh. Mixed chemicals don't last, and if they have been around for two weeks, start getting suspicious. Film processed in

Figure 7–1　To keep the temperature of color chemicals constant, put the containers in a tub filled with water that is at the correct temperature. If you do much color work, consider buying an immersion heater to keep the water bath up to temperature.

old chemicals can't always be saved, although the consequences of old print chemicals are less severe. It's poor economy in the long run to stretch the useful life of color chemicals beyond the manufacturer's recommendations.

Processing Details

The charts in this chapter summarize the steps for both E-6 and C-41 processing, and are based on Unicolor chemicals, which are convenient and readily available. Be sure to check the instructions packed with the chemicals you plan to use. You may run into shortcut methods used by some news agencies, but until you have some experience, stick with these sure-fire procedures.

Processing temperatures must be kept constant. The easiest way to do this is with a simple water bath, as shown in figure 7–1. Set the flow of water from the faucet to 100° F and let it flow into the tub to preheat the chemicals and processing equipment. Keep the flow going during processing to keep the temperature constant. This may seem like a nuisance, but the temperature of warm developer will drop during processing if the film processing tank is left sitting on the counter. It will take some time for temperatures to stabilize; don't cut corners on this step. When the chemicals are ready, load the processing tank and follow the steps in the chart or the manufacturer's instruction sheet. It seems to me that the emulsion of wet color film is softer and more fragile than black-and-white film, so when hanging it to dry, handle it with the utmost care.

TABLE 7-2 C-41 Processing for Unicolor Chemicals

Step	Time (at 100° F)	Agitation
Developer	3¼ min.[a]	Continuous for first 15 sec., then 2 sec. each 15 sec. thereafter
Blix	6–7 min.	Continuous for first 30 sec., then 5 sec. each 30 sec. thereafter
Wash	3–4 min.	Be sure water changes at least six times
Stabilizer	½–1 min.	Initial 10 sec.

[a]Time increases when developer is reused. See instructions packed with chemicals.

TABLE 7-3 E-6 Processing for Unicolor Rapid E-6 Chemicals

Step	Time (at 100° F)	Agitation
First Developer	6½ min.[a]	Constant for first 15 sec., then 2 sec. each 15 sec. thereafter
Water Rinse	2–3 min.	Six rinses
Color Developer	6 min.	Same as first developer
Water Rinse	2–3 min.	Use film washer
Blix	6 min.	Same as developer
Water Rinse	2–3 min.	Use film washer
Wetting Agent	15 sec.	Gentle

[a]Time increases when developer is reused. See instructions packed with chemicals.

Making a Color Print

Making a color print is basically the same as printing black and white, so I won't repeat the fundamentals that were covered in chapter 5. And because photojournalists rarely need to make a print from a transparency, only negative-positive printing will be covered here. If you'd like to make prints from transparencies, several brands of chemicals and paper are available and the process is fundamentally the same. The important differences are covered in the instructions packed with those products.

Equipment

In addition to the enlarger, easel, timer, and other common printmaking paraphernalia, you'll need a set of color printing filters or a special color printing head for your enlarger. The filters (or the color head) are used to adjust the color balance in the print. Filters are available as either the CC type, which can be suspended under the lens, or the CP type, which are not optically pure and should be used only inside the enlarger between the light bulb and the negative. A set of printing filters should contain yellow, cyan, and magenta filters. Although the colors won't look very deep, you'll discover that they greatly affect the color balance of the print.

Color printing heads have filters built into the light source. These heads are much faster and easier to use than the separate filter packs and are what you would most likely use in professional situations. Filters in a color head are changed with control knobs on the outside of the head.

A voltage regulator is also a valuable accessory. If the line voltage to your enlarger changes during your printing session, you'll find it almost impossible to get consistent results.

Color analyzers are also frequently used. They are sophisticated light meters that can tell you what filter combination to use. When used by an experienced printer, analyzers save time and materials by eliminating or reducing the need for test prints. But analyzers take skill and practice to use. They must be calibrated by the user to read a specific color, such as a known flesh tone or other subject item. If there isn't an equivalent area in the negative being printed, the meter won't give a correct reading. In practice, experts have several settings for their analyzers so they can handle an assortment of subjects. I suggest that you wait on using an analyzer until you have some experience with color printing fundamentals.

Safelights designed for color are available, but quite frankly, they are so dim that they are almost worthless. I find their only value is as a target I can aim for as I grope around in the dark. If you use a processing drum, developing the print can be done with the room lights on, so if you don't have a safelight, don't worry. You aren't missing much.

On the wet side of the darkroom, a water bath to control the temperature of the processing chemicals is just as important in printmaking as it is in color film processing. Use the same technique you used with film to keep your chemicals warm.

You'll definitely want a print processing drum; a light-tight tube in which your paper is developed. With a print processing drum, processing can be done with the room lights on, so your time in the dark is cut to only what it takes to focus the enlarger, expose the print and stuff it in the drum. A motor base is also valuable for agitating the drum consistently from print to print. Be sure the drum sits level on the motor base. Sink bottoms may slope toward the drain, so set up the base and drum on the countertop, not in the sink. In an emergency, you can process prints in a tray, but you'll have to work in the dark and float the tray in a larger one used as a temperature-controlling water bath.

Of course, you'll need the color paper and chemicals. I don't favor any particular brand—they all work well—but the one presented here is commonly available. Keep in mind that changes may have been made after this book went to press, so be sure to check the instructions in your processing kit.

Finally, for checking the color of the finished print, a Kodak Color Print Viewing Kit is a worthwhile accessory.

Exposing the Print

For your first print, make a negative similar to the one in the examples in plate 23. I know it's a boring shot, but you need to establish a standard starting point. If you pick one of your favorite photos, it might have a unique color balance that won't help you find a basic filter pack. Shoot your test negative in full sunlight, being careful to stay away from colored walls or masses of foliage that could reflect light onto your subject and cause a color shift. Because this print will be your test standard, either process the film in freshly mixed chemicals, paying close attention to accuracy, or send the roll to a reliable lab.

With your processed test negative in hand, the first step is to make a test strip. Making a color test strip is similar to making a black-and-white one except that color paper is more sensitive to changes in exposure time. Using the filter data recommended by the instruction sheet that comes with the paper, put the appropriate combination of filters in the enlarger (or set the dials of the color head). Be sure to include the ultraviolet-absorbing filter that is included with the filter set. Make the exposure test by changing the aperture rather than the time. Extremely long or short print exposures can cause unwanted color shifts that could make it hard

Figure 7–2 Four exposures can be made on one sheet of color paper by reversing a black card such as this.

to interpret your test. A series from f/5.6 to f/16 at 10 seconds each would be a good start. A piece of black mat board cut like the one in figure 7–2 will help you make four separate exposures on the same sheet of paper. Just rotate the sheet, placing the open section over a different quarter of the print paper for each test exposure. Keep notes of your exposure times and filter pack.

Put the paper in the processing drum and turn on the lights. Then follow the processing steps packed with the chemicals you intend to use. Because there are a number of variables, including the type of processing device, method of agitation, and time and temperature of processing, a chart of processing times printed here could be misleading. Be sure to follow package directions to the letter. *The main cause of problems and frustration in color printing is inconsistent processing. Be sure your chemicals are up to temperature, that your agitation and processing time are* **exactly** *the same for each print, and that the processing drum is thoroughly cleaned after each print.*

Evaluating the Test Print

When the print is dry, check first for the square with the best exposure. Check highlight areas that should show texture; don't try to make exposure decisions based on shadow areas. As with black-and-white printing, a dark print is overexposed, a light one is underexposed. Then check the midtone areas for color balance. Bright highlights and shadow areas are not good spots to check for color balance because they often take on color casts from the subject or scene lighting.

TABLE 7-4 Filter-Pack Adjustments

Color Cast	Solution
Yellow	Add Y or remove M and C
Green	Remove M or add Y and C
Cyan	Remove Y and M or add C
Blue	Remove Y or add C and M
Magenta	Add M or remove C and Y
Red	Add Y and M or remove C

(Be sure to recalculate your exposure when making filter pack changes.)

Checking color balance is a skill that takes practice. At first it may be difficult to tell the difference between blue and cyan, or red and magenta. Do yourself a favor and use a set of print-viewing filters. To use color print-viewing filters, hold them above the print so the light striking the print does not go through the filter twice, once on its way to the print and then back through the filter to your eye. Move the filter quickly in and out of your field of view so your eye doesn't adapt itself to the change. If the print is intended for display, view it under the same type of light that will be used when it is displayed. Otherwise, use a daylight-balanced photoflood as a viewing light. When you determine which color is too strong, make the change by *adding* that color to your filter pack. Add about half the amount of the viewing filter. In most color printing, changes are made only in magenta and yellow because cyan rarely enters the basic filter pack. Use the chart in table 7–4 as a guide.

An added wrinkle in the process is that changes in the filter pack also change print exposure. The filter set you use should contain an exposure calculator or chart. Note your changes and make another print.

An important point: Never use a filter pack containing all three colors, yellow, magenta, and cyan. These three add up to neutral density, which will needlessly extend your exposure time. Eliminate the filter with the lowest value by subtracting that value from the other two as well. For example:

Your pack:	30Y	20M	10C
Remove 10 from each:	−10	−10	−10
New correct pack:	20Y	10M	0C

Local Control

You can burn and dodge color prints, but if taken too far, you'll get abnormal color shifts. Also, too much dodging makes dark areas look gray and washed out. You can use color filters as dodging tools to correct color in local areas of a print. If, for example, a print looks fine but the face is too magenta, use a small piece of magenta filter material as a dodging tool for about one-third of the print exposure time.

Once you have a basic filter pack for your test negative, jot it down. Because each batch of print paper is slightly different, you'll use your basic pack to quickly determine the adjustments for the new paper. Also, pros keep files regarding filter packs that work best when printing shots from particular locations so they can make a color-corrected print more quickly.

If you have a tight-deadline assignment coming up, try to shoot a test roll at the assignment location and make a color-corrected print ahead of time to help you find the right filter pack and reduce the reprinting when minutes count.

Black-and-White Prints from Color Negatives

One big advantage of color negative films is that black-and-white prints are easy to make if the editors decide not to use a shot in color. Kodak makes a special paper, Panalure, that works quite well, and Seagull has one called RP Panchromatic. But because these papers are panchromatic, you must use them in total darkness. Some photographers are satisfied with the results from ordinary variable-contrast paper, but the black-and-white rendition is slightly distorted because of the limited color sensitivity of the paper. Blues print too light and reds print too dark.

Tips and Techniques for Advanced Photographers

The problem of matching the color of the light to the color balance of the film can be compounded when you need to mix two different light sources. You are most likely to face this situation when you need to combine flash with fluorescent or some other artificial light source. For example, suppose you are in a room lit with fluorescent light and you want to use a flash as a fill light. These two sources are quite different in color. If you shoot daylight-balanced film without a filter, the flash will be correct but the fluorescent light will be green. And if you shoot with a filter to correct the fluorescent, the flash will be too magenta. The solution to this problem is to filter one of the light sources so they are both the same, and then use a filter over the lens if necessary to match the pair of light sources to the film. Put a green filter, such as a Rosco Tough Plusgreen, over the flash to match it to the fluorescent light, and then use a CC30 magenta filter over the lens to take out the green

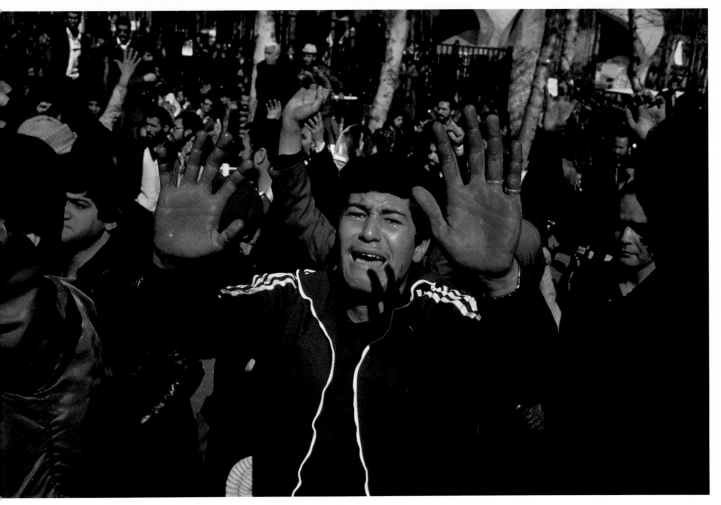

Plate 1 A Shiite after dipping his hands in the blood of a "martyr" killed by the Shah's troops, Tehran, January, 1979. This well-known shot by David Burnett owes much of its success to the dramatic interplay of the bright red blood on the man's hands against the muted tones of the background. In black and white, the image would be only one-tenth as effective. *(© 1988 David Burnett/Contact Press Images)*

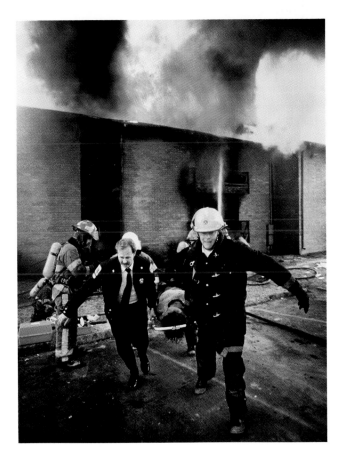

Plate 2 Five people died in this apartment-house fire. While the drama of the moment would hold up well in black and white, the flames would appear white and a certain level of intensity would be lost. The rescuers' faces and hats are balanced against the red flames, while the rest of the image is muted. Look at any of these images through a strongly colored filter (such as a 25A deep red) for an idea of what they might be like in black and white. *(Charles Bertram/Lexington Herald-Leader)*

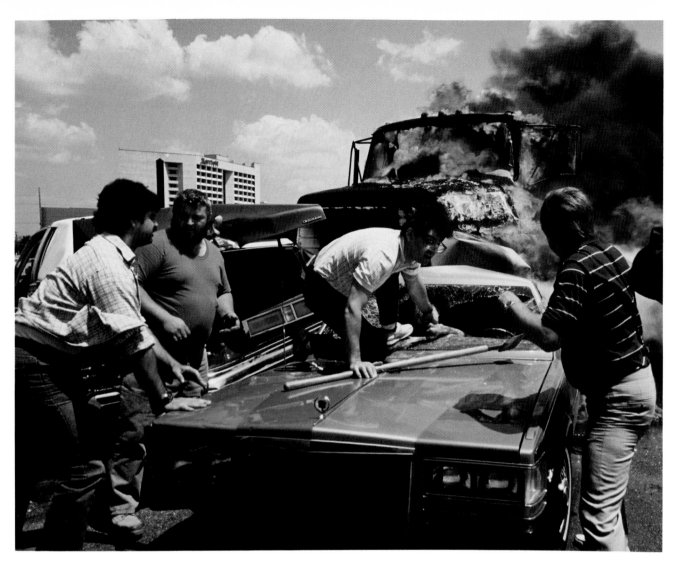

Plate 3 Photographer Ricardo Ferro said the flames were so hot the victim was stuck to the car's melted upholstery. The trapped man was freed with seconds to spare. While flames always jump out in a color photograph, it is the bloody arm just visible in the broken windshield that is the visual exclamation point for this image. To be successful, the shot also has to run large enough so the arm can be readily seen. *(Ricardo Ferro/St. Petersburg Times)*

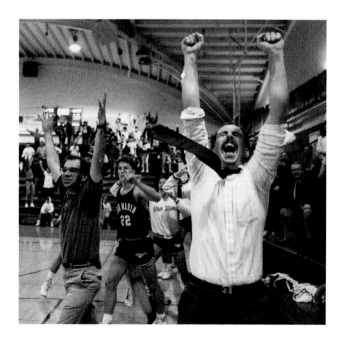

Plate 4 Photographer Robert Tong said this gym is a difficult one in which to shoot due to poor lighting, a typical situation in high school gyms. He had to push ISO 1600 Fujicolor film to ISO 3200. The low color saturation and increased grain are caused by the color balance of the gym lighting combined with push processing the film. *(Robert Tong/Marin Independent Journal)*

Plate 5 This image is hard to look at because the somewhat clinical aspect of seeing the man's wounds in color increases the pain we see on his face. The image ran full-page in the paper's Sunday magazine, and photographer Patrick Sullivan said readers did not object. Sullivan used color-negative film for this burn center story because of the different light sources in various parts of the hospital. Negative film eliminated the need for careful filtration when shooting, since color corrections could be made at the time of printing. *(Patrick Sullivan/ Kansas City Star).*

Plate 6 For a story on a military school, Rick Rickman photographed in this dorm under a warm-colored tungsten light and used a flash fill near the camera. The flash, which is almost the same color as sunlight, kept the face of the boy in the foreground from being too yellow. However, Rickman let the rest of the scene record slightly yellow to add to the mood. A slow shutter speed allowed the background to expose properly. A slow shutter speed combined with flash is a common technique in color photography. See also Plate 13. *(Rick Rickman/The Orange County Register)*

Plate 7 Late afternoon sun is quite warm, while the shadows are blue. You can see this difference by comparing the highlight and shadow areas on the girl's shawl, the fence, and the barn in the background. Many magazine photographers such as Jim Brandenburg prefer to shoot early or late in the day, avoiding the noon hours, in order to take advantage of the more dramatic light. *(© Jim Brandenburg)*

Plate 8 Mike Penn found this scene during the Iditarod dog-sled race in Alaska. Notice the lens flare to the upper left and lower right of the sun. The star-like rays around the sun are also the result of flare. *(Mike Penn/Anchorage Daily News)*

Plate 9 Color is not always best. Photographer Tony Bacewicz felt the black-and-white version of this shot had more impact. In color, the people tend to blend into the background. *(Tony Bacewicz/The Hartford Courant)*

Plate 10 Wildlife photography is much more difficult than you might imagine. Telephoto lenses, patience, and a thorough knowledge of the animal's behavior are prerequisites for success. Mike Penn captured this grizzly bear fishing in Alaska's McNeil River. *(Mike Penn/Anchorage Daily News)*

Plate 11 As explained in the text, don't try to pack your color photos with every color in the rainbow. Sometimes a limited palette approach is best. This monochromatic image was made with the last light at the end of a dreary winter day. Pat Davison said he was experimenting with grain and made the photo on Fujichrome 1600 film pushed to 3200. An approaching storm and a little of Davison's breath on the lens added to the effect. *(Pat Davison/Albuquerque Tribune)*

Plate 13 A small hand-held flash unit was aimed through the windshield for this family portrait. Rick Rickman used a slow shutter speed to also allow the background to expose. The blue in the background is due to late-afternoon shadows. For another example of flash combined with ambient light, see Plate 6. *(Rick Rickman)*

Plate 14 Here is a third example of flash used with ambient light. In this case, the camera's aperture and shutter speed were set so the background would be about one f/stop underexposed, then the flash was set so it would expose the model correctly. A shutter speed that will synchronize with flash must be used. See chapter 6 for more details on flash. *(Mike Penn/ Anchorage Daily News)*

Plate 15 Rita Reed said she needed an illustration to go with a story on chocolate. "Lots of ideas came and went," she said. "None ever seemed good enough. Three elements were needed: first, chocolate displayed center stage in all its beautiful tempting glory; second, symbolism for richness, decadence, and maybe even a touch of evil; third, bold, simple graphics." She had been struggling with ideas when she awoke at 6 A.M. and said out loud, "Original sin, I need a snake!" She went through three boas and a python before she found this milk snake. The main light is coming from a soft box to the right and slightly behind the spoon, a second box was used for fill, and a third light adds a highlight to the front rim of the spoon. *(Rita Reed/Cedar Rapids Gazette)*

Plate 16 Brad Graverson's original idea was to make a map from corn and paint the flag on that. That idea was rejected as too time-consuming, but this version took several evenings and about a dozen ears of corn. The painted ear was inserted in husks from another ear, a difficult task since the elements were so fragile. The main light is a soft box placed to the camera's right, while another light covered with an orange gel was placed to the left as an accent. Type ran in the upper left and along the right side. *(Brad Graverson, reprinted with permission of The Daily Breeze)*

Plate 17 For food and small products, backgrounds are an important part of the image. Here, the pizza was set on a plastic panel from a ceiling light. The panel was supported at the ends so a spotlight could be aimed at the underside to create the red accent. *(Rick Rickman/The Orange County Register)*

Plate 18 When creating illustrations, try to come up with visual equivalents of the concepts in the article. This illustration was created for a story on Guillain-Barré syndrome, a neuromuscular disease. Gary Chapman knew he was successful when a patient said that's exactly what she felt like. See figure 11–14 for a view of the set-up. *(Gary Chapman/Louisville Courier-Journal)*

Plate 19 When Rick Rickman went to photograph this scientist and his particle accelerator, he found the machine stuffed in a cluttered room in the basement of the building. Too large to move, the only way he could photograph it and reduce the visual confusion was to turn out the room lights and set up his own. The main light is at the right of the camera. The light on the left background was covered with a blue gel. Rickman also noticed a portrait of Einstein in the hallway at the right and lit it with a small strobe. By using colored gels over accent lights as Rickman did, you can often salvage some potentially disastrous situations. *(Rick Rickman/The Orange County Register)*

Plates 20 & 21 These two images were made with a Sony electronic camera by a *USA TODAY* photographer. Although the images are not as sharp as those made by conventional means, they are acceptable when deadlines are tight and logistics prevent the use of conventional darkrooms. See Epilogue for a complete discussion of electronic imaging. *(Robert Deutsch/USA TODAY; Copyright 1988, USA TODAY)*

Plate 22 The color wheel. The primaries are red, green, and blue, while the secondaries are yellow, magenta, and cyan. See chapter 7 for a complete explanation. *(Reprinted courtesy of Eastman Kodak Company)*

Too red

Too magenta

Too yellow

Normal

Too blue

Too green

Too cyan

Plate 23 These color prints were made with varying filtration. Compare your results with these examples. Many beginners confuse blue with cyan and red with magenta. When checking color balance in prints, be sure to use print-viewing filters and a daylight-balanced light source.

of both the flash and the fluorescent. Check a well-stocked camera store for Rosco filter material. To balance flash for tungsten light, cover the flash head with an orange filter such as the Roscosun 85.

Here's a tip that should only be used with caution—you'll rarely have time for this technique in a news situation, and that's not the place to take risks anyway. But you can change the color saturation of your photo by making subtle changes in exposure. Transparency films work particularly well for this purpose. By slightly overexposing transparency film, you can decrease color saturation. A slight underexposure increases the intensity of the color. When experimenting with this technique, bracket your exposures. Shoot two on the overexposed side, two on the underexposed side, and one at the meter's recommendation, changing the aperture by increments of one-third. Then compare your results.

Making a Quick Print from a Chrome

The best way to make a black-and-white print from a chrome is to copy the chrome with a slide-duplicating attachment fitted to your camera. For shooting the copy, a fine-grain film is best, but for newspaper work, trusty old Tri-X will do. In an emergency, I have seen photographers just put the chrome down on a light table and shoot it with a macro lens on the camera. Dust on the transparency will show up as black specks in the final print, so be sure the chrome is clean.

If you need only a quick print for yourself or an editor to check, just put the chrome in an enlarger, print it on ordinary black-and-white paper and accept the reversal image that will result. If you're in a hurry for a positive, first make a print in the ordinary way. Because its tones will be reversed, this print can be used as a full-sized negative and contact-printed on another piece of paper to create a positive image. If time is short, don't bother to wash and dry the negative print, just put an unexposed piece of paper in the print wash tray and sandwich it with the negative print under the water, which should insure even contact. Then expose the pair as you would a contact sheet. Sometimes the paper's brand name is incorporated in the paper's backing; if so, it will show in your final positive. To avoid this problem, find a brand not marked in this way.

Communicating in Color

Before we leave the topic of color, I should suggest a few thoughts about what color does to the photographic image. When shooting color, most photographers say they use different thinking than when they shoot black-and-white. Arthur Rothstein, who made some of the best-known documentary photographs of the Great Depression and was director of photography at *Look* magazine, said:

> Compared to color photography, shooting in black and white is simpler in some ways, but far more complex in others. The photographer who works in black and white must learn to disregard color and evaluate his subject in shades of gray. He emphasizes contrast, shapes, lines and texture. Through the use of filters he can darken skies or create dramatic impressionistic effects. The black and white photographer thinks of color in terms of its transformation into gradations of light and dark. A good black and white photograph may be more exciting for the viewer than a color photograph of the same scene, because the viewer's imagination must provide missing color information. The essence of a picture may be more easily understood in black and white without the added and sometimes confusing qualities of color. For example, a slum in color may become more aesthetically pleasing than pitiable.
>
> The approach of the color photographer is decidedly different. Far from disregarding color, he is very conscious of its attributes. He develops an eye for color which is sensitive to shifts in color intensity, brightness, and saturation. He develops an appreciation for color harmony and the psychological effects of color. The photographer often will use great restraint and selectivity in creating a color image. He discovers that in a color photograph contrast results from the colors themselves rather than from the tonal value differences or minor changes in lighting.[1]

The psychological effects of color that Rothstein mentioned are possibly the most difficult part of color photography to understand. So much of the interpretation of color depends upon context and cultural definitions that generalizations are hard to make. Standard classifications divide colors into two groups: warm colors such as earth tones, reds, yellows, orange, and white, and cool colors, such as green, blue, violet, and black. Warm colors are said to advance, and cool colors are said to recede.

We can also assign certain emotional characteristics to colors. For example, red is usually associated with danger, violence, and hate. Red is also a political color, and the color of fire and war. Green is a calm color. Ideas associated with green include coolness, freshness, nature, and growth. Like green, blue is also a cool color. Blue is associated with depth, water, height, truth, and distance. Many more associations exist, but it is important to note that many of them are culturally based. In some parts of the world, white is a color of mourning and death, whereas black is that symbol elsewhere. Royalty is often associated with deep reds and gold, and certain colors are often connected with specific religions.

But skillful use of color in the photograph must go beyond the full-spectrum assortment found at the county fair. It's not unusual for photographers who are just starting to work seriously in color to look for a variety of color in every image. But this approach is not always best. I remember when a misguided printer demanded that a headline be run in red over a cemetery shot of mine that was limited to misty greens and the greenish-white of the headstones. Every color photo, he said, should include at least some red. Unfortunately, I wasn't in a position to overrule him.

Color for Color's Sake?

I've heard photo editors get rather emotional over this topic, particularly those who went through the introduction of color in their papers. Some have had publishers who, like the printer who ruined my cemetery photo, demanded that there be a full color photo on page one every day, and if the photo didn't have lots of colors in it, heads would roll. Skilled editors are past the novelty of color in their publications and understand that they shouldn't run a color photo just because it is in color any more than they should run a paragraph just because the writer used a few nifty words.

But just as the geometry of the composition is an integral part of the photo, color can't be divorced from the image. Color contributes its share just as the lines and shapes of an image add their statements. The photo by David Burnett in plate 1 owes much of its success to the redness of the blood on the man's hands. In black and white, the hands could look like they had been dipped in motor oil.

But sometimes, the reality of color is too strong. When the *Reno Gazette* printed a color photo of a suicide victim who had shot himself on a public sidewalk, the shock of the blood on the pavement was more than some readers could bear. Perhaps readers could have accepted the photo in black and white, where the color of the pavement and the blood would have been the same indistinguishable shade of gray.

And for the photographer, composition in color becomes more complex, because the elements and principles that will be discussed in the next chapter are modified by the colors of the image. On the one hand, the black-and-white image is somewhat abstracted from reality. By presenting its information only in shades of gray, certain emotions and moods are strengthened. Because the event has already been taken out of its time context and the viewer can't experience the other sensory stimuli that were part of the scene, removing the color keeps the viewer's attention focused on the most basic level of imagery. It is, as Wilson Hicks says, an independent reality.[2] See plate 9 for an example.

But on the other hand, Hicks points out that color can produce its own interpretive result, through variations in exposure or filtration, for example. The special colors of a gray morning, or the warm late afternoon sun can be altered subtly by slight changes in exposure. (Be sure to check the cutlines accompanying the other plates for additional thoughts on this topic.)

We must remember that, as Adam D. Weinberg has suggested in a commentary on color photojournalism,[3] color itself should not *be* the subject. A documentary photograph should not exist solely for the purpose of its beautiful color. You don't necessarily want to see the color first, for its own sake, but as an integrated part of the message. If the color is only an innocuous element, fine. But when the color becomes the photo or works at cross-purposes to the rest of the image, problems begin.

Summary

Modern photojournalism has become a color medium. The classic black-and-white news photo is seen less and less as improved technology lowers the price and production time required to print color.

Color actually begins with light. White light is a mixture of colors, three of which are the primaries red, green, and blue. The three secondaries are yellow, magenta, and cyan. Any color on the color wheel can be blocked by a filter of the color opposite it on the wheel. These opposite pairs are known as complementary colors. An example of using complementary colors is when shooting a scene that has a color shift, possibly due to an off-color light source. By using the complementary color as a filter over the lens, the scene can be color-corrected.

Another quality of light is color temperature. Low-temperature sources are warm ones, such as candle flames and household light bulbs. As the light source becomes more blue, its color temperature increases. Light from the sky, for example, is very cool and has a high color temperature.

Color film is made to produce correct color rendition under certain color temperatures, specifically those of daylight or tungsten. When daylight-balanced film, for example, is shot under any other type of light, a color shift will probably be noticeable in the image. But by placing a correction filter over the lens, these color shifts can be neutralized. For example, a CC30M magenta filter works well to correct the green cast of fluorescent lights.

When deciding whether to use either negative or transparency films, check the requirements of the publication you're shooting for. When transparency films are processed, the result is a positive image on the film,

known as a slide or a chrome. In photojournalism, this image is the one sent to the printer. Negative (print) films are usually printed before being sent to the printer, although technical improvements at the printer's end of the process may soon make printmaking unnecessary.

When processing color film, be clean and consistent. Small errors that were tolerable when processing black-and-white may cause trouble in color work. Extra care is even more important in color printing. When making a print, start with the filter pack that worked well with your test negative, and make changes from there. When evaluating your test print, find the correct exposure first, then judge color, being sure to use print-viewing filters until you gain some experience. Remember, to correct a color shift in a print, *add* that color to your filter pack.

Black-and-white prints can be made from color negatives. For best results, use Panalure paper, which must be handled in complete darkness.

In photojournalism, color should not become the photograph. Color can add to the message, but it can also take away from it. Remember that the photojournalist's job is to tell the story visually, using all tools available. Although color is one of those tools, it is rarely the story by itself.

Endnotes

1. R. Smith Schuneman, ed., ''The Editor-Photographer Team,'' in *Photographic Communication: Principles, Problems and Challenges of Photojournalism* (New York: Hastings House, 1972), 94–95.

2. Wilson Hicks, *Words and Pictures: An Introduction to Photo-Journalism* (New York: Harper & Brothers, 1952), 140.

3. Adam D. Weinberg, *On The Line: The New Color Photojournalism* (Minneapolis: Walker Art Center, 1986), 42.

Part III
Techniques

Leukemia victim. *(Sarah Fawcett)*

Chapter 8

Composition: Arranging the Image to Communicate

"Composition is merely the strongest way of seeing."

—Edward Weston

Composition: A Photographic Language

Composition is the way the parts of the picture are arranged. It is a way of clarifying the image, of recognizing visual problems and correcting them. It is a means toward clear, concise communication that will leave no doubt in the reader's mind about the intent of the message. Your goal is to present the information in a visual order that is easily understood, gets to the point quickly and excludes distractions.

And because composition is considered when making the print as well as when taking the picture, it is the closest thing you have to a rewrite. But, unlike a rewrite, you are limited to selection and elimination; you cannot add something that was not on the negative originally. When shooting, you can change only angle, lighting, lens, and the moment of exposure. In the lab, you are limited to cropping, and burning and dodging for emphasis.

Eliminating distractions is important, because photography is a medium of exclusion. The frame can include only so much, even with the widest lens, and your task is to decide what to exclude as well as what to include. As a sculptor goes to a block and eliminates everything that doesn't look like the subject, you must go to reality and eliminate everything that doesn't contribute to your story. Deciding what to cut is as important as deciding what to keep.

Photojournalism is also like a hunt—you are looking for the picture that is already there. Whereas the painter can invent anything he needs for his picture, you can work only with existing raw materials. If the painter doesn't like the telephone pole, it is a simple matter to leave it out. And if a basket of fruit is called for, he has only to direct his hand to create one on the canvas. But you must find your best image in what already exists.

Composition Is Intuitive

Composition is difficult to discuss, because it is a part of a visual language that isn't easily translated into words. Just as certain idioms in one verbal language can't be translated into another, some visual ideas are understandable only in visual terms.

Edward Weston, quoted at the beginning of this chapter, knew that composition is intuitive. It resists categorization, and there are so many examples that seem to go against any advice that I can give, that I present the tips here with great caution. Every picture is a different case, and the features that make one picture work may contribute to the failure of another.

Don't get into a trap of making formula pictures. Keep in mind that composition is a tool to help tell the story, not an end in itself. Beware of falling in love with dramatic graphics that end up overriding journalistic content. An example of this failing is figure 8–1. There

Figure 8–1 This photo depends on its graphics. Good photos should have strong graphics, but should not rely on graphics alone. *(Glenn Moore)*

is no doubt about the strong design in this image. But in spite of that, there is little other information for the reader. The ideal is when the composition—the graphics of the image—is consistent with the subject matter and adds to, but does not override, the message.

Every factor in composition interrelates. None of the features discussed here operate alone, and there is almost always a compromise. The best angle may be the worst light; the perfect balance may include a terrible background.

And finally, although any technique or device poorly used can become a cliche, you must start somewhere. Try these ideas. They will serve you well while your vision develops, and you'll soon move on to other approaches. Because composition is an intangible concept, there is no ultimate right or wrong approach. The answer is always in the photo. If it does its job, it is successful.

Camera Vision vs. Human Vision

Before we look at composition, it is important to understand the differences between the camera and the eye. Many problems that arise in beginners' photos are because beginning photographers haven't yet learned to see the way the camera sees.

The camera has a much narrower field of view than the human eye. You may have taken a peripheral vision test in a drivers' education course and learned that some people can see almost 180° from side to side (of course, parents and teachers can see 360°). But only the widest of wide-angle lenses have that field of view. As you saw in chapter 4, the commonly used 24mm wide-angle lens has a field of view of 84°, whereas a normal focal length lens has a field of view of 46°. So keep in mind that you will see things at the edges of the scene that the camera will not.

But although the field of view of the camera is narrow, it is sharp all the way across. Try this: Touch your thumbs together and hold them up at arm's length in front of you. Then look at them through one eye. Look at just one thumb, but be aware of the other thumb. How much detail do you see in that second thumb? Now move that second thumb about 6 inches away from the one you're focused on and see how much detail you can discern. But, if you replaced your eyeball with a camera, it would record both thumbs equally sharp and detailed. It is amazing to think that we perceive so much even though our field of sharp, detailed vision is so limited. That saying, "Seeing out of the corner of your eye," is an important talent for a photojournalist.

Part of the reason we see so much despite a limited field of sharpness is because our eyes are constantly scanning our field of view. And this scanning action is another difference between the camera and the eye. What we see is presented to us in a piecemeal fashion, but the camera takes in the whole frame at once.

You can also be fooled by your three-dimensional vision. Hold up one thumb and look at it with both eyes open. Hold your thumb about 18 inches from your eyes, and be sure there are some background objects about 10 feet beyond. While looking at your thumb, you should see double images of everything in the background. These double images may be hard to perceive, because your brain has learned to block out visually confusing signals. Now, with the other hand, block the vision of one eye. What happens to the background? It becomes clearer. The objects there are now distinguishable, even though they are out of focus. This two-dimensional view is what your camera sees, and the background now becomes an element to be dealt with. Light and dark, overlapping planes and the like impinge upon your subject. Unless they are so far out of focus that they are totally obliterated, background details become an important consideration. You learned how to control backgrounds by changing depth of field in chapter 4, but even fuzzy backgrounds become a compositional element.

This issue of the background is also affected by another camera/eye difference. Your eye is connected to a brain that is constantly interpreting incoming messages. The things that you aren't interested in are dropped out; thus, you don't notice a tree that looks like it is growing out of someone's head, or a clothesline that appears to be running through someone's ears. The camera, however, takes a narrow image out of the context of the rest of the scene and presents it to us without interpretation. All parts of the image along the plane of focus are given equal emphasis, yet the other stimuli, sounds, smells, the feel of the breeze, escape the lens.

If you have ever taken photos during a trip to a scenic spot, you probably have experienced this information loss. The pictures just don't capture the grandeur of the scene. Yes, the colors and details are there—the blue sky, the snow-capped peaks, the lush grass surrounding the lake—but something unidentifiable is missing. That something is the context, with all the other stimuli.

But degradation of the experience is not the only type of distortion that can occur. The photo can sometimes improve upon reality. Look at the products advertised in catalogs and magazines and see if they look that exciting when you get to the store. Does the flaw lie in the photograph or the store display? Perhaps our visual perception is clearer when not distracted by other stimuli.

In his classic essay "What Is Photojournalism?"[1] Wilson Hicks elaborated on this idea with the example of a person being chased by a bull. What that person saw at that moment would probably be quite different from what a camera would show. The person was emotionally involved and his perception of the event was colored by his participation in it, whereas the camera would see the event without emotional involvement. The camera would take a moment of time out of the continuum, and separate it from all other stimuli of the moment. Would that be an accurate depiction of what happened? Some people say the camera never lies. Is your high school senior portrait an accurate representation of who you really are?

One more difference to mention is color. Even the best color films available do not have the color sensitivity of the human eye, and in fact, some of the most popular color films are designed to produce more intense colors than existed in the scene. (This enhancement resulted from filmmakers' marketing studies—people want color photos that fit their memories and

Figure 8–2 The figure is easy to find in this photo, but the field is equally important. *(Lane Turner)*

expectations, which are not necessarily in line with reality.) And when shooting in black and white, we are presented with a view that the eye has never seen on its own. Of course, these aren't the only differences between the camera and the eye, but they are perhaps the most important and will aim us toward Weston's "strongest way of seeing."

Elements and Principles of Composition

Every factor in composition depends upon and interacts with every other factor. And they interrelate so closely that the image should be taken in as a whole. But in order to talk about it, we must find some way to create parts within this tightly woven unit. In a very thorough book about this subject, Ben Clements and David Rosenfeld divided composition into two areas: elements and principles.

> In a sense, the qualities of the elements (not just the terms) are the vocabulary of visual communication, just as words are the vocabulary of verbal communication.

> . . . Shapes, lines, textures, and volumes used in combination are capable of supporting each other for increased effectiveness. Unless they are directed by an organizational premise, the artist's idea may fail to make its point. The principles, contrast, rhythm, dominance, balance, and unity, are the operational process the artist uses to bring all the design elements together into a harmonious combination. The whole process—selecting elements that express the idea and arranging them in relation to the principles—is pictorial composition.[2]

Because all these factors interrelate, their meanings are dependent upon how they combine with each other and the message content of the subject. What works in one situation may not work in another.

Figure, Field, and Space

The figure, sometimes called positive space, is the thing you usually look at. In figure 8–2, the figure should be obvious. Your eye goes quickly to the child and the jet of water. But the field, which is sometimes called the negative space, is the area in which the figure exists.

Figure 8–3 Space is an important element in composition. Try cropping out the top of this image by laying a piece of paper on it and you'll see that the space is necessary. *(Roger Jerkovich)*

Too often, beginners' awareness of space stops at the figure—get the subject into the viewfinder, don't cut off the head, and press the button. But the negative space, the space *not* occupied by the subject, is also important. In figure 8–9 the negative space above the two people creates the feeling that they are alone on a cold, dark night.

Space influences a photo in subtle, yet important ways. Lay a piece of paper over the top part of figure 8–3 and you'll see how that space is important to the image. The arrangement of space is a key to the cohesiveness of the image.

The Elements

Line is the fundamental element of composition. Lines mark the edges of shapes, provide clues for motion (or lack of it), and suggest subtle conceptual meanings.[3]

A straight vertical line is often associated with ideas of power, strength, rigidity, height, and, on a two-dimensional piece of paper, depth. Horizontal lines suggest calmness, passivity, breadth, weight, finality, and distance. Angled lines suggest motion and strong action, whereas curved lines are associated with grace, beauty, love, and nature. A commonly discussed curved line is the classic *S* shape, which is said to be the most beautiful kind of line. Jagged lines indicate tension, anger, confusion, and chaos. Notice the strong lines in figure 8–4.

Lines can also be an implied alignment of objects. Several things in a photo can work together to create a line. In figure 8–5, you can see a line created by such an arrangement.

Lines also delineate shapes. Circles, triangles, and rectangles are common shapes which, in photographs, usually represent three-dimensional objects, such as cylinders, pyramids, and spheres. Shapes have meanings similar to those of line, but as with all these concepts, the exact meaning depends upon context.

Shapes are revealed by light, which creates tone. Tones of light and dark can make surfaces seem to protrude or recede, and through these clues we gain an understanding of the third dimension and spatial orientation. In the chapter on light, I explained how light and shadow carry three-dimensional reality onto two-dimensional paper. Highlights and shadows tell us about the surface features of the subject. Tone also becomes a part of the principle of emphasis (which will be discussed below), because objects that are radically different in tone will stand out.

Light also shows texture, which, as I've said before, is an important tactile indicator. And although the texture you might think of most often is one you can feel with your fingers, there is also the large-scale texture of a corn field as seen from the air, or the texture of distant hills. These large-scale textures are purely visual, but they are just as important to a successful visual image as timbre is to musical expression. Remember that texture is not only the roughness of weathered wood or a brick wall. It is also smoothness. There is always texture; it is just a matter of type.

Figure 8–4 Lines are a fundamental element of composition. One of the key features of this photo is its strong lines. *(Glenn Moore)*

Figure 8–5 There is a strong diagonal line created by the faces in this photo that extends down to the woman's hands. Notice how the jagged lines in the background contrast with the round lines in the faces and the woman's glasses. This photo was made in 1939 by Dorothea Lange as part of the FSA project to document the plight of people displaced by the Depression. *(Dorothea Lange/Courtesy of Library of Congress)*

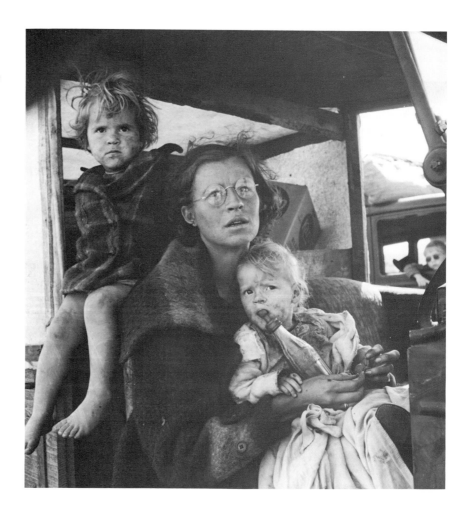

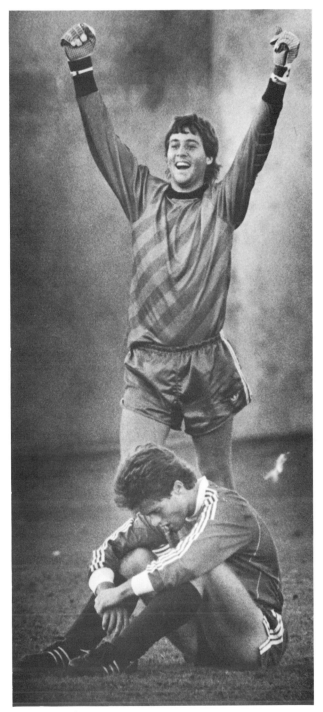

Figure 8-6 The winner and the loser. A contrast of moods. *(Gary Kazanjian)*

The Principles

The elements of composition—line, shape, tone, and texture—are the building blocks for every image. They will be there in some form, perhaps clearly visible, or perhaps working quietly in the background. The manner in which they combine leads us to the syntax of visual communication, the principles of composition: contrast and variety, rhythm, emphasis or dominance, balance, and unity.

I like to think of photographic composition as having many parallels to music. The elements we have talked about are like the musician's notes. The principles are how those notes are put together, including the harmony, the tempo, the key, and the dynamics of the piece.

Contrast and variety work like the various instruments in an orchestra. This kind of contrast is not the type we discussed in the chapter on darkroom technique. This principle is a contrast or variety in shapes, tones, moods, or content. For example, in figure 8-6, there is a strong contrast of mood between the winner and the loser. The two are opposites that generate variety and interest. In figure 8-7, the contrast is one of size.

Rhythm is the visual percussionist. And although the percussion section in the orchestra maintains the tempo, its contributions are far greater. So are those of visual rhythm. The beat need not be symmetrical. Just as there are snare drums, bass drums, cymbals, and such that create musical rhythm, visual rhythm also has different instruments. And a given instrument may only sound one note in the photo. In figure 8-8, there are a lot of little beats but only a few big ones. Some photos don't have any repeats at all, but are more like a musician's improvisation or chance composition—a John Cage piece for example. Yet despite the apparent randomness, there is some underlying feeling that ties the whole thing together.

Emphasis is the visual crescendo. It is the theory behind the focal point we will discuss. Emphasis is created by combining the elements so that one object or area dominates. And, as with music, there may be secondary emphasis. But emphasis does not necessarily refer to the largest object in the image. As figure 8-9 shows, a small area can have a big impact, just as the drummer's triangle can when the entire orchestra pauses for it.

Emphasis is also energy flow. This idea can be rather abstract, but every photo has real or implied energy flowing within or out of it. In many cases, the energy is easily connected to the action, as in figure 8-10. Here, the energy flows away from us from right to left, with an interesting counterpoint created by the curve of the dog. In some images, the energy flow is suggested by the arrangement of the objects. As with space, energy flow must be carefully considered when cropping an image. Room for energy flow should be either provided or denied after careful consideration of the consequences.

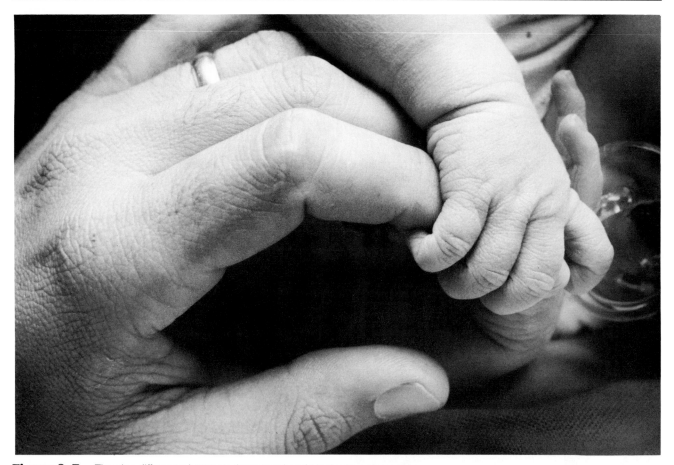

Figure 8–7 The size difference between these two hands is the key element in this photo. *(James Skovmand/Union-Tribune Publishing Co.)*

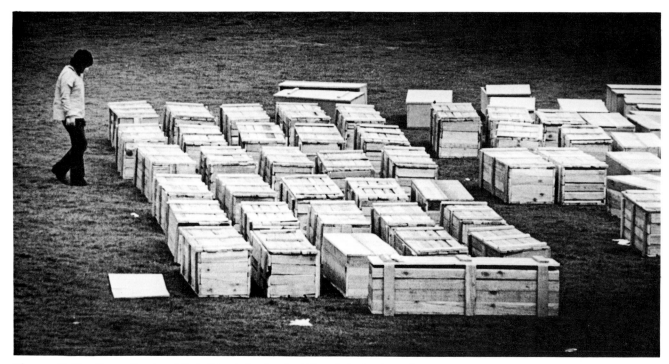

Figure 8–8 The rhythm is subtle in this photo of makeshift caskets lined up after the 1986 earthquake in Mexico City. *(Lane Turner)*

Figure 8–9 If you shout too much, nobody will hear you. Although the main emphasis in this photo is a small area, it is quite effective. *(Gary Kazanjian)*

Figure 8–10 The energy flow in this shot is easy to find. The slight tilt to the frame and the dog make the shot sing. *(Kristy MacDonald)*

Figure 8–11 When both sides of an image are equal, it is symmetrically balanced. *(John Walker/The Fresno Bee)*

Balance is an idea that has been discussed, praised, and discredited by any number of photo critics. When discussing balance, the classic examples come from the chemist's scale or playground teeter-totter. If both sides are of equal weight, the image is symmetrically balanced, as in figure 8–11. If one side is heavier than the other, the fulcrum must move in order to balance the uneven pair. This distribution is called asymmetrical balance. But visual balance doesn't mean both sides of the scale must be level. In figure 8–12, the image is balanced even though you can't set it on a fulcrum and expect it to stay there.

Another way to look at balance is through the music analogy. Not all instruments play at the same volume. Some are loud, some are soft. Sometimes there is a solo, but even then, other instruments might play underneath. Visual instruments can work the same way.

Symmetrical balance is sometimes called formal balance, and it is useful for creating feelings of formality, power, or boredom. It is a static placement.

Asymmetrical balance is informal and active. The *golden mean* is sometimes brought up when discussing these ideas. The golden mean is the proportion thought by the ancient Greeks to be an ideal. It is created by dividing the space into five parts on one side and eight on the other, as in figure 8–13, and it is the foundation for the rule of thirds that will be discussed.

Unity is probably the most verbally elusive of these concepts. Unity is a cohesiveness of the image. It is the combined coordination of everything that makes the image successful. It is the thread that ties the parts together so that they become something greater than the sum of their individual parts. It is difficult to point to a photo and identify a single unifying force, because unity is a wholeness that involves all the elements and principles. Perhaps unity could be compared with the difference between an orchestra playing with a score and a conductor, and the chaos of the practice room backstage.

Sometimes a photo needs to be without obvious balance and unity, particularly if it is a photo of chaos, because chaos is unbalanced and disunified. But photographic unity and balance are usually there, and these photos can be well composed. Frequently, students in my photo editing class will object to the composition of such a photo—a wreck, disaster, or scene of visual clutter similar to figure 8–14. The point of the photo is to show the clutter, yet even though the image is well composed, the students will react to the clutter and label the image as poorly composed. They react to the content of the image, not the way it is put together. Although content is a part of composition, keep in mind that even content that causes a negative reaction can be well composed. You may not like the picture for what it says, yet what is said is said well.

Common Compositional Devices

As I said above, there are no set rules for composition. But beginners need a place to start, so below are some ideas that you can use right away to make your photos communicate more effectively. As you grow, you'll use these less as formulas and more as starting points for your own visual vocabulary.

Focal Point The focal point is the main attention-getting spot in the photo. Every shot must have a focal point. Without one, your reader's eye wanders about inside the image, trying to figure out what the picture is supposed to be about. Sometimes the focal point is called the center of interest, but this phrase can mislead

Figure 8–12 Visual balance does not mean that an image needs to be equally weighted across the frame. In contrast to figure 8–11, this image is asymmetrically balanced. While the baseball is important to the story, it also balances the player. *(Kurt Hegre)*

Figure 8–13 The Golden Mean, which consists of 5:8 proportions, was thought by ancient Greeks to be the most aesthetically pleasing. See figure 8–15 for a practical example.

people into putting the main subject in the center of the frame, a spot that, unless you want to create formal balance, usually should be avoided.

Most of the time, a photo should have only one focal point, but it is possible for a shot to have two or even more. That is what makes some photographs so exciting—the discovery of the second level. But this second level must be subordinate to the primary one in order to avoid confusing the reader. Confusion may be a valid purpose in other photographic genre, but not in photojournalism. Multiple focal point images can get quite complicated, and it takes great care to make them work. In the beginning, look for a strong, simple focal point, and make only one statement with the image.

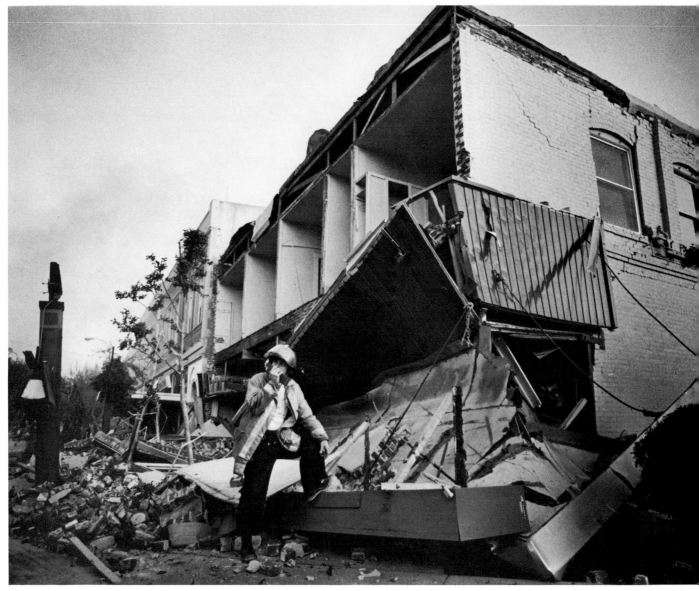

Figure 8–14 Even though a photo contains clutter and chaos, it can still be well composed. This photo is a close fit for the rule of thirds, has a dominant element, and a strong focal point. *(Robert Hanashiro/Visalia Times-Delta)*

Rule of Thirds The *rule of thirds* is an imaginary grid that you create in your viewfinder. To use the rule, divide the frame into three equal parts, both horizontally and vertically, as in a tic-tac-toe game. The rule says that a major element placed on one of the lines or at one of their junctions will create a more dynamic photo (fig. 8–15). Horizons, for example, should be on one of the horizontal lines just above or below the center of the frame.

This rule helps beginners avoid the "bulls-eye-vision syndrome," the tendency to put the main subject dead center in the frame. I suspect this happens because there is a focusing spot in the middle of the ground glass. Photographers focus on the subject, which must be placed in the center in order to use the focusing spot, and then just leave the image framed that way and press the button. In fact, I have had students look into the viewfinder and ask me if that spot is where the subject's head should be. Although the question is an honest one, the answer is usually no. Dead center is a useful spot if you are trying to create a static or heavily symmetrical look

Figure 8–15 This photo is a good example of the rule of thirds. It is as though the frame had been divided like a tic-tac-toe game and the major elements were placed along the grid lines. *(Lane Turner)*

to the image, but this isn't needed most of the time. Try the rule of thirds. Look through the photos in this book and see how many fit this simple grid. But don't hesitate to try something else if it would work better.

Foreground Framing Foreground framing is a great way to create a feeling of depth and add emphasis to your subject. In figure 8–16, the image is rather two-dimensional. On the other hand, compare that example with figure 8–17. This photo has depth and a sense of reality that brings the image closer to the reader. In the first example, one feels like a distant observer, whereas the second photo pulls the viewer into the room.

Foreground/Background Relationships Closely allied with foreground framing are foreground/background relationships. Tying foreground objects to the background gives the reader a sense of scale as well as depth. In figure 8–18, the foreground doesn't frame the image as in the examples of foreground framing, but it gives you a sense of your vantage point as you look at the scene.

Scale The mention of foreground/background relationships leads us to scale, which is also important as a reference for the viewer. At the beginning of this chapter, I mentioned landscape photos you may have taken that don't seem to capture the grandeur of the scene. One missing element is probably an indicator of scale—something that tells the reader just how far it is to those distant peaks. The traditional solution in such an example is to put a person in the foreground. But other kinds of shots may need a scale indicator. Figure 8–19 is a good example. It could be difficult for the reader to understand the size of the pieces of debris and the scope of the damage without something in the shot that the reader can identify. The people and the house both do that, the person in the mid-foreground being a key to the size of the pieces of rubble nearby.

Figure 8–16 Although the photographer was quick to respond, this photo feels rather two-dimensional when compared to figure 8–17. *(Rollin Banderob/Manteca Bulletin)*

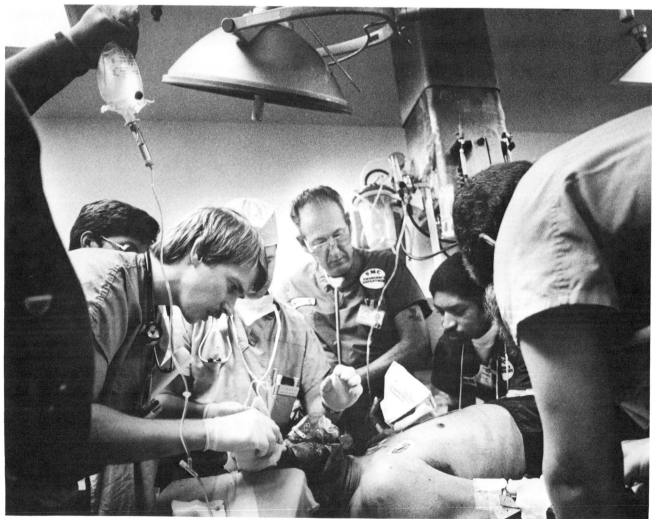

Figure 8–17 When compared to figure 8–16, this photo draws you into the scene, and it has a strong three-dimensional effect. *(Tony Olmos)*

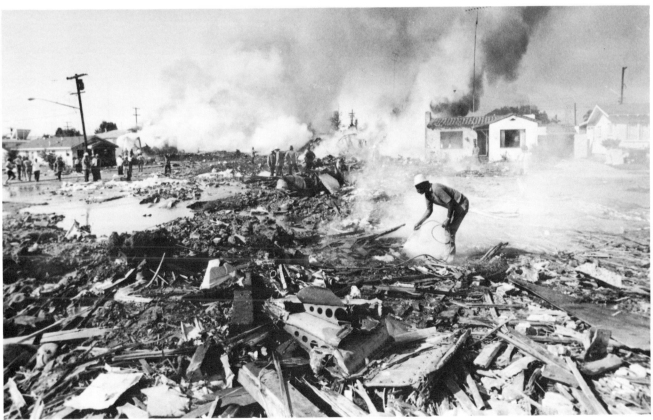

Figure 8–18 Tying the foreground with the background is a useful technique. Although the Secret Service agents are visually tied to the plane, they are still distant from it, symbolizing their close yet detached relationship to the plane's key passenger. *(James Kinney)*

Figure 8–19 This photo of a plane crash in Southern California needs the person in the middle foreground to give the viewer an idea of the size of the pieces of rubble. The people and house in the background indicate the scale of the scene. *(Joe Holly/Union-Tribune Publishing Co.)*

Figure 8–20 The lines in this photo lead your eye to the man's face. *(Tony Olmos)*

Leading Lines Leading lines are those that tend to draw the reader toward the focal point. Figure 8–20 is a good example of leading lines. There may be some dispute among experts as to whether a reader's eye actually follows such lines, but they certainly are a strong graphic element. Even though a reader's eye may wander, I think leading lines can be a useful strategy and worth keeping on your list of useful tips.

Repeated Pattern Repeated pattern is a direct manifestation of the rhythm that we discussed previously. This repetition is the visual beat of the image, and as with music, there often needs to be a rebel that is off just enough to make it interesting, but not so far out that it is abrasive.

Figure 8–21 is an example of a repeated pattern. Although exact repetition can be boring, it is the slightly uneven quality of the repeat that can be interesting. But repeated patterns need not be like this example. Repetition can take more subtle forms, ones I like to call visual echoes. Figure 8–22 is an example of visual echoes. The repetition is subtle, but it is there and does function as an important part of the image.

Camera Angle Camera angle is certainly a compositional device. By using a radical angle, the subject can be changed considerably. Look at figure 8–23. Here, the camera angle contributes significantly to the impact of this image. Of course, not all photos should be shot this way. It's not always appropriate for the message, and a

Figure 8–21 Repeated patterns are useful compositional devices, but just as in music, a break from exact repetition is important. *(Glenn Moore)*

Figure 8–22 This is a great example of visual echoes. The repetition is there in the faces and arms, but it is not an exact duplicate. *(Robert Gauthier)*

Figure 8–23 Try to break away from the usual eye-level perspective. While this extreme viewpoint could be overused, it is appropriate from time to time. *(Paul Kuroda/The Fresno Bee)*

steady diet of this technique would quickly tire the reader. But a radical camera angle can help save potentially boring images.

Aside from the extreme example in figure 8–23, a subtle change from the stand-up-and-aim-the-camera-dead-on approach can make a big difference, as you can see in figure 8–24. Remember, one unique feature of photography is viewpoint. Take advantage of a slightly different viewpoint when you can. By the way, high and low camera angles are one way to eliminate a bad background.

Choice of Lens and Selective Focus Choice of lens and selective focus may not, at first, seem like tools of composition, but they are because of the impact they have on the image. (Lenses and selective focus, also known as depth of field, were discussed quite thoroughly in chapter 4.) The lens focal length affects camera angle and foreground/background relationships. Wide-angle lenses emphasize and enlarge foreground objects while diminishing background ones. Telephoto lenses will compress distance and de-emphasize objects outside the plane of focus.

Cropping Cropping, which can be done in the lab or at the editing stage, is also a compositional device. Consider changing the proportions of the image to something other than the 1:1.5 ratio of the 35mm frame or the 1:1.25 ratio of 8 × 10-inch print paper (fig. 8–25).

Another aspect of cropping can be useful; I call it "a part of the whole." Sometimes you can create a stronger image by not including the whole object, but just enough of it so the reader knows what is going on. I think figure 8–26 is a good example of this kind of cropping.

Figure 8–24 On every assignment, try to get a few shots from a different viewpoint. This low angle creates a strong graphic image and is one way to deal with a bad background. *(Tony Olmos)*

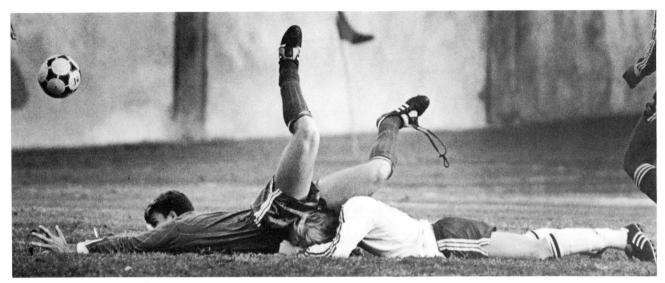

Figure 8–25 Not all photos should be used in standard proportions. This photo works well as a strong horizontal image that echoes the flow of the action. *(Gary Kazanjian)*

Figure 8–26 Neither the whole plane nor the man's legs are included in this shot, but we can tell that this pilot is none the worse for the incident. Remember, too, that captions confirm our presumptions and fill in important details. *(Ralph Thronebery/ The Fresno Bee)*

TABLE 8-1 Common Errors in Composition

Problem	Cause	Solution
Bad background	Failure to see as camera sees	Use low or high camera angle Use minimum depth of field
Weak or nonexistent focal point	Photographer unsure of message Too far away Bad background	Decide what is most important Move in closer Change camera angle or use minimum depth of field
Centered subject	Bulls-eye vision	Try rule of thirds Learn to check corners of frame

Common Errors in Composition

Table 8–1 lists some common problems often found in beginners' photos. But because each photo has its own unique character, it is important for you to get outside feedback on your work. If there is no critique session in your class, start your own group or get a professional to look at your images. Be sure to show the ones that failed as well as those that succeeded. You may be making a consistent mistake that could be pointed out and corrected, and you can also learn from the failures by learning why they failed.

One common mistake, bad backgrounds, is a constant headache for even the best pros, but the professional sees the problem before shooting and finds a solution. The classic tree-growing-out-of-someone's-head example is not the only type of background problem that can occur. Often, the background is just a clutter of shapes and tones that steal emphasis from your subject. Other times, a more insidious background problem will arise—the blending of similar tones in both the subject and background. Called the *tone merger* or *background merger,* this trap catches beginners who haven't learned to see as the camera will see. Figure 8–27 shows an example of background merger. The solution is the same as for other background problems: change camera angle or depth of field.

A similar, but less frequent problem is the empty foreground, which is usually caused by being too far away. Al Grillo, chief photographer at the *Anchorage Times,* says that if you don't move in close, all you'll get is "little ant-people" and wasted foreground space in your pictures.

Weak focal points are usually caused by the photographer's confusion about the intent of the photo. The key to a strong focal point: know your subject and think carefully about what you are trying to say. Move in close. Get faces. The face is the primary human communicator. Many times, a beginning photojournalist will come back with a roll full of pictures that show nothing but the backs of people. Avoid "back shots." Assert yourself, get up front, and show us what the people look like.

The problem of the centered subject should be easy to deal with. The rule of thirds helps, but also learn to see into the corners of the frame. Watch what is happening at the edges of the image. Check these spots before you shoot and it will soon become second nature.

One last thought. Many times I have been on assignment when people will come up and look at my professional-quality camera. "Boy, I'll bet that camera takes good pictures," they invariably say. I just say yes, and that satisfies them. But just as an expensive paintbrush does not create a great painting, the camera alone does not make great pictures. Remember, these are mind-guided photos, not snapshots. Know what you are trying to say. Often, I'll ask a beginner what he or she was trying to do with a photo, but the photographer wasn't sure, and it always shows in the image—message unclear.

The overriding goal is to tell the story. Composition should aid the goal but be subordinate to it. Graphics without content are similar to a string of interesting words. Unless there is an order to them and a message to be conveyed, they are nothing more than a vocabulary list. Learn the tips, see how the elements and principles work, and use them to create messages with content.

Figure 8–27 Beware of backgrounds that will blend with your subject. Foliage is a typical problem background. Solutions include finding a different camera angle, or using a telephoto lens and a wide aperture to throw the background out of focus. *(Anne-Mette Madsen)*

Summary

Composition is the way you organize the visual message. Good composition is similar in many ways to good writing. The writer must find the right words and arrange them in the right order for maximum impact. The photojournalist must do the same thing, but with different tools and processes, and in a totally different language.

To understand composition, you should first understand how the camera and the eye see differently. One obvious difference is that the camera sees in two dimensions whereas we see in three. A second difference is field of view. You see a wide field of view, yet only the central portion of that field is sharp, whereas the camera sees a narrow field, but sees it equally sharp from edge to edge. Therefore, you must learn to see into the corners of your frame and make maximum use of the entire area.

Third, you tend to see only what you are interested in at the moment. The camera, however, does not have a brain to interpret and control what it sees, which is why distracting objects tend to appear in your photos—they went unnoticed when you pressed the shutter.

Finally, another important difference is the objectivity/subjectivity battle between human vision and camera vision. When we see something, we are influenced by other stimuli, sound, smell, and emotional involvement, but the camera records only its own special visual image. Which is more accurate: the mental impression that encompasses all the messages, including the emotional influences of the moment, or the impartial record that is not affected by outside forces?

In discussing composition, we can divide it into two broad areas: elements and principles. The elements are similar to the words of the writer, and the principles are similar to the syntax of language. The words, visual or verbal, must be the right ones, but they must also be in the right order for the message to make sense.

The photographer's words, the elements of composition, are line, shape, tone, and texture. The principles—the way the elements are organized—include contrast and variety, rhythm, emphasis or dominance, balance, and unity.

To use the theories of composition, you can apply some practical tips to your pictures, but don't become a slave to these methods. Every photo is different, and many call for innovative treatment.

Probably the most important tip is to create a strong focal point in every photo. Some part of the image should call out to the viewer and say, "Hey, look at me!" Without a focal point, your reader will wander around inside the image trying to figure out the message. More than likely, the reader will quickly give up and move on to something else. A strong focal point should be your primary goal.

A second tip, related to the concept of balance, is the rule of thirds. Dividing your frame into thirds and placing major items on the division lines or their intersections is a step toward correcting the "bulls-eye

vision" that afflicts so many beginners' photos. The rule of thirds shouldn't be called a rule, though; it's only a guideline. There are many instances when some other placement would be better.

Third, foreground framing and foreground/background relationships are ways of creating depth in the photo. By placing something close to the viewer, a feeling of scale is created that gives your reader clues about size, and draws the reader into the image.

Watch also for leading lines and repeated patterns, simple graphic devices that can emphasize the focal point and help unify the image. And don't forget that camera angle, choice of lens and selective focus have major influences upon composition. Selective focus, particularly, can give you control over backgrounds and emphasize or de-emphasize other areas in the image.

While learning composition, watch out for common errors such as bad backgrounds, which creep in because of failure to see as the camera sees. Weak focal points are another common problem, and the cause is usually a photographer who isn't sure of the message or how it will be interpreted by the camera. Lastly, beware of the centered subject. Sometimes it is important to put the subject in the middle of the frame, but most of the time that placement leads to poor use of space and images without impact.

Endnotes

1. Wilson Hicks, *Words and Pictures: An Introduction to Photo-Journalism* (New York: Harper & Brothers, 1952), 3–45.
2. Ben Clements and David Rosenfeld, *Photographic Composition* (New York: Van Nostrand Reinhold Company, 1979), 125.
3. Ibid., 62.

Chapter 9

News and Features

Outline

"Of all the means of expression, photography is the only one that fixes forever the precise and transitory instant. We photographers deal in things which are continually vanishing, and when they have vanished, there is no contrivance on earth which can make them come back again. We cannot develop and print a memory."

—Henri Cartier-Bresson

News or Features: What's the Difference?

Traditionally, photo assignments have been categorized as news, features, and sports. But it is hard to draw firm dividing lines between these categories, because some sports stories are more like features, some features are more like news, and some news stories could fall into either category.

I think most of us have an intuitive feeling about what is news. It is what is new and different from the routine. In photojournalism, news assignments frequently include political or criminal events, weather, fires, and accidents and the like, but anything that is of immediate importance to a majority of readers could be considered news. News is important today, and history tomorrow.

Features are hard to define. They can range from the controlled situation, such as a personality story, to the grab shot, an unexpected photo of an unplanned event. In many cases, features don't have the time value of news photos. Some features could be run today or held until next week and still be fresh and interesting. Feature photos are sometimes accompanied by full-length written stories, but frequently a brief caption or a couple of paragraphs are all that's needed. What blurs the line between news and features is that some news events can be covered with a feature approach. A swim meet, for example, could be covered from a news angle—the winners, major contenders, etc.—or it could be covered from a feature angle, concentrating on the stress of competition or the emotions of winning and losing. Features include just about everything that isn't news or sports, yet it's hard to list examples because the category is so broad. More important than trying to categorize pictures is learning to recognize what will interest your readers and how to bring that story to them.

Covering an Assignment

There's a story in photojournalism about the young photographer who asked the old pro how the pro got such great photos. The pro answered, "F/8 and be there." Well, by now you know about exposure, and you know that there is much more to it than a simple f/8. And although you certainly must be on the scene to get the picture, there is much more to successfully covering an assignment than the old-timer's advice.

Know Your Audience

You must first know your audience. You are making pictures for them. You are their representative on the scene, and your job is to tell them what happened. If your publication is a community weekly, a daily newspaper, or part of the campus press, your readers will have special interests and needs that must be met. Remember what I said about personal pictures and photojournalism in chapter 1. The photos you make on an assignment must show your readers what happened, clearly, concisely, and without ambiguity. Your personal feelings or interpretations must be subordinate to this goal.

To know your audience, you must also know the issues that are important to the community. Read the publication you shoot for. This advice may sound self-evident, but it is surprising to discover how many photographers neglect this important means of keeping up. A glance at the front page and the sports section isn't enough. Reading the opinion columns and particularly the letters to the editor will give you a feel for the attitudes and concerns of the community. Keeping up with regional, state, and national events is important too, because you need to be aware of distant events that affect your readers.

Along this line, you should be able to find the local angle to the large or distant story. How do events in the state capital affect people in your community? If something happens in a third-world country, is someone in your area involved?

Finally, get out into the community. Expand your network of contacts beyond your own circle of friends and co-workers. Explore unfamiliar areas of your community and develop contacts there. Talk to people and find out their interests and concerns. Let it be known that you are a photojournalist and are always looking for interesting things to report. It is surprising how many stories can come through these contacts and how many times one story will lead to another.

Know Your Message and Plan Ahead

Before you can communicate to your audience, you need a clear understanding of what you are trying to say. You need to know the story better than anyone else if you expect to successfully interpret it visually for the reader. Begin with research. If someone has already been working on the story, check with that person and get as much information as you can. If the story has already been written, read it. If not, get together with the writer and share ideas. Check the paper's files for other stories that may have been done on this person or subject. This research isn't just for your personal edification—the more you know about your subject, the easier it will be to see the things that tell the story visually.

Part of knowing your message involves anticipating the event. Anticipation includes looking ahead on three levels: for trends, specific events, and moments within events. Planning for trends is a long-range type of anticipation. For example, if you notice an unusually severe or mild winter, think ahead to the consequences that will arise during spring and summer. At the second level,

Figure 9–1 When the space shuttle *Challenger* exploded in January of 1986, photographer Judy Griesedieck localized the story by finding this man reacting to the news in a local TV store. *(Judy Griesedieck/San Jose Mercury-News)*

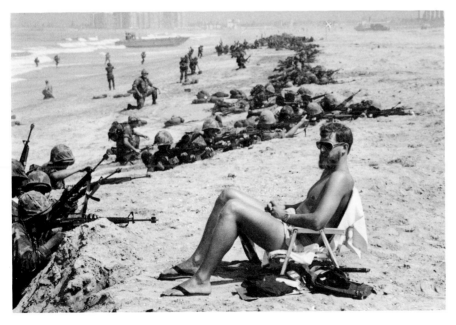

Figure 9–2 Advance planning is a key to many good photos. San Diego photographer Rick McCarthy knew that this stretch of beach, which had been reserved for military training for years, had recently been opened to the public. When he learned that training would continue, he was there when the Marines landed. *(Rick McCarthy/Union-Tribune Publishing Co.)*

Figure 9–3 Try to photograph people in active situations whenever you can. Concentrate on faces. *(Roger Jerkovich)*

planning for the event includes the preparations you might make weeks or days in advance to insure that you are at the right place at the right time with the right equipment. At the third level, anticipation means a strong intuition about what will happen next. If you see a tiny toddler eating an ice cream cone and it's the hottest day of summer, you should be ready for the inevitable.

The preparation phase also includes making a shooting script. A shooting script might be a formal written list when working on long stories, but more often it is a mental list of shots that you plan to look for at the event—notes that you update as the assignment progresses. This list is only a guide and should be flexible. The primary reason for the list is to help you provide complete coverage and avoid getting involved in the event to the extent that you forget what you are trying to do.

Here's a personal story to illustrate the point. Years ago I was covering an enormous brush fire that was threatening a large farmhouse, barn, and other outbuildings. I drove into the area through thick smoke and found the fire crew sent to protect the buildings. Everything around us was burning. The sky was an eerie color beyond description, and the hot air created its own abnormal currents. The fire crew knew what they had to do, but I was so overcome by the other-worldly spectacle of it all that I didn't get any usable pictures. At the very least, I should have recited the basic three shots (discussed in the next section) to myself and sought to get them. Then I should have looked for a photo that tied the fire to the fire crew or that showed its scale relative to the buildings. Instead, I was so overwhelmed I couldn't think of what to shoot and came back with only some close-ups of a fireman with a hose, and a shot of a burning pile of brush.

Figure 9-4 Even when the story does not directly include people, try to show how people are affected. In this case, the weather had brought several days of high winds. *(Paul Kuroda/ The Fresno Bee)*

Although your experiences as a beginner will probably be much less dramatic, you still should be able to explain, in words, what you are trying to say about the event. If you can't explain it, then the photo will probably be confusing, too.

Show How People Are Involved or Affected

One definition of photojournalism is "pictures of people doing things." I think this point is good for beginners to remember. For the most part, photojournalism is not pictures of static, inanimate objects. One common obstacle for beginners is a certain shyness about approaching people. But photos of the backs of people, or pictures without people at all, rarely tell us much about what was going on.

When at the event, show what most readers want to see: how people are involved or affected. For example, if I sent you out to get some shots of opening day at the county fair, I'd be very disappointed if you came back with nothing but photos of display booths. But I'd be happy if you brought me pictures of people involved in the activities—4-H members preparing their animals for show, little kids enjoying the rides, some of the behind-the-scenes activity, and so on.

In the end, knowing what you are trying to say is answering this question: "What is this event about and how can I capture its essence with my camera?"

The Three Basic Shots of Photojournalism

Writers are lucky. They can telephone the subject and ask another question. But you can't hold the phone up to the lens to take another picture. The only material you and your editor will have to work with when you return is what you capture on the film. You can't rewrite a photograph.

How, then, can you be sure you have a full set of photos before leaving the assignment? One way is to look for the three basic shots used in cinema: the long shot, the medium shot, and the close-up. These three shots are a great starting point for providing complete coverage and insuring that you'll get a picture that the editor can use.

The long shot establishes the scene and shows the relationships between the various elements. The long shot is often important for conveying scale and showing the location of the event.

The medium shot moves close enough to clearly identify the major individuals involved. We can see detail, yet we are still far enough away to see parts of the setting.

The close-up moves in on details. It adds impact and creates emphasis by bringing us right up to the situation. Sometimes the close-up is so tight that there is nothing more to see than a face.

Of course, exactly what a long shot, medium shot, or close-up are depends on the story. If, for example, you work on a feature about some particular agricultural trend in your area, a long shot could be an aerial photo of a thousand-acre field. A close-up might be a farmer examining a sample of the crop. But a story about a dentist who bakes miniature paintings into the enamel of false teeth for his eccentric patients would require the three basic shots to be on an entirely different scale.

*Providing Full Coverage:
The Saturation Method*

But long shots, medium shots, and close-ups are not made by merely pushing the shutter button as you walk closer to your subject or by twisting the zoom ring on

Figure 9–5 (a) Of the three basic shots of photojournalism, the long shot shows the overall scene. *(Paul Kuroda/The Fresno Bee)* (b) The medium shot moves in for a closer look at the action. *(Lane Turner)* (c) The close-up shows detail. A close-up might be even tighter than this depending on the needs of the story. *(Glenn Moore)*

(a)

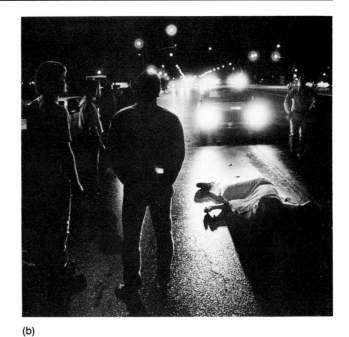

(b)

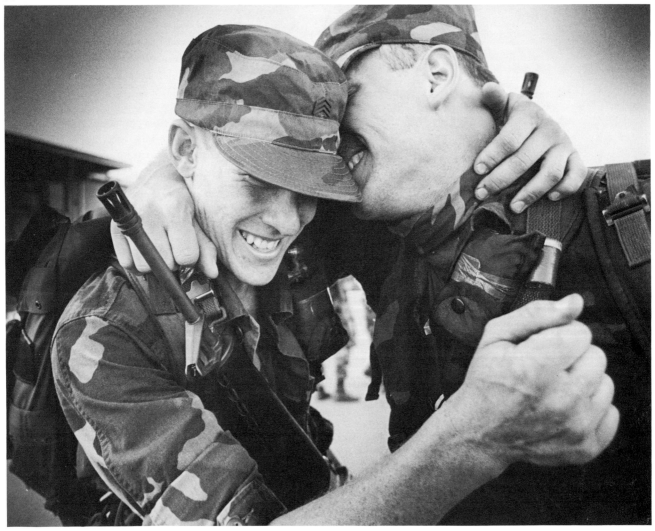

(c)

a zoom lens. The same result could be achieved by enlarging the long shot in the darkroom. And in any event, your coverage should not end with the basic three. You must continue shooting, covering your subject from as many different angles as possible or appropriate.

Photography writer Milton Feinberg calls this method "saturation shooting."[1] This term is appropriate because your goal is to visually saturate the situation by making the three basic shots from a variety of angles. In addition, you must capture expressions and, as Henri Cartier-Bresson calls it, "the decisive moment."

Shoot high angles, low angles, vertical compositions and horizontal ones, long shots, medium shots, and close-ups. Watch for the angle and moment that tells the whole story in one frame.

Look for the Peak Moment

Common practice in most publications is to use only one picture from an event; therefore, you must look for that one moment when all elements of the story come together in one neat visual package. This instant is called the peak moment, and photographing it is a major challenge that requires all the resourcefulness you can muster. You must have all the technical problems solved, because you can't concentrate on looking for the decisive moment if you are worrying about f-stops or fumbling with a flash. Camera operation should be second nature. You should be able to reload in an instant and operate the camera's controls reflexively. Then use your knowledge of the story and your ability to anticipate the action to capture that peak moment.

Figure 9–6 Here is part of a set of pictures from a story on a youth equestrian group. The photographer has tried to provide complete coverage, including long shots, medium shots, and close-ups. Always provide your editor with as many choices as possible.

TABLE 9-1 How to Cover an Assignment
• Know your audience.
• Find out what the story is about and decide how to capture that element visually.
• Keep moving.
• Include faces. Remember, the face is the primary human communicator.
• Don't wait for the scene to get better. Shoot right away; then get ready for a better shot.
• Keep looking for the three basic shots and the decisive moment.
• Learn to operate your camera reflexively.

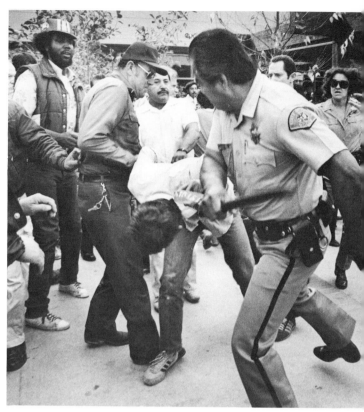

Figure 9–7 In spot news situations such as this, you must be able to operate your cameras by reflex action. *(Mike Penn)*

How many pictures should you shoot on an assignment? That's hard to say. It depends upon the situation. A dozen might be enough for a simple portrait, although ten rolls or more would be expected on a major event. It is more important that you cover the event thoroughly without overshooting—wasting frames on shots you know don't stand a chance of being used. There is no need to make a half dozen exposures on something that remains exactly the same. At the same time, don't force yourself into a corner editorially by bringing back only the obvious, expected picture. Keep chanting to yourself: long shot, medium shot, close-up.

News

Hard news includes events of major importance and immediacy. Major political developments, accidents, disasters, and public events are some examples. Generally speaking, you must be ready to react quickly at these kinds of events. When faced with an unpredictable situation, professionals often carry three cameras, each fitted with a different lens and set in advance for the expected conditions. That way, the photographer can quickly grab the needed lens and shoot.

Lenses often used for hard news include a wide angle such as a 24mm or 28mm, a medium focal length telephoto such as an 85mm or a 105mm, and a long telephoto such as a 180mm or 300mm. With these three lenses on cameras and ready to go, you can handle a high percentage of the situations that come up.

As discussed in chapter 4, telephoto lenses reach out and magnify distant objects, and wide-angle lenses include wide fields of view. An important use of a telephoto is to decrease depth of field and throw a distracting background out of focus. If you don't have this option, you'll need to move closer to the subject and find a camera angle that favors a clean background.

At the other extreme, the wide-angle lens gives the pro the ability to work very close to the subject and still include important parts of the scene. This option is important in crowded situations where there is no space to back up, or when backing up puts you at the outside edge of a circle of people. Unless you are in the midst of the group, all you'll get is the backs of people's heads.

As a beginner, you may have only one lens, and it will probably be a normal focal length. Because you don't have the optical advantages of wide-angle and telephoto lenses, you'll have to work harder to include or exclude important elements of the event—move in close, try to get faces, and watch for distracting backgrounds.

Shooting Tactics for News

When the going gets tough, shoot—don't wait for things to get better. I admit that too many times I've waited a second or two hoping for a slight change, say, for a person in the foreground to move slightly and improve the composition. But instead the person moves the other way and makes the shot, any usable shot, impossible. Few pictures are perfect. Shoot what you see and hope things will get better for a second try. If things get worse, at least you have something.

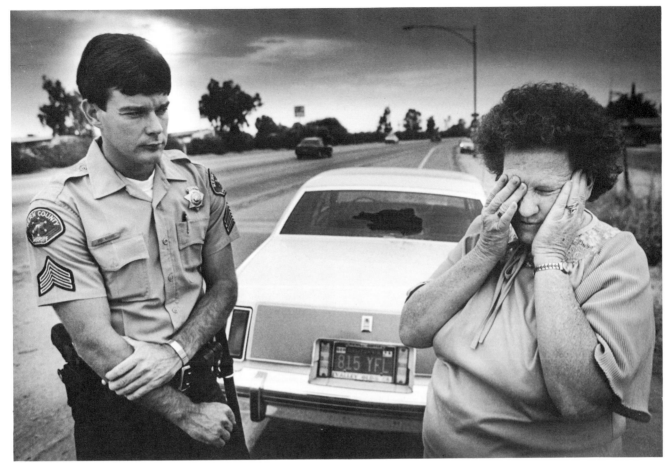

Figure 9–8 Reactions are often just as telling as the cause. The rear window of this woman's car was shot out by someone in a passing vehicle. *(Lane Turner)*

When you first arrive, make some protection shots. These are low-risk pictures that you are positive will succeed. Unusual viewpoints, lenses, or other special photographic techniques should not be used at this point if there is any risk that the photo will not work. With protection shots for insurance, you can then try for that different viewpoint, and, if not yet captured, the peak moment.

I repeat: provide complete coverage, including the basic three—long shots, medium shots, and close-ups. Get faces. The face is the primary human communicator. Move in close and look for expressions.

Of course, you'll look for the action, but also look for the reaction, from bystanders as well as from key persons. Remember, too, that reactions can come quite some time after the peak moment. The aftermath often includes a moment when the key persons are reflecting on what has happened, and that could be the moment you are looking for.

You need to develop a sixth sense about access to shooting positions. Sometimes you should ask permission to move into a spot, but other times, if you ask,

you'll give the person in charge an opportunity to say no. In such a case, if you move in on your own initiative, you may be left there as the participants deal with other things. If someone objects and you are asked to move, it won't matter because you'll already have the shot. Obviously, this tactic must be applied judiciously, but the good photojournalist knows when to be aggressive. Your editor wants pictures, not a list of excuses.

Professional Behavior

There's not space here to list every personality trait needed by photojournalists, but start with some common sense about dealing with others and the image you project. There is a lot of truth to the saying "What goes around comes around." Respect and cooperate with people and they will respect and cooperate with you.

At first you may feel somewhat shy or inhibited about getting out where other people are bound to see you. But you can't get all the photos you need from the sidelines. You must be assertive and move right up to the action when necessary. If you project an image of professionalism, people tend to accept that. But if you

convey a feeling of uncertainty, people will sense that and it will work against you.

On the other hand, know when to pull back. Be aware of an individual's space, and stay out of it. Photographer Ed Dooks says,

> "[T]his can be physical space and/or emotional space. How much space varies from time to time. Space seems to be the important element in accidents and other tragedies. Your space will be determined usually by the police at the scene of an accident or other type of tragedy. Victims, fire fighters, police, and medical personnel all need space and that space is crowded by news photographers, reporters, and the general public.
>
> "The order of things will go in a priority of victims' needs, public safety, media needs, and the general public's need to be at the scene. If you present the perception of not intruding on the space and feelings of others, you will usually have no problems covering an emotional story."[2]

My experience has shown that at tragedies the individuals directly involved are usually in such shock that they don't notice you. But the second-level people, close friends, relatives, emergency personnel and so on, will react, and perhaps strongly. Keep a low profile. Use telephoto lenses. Work quickly and quietly, don't over-shoot, and know when it is time to leave. Above all, remember the Golden Rule. (By the way, I don't believe in sneak pictures. I think people should know who you are and what you're doing. The ethics of these situations will be covered thoroughly in chapter 14.)

Professional behavior also includes dressing appropriately for the assignment. Take your cue from the participants. If they can be expected to be wearing business dress, then that's your uniform, too. Remember, you represent your publication when you meet the public. Photographers who look like transients get little respect from anyone. Many photojournalists find a middle ground so they can look casual most of the time but grab something more formal from their car when needed.

Funerals If you are assigned to photograph a funeral, here are some practical tips adapted from the August 1986 issue of *The News Photographer* that might reduce the tensions:

1. Try to contact a family member or spokesperson in advance and let them know you will be there. Express sympathy. Let them know you do not want to interfere, and see if you can work something out. You may have more success getting permission from a family member than from the funeral director.

2. Dress appropriately: dark suit or dress.

3. Be early so you don't cause a commotion when you enter. That way you'll also have a chance to talk to the funeral director. If photos are prohibited during the service, you might be able to get something beforehand.

4. Keep technique to a minimum. Use telephoto lenses, one camera, no motors, no flash. If the light is too low for even 3200-speed film, a floodlight bounced from the ceiling or a wall might be enough. This light should be set up and turned on well in advance and left on throughout the service.

5. Be careful about offending others who are grieving or who don't know you have family permission.[3]

Fires and Accidents

At fires, look for the overall shot that shows the complete situation. Try to show the building in flames, if that is the nature of the fire. Include people for scale. If the fire department beats you to the scene by more than a couple of minutes, you probably won't find lots of flames. Look for the human element. Are there victims? How are they reacting? Can you visually tie them to the fire (victim in foreground, fire in background)? If the victims are injured, show them being treated. If you can include the fire in the shot, so much the better.

Shots of fire fighters squirting hoses are rather ordinary. If it has been a difficult fire, try to show that strain on fire fighters' faces. If the situation is under control, the captain or engineer might let you climb on the fire truck for a high angle, or even inside the structure for a shot of the results of the fire. When shooting interior damage (or any other scene involving rubble), try to include a person, again to show scale. A photo of a pile of charred wood probably won't tell your reader much, and may leave her wondering what she is looking at.

If the fire is major, with streets blocked and many pieces of fire-fighting apparatus in use, consider a wide-angle shot from a viewpoint high in a neighboring building.

At an accident, use a similar approach. Get the three basic shots, looking particularly for victims. Twisted metal can be a photographic cliche if that is all there is to your picture. Show the people involved and the consequences of the wreck. Rescue shots are rarely effective if all you have are medium shots of the backs of the rescue crew. Either move in close with a wide-angle lens or work from a distance with a telephoto. Use careful judgment about getting too close. If you'll get in the way or upset people that are already under strain, stay back, but look for the vantage point that will enable you to see faces.

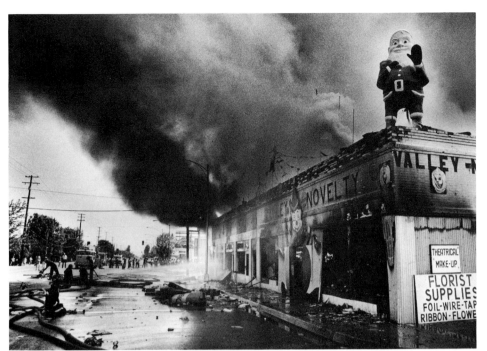

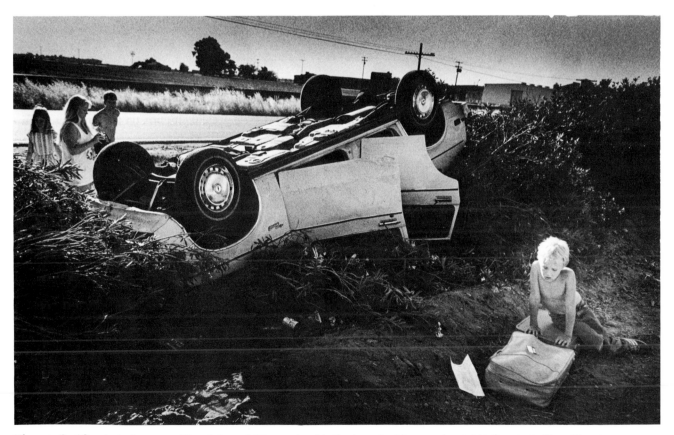

Figure 9–10 Including one of the victims of this wreck adds the important human element to the news. *(Tony Olmos)*

Beware of Hazards It should be self-evident that you must stay out of the way when shooting accidents and fires. Photographers who get in the way not only endanger themselves and others, but also can be subject to arrest. Furthermore, many emergency scenes are dangerous. Specific hazards to watch for include downed power lines and spilled chemicals and smoke. Hazardous materials are involved in more emergencies every year, and even routine garage fires can expose you to dangerous chemicals. There have been numerous incidents where photographers have been exposed to hazardous materials, including poisons and carcinogens. No picture is worth a risk to your health. Assume that any tank or spilled material is hazardous unless you are told otherwise. At industrial fires, assume the smoke is laced with chemicals. At fires or accidents that could involve hazardous materials, follow these safety guidelines:

1. Stay uphill and upwind. Heavier-than-air fumes can flow downhill and displace oxygen. Some deadly fumes are odorless and colorless.

2. Do not walk into or touch any spilled material. Even firefighting runoff can be contaminated.

3. Avoid inhalation of all gases, fumes, and smoke. Oddly colored smoke is more than likely from chemical sources.

4. Do not leave the scene if there is any possibility you have been contaminated. Decontamination should be done immediately and at the scene. Go to the command post or tell an emergency official. Do not go to a hospital emergency room first.

About Press Passes If you've seen photographers in movies flash a press pass and gain immediate access to an event, I can assure you that what you've seen is pure Hollywood. The press passes you can buy at camera stores or get through some club memberships are unlikely to carry much weight in serious circumstances. Almost every law enforcement jurisdiction issues its own press ID and will demand to see that card. I have been ejected from emergency scenes by deputy sheriffs who refused to honor cards issued by the state highway patrol and a neighboring county whose border was only 500 yards away. Press IDs are granted to those who can prove they are legitimate working press, and it's not unusual for a working photographer to carry a half dozen press cards issued by various agencies. Having the card does not guarantee you admission, nor is it a license to break any law.

Get the Story Behind the Story

Quite frankly, too many assignments are good stories for coverage with words, but provide little visual material. News conferences, meetings, awards ceremonies, and

TABLE 9-2 Cliches to Avoid
• A person allegedly "talking" on the phone (or any other fake action)
• Two or three people supposedly "conferring"
• One person handing a check to another person
• Grand openings (including ones with the giant scissors)
• People holding trophies
• A group of people lined up against a wall
• Medium shots of people speaking (or singing) into microphones
• Shots of people with arms crossed, facing the camera

the like are visual cliches that result in the same photos time after time. The best approach is to show the cause or the consequences of the story.

This is where planning is essential. If you know the assignment is coming up, you can find a way to photograph the real reason behind the story.

In this context, you might hear the phrase "story angle." In contrast to camera angle, the story angle is the aspect of the story that makes it interesting and different from other, similar situations. You should discuss the story angle with the person who assigned the photo, but think about it on your own, too. Sometimes the person who assigned the story can't see past the obvious cliche photo, and the best story angle may be found only by some probing on your part.

Here are a couple of case histories. Photographer Bob Durell was assigned by the *Fresno Bee* to get a photo of a bar owner frustrated by the prostitutes who cruised the street in front of her bar. She said they were driving business away. Durell didn't want the cliche long-lens shot of the backs of prostitutes walking along the street, and he also wanted to avoid a confrontation between the prostitutes and the bar owner in front of the business. When Durell asked her how she kept track of the women outside, the bar owner went to the window, pulled down the blind, and a prostitute walked by. Figure 9–11 is the resulting photo.

Judy Griesedieck of the *San Jose Mercury-News* was assigned to get a photo of a professional sky-writing pilot. The assignment sheet instructed Griesedieck to get a shot of the woman standing next to her plane, which is a rather ordinary, person-looking-at-the-camera picture. Knowing that this shot wouldn't tell readers much, Griesedieck probed until she discovered that the woman had a dog that liked to fly. Figure 9–12 is the resulting photo.

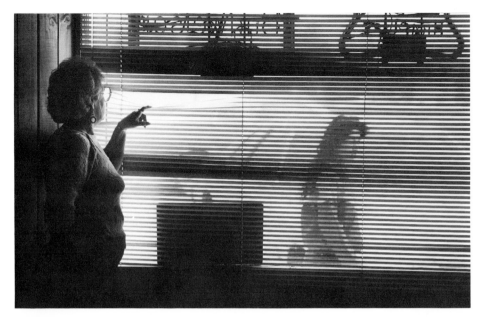

Figure 9–11 Try to go beyond the obvious solution to an assignment. As explained in the text, this photo shows the cause of the woman's complaints to the police. *(Bob Durell/The Fresno Bee)*

Figure 9–12 Avoid photos of people standing with arms folded, looking at the camera. Instead of a picture of this woman pilot standing next to her plane, the shot the editors originally wanted, photographer Judy Griesedieck brought back something much better. *(Judy Griesedieck/San Jose Mercury-News)*

(a)

(b)

Figure 9–13 (a) Although well done, this photo of 1984 vice-presidential candidate Geraldine Ferraro is typical of politics and news conferences. If you are sent to cover this type of event, make the shot, then get some close-ups as in (b), and then look for something different. *(Robert Hanashiro/Visalia Times-Delta)* (b) When shooting speakers, use a long lens in order to get good face close-ups without including the microphone. Look for characteristic expressions. *(Tony Olmos)*

Survival Guide to Cliche Events

The examples above are typical situations faced regularly by photographers who try to provide more than routine photos. But sometimes the event itself is a cliche and getting a different type of photo is a major challenge. The suggestions below will help you make the best of some essentially nonvisual situations.

Politics and News Conferences

Much of the photography of politics is at staged events where the candidate or politician is prepared to meet the media. Try to avoid the picture of a person speaking into a microphone. Get extreme close-ups of the speaker's face, cropping out the mike. Look for animated expressions. Look also for what else is going on at the periphery of the event. Make a few long shots that show the context of the situation.

If the subject of the assignment is a major political figure, you must arrive well in advance, sometimes several hours, to claim a shooting position. Security for national political figures has become so tight that you may not gain access to the best spots without credentials arranged in advance.

To get that tight close-up, you'll need a telephoto lens, such as a 180mm or even a 300mm. If the event is covered by television crews, their lights can help you by providing some modeling on the subject's face and by boosting the illumination as well. (When shooting in color, have some tungsten-balanced film handy for use with TV lights.) If flash is called for, use it, but beware of the flat light from on-camera flash. On-camera flash is your last resort if available light is too weak and there is no way to place the flash to one side. Keep in mind the maximum range of your flash.

As with any assignment, be on the alert for a different angle. Perhaps the best shot is after the event, when the key person is relaxing or leaving (fig. 9–14).

Figure 9-14 If deadlines permit, waiting until after the event can result in photos that are more revealing. This politician is being congratulated on his election victory. *(Robert Gauthier)*

Arrivals and departures can be an opportunity for some different shots, but be ready to react in an instant. It only takes a few seconds for the VIP to walk from the airplane ramp to the limousine, or from the car to the building entrance, and you'll have only one chance to get a shot. If possible, check out the route in advance and plan your coverage.

Meetings

Meetings should be handled the same way you handle assignments for speakers and news conferences. The primary visual element is the faces of the participants. Get some close-ups, filling your frame with the subject's face. Then look for something different. Watch also for reactions from listeners that symbolize the mood of the event.

Groups, Handshakes, and Awards

Group pictures can be horridly boring if the photo looks like a police line-up. Try to make a photo of the group while members are legitimately involved in some activity. If that is impossible, there are at least two ways to improve upon the cliche. First, arrange the group so some of the members are toward the front and some toward the back; then pose them so their heads are on different levels, as in figure 9–15. Make the background one of the story-telling elements if possible, but beware

Figure 9-15 David Yarnold of the *San Jose Mercury-News* says new officers of civic and other such groups warrant a news brief, not a photo. But if you are required to make a group photo, set it up so each person's head is on a slightly different level. Place some of the people toward the front, some in the back. Be sure the shoulders, and the knees of those seated, are turned slightly away from the camera.

of confusing or distracting backgrounds. A second solution is to make individual close-up portraits of the group members, which can then be laid out in the publication as a series of small shots. Be sure to coordinate this idea in advance with the page editor.

The dreaded handshake shot has been laid to rest at most newspapers, but if you are sent out to make such a photo, try a close-up portrait of the two instead of a meaningless picture of two people clasping hands. Although the shot may not have much more meaning, at least it does away with the artificiality of the handshake. If one of the two has won an award, perhaps just a close-up of that person is the best way to show what he or she looks like. Trophies and plaques all look alike in photos, so if one of these must be in the shot, arrange the composition so the person is the dominant element, not the award. For example, try putting the award in the background so it is slightly out of focus, while the recipient's face is sharp. Spare us the shot of the person holding the trophy at belt-buckle level, the whole scene looking like a piece of poorly done taxidermy. Of course, the best photo is the one that shows us the reason behind the award.

Avoid setting up fake action. Never have people pretend to do something when it is obvious they are posing for the camera. That is a blatant fraud. Your readers know it and deserve better. If there are absolutely no other options, it is much better to have people looking directly into the lens than to pretend to do something we all know is artificial.

The main purpose of the photos in all the situations above is to show us what the people look like. If your well of ideas runs dry, you can always accomplish that task by making a window-light portrait as explained near the end of this chapter.

Concerts and Stage Shows

Photographing at major concerts has become difficult if not impossible. Security and concert promoters usually limit or prohibit photography. In the case of a superstar, about all you can do is contact the concert promoters well in advance to arrange for coverage. If they are uncooperative, you can complain but, as explained in the law chapter, it's their show.

As with speakers, pictures of people and microphones don't tell readers much. Look for characteristic gestures and expressions. Look also for shots that capture the feeling of the event—perhaps a shot of the audience, or some particularly enraptured listeners, or a backstage shot of the performers. If the story is more about the performers than the performance, try to give your readers something they wouldn't see if they attended the show, such as a shot during a rehearsal, or an image made during a break that reveals another side to a performer's personality.

Photographing during a legitimate theatre production is never advisable. You'll create a disturbance that will interfere with the show. Make arrangements to photograph during a rehearsal where you can be on stage for better angles and the cast can run through a scene just for your benefit. It bears repeating, though, that the most interesting shots are usually those that reveal something not seen in the show itself.

Cameras in Court

Not long ago, photographic coverage of courtroom activities was prohibited. Today, cameras are allowed inside state and local courthouses more regularly. (Federal courts remain closed to photography; see chapter 15.) Courts impose rules on the photographer, and you must follow these exactly or you will find yourself outside in short order. Common rules require the photographer to sit in one seat for the duration of the proceeding and to shoot without flash. Some courts have limits on the noise from the camera, and special sound-deadening covers must be used. Because the visual elements of a courtroom are centered around the faces of those involved, a telephoto lens is a must for complete coverage. Check with court officials well in advance of your assignment to see what arrangements must be made.

Weather

The weather is a constant topic in the news. Keep in mind the basic guidelines for all photojournalism when looking for weather photos: Show how people are involved or affected. One useful technique for getting good weather photos (and some feature photos, too) is the stake-out. Find a spot where something is likely to happen, then wait. An obvious example is the intersection that always floods. Sooner or later a pedestrian will try to leap across, or a car will stall and the owner will have to jump into the water to abandon ship. One photographer I know heads for a certain freeway during foggy winter mornings because pile-ups are common then. If you think this approach is rather predatory, keep in mind that what you are looking for will happen anyway. You can't prevent it, and your job is to photograph it, so you might as well be there to get the picture.

Shooting weather can be as much a technical challenge as a content one since you are also out in the elements. Al Grillo, photo editor of the *Anchorage Times,* warns against bringing your gear in from the cold too quickly because condensation will form on the lenses. He also says that batteries suffer in freezing weather, sometimes putting out only one-fourth their usual capacity. To solve this problem, he uses a battery pack that he can keep in his pocket until the last moment. Grillo says that at temperatures below $-10°$ F, film gets brittle and will break unless you operate your film advance and rewind slowly.

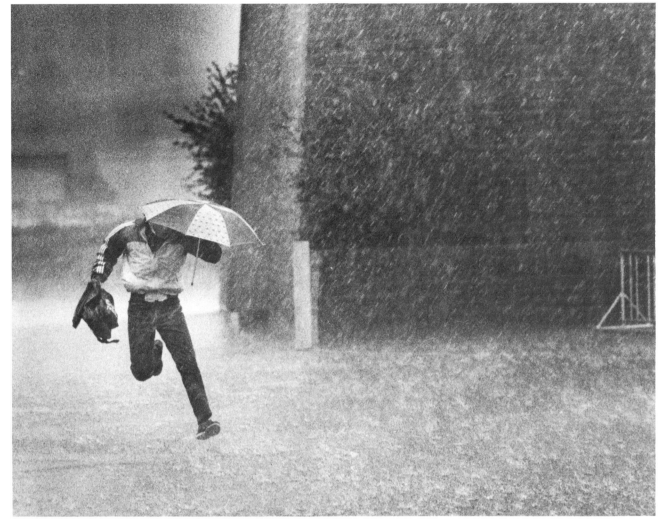

Figure 9–16　This shot was made from the newspaper's office. Photographer Bob Durell had just entered the building when he looked back and saw this man, who was late for work, rushing across the parking lot. *(Bob Durell/The Fresno Bee)*

In hot weather, don't leave your cameras or film in your car. Temperatures inside can reach 130° F and can ruin film and cause lubricants inside cameras to run into places where they can gum up the mechanism. Some photographers use a picnic cooler for film transport, with a package of reusable Blue Ice in the bottom to keep heat from building up.

Rain is another problem. You can put your camera in a plastic bag and cut a hole for the lens, which will help keep the camera from getting flooded. Many camera stores sell an underwater camera housing made of vinyl that is handy for foul weather. I have yet to find a way to keep myself completely dry. If you must photograph in the rain, plan ahead and have dry clothes available. Be sure to use skylight filters to protect the front elements of your lenses from blowing sand, sea spray, rain, and accidental scratches.

Features

Although news photos are often made on the run, with deadlines adding to the pressure, features usually offer a chance to try new ideas and approaches that can't be risked in the limited time available on a news assignment.

As I said at the beginning of this chapter, features are hard to define. They can range from the slice-of-life photo that you happen to see while on the way to the market to the in-depth coverage of someone struggling against the odds.

There is no easy formula or checklist for making good feature pictures. Of the three skills in photojournalism, technical, perceptual, and human, it is the human skills that are so important for successful feature photography. You must first understand people: what

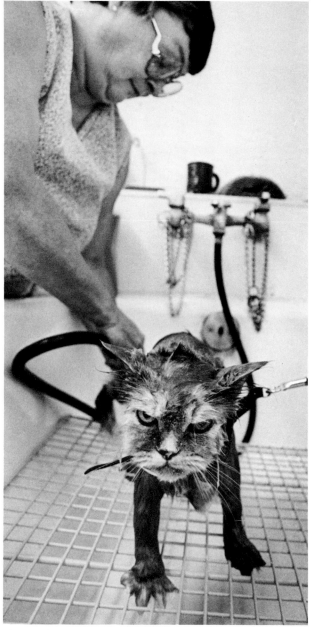

Figure 9–17 The slugline for this shot was "Murder on his mind." *(Alison Portello/Davis Enterprise)*

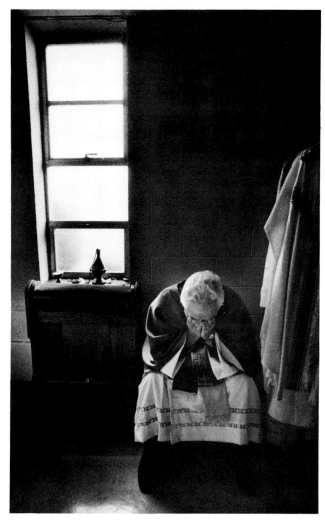

Figure 9–18 Features also deal with serious subjects. This shot is from a story about a blind priest. Here he prays before Mass. *(Mike Penn)*

motivates them, how they think and why. You must know when to speak out and when to keep quiet and blend into the background. A good feature photographer is sensitive, compassionate, patient, and tolerant. She finds it easy to get along with all types of people, is curious but not nosey, assertive but not aggressive.

Dealing with People

I suspect that no other job will bring you in contact with as many different personalities as photojournalism. You'll deal with shy people as well as egomaniacs, bossy types as well as those who are almost too helpful. But dealing with people is part of the excitement of the business.

Shy people are best approached in a low-key manner. They need to gain confidence in you before they will open up. Talk to them for a while before starting to make pictures. Sometimes, it is best to leave your cameras in your car until you get a signal that the subject has accepted you. I remember one assignment when I had to photograph a four-year-old child. I don't remember the story, but I was on deadline and had to get back with the photo in about an hour. The boy took one look at me, decided he didn't want his picture taken, and retreated to his bedroom. I knew that if I asked his mom to bring him out, all I would get would be a shot of a

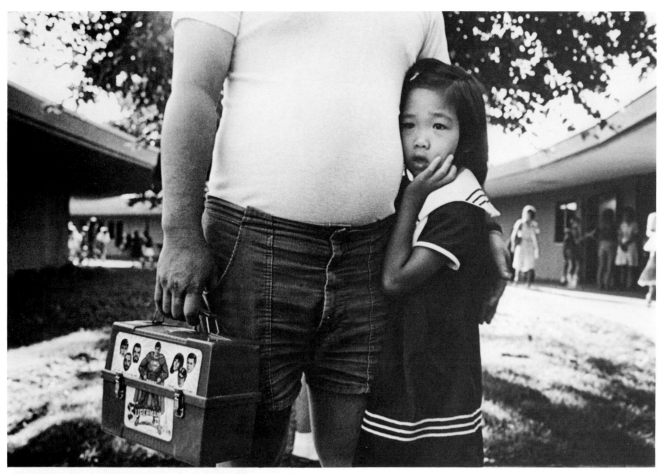

Figure 9–19 The first day of school. The photographer said this shot was rejected by the editors, who wanted a photo of smiling kids. *(Robert Gauthier/ Escondido Times-Advocate)*

screaming youngster. Instead, I asked the mother to tune in a cartoon show on TV, then we sat on the living room floor and played noisily with the kid's toys. In less than ten minutes, the boy came out to play with us, and I asked him to show me his tricycle. After he was on the trike, I got some nice shots. I made the deadline with five minutes to spare.

Bossy types can be a problem unless you let them think they are getting their way. They will have all sorts of suggestions about how you should make the photos. The best way to deal with this attitude is to shoot some of their ideas. (Sometimes your subject's ideas will be good ones.) Then, you can say something like, "Now let's try another way. My editor wants me to always bring back several choices."

The key to dealing with personality types is to find points of agreement and avoid controversy. Get people to talk about themselves and what they are doing. Don't talk about yourself or your problems. Never get involved in a political or philosophical debate. Your task is not to change a person's mind, but to gain his or her confidence.

When you encounter an uncooperative subject, figure out the reason and try to eliminate the objections. If your subject says there isn't enough time, ask for a specific amount of time. Make it an odd amount, such as eight minutes. Then stick to that. Make your protection shots right away, and when the eight minutes are up, announce that the time has expired. Often, the subject will have discovered that you are a likable person and will extend the time.

If you are pursuing your subject because he or she is involved in a negative news story, you may never get cooperation. In these cases, you'll have to rely on arrival/departure pictures at the courthouse entrance or the like.

When shooting kids, particularly in a classroom, tell them who you are and what you are doing. Their curiosity is so strong that they won't be able to ignore you. Sometimes, it is best to take one group picture at the beginning to cure the "Hey, take my picture!" syndrome. Let them clown for the camera if that seems appropriate, but don't let that get out of hand. Then, tell them that if they want to be in the pictures, they must pretend you are invisible. There is usually one kid who will test you, and when that happens, be sure to turn your camera in another direction so he or she will know you're serious. After about twenty minutes, they will get used to the camera and lose interest in you. I've never had this technique fail, even in junior high schools.

When you are working with one or two people, be sure to give them positive feedback during the shooting session. When you think you have a great shot, say so. Always project an air of self-confidence. Never reveal technical problems lest your subjects doubt your ability.

Window-Light Portraits

Many news publications use mug shots, close-up pictures of faces that serve as a visual identification of the individual. But the term *mug shot* also calls up memories of your favorite driver's license photo, or a set of police ID photos hanging in the local post office. However, there is no reason why a close-up portrait for newspaper use should look like an ID card photo. By making a simple window-light portrait, you can create an image that will show what the subject of the story looks like, without making him or her look like an escaped convict.

All you need is a window and a plain background. Pose your subject so her shoulders are at an angle to the lens and her face is turned toward the camera. Be sure the background is free of distractions. If you keep the background about ten feet behind your subject and use a wide aperture, the background will be out of focus

Figure 9–20 Soft light coming in a window makes good portrait light. Use a plain wall as a background, move in close with your camera, and be sure the light is soft skylight, not hard sunshine. *(Trish Ellebracht)*

and its texture will disappear. Measure the light carefully. Take a close-up reading from her face or use an incident meter. If the shadow side is more than two f-stops darker than the bright side, have a helper hold a piece of white card so light is reflected from it into the shadow side of the face. If a card isn't available, you can use any light material, such as a pillowcase, bedsheet, or tablecloth. (Beware of using bedsheets for backgrounds, though. Unless they are ironed and hung so they are wrinkle-free, the wrinkles will show.)

The background can be either light or dark, but beware of a very dark background when your subject's hair is also dark. The two can blend together and all you'll see in the final print is a face floating in the darkness.

When composing this type of shot, move in close. Shoot a vertical image and crop in the viewfinder so the top frame edge is a couple of inches over the subject's head and the bottom is about midchest level (see fig. 9–20.)

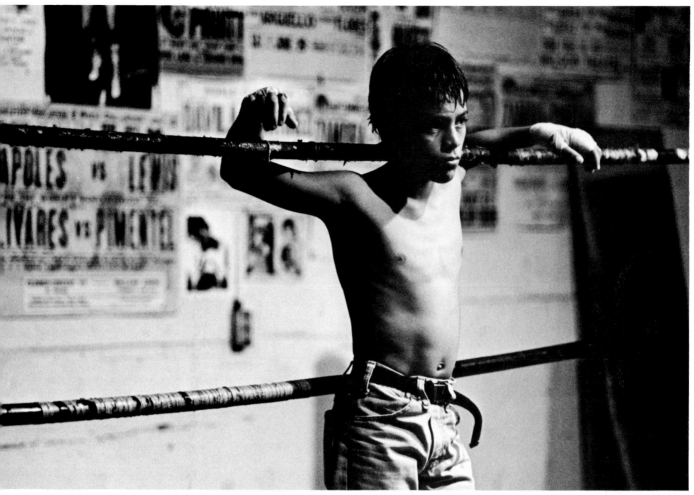

Figure 9–21 The lighting in this environmental portrait helps create a strong mood. Twelve-year-old Francisco Lisarraga, boxing for five months, has a record of eight wins and three losses. *(Tom Spitz)*

Environmental Portraits

The environmental portrait shows the subject with elements of his or her environment that reveal the person's personality (fig. 9–21).

These kinds of shots are usually made with wide-angle lenses. A common weakness is an elusive focal point. Even though your subject's environment may be cluttered, you must compose so there is a dominant element. Be sure the person is in a dominant position in the composition. Pay close attention to lighting, looking for light that emphasizes the mood.

Some critics say modern photojournalism relies too heavily on this picture style. Too many times this type of photo is used when the story is about active people. Although I think the photo in figure 9–21 is a good one, a portrait is a static image. If at all possible, show your subject in action, not posing or acting for the camera, but doing what the story is about.

Figure 9–22a through 9–22c show how *San Jose Mercury-News* photographer Cheryl Nuss successfully solved this problem. The assignment sheet correctly described all the wonderful things this man does, but then requested a photo of him in his office. Nuss recognized this approach to be a waste of a good opportunity to make photos in a real situation. She called the subject, arranged to spend time with him, and the resulting photos prove the time to have been well spent.

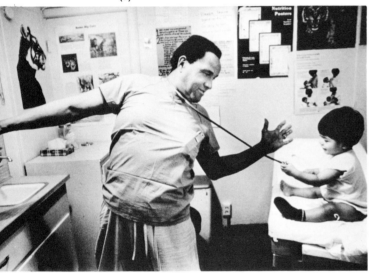

Figure 9–22 (a) Here is the assignment sheet discussed on page 165. In the second paragraph on the sheet, the photographer is asked to make a photo of this man in his office with his diplomas and stuffed tiger collection. (b) Instead of a static photo of this man in his office, photographer Cheryl Nuss found a better way to tell us about this person. (c) Sometimes a pair of photos is a better way to tell the story. When this photo is combined with (b) and a good cutline, we can learn much more about this person than by looking at a simple portrait. This man is a pediatrician and a preacher and also has a law degree. *((b) & (c): Cheryl Nuss/San Jose Mercury-News)*

(a)

(b)

(c)

Figure 9–23 Space for caption information is provided on most publications' film-processing envelopes. Supplying complete, accurate caption information is vital.

Caption Information

You must get caption information for every photo you make. If at all possible, get enough information to write a small story to go with your photos. Although you might never be asked to write such a piece, as a complete journalist, you should be ready to do so.

Names are the first priority. If there are recognizable people in your photos, you must make every effort to get their full names—not just nicknames or first names, but first and last names. Find out their addresses and, if possible, phone numbers in case questions arise later. Thoroughness cannot be overemphasized. Be accurate! Check spellings with your subjects—some common names have many spelling variations. Too many times problems arise with identification of persons in photos, and in some cases mistaken identity could lead to legal problems for you and your publication.

Use common sense on crowd shots. Obviously, if there are fifty people in your shot, you can't get all their names. But if several are featured prominently in the composition, get their names.

In addition to names, jot down the time and place the shot was taken. Include your name on the caption sheet, and explain anything that might not be clear in the photo. Don't waste time stating the obvious. Don't say "Smith looks at Jones." We can see that. Tell us which one is Smith and which is Jones and why Smith is looking at Jones.

Summary

The first step in covering news and feature assignments is to know your audience. You must look out for their interests, not yours. If you understand the issues that are important to them, you'll be able to recognize the images that will speak to that audience.

Planning is as important to photojournalism as lenses and film. Plan for the long term as well as tomorrow, be sure to read the publication you are shooting for, and learn to anticipate the moment. Determine the essence of the story, then decide what part of that essence can be shown or symbolized visually. Show people doing things rather than posing for the camera.

The three basic shots of photojournalism, the long shot, the medium shot, and the close-up, should be a part of every shoot. Keep looking for these as you work. Don't back yourself into a visual corner by failing to cover the event thoroughly. Be sure to look for different angles, and most important, the peak moment, the instant when everything comes together in one image.

When shooting news, work fast. You never know how the event will unfold, so make a few shots as soon as you arrive. Then, after you have these protection shots, look for a different way to tell the story. At all times, be alert for that peak moment.

Your professional behavior is just as important as your skill with the camera. The way you deal with people and your personal appearance affect your subjects and, through them, the final results. If you act like a professional, you will get cooperation and respect. Be assertive, but know when to be low-key.

Always get complete caption information. Double-check the spelling of names, even those that seem obvious.

Here are some tips to keep in mind while on assignment:

1. Make camera operation second nature.
2. Keep equipment to a minimum.
3. Don't say "hold it."
4. Keep moving.
5. Don't operate in a field of doubt (either yours or your subject's).
6. Set technical elements before the shooting session.

Endnotes

1. Milton Feinberg, *Techniques of Photojournalism,* (New York: John Wiley & Sons, 1970), 94.
2. Ed Dooks, "Unending Debate" (letter), *News Photographer,* August 1986, 34.
3. Mary Lou Foy, "On Covering Funerals" (letter), *News Photographer,* August 1986, 34.

Chapter 10

Sports

"Sports is the toy department of life."

—Jimmy Cannon

The Challenge of Sports Photography

Sports is an amazingly wide-ranging subject, from team events such as basketball and football, to surfing, skydiving, hot air ballooning, and horse racing. There's track and field, gymnastics, and weight lifting; archery, boxing, and golf. To capture the action on film, the successful sports photographer needs a thorough knowledge of the sport and the individual players, the right equipment, the right shooting position, quick reflexes, and good timing.

These last two are best developed by practice. Photographing high school sports is good practice because it is easier to get good shooting positions. At these games, the officials usually exert less control and you'll have more freedom to move around. Make contact with the coach several days in advance and arrange for a pass.

By the way, press credentials for major events are usually arranged well in advance and offered to credentialed media only. If you are on assignment, by all means apply for a pass. But if you are just shooting for yourself, be considerate of those who are working the game and shoot from the stands. At many events, space in the best shooting spots is limited, and the working pros don't need extra photographers in their way.

The intent of this chapter is to get you started and to give you practical advice. Most tips offered here will help you get protection shots. Protection shots, you will remember from chapter 9, are photographic insurance—angles and moments that are fairly certain to result in usable pictures. After you have some of these, then try the unusual angles or other techniques that may or may not succeed. Be as creative as you can, but be sure you have something your editor can use before taking chances.

Figure 10–1 Sports photography includes features such as this shot of a losing football team. These types of photos are not just the result of luck but require a thinking photographer behind the camera. *(Mike Penn)*

Action and Feature

The action shot is the staple of sports coverage. A friend of mine who shoots for Associated Press, says the job of the sports action photographer is to get a good picture of the significant moment. And this is a major challenge. You aren't sent to the game as an artist; a beautiful picture isn't enough. You are sent as a journalist, and you must constantly be alert for the key play that turns the game around, clinches the title, or sets a new record. It can be frustrating when the best photo is of an insignificant play and the important moments escape your lens.

We often think of the action shot when thinking of sports coverage, but the feature is just as important. This shot shows us another side of the event—the contestant warming up, enjoying victory, or suffering defeat. And sometimes the best shots come after the game is over.

The feature category also includes the illustrative shots that are carefully planned and set up. The techniques for sports features include those you'd use for news, other types of features, and illustrations.

Preparations

Just as the athlete prepares for competition before the event, you'll bring back better pictures if you also prepare before the event.

First, memorize these three rules for good sports coverage: (1) know the sport; (2) know the sport; and (3) know the sport. It's obvious that you must understand the basic concept of the game, but you can't stop there. You need to understand the strategies of the teams or the individuals and what type of action might be expected in certain situations. If you know who the key players are, you can keep your eye (and lens) on them.

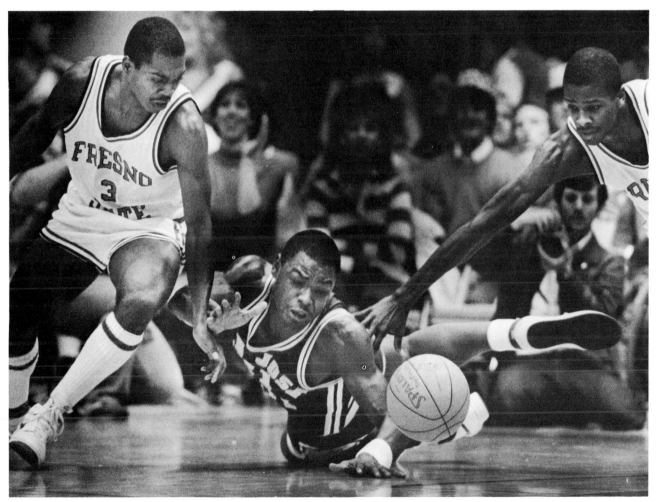

Figure 10–2 The action shot is the basic sports photo. Getting good action shots requires a knowledge of the sport and the teams, the ability to anticipate, and quick reflexes. *(Gary Kazanjian)*

Figure 10–3 It is not unusual for photographer Curt Chandler to have to shoot in bad weather. Sometimes cold and wet is the lot of the sports photographer. *(Nancy Stone/Plain Dealer)*

Check with your sports editor or the press information official at the event for tips on who to watch. Perhaps someone is expected to break a record, or maybe a certain player has a personal trademark maneuver that you should watch for.

Robert Hanashiro, an award-winning photographer who has shot almost every sport from small-town basketball to the Olympics, says, "Read your own paper! You'd be surprised how many journalists don't read the paper they work for. Most sports sections run 'pre-stories' or player features before the game. Study these stories. Often they will tell you a lot (especially about the opposition which, if they are from out of the area, you may

know nothing about). Often you can find out who the key players are, what type of offense they run, and so on. The more information you have on these teams, the more prepared you are to shoot the game."

I remember learning this lesson the hard way. I used to shoot high school football games along with the sports editor for a small newspaper. The editor also took along a camera, and we would usually stand near each other along the sidelines. I'd shoot every play like crazy, and this editor would only occasionally raise his camera and take one frame. He'd shoot one or two rolls per game and always get better shots than I did. It finally dawned on me that he out-shot me because he knew the teams, their players, and techniques. While I was trying to follow the ball through my lens, and often getting fooled, he had a fairly accurate (as accurate as you can be with high school football!) idea of what was going to happen.

Equipment

It is the photographer, not the camera, that makes the pictures, and some of the most famous images in the history of photojournalism were taken with simple equipment. But good sports photos are a lot easier to make if you have the advantages of telephoto lenses and other specialized gear.

Although you can get by without the fancy stuff you see some professionals carrying, a telephoto lens is a must. Most sporting events are such that you can't get close to the athletes, and photos taken with a normal focal length lens will require so much enlargement that the image will fall apart technically. Remember, when you enlarge an image, you enlarge its defects, too. Grain and lack of sharpness add little to your photos. And even if the grain and sharpness were acceptable, you'd probably discover that the enlarger won't blow up the image as much as needed anyway.

Of course, the telephoto reaches out to the distant action, but its minimal depth of field also isolates the player from distracting backgrounds. Remember the discussion of depth of field in chapter 4. By using a telephoto lens at a wide aperture, backgrounds are easily thrown out of focus.

A good all-around choice for many sports is a 300mm lens. This size is perfect for baseball and football and works well for soccer, tennis, and many other outdoor sports. Lenses with a maximum aperture of f/4 to f/4.5 are common and will work well for you if you shoot day games. The huge lenses you see many pros carrying have wide maximum apertures of f/2 or f/2.8. These lenses are almost a must for night events when low light levels require as much light-capturing ability as you can get. The drawback to these lenses, aside from their bulk and weight, is their price. You can buy a rather nice used car for what it costs to own one of those mon-

sters. If you can afford it, enjoy. If you can't, special lenses can sometimes be rented. Check with camera stores in major cities.

Holding long lenses steady can be difficult, particularly those over 300 mm. As the focal length increases, focus and camera movement become more critical. Many photographers rely on a monopod, which takes the strain off their arms and supports the camera. Tripods are useful, but only if you're shooting from a spot where you won't have to move and won't be in anyone's way, such as a photo box in the stands.

Zoom lenses can be useful for some sporting events, but most of them don't zoom past 200mm, which is not quite long enough for field events such as football and baseball. Further, their maximum aperture is usually relatively small, such as f/3.5 or f/4, which limits their use to daylight events. But you might try a zoom lens if you are stuck in one shooting position yet must cover action in several different spots. Keep in mind, though, that the action will probably happen faster than you can zoom and focus, and unless you're extremely talented with zoom lenses, you'll need to set your zoom long before the action happens. Review my comments about zoom lenses in chapter 2 if necessary.

Of course, every other type of lens has its place in sports photography. I'll make some recommendations in the section for each sport, and you'll discover your favorite choices as you cover the various events. The best lens in any situation is the one that works for you.

Motor Drives Many beginning photographers think that a motor drive is a must for covering sports. Not true. It helps, but look back to some of the great sports photos taken in the days of the Speed Graphic, when every shot required a separate piece of film in its own film holder. Those photographers succeeded because they were able to anticipate the action. You must develop the same talent, even with a motor drive.

Why? There are several reasons. The primary one is a matter of timing. During a motor drive sequence, the shutter is closed, not open, most of the time, which means that the odds are good the peak action will happen when the shutter is closed. I suggest, therefore, that you learn to shoot the moment you want to capture. Then you can let the motor make subsequent photos in the instant that follows. Even this technique isn't necessary on every play, because the follow-through just isn't always worth photographing, and editors don't run sequences of photos as often as you might think.

A good use for a motor is when you want to make several photos a fraction of a second or so apart. Use the motor to wind the film for you so you will be ready for the next shot. Those of us who are left-eyed particularly appreciate this feature, because we must move the camera away from our focusing eye to operate the film-advance lever if there is no motor.

Another reason for going easy on the motor drive is one of logistics. The more you shoot, the more photos you must process and edit. At a major event, the publication may be set up to process and edit as much as the photographers can shoot, but at routine games and under tight deadlines this is no small consideration. So if you don't have a motor, don't despair. And if you have one, use it with careful intent, not reckless abandon.

Basic Techniques

First, arrive early so you can check the lighting. At night or indoor events, you should be able to get onto the field or arena floor to take light meter readings. An incident meter is useful for this because, as you recall from chapter 3, it reads the light as it comes from the source without the influences of the subject. Take meter readings from the edges of the playing area as well as the center; there can sometimes be a big, yet visually unnoticeable, difference.

Artificial lighting at a particular arena usually stays the same, therefore, keep a file of exposure information so you'll remember what works best. If you find yourself shooting an out-of-town game, check with the local newspaper's photographers or the stadium's press relations office for any special tips they can offer.

Second, check the shooting positions. If the event is drawing major coverage, you might have to pick a spot and stay there to keep someone else from claiming it. (At some events, shooting spots are assigned by stadium management.) Check for unusual shooting positions, such as particularly high or low angles, or side views. Catwalks and towers provide different perspectives, but be doubly careful when up there. A lens dropped from a catwalk could be fatal to someone below.

Speaking of shooting positions, if you are covering an event with another photographer from your own publication, do *not* stand side by side. You'll both come back with the same shots. Work a different side of the field. Remember, for photographers a sports event is not a social event.

Before the game is also a good time to get close-ups of athletes warming up. These shots can come in handy if an athlete does exceptionally well and you don't manage to get an action shot of him or her during the event.

Be sure to stop by the press box and pick up a program or speed card. A speed card is a single sheet with projected starting line-ups and complete rosters both numerically and alphabetically. Don't depend on the reporter to provide your IDs.

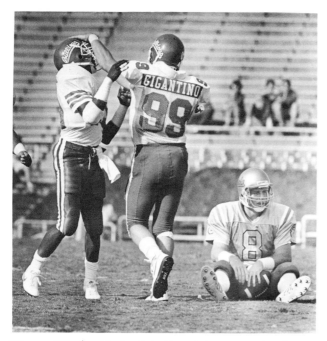

Figure 10–4 The best shot is not always a peak action moment. Here the winning quarterback reacts to his tenth sack of the game by players his team has still soundly defeated. *(Kurt Hegre)*

Shooting Tips In general, watch for faces as much as possible. The face is the primary human communicator. Shoot not only the action, but also the reaction (see fig. 10–4). Sometimes a photo of an athlete reacting to a win or loss says more about the game than anything else.

When shooting action, look for the peak moment— the instant when the athlete has put forth maximum energy. The peak moment of a jump, for example, is when the jumper has reached the highest point but hasn't yet started back down.

When you first start shooting sports, you might be disappointed at the number of shots that don't work out, particularly those taken at fast-paced events. If you see a shot and you haven't time to focus precisely, push the button anyway—you might get lucky. Accept the fact that a certain percentage of your shots will be fuzzy.

But the editor wants pictures that are sharp. You can increase your average by using the techniques discussed in chapter 4, such as zone focusing and prefocusing. Follow focusing, focusing the lens as the action moves within your frame, is very important, and you should practice this technique. Just as a trombone player knows where the instrument's slide should be for a certain note, you must know where the lens' focusing ring should be for a particular distance. Find a busy intersection and practice focusing on passing cars. No need to shoot pictures—just practice focusing the lens.

Microprisms and split-image aids on focusing screens often go dark when used with telephoto lenses, so some photojournalists replace the screens in their cameras with plain mat screens which they find easier to use. If your camera does not have this option, you can still use the mat area around the central focusing aids.

In addition to skilled focusing, anticipating the perfect moment is important. It will take a half a second or so for your brain to tell your finger to press the button, and a few more tenths of a second for the shutter to open. If you wait until you see the perfect moment, it will be too late.

Framing is another factor you must consider before it is time to press the shutter. Some shots are better framed horizontally, others vertically. Plan ahead, since the time it takes to twist the camera around could cost you the shot. For example, many basketball photos are best shot as vertical compositions, and a lot of football plays are best shot as horizontal compositions. But you might want to use vertical framing for a football pass receiver, or a horizontal frame for midcourt basketball action.

Keeping Notes Taking pictures is only part of the job of a sports photographer. You will also be expected to keep track of the players and the plays that you photograph. Be accurate. Of course, you'll have picked up a program and speed card before the event so, in the case of team sports, you'll have a record of players' names and jersey numbers.

But don't count on being able to see jersey numbers in every shot. Make a note after the play so you can refer back to it later. It is also good practice to shoot the scoreboard after any major play and at least once on every roll. This shot provides you with a visual clue, and can help you and the sports editor determine which play is which.

If there is no scoreboard, or you need to record some other information, you can write it in your notebook and then take a close-up shot of the note. You've probably seen motion picture photographers use a slate to identify take one, scene two and so on. Some photographers use microcassette recorders for keeping notes, but the drawback is that you have to listen to the tape later, and there may not be time. If you're not working with a writer, stop by the press box after the event to get the statistics and official results.

If the game is being broadcast, you can carry a personal radio and let the announcer help you keep up with the action. After a play, the announcer will probably identify key players. If you hear a lot of talk about a particular player, that's a tip-off that you should try to get some action shots of him or her.

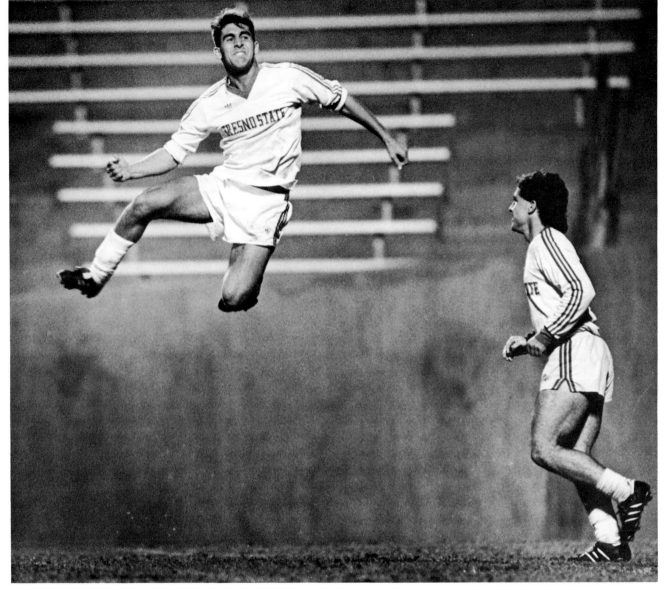

Figure 10–5 To capture the peak moment, you must anticipate a bit since there is a split-second delay between the time you see the moment and the time the shutter opens.
(Glenn Moore)

The following sections list some tips for specific sports, but keep in mind that the ideas I offer for one sport might be just as effective for another. At the fundamental level, the keys to good sports photography are universal.

The Big Three: Football, Baseball, and Basketball

A recent survey showed that 60 percent of Americans are interested in pro football, and 59 percent are interested in baseball.[1] Nationwide, basketball, both college and pro, draws the attention of about 30 percent of our citizens. Readers want to read about their favorite teams, and it's our job as journalists to report the action.

Football

Although baseball has been called the national pastime, I think football probably could be called the national passion. To do the best job of capturing the essence of the game, find out who the key players are and whether they tend to pass or run the ball. And learn some game strategy, such as when a team is most likely to run, pass, or punt.

The stands provide a good vantage point, but unless you have a very long telephoto lens, such as a 1000mm, the action will be too small in the frame. Even if you could borrow such a lens, its relatively small maximum aperture (surely not wider than f/4 or f/5.6) might not admit enough light for night games.

Figure 10–6 Due to the helmets and face guards, getting good facial expressions from football players is difficult but still something to try for. *(Lane Turner)*

The most common spot for shooting football is along the sidelines. Beware of the restricted zone in front of the players' bench. It's usually marked off with a line, and you'll have to stay out of this zone. NCAA rules set the bench area between the 25-yard lines; in the NFL, the bench area is between the 30-yard lines. Walk around behind the players to get to the other side. Also, there may be a second line painted on the field four yards outside the playing field sideline. This second line is the limit for photographers. At some fields, this limit is rigidly enforced; at others you can get right up to the sideline. Photographers are sometimes required to kneel when shooting along the sidelines so that people behind them can see the field. In these cases, you may find it helpful to wear knee pads. At some important games,

you may be assigned to a particular side of the field, but usually, you'll have a choice. For day games, your decision should be based on which side has the best light.

The weather can be a problem, and the challenge here is to dress to stay warm and dry yet still be able to move freely. Sometimes, wet and cold is the lot of the football photographer. If it rains, put a plastic bag over your camera to keep it dry. A loose-fitting parka with many pockets is very useful.

During the game, pay careful attention to what's going on, but don't root for your favorite team. I know one photographer who always ends up cheering for his home team when he should be shooting pictures. And I shouldn't have to warn you about players heading in your direction. If your eye is glued to your viewfinder

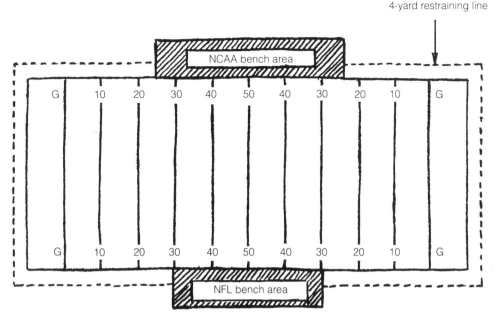

4-yard restraining line

NCAA bench area

G | 10 | 20 | 30 | 40 | 50 | 40 | 30 | 20 | 10 | G

G | 10 | 20 | 30 | 40 | 50 | 40 | 30 | 20 | 10 | G

NFL bench area

Figure 10–7 Under NFL and NCAA rules, photographers must stay four yards back from the sidelines. The players' team area is between the 25-yard lines in the NCAA and the 30-yard lines in the NFL. Photographers must walk behind this area to get to the other end of the field.

and you don't realize how close the players are, you might find yourself underneath several hundred pounds of muscle and sweat. Some photographers learn to shoot with both eyes open, one looking through the viewfinder and the other watching for hazards. This technique takes a bit of practice, but it's useful.

Your position along the sidelines is a key to getting good shots. The tried-and-true shooting position is about ten yards ahead of the line of scrimmage. This spot has its hazards, though, because the officials stationed beside the line of scrimmage, the line judge, and the head linesman, often end up in front of your lens. When the play begins, try to follow the ball. You'll be fooled often enough—after all, deception is one job of the offensive team—but if you've done your homework, you'll succeed, too. On a pass, don't follow the ball, but swing your lens to the receiver and use the second or two before he catches it to focus. (This technique is also useful for any other sport involving a ball in the air.) Sometimes you can anticipate a pass and move downfield to be closer to the receiver. You'll just have to rely on luck to put you on the right side of the field. If the team has a star receiver, and particularly if he's working on a record, you might concentrate on being in the right place to get the record-breaking moment.

Beware of bringing back nothing more than the usual standard shots of the halfback carrying the ball or getting tackled. Watch for possible quarterback sacks and

pass receptions. Keep in mind the strategic situation on the field. When an offensive team moves within about 20 to 30 yards of the end zone, it is in scoring position, and you should move downfield to be ready for a possible touchdown. When the team gets within 10 to 15 yards of the goal, consider moving to the end of the field to get the action coming toward you. If the offense is playing near its own goal line, watch the defense since it could get possession of the ball and change the course of the game. At night games, double-check your exposure in the end zones, as these areas typically are not as bright as midfield.

Don't forget that there are pictures off the field, too. The coaches and players on the bench will be reacting, so use this chance to get tight close-ups of their faces. One beginners' mistake is to shoot too many pictures of cheerleaders, mascots and fans at routine games. If the event is a big one, there might be a place in the paper's coverage for these photos, but otherwise, one or two photos will be run and they will probably be action shots or sideline reactions. Don't force your editor to wade through a batch of useless pictures in search of what is needed.

Equipment Sports photography expert Robert Hanashiro advises photographers to take only what will be needed to the sidelines. ''All a camera bag does at a football game is weigh you down and get in the way. It

Figure 10–8 The most common shooting spot is along the sidelines. Your exact spot depends upon the teams' position on the field. *(Robert Hanashiro/Visalia Times-Delta)*

doesn't help you while you're following the action and trying to balance a 400mm lens on a monopod. And putting that camera bag on the ground on the sidelines is a definite no-no. Take two or three camera bodies with just the two or three lenses you need for the job.''

You'll need a telephoto lens to get close to the action, and a 300mm lens is a good choice. This focal length lets you move in visually yet still leaves some room in the frame to show the overall play. A longer focal length, such as a 500mm or a 600mm will be needed to isolate individual players. It takes some practice to focus these extremely long lenses though, and your percentage of sharp pictures will be rather low at first. If you must work with shorter lenses, particularly those shorter than 200mm, you'll have to wait for the action to come to you. If you try to shoot all the way

across the field with, say, a 135mm lens, you'll have to enlarge the image so much that you'll probably end up with objectionable grain and loss of sharpness. If all you have is a normal lens, then you'll have to use a technique that was common before high-speed films and fast telephoto lenses were available. Find a spot along the sidelines ahead of the line of scrimmage and wait until the action comes close enough to you to fill the frame as much as possible. Sure, you'll miss many plays, but chances are good that with concentration and good timing, you'll get something.

An important technical consideration is to use a wide aperture combined with a telephoto lens to produce minimum depth of field. Because there is usually a lot of clutter along the sidelines, this technique is important for separating the players from the background. At

Figure 10–9 A telephoto lens used at a wide aperture creates a clean background for this shot of San Diego Chargers receiver Charlie Joiner on his way to the turf after catching yet another pass. *(Robert Hanashiro/Visalia Times-Delta)*

night games, minimum depth of field is easy to get, since you will more than likely be shooting at the lens' maximum aperture. But at day games, bright sunshine might require an f-stop of 11 or 16 with 400-speed film. If you face this problem you can switch to a slower-speed film or use a neutral-density filter. Either of these options will require a wider aperture, which would reduce your depth of field, although the filter will reduce the light passing through the lens and therefore make the focusing screen darker.

Generally speaking, use the fastest shutter speed you can. Unless you are looking for blur as a special effect, football photos should be sharp and blur-free. If the light is weak and you have to use a speed of 1/250 second or less, wait until the action comes straight toward you and side-to-side motion is minimized. This will reduce blur since subjects moving toward the camera look less blurry than those moving across the field of view.

I have seen some high school fields where the light was so weak there was no way to shoot without flash. In these cases, all you can do is wait for the play to come within the range of your flash. And unless you have a

high-powered one, that range is probably limited to a maximum of 20 to 25 feet.

Remember that football is a contact sport, so look for images that show that contact. Look for good defensive and offensive moves. It's not unusual for a beginner, particularly one without much knowledge of the sport, to come back with lots of photos of players running alone down the field, side views of the line of scrimmage before the ball is snapped, player pile-ups after the peak moment has passed, and so on. Remember that, just as in learning to play a musical instrument, good sports photography takes concentration and practice.

Baseball

Baseball can be tough to shoot. The game might be a pitching duel or a battle of strategy that doesn't involve a lot of spectacularly visual plays. And you can wait patiently for several innings and then have a flurry of action on one play, followed by little else. In some ways, this pace works in your favor, since there is time to prepare for action and you can usually predict where it will happen. But if you let your mind wander, fate will get even with you and you'll miss an important play.

Shooting Positions The most common shooting spot is along the first- or third-base line. There is a lot of action at first base, and if you station yourself there, look for pick-off attempts. If the runner makes a diving return, he'll be coming right at you. This is also a good place to get the face of the second baseman during a double play, since he'll be looking toward first base.

If you decide to sit along the third-base line, the third baseman and the shortstop will be facing away from you, but you'll be in a good position to catch the runner heading for second. Either spot will work for action at home; you'll be more likely to see the runner's face when shooting from first, and the catcher's face will be toward you when you are near third.

The outfield is tough to shoot no matter where you sit because the players are so far away. You'll need a 600mm or 1000mm lens for these players, and a tripod or monopod will be necessary to hold it steady. For the infield and the bases, a 300mm is a good choice if you can get fairly close to the foul line. If you shoot from the stands or a photo box, you might need a 400mm.

Beware of shooting from behind a fence because it will show up in the photos. If you can get right up to it, you can poke your lens through a gap in the wire, but be sure the entire front of the lens is unobstructed.

Because so much of the action happens at the bases, you can set up one camera on a tripod and aim it at, say, second base. Keep it focused and ready to go. You don't even have to look through the lens. Just reach over and push the button. I once knew a photographer who used this technique by aiming a separate camera at each base.

Figure 10–10 When a runner is on third, you should be ready for home-plate action such as this. *(John Walker/The Fresno Bee)*

Figure 10–11 Action on the bases is best shot with a 300 or 400mm lens. *(Lane Turner)*

He had rigged up the cameras' motor drives to foot pedals so he could cover the action at any given base or bases by pressing the pedals with his feet while shooting infield action with a handheld camera.

Baseball is one sport where prefocusing techniques are a big help. Remember the analogy of the trombone player I used earlier? It applies here, too. During lulls in the action, practice focusing your lens so you know the feel of your wrist when you are focused on each base. Don't try to follow the ball. Aim instead at its destination and wait for the moment.

As with any sport, it helps to know some strategy. If there is a runner on first and he takes a long lead, watch for a steal or a pick-off. If a runner is on second or third, be ready for action at home.

I suppose the biggest photo cliche in baseball is the second base slide. Shoot it if it happens, but try to provide your editor with something else. The shot from behind the plate of the pitcher throwing is also rather well-worn. Keep your eye on the dugouts for a few reaction shots of the managers and coaches. If you need a shot of a strong hitter, anticipate the swing slightly. If you don't anticipate the swing, it will be long over by the time your shutter opens.

Use the highest shutter speed you can to stop the action. If part of the field is in shadow and part in sun, you might need to set your exposure system on automatic or make manual adjustments . (If you do this with an aperture-priority exposure system, beware of letting the camera set shutter speeds slower than 1/250.) Keep an eye open for a drop in light caused by passing clouds, too. At night games, wait for the peak action if the light is too dim to permit a shutter speed of at least 1/250.

If you shoot a day game in bright sun, you will be working with a very high-contrast scene. In black and white, the white uniforms could be so white they lack detail and texture in your print, while the faces under the caps are too dark. It is almost impossible to burn and dodge these small areas. A solution to this problem is to reduce the contrast of the negative by overexposing it and underdeveloping it. Try shooting 400-speed film at a speed of 200 or even 100 and reducing your development time by about 20 percent. This method will reduce the negative contrast and make the shots easier to print.

By the way, there aren't many papers that can afford the luxury of paying a photographer to spend the whole afternoon at a baseball game. It's not unusual for a photographer to have other assignments or early deadlines and have to get a good photo in an hour or two. This is true for many sporting events, and it definitely puts pressure on the photographer. If you find your time running out and you have yet to get an action picture, shoot

Figure 10–12 Keep your eyes open for exchanges such as this. At some games there is so little action that this might be all you will get. *(Peter Koeleman/Union-Tribune Publishing Co.)*

some pitcher or batter shots and some reaction shots of players in the dugout. Such routine shots don't win awards, but at least you'll have something.

Basketball

There are two big challenges in shooting basketball: lighting and keeping up with the action.

The first problem exists because the light in so many gyms just wasn't designed for photography. At normal exposures with 400-speed films, you might find your

meter calling for shutter speeds of 1/250 or 1/125 second, even with the lens wide open. These shutter speeds just aren't fast enough to stop the action in basketball. One solution is to rate your film at a higher speed. For example, 400-speed film can be exposed as if it were 1600-speed film. This common technique, known as pushing the film, is discussed in the Appendix. The higher film speed will allow you to use a faster shutter, such as 1/500 second, a speed that will help stop that lightening-fast action.

Figure 10–13 Because most of the action in basketball happens around the basket, many good photos are made in that area. Photographer Gary Kazanjian found a spot in the stands about even with the basket rim and used a 300mm lens to get this shot. *(Gary Kazanjian)*

The new 3200-speed films are an excellent alternative that will allow you to use a shutter speed that is three speeds faster than what you'd need for a 400-speed film. Although these amazingly fast films help solve the problems caused by low light, even they may need push processing for some extreme situations. Robert Hanashiro says T-Max P-3200 will yield very acceptable negatives at a speed of 12,500. (See the Appendix for details.)

If the gym is so dark that even push processing won't help, you'll have no choice but to use flash. Ordinarily, you'll just have to attach the flash to your camera and accept the unnatural results. If you have several flash units, you can tape a couple of them to the wall behind the backstop with duct tape and trip them with slave triggers. A slave trigger is a small electric eye that plugs into a flash unit. When the trigger sees the burst of light from any other flash, it trips the flash it is attached to. You can get slave triggers at camera stores for a fairly low price, but you'll need an additional flash unit attached to your camera to trip the remote units. Unfortunately, slave triggers will react to the flash from any photographer's strobe, so if someone shoots just an instant before you do, the remote units won't be recycled in time for your shot. Professionals with big budgets use powerful strobes, with suitcase-sized power packs, that are mounted in the catwalks above the court. These lights are tripped by radio devices attached to both the camera and the flash units. If you shoot an important game, you might persuade your employer to rent a set of these lights for you. Check with large camera stores in major cities for rates.

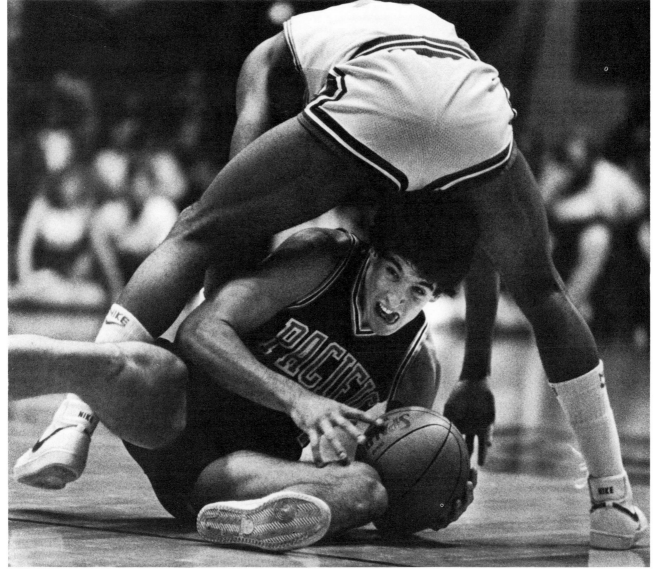

Figure 10–14 The human elements of the game are hard to get—you may have only one chance for a shot like this. To succeed, concentrate on the game and avoid socializing with other photographers. *(John Nelson)*

Be sure to check with the school's sports information director or athletic director before using flash. Some fear the flash will interfere with play.

Keeping Up with the Action I previously discussed focusing techniques, but you also need to zone-focus your attention, too, particularly in basketball. Find out who the key players are and pay attention to them. Forget trying to follow the whole game. It's just too fast. The odds are that the key players will be involved, so make those odds work in your favor.

The most common shooting position is at the end of the court to one side of the basket. In this spot, you can use a lens with a focal length of between 50mm and 105mm to get medium shots of the action at that basket.

This is probably the best spot to make your protection shots from. Then, you can try shooting from a seat at the side of the court about even with the basket. From this spot a longer lens, such as a 105mm or 180mm, is useful. If you want to try some high angles, move to the seats higher up in the stands so your eye level is just above the rim of the basket. You'll probably need a 300mm to shoot from this spot. Keep in mind that jump shots and slam-dunks have become cliche shots. As a beginner, it is fine to work on mastering these basics, but try to get photos of good offense and defense action away from the basket, too. Because of the fast-paced action, you should expect to shoot a lot of film to increase your chances of getting a good, sharply focused shot.

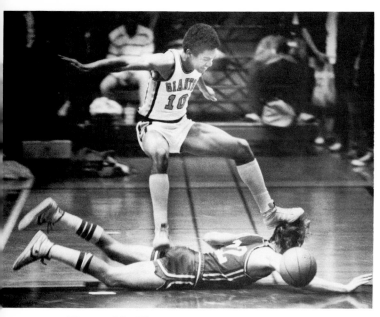

Figure 10-15 Luck does count—photographer Robert Hanashiro said this was the last frame on the roll. The player suffered a broken nose. *(Robert Hanashiro/Visalia Times-Delta)*

When shooting toward the opposite end of the court, keep your eye open and your camera ready for some midcourt action as the players run toward you. Remember, although most of the action is under the baskets, the shot of players with arms in the air has been seen thousands of times. You'll undoubtedly get a few jump shots, but also watch for good offensive and defensive moves away from the basket.

Other Sports

Although the fundamentals of sports photography remain the same, here are some specific techniques that might help you when shooting other sports. The list is far from comprehensive, but you should find tips that can be applied to any sport not covered.

Soccer

Shooting soccer combines some of the techniques used for basketball and some of those used for football. Although football moves slowly down the field allowing you to position yourself for each play, you can keep up with soccer only by picking a spot and hoping for the best. Since much of the action happens at the goals, one good shooting position is at the end of the field and just to one side of the goal. Lenses in the range of 85mm to 135mm work well from this spot.

For midfield action, you'll need a 300mm. You can shoot from the center of the sidelines, but as the players move downfield, you'll need a long lens, such as a 500mm or 600mm. Remember, the players must be reasonably large in your frame. You can't enlarge ant-sized images and expect them to be technically acceptable.

For insurance, get some goalie shots. Since the goalie moves within a limited range, focusing and following the action aren't too difficult. You should be able to get a few good saves or a successful goal. Then try for the unusual action out on the field, either by following the ball or a specific player. As with any sport, watch after the play for reactions of players and coaches.

Gymnastics

The good news about shooting gymnastics is that, except for floor exercise, the athlete's peak action takes place in a limited area. You can find a good shooting position, prefocus and wait for the moment. The bad news about this sport is that it often takes place in extremely dark gyms, and flash is usually prohibited.

Be sure to arrange for your credentials well in advance, since access to the competition area is usually restricted and you'll want to move around the floor to cover the different events. In both men's and women's gymnastics, the athletes perform both compulsory and optional routines, although a given meet may be limited to either compulsories or optionals. When shooting compulsory routines, you'll know after the first person performs what to look for since all the other athletes must make the same moves.

Telephoto lenses are a must, since you won't be allowed too close to the performer. Also, by using telephoto lenses at wide apertures, you can throw distracting backgrounds out of focus. Lights, spectators, and other equipment in the background can easily spoil a shot.

Golf

Golfers are very sensitive to distractions; you must stay out of their field of view and keep quiet. Long lenses are best for shooting the swing without upsetting the golfer. At big tournaments, photography is restricted, and you may be limited to specific shooting spots. Keep out of the line of play, and if your camera can be heard, do not shoot until after the shot has been made.

Because concentration is a big part of the game, watch for faces. The movement is usually either a drive or a putt, but you can also shoot the golfer planning the shot. Putts are often shot from a low angle to include the ball and the golfer. If you are expected to photograph a number of players, get a map of the course and take shortcuts. You might consider asking the local pro where the most troublesome holes are. Keep your eye open for strange juxtapositions, such as animals running across the course or something going on in the distant background.

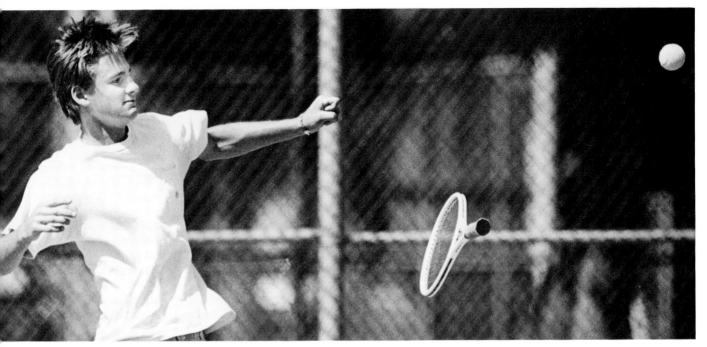

Figure 10–16 Don't try to follow the ball as it goes back and forth—just concentrate on one player. *(Ron Holman)*

Skiing

There can be beautiful action in skiing. Check the course in advance for good shooting positions, such as turns, ridges, or jumps. Backlight makes snow spray more brilliant, but be careful when calculating exposure—snow is a major meter-fooler. Play it safe and take an incident or gray-card reading. Keep in mind that a polarizing filter will reduce reflections from the snow, and that when shooting black and white, a yellow or orange filter will darken skies. If you shoot black-and-white film in bright sun, you can overexpose by about one f-stop and cut your development 15–20 percent to reduce contrast in the negative. On cloudy days, you might need to increase the negative's contrast by underexposing one f-stop and increasing development by the same percentages. I haven't found any trick that will make snow look good under overcast skies. The soft, unidirectional light that filters through the clouds masks the snow's texture and makes it look like a featureless white mass. The only alternative I have come up with is to avoid too many long shots and concentrate on medium shots and close-ups.

As with any cold-weather shooting, keep your batteries inside your coat until the last minute. Before bringing your cameras indoors, put them in a zip-seal plastic bag to prevent condensation from forming inside the camera.

Tennis

This fast game requires good follow focus and long lenses. If you are at court level, a 200mm to 500mm lens works well. Good positions are from the side or end, and if you use a high angle, you'll have better luck avoiding bad backgrounds. Outdoors, you'll rarely have exposure problems since tennis is almost always a daytime event. Indoors may be a different story, and you may have to use 3200-speed films or the push-process techniques discussed in the Appendix. Remember, though, that if your exposure drops below 1/250 second, you'll have blur problems.

Track and Field

This sport will challenge your creativity. You can use long lenses, wide-angle lenses and any number of camera positions to get an unusual view of the event. Be careful, though, of distracting an athlete before he or she starts the event. Also watch out as you move around the field since several activities are usually going on at the same time.

If you have a motor drive, you can try special remote set-ups, triggering your camera with a remote cord made to fit the motor. Discuss any unusual camera placements with meet officials in advance. Panning is a good technique for running events, and 1/125 second or slower will blur the background effectively. Some interesting

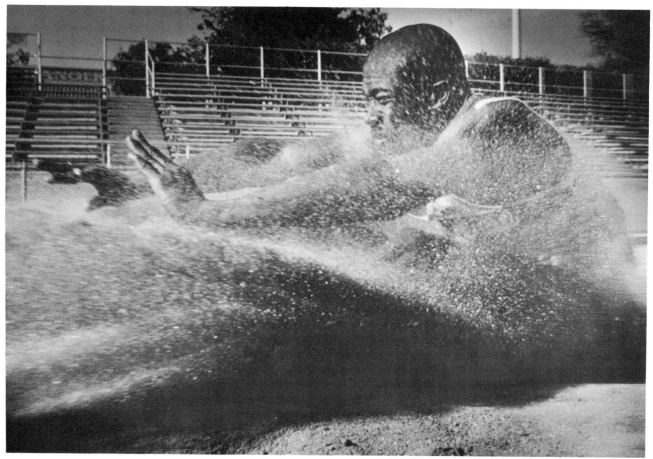

Figure 10–17 This would be a good shot to go with a profile on this athlete. At local track meets, you will have considerable freedom to roam; many different viewpoints can be found. *(Robert Hanashiro/Visalia Times-Delta)*

effects shots can be made with shutter speeds as slow as 1/15 second. When shooting relay races, watch for the baton hand-off. In races, the finish-line shot is standard, but watch for reactions after the finish, too.

Be sure to do your homework beforehand and find out if there are any potential record-breakers to watch for. Plan your coverage so you won't miss a star performer.

Ice Hockey

This fast-paced sport has lots of fights, movement, and emotion. As with soccer, the goal is a point to watch for heavy action. A good spot for covering the goal is from the side, even with the net, but there may be photo spots available near the center of the ice or near the goal. Shooting through the clear plastic safety barrier will degrade your images, so avoid that at all costs. The ice reflects light that can fool an in-camera meter, so use an incident meter or take a reflected reading off a gray card.

Boxing and Wrestling

Unless you want an overall view of the arena, you'll have to shoot from a spot close to the ring. If you can get right up to the ropes, you can use a lens between 28mm and 85mm for full-length to medium close-ups. Shooting at ringside also forces you to aim up into the overhead lights. Removing the skylight filters from your lenses helps reduce glare. With a fast telephoto such as the 300mm f/2.8, you can shoot from a little farther back and get some nice face close-ups. A peak moment to watch for is just after the punch but before the fighter pulls his fist back. In large arenas, the lights may be bright enough for normal film speeds and exposures. Smaller places are usually less well-lit and you may need a 3200-speed film or a strobe.

Wrestling usually moves a little slower than boxing. When shooting pro wrestling, watch out for fighters being thrown out of the ring—you don't want to be the landing mat. In college wrestling, the faces of the wrestlers are often turned toward the mat and will be in

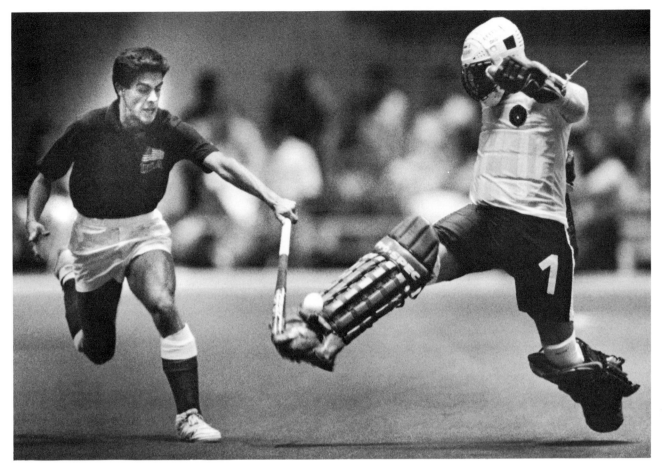

Figure 10–18 For fast-paced sports such as hockey and soccer, it is sometimes best to concentrate on several key players rather than trying to follow the ball. Quick focusing reflexes are a must. *(Robert Hanashiro/Visalia Times-Delta)*

shadow. If you can get close to the edge of the mat, consider using strobe as a fill light along with a low camera angle to catch those strained expressions.

Auto and Motorcycle Races

The prime shooting positions at motor races are often tightly controlled. Some of these spots are not behind the spectators' barricades, so you must pay attention and be careful. As with most events, get there early for a choice of spots. If there is a safety fence in front of you, it will more than likely show up in your photos, so if you can't find a spot without a fence, poke your lens through a hole in the mesh.

For road races and oval tracks, turns are good spots to watch, while pits provide a different type of action. Pan shots, taken with a slow shutter as you follow the cars, work well. Head-on views taken from a turn are also good bets. Prefocus on the pavement and wait for the cars to come into focus. At drag races, you can shoot the start or the finish, or down the track from near the finish with a telephoto. At any race, long telephoto lenses will help isolate the cars from the background, but keep your eye open for a background that can become part of the story. If you have a pit pass, get shots of the crews and drivers working on cars. Look for faces; shots of the backs of people as they bend over their machines are not interesting. Because of the lack of light, photographing night races is almost impossible.

Equestrian Events

At rodeos, needless to say, stay out of the ring! If you take a spot opposite the chutes, the action will start out coming right toward you. Remember that the cowboy-on-bucking-bronco shot is rather routine, so look for some different action shots. Don't spend all of your time on the ring, though, as there is lots of good character material around the sidelines.

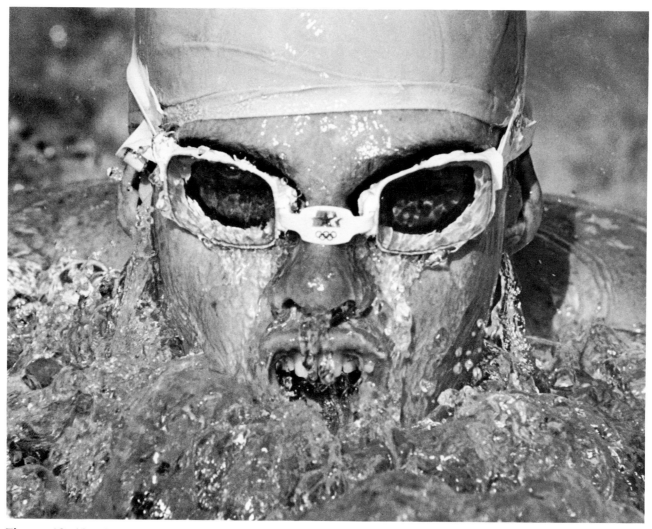

Figure 10-19 Swimmers' faces come out of the water only for a second, so you will need good follow-focus technique. *(Robert Hanashiro/Visalia Times-Delta)*

At other types of riding competitions, jumping events are visually dramatic and reasonably easy to photograph if you can get a good shooting position. A three-quarter view on the jump is a good spot to begin, but a direct side view or head-on are also good. Dressage is a specialized event that is hard to present visually because the significant movements are not overtly photographic. In thoroughbred racing, the shooting positions will probably be controlled because of the high-strung nature of the animals. Be prepared with telephoto lenses.

Water Sports

There are too many types of boating events to cover in detail here, but generally, shooting from shore is difficult. Needless to say, if you are on a competitive boat, you'll be able to get close-ups of the crew members as they work. If you can get a chase boat with an operator, you'll have many more opportunities for shots. Skiing can be shot from the tow boat; exhibitions can sometimes be shot from shore with long telephoto lenses. Drag boats can be shot from shore, since the start or finish is usually within sight of shore-bound spectators. When on the water, be sure to protect your gear from spray. Keep skylight filters on your lenses and cover cameras with plastic bags if necessary.

Swimming events can be shot from the side or the end of the pool. Diving is best shot from the side. A 200mm or 300mm lens is useful for getting face close-ups. It is often quite bright around outdoor pools so check exposure carefully. Indoor pools can be dreadfully dark and you will probably have to push process your film.

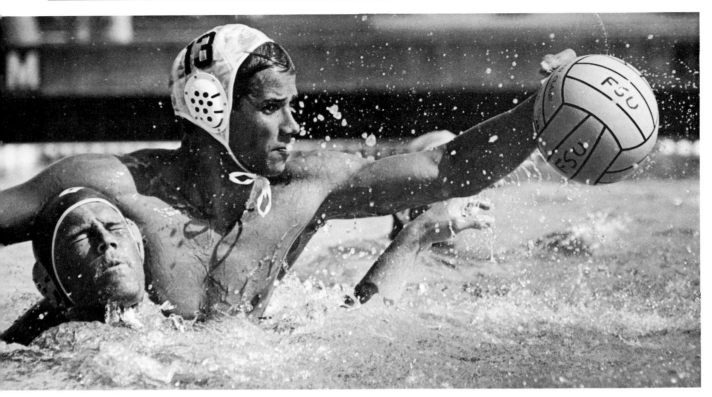

Figure 10-20 Outdoor water sports can cause overexposure because of the light reflected back up from the water and the deck. An incident meter reading is the easiest way to avoid problems. *(Glenn Moore)*

Hanashiro, who shoots for *USA Today,* says, "Timing is essential and good follow-focus technique is a must in shooting swimming. The swimmers' faces come out of the water for just a split second and there is no way to prefocus on a specific spot. The butterfly, breast stroke, and distance freestyle events offer enough opportunities for good shots. At sprint freestyle races you'll have to rely on start, finish, and reaction shots because often the swimmer does not lift his or her head out of the water for the entire length of the pool."

Shooting Under Water Aside from breathing, the big challenge in underwater photography is exposure. Unless you have an underwater meter, take a reading on the surface and add one and a half to two and a half stops more exposure as you descend from just under the surface to about 20 feet. Below 20 feet, use an underwater flash. Auto-exposure cameras will do their job, but be careful that the shutter speed doesn't get too slow. Fairly inexpensive underwater housings are available at camera stores and dive shops. Ask about renting if your need is temporary.

You probably won't be able to see through the camera's conventional finder, particularly if you wear a face mask, so be prepared to estimate focus and framing, or check with a dive shop for special framing attachments.

Wildlife

Wildlife is probably the hardest of all subjects to photograph well. Someone once said you must know the animal as if you were one. Stay downwind and plan to spend a lot of time waiting; the most likely time to catch your prey is at feeding time. You'll need to use special blinds, telephoto lenses up to 1000mm or more, remote camera set-ups, and as many other tricks as you can think of.

One *National Geographic* photographer mounted a camera on a toy remote-control tank and disguised the rig as a bush. He rolled this gadget right up to his surprised prey and got some great close-ups. I've also heard about another photographer who was well known for his hunting and fishing magazine covers that featured fishermen with record-breaking trout and bow hunters ready to shoot bear and deer that were only a few yards away. But the photos were illustrations, not photojournalism. The animals in many of the pictures came from the taxidermist.

Summary

Success as a sports photographer requires quick reactions, the proper equipment and a thorough understanding of the sport. Although your talent is the primary ingredient in good sports photos, you'll also need telephoto lenses and possibly a motor drive if you want to compete with the professionals. The 300mm telephoto is probably the most universal sports lens. When shooting with a motor, don't let it become a crutch for good timing. Learn to focus quickly and accurately by practicing; if you use a focusing technique such as zone, follow or prefocusing, you'll have a better chance of getting a sharp picture. When shooting, look for the peak moment, that one instant when the action seems to stop.

Captions will depend upon the accuracy of your notes, and you can help note-taking by shooting the scoreboard at least once on every roll. Be sure to get identification of the players involved in the plays you photograph. In general, when shooting any sporting event, make some shots from tried-and-true positions before you experiment with unusual camera angles or techniques. If your experiments fail, at least you'll have something to fall back on.

When shooting football, the spot for protection shots is just ahead of the line of scrimmage. But pay attention to the progress of the game, since you might want to move downfield to photograph a pass reception or into the end zone for a goal attempt. Baseball is almost always a risk since games can go on inning after inning without much overt action. You must stay alert to catch what might be the one flurry of action. A common shooting position is along the first-base line where you can see the face of the second baseman during double plays and can cover action at first at closer range. Practice focusing so you can quickly shift focus to any base when the moment arrives.

In terms of pace, basketball is probably the opposite of baseball. Focus is a challenge because you will often shoot at wide apertures while trying to follow the action. Beware of overloading your coverage with jump shots; try to get some good midcourt action as well. Depending on what lenses you have available, there are several good shooting positions. The most common is at the end of the court and to one side of the basket, where a normal or medium focal length telephoto works well. If you have a longer lens, you can shoot from the stands at a point level with the basket.

There are so many other sports, each with its own special characteristics, that it is hard to generalize, but if you plan ahead rather than relying on last-minute arrangements, your coverage will benefit.

Endnote

1. "Sports Survey," in *The World Almanac and Book of Facts* (New York: Pharos Books, 1987), 859.

Chapter 11

Studio Photography

Outline

"I have found that the successful photographers usually are not successful only because they are technically good."

—Philippe Halsman

A Different Approach

You might be puzzled to find a chapter on studio photography in a photojournalism book. But you'll understand why it's here by looking carefully at many of the same publications you look to for examples of good news, features, and sports. In fact, many photos we include in the category of photojournalism are carefully set up and lit for the camera. Skill in the studio has become just as important to the photojournalist as any other skill the medium requires.

Additionally, by now you should be convinced that photography means "light writing," and that learning to use light to your advantage, regardless of the situation, will expand your photographic vocabulary enormously. Studio work is an excellent means of developing your lighting skills.

There is a big difference, of course, between the conceptual approaches of working in the studio and shooting on the street. Shooting news is like hunting. You are looking for the picture that is already there. Your controls are limited to vantage point, choice of lens, and timing. Your thinking must be fast, and usually involves anticipating or reacting to the event. But in the studio, you create an image from nothing. You have complete control over every detail, and your thinking can be as deliberate as deadlines permit.

Some photographers enjoy this total control and carefully planned image making, yet others find walking into an empty room and coming back with a photograph to be horridly frustrating. Regardless of how you feel about working in the studio, you'll find the lessons learned there carry over to the work you'll do in the field.

Equipment for Studio Photography

The equipment inventory of many studios looks like a cross between a hardware store, a mad scientist's laboratory, and a junk shop. Improvisation is the rule. You don't need a lot of fancy stuff to get started, and a heady dose of ingenuity will help solve most problems. Keep in mind that you control only what the camera sees, and that your controls include anything you can do to the light as it comes from its source, reflects off the subject, and makes its way to the film.

The primary equipment in the studio is the lighting instrument along with its accessories. You must control the type of light—hard, soft, or somewhere in between—and where the light falls on your subject. Although there is a plethora of lighting equipment available, you can do a lot with a few simple items.

I want to emphasize that studio photography is not limited to those photographers lucky enough to have a big room filled with expensive equipment. The large lighting units you see in some studios put out lots of light for those cases when small apertures are a must or large scenes are on the agenda. All shots in this chapter as well as the illustrations in the color section could have been done with inexpensive floodlights or small flash units such as those in figure 11–2. Diffusion and reflector panels like those in figure 11–1 can be made from plastic water pipe and white rip-stop nylon for less than ten dollars.

Light Sources: Flood or Flash

Two types of lights are commonly used in the studio: flood and flash. When using floodlights, you can see the

Figure 11–1 Studio lighting equipment. At the far left is a diffusion frame made from plastic water pipe covered with white rip-stop nylon. To the right are a photo flood and an electronic flash head with a snoot attached. Next is an electronic flash unit bounced into an umbrella followed by a lamp equipped with barn doors.

lighting effect while you work, and the lights them-selves are inexpensive, lightweight, and portable. One big disadvantage is that they generate a lot of heat. In fact, photographers who work with floods often call them "hot lights." A second drawback is output. The small floodlights that you are likely to use are not as bright as many electronic flash units.

A good electronic flash unit, however, is bright and cool, but it is hard for a beginner to estimate the results since the effects of its short burst of light can't be studied. Flash equipment made for studio use solves this problem by including a small modeling light that stays lit during set-ups. If you have access to this type of equipment, enjoy. If not, you can set up your shot with floodlights and then replace them with flash units for the final exposure. After you gain some experience, you'll be able to predict flash effects with reasonable accuracy.

Many news photographers use small handheld flash units such as the Vivitar 283 or 285 when studio-type lighting is needed on location. Two or three of these flash units, some lightweight stands and a cheap white umbrella bought at a variety store during the rainy season can become an inexpensive portable lighting system. One flash must be connected to your camera so it will fire when the shutter opens. The other flash units are tripped via slave triggers. These gadgets are about the size of a ping pong ball and are plugged into the sec-ondary flash units. When the main flash goes off, the slave triggers sense the light from the main flash and trip the remote units. Using such a set-up is fundamentally the same as using larger, heavier units in the studio.

Figuring exposure for flash is different than for floodlights because the short burst of an electronic flash unit cannot be read by a conventional light meter. Studio systems do not use automatic exposure devices such as those discussed in chapter 6, and the exposure control circuits in small flash units won't work unless the sen-sors can be aimed directly at your subject. If you don't have one of the special exposure meters made for flash, you can make estimates based on the charts or calcu-lator dials that come with most flash units. Professionals often use Polaroid instant films to make exposure tests. If you have a film processing tank and chemicals handy, you can always shoot and process a test roll of the same film you intend to use for the assignment.

Light Control

Remember from the discussion of light in chapter 6 that light and shadow give shape and form to your subject. Light, or lack of it, also creates atmosphere, mood, and dramatic impact. The goal in light control, then, is to establish a light source and apply it to the subject so the mood and shape seen by the camera are exactly what you want.

When shooting news, you'll almost always have to take the light as it comes, but in the studio, you can decide whether to use hard light, soft light, or some-thing in between. Hard light is easy to create—just aim the flash or floodlight directly at your subject. To create soft light, you can diffuse the light emitted by the bulb either by bouncing it off a broad panel, a light-colored wall, or into a white umbrella, or by aiming it through a translucent panel like the one at the far left in figure 11–1. Devices like these are also very handy for creating fill light. Just use them to reflect light into the areas that need fill. White cardboard, aluminum foil, and small mirrors also make great reflectors.

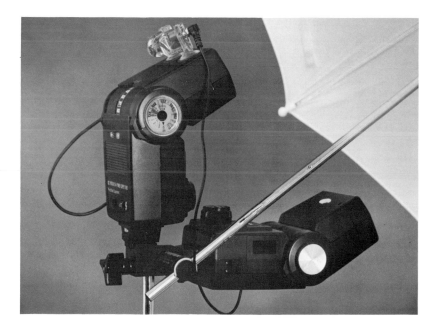

Figure 11–2 Two Vivitar 283s and an inexpensive umbrella can be combined for a handy lighting unit. The small devices atop the upper flash are slave triggers. The flashes and umbrella are held onto the light stand by an adaptor invented by a news photographer and marketed by Stroboframe.

There are any number of ways to gain additional control over the spread of the light. You can make *flags,* which are pieces of cardboard used to block the light from reaching specific areas of the subject. *Snoots* and *barn doors* are light controllers that attach directly to the lamp and help narrow and aim the light beam. You can improvise these with aluminum foil or pieces of mat board. (By the way, if you work with floodlights, be sure that any material used close to the bulbs is flame-proof.) Examples of some of these devices are shown in figure 11–1.

Other Equipment

Other important studio equipment includes light stands, a tripod and a cable release. A handheld light meter makes exposure calculations easier since so many set-ups call for either incident or close-up readings. Useful items include a lens shade to cut down the chance of lens flare, and masking tape, duct tape, spring clamps, and clothespins for holding things in place.

Basic Tips for Studio Photography

One interesting facet of studio work is that each assignment presents a different problem which, in turn, calls for a different solution. This fact makes it very difficult to set out a series of general guidelines, but if you keep a few basic principles in mind, solutions to new problems will be easier to find.

First, be sure to have the scene and camera position set before you try to set lighting. Since highlights, shadows, and other aspects of your lighting must be set according to what the camera sees, it is a waste of time to light before this viewpoint is established.

Second, keep lighting simple. Lighting should help, but not *be,* the photo. If the reader looks at the photo and sees only your masterful lighting job, then you've failed. There should be one dominant light source. If possible, stick with one lighting instrument and use reflector cards for fill. When you add lights, you increase the complexity of the set-up and increase the chance for error. (Besides, lighting equipment costs money. If you can do a good job with less, why not?) Always start with all lights turned off (including room lights) and add one light at a time, checking the effect carefully from the camera position as you go.

Third, crop in the camera. Framing your image the way you intend it to be seen is just as important in the studio as in the field. Extensive cropping and enlargement in the darkroom increases grain and fuzziness, and there is little excuse for this result when you are in complete control.

Fourth, use a tripod. A steady camera helps make sharp pictures. Also, because your scene must be arranged and lit for a specific camera position, control is easier to maintain if the camera position is fixed. By the way, once I have the tripod in position and the camera set, I tape the tips of the tripod legs to the floor with duct tape so they won't get bumped out of place. No matter how careful I am, Murphy's law always intervenes and I trip over a tripod leg just after everything is perfectly set!

Fifth, use a slow-speed film if possible. You'll almost always want the finest grain and sharpest image possible. If you're using floodlights, their low output might force you to use long exposures, but this situation should be no problem because your camera will be held steady by the tripod and your subject will often be static. Even in the case of a portrait, 1/8 second is not unusual. Your subject should have no problem holding still for that brief moment.

One important exception: If you use floodlights and want to freeze a moving subject, you may have to use a high-speed film in spite of its grain, because floodlights may not be bright enough to permit short, action-stopping exposure times with slow-speed films.

And a final, miscellaneous tip: Use care in choosing background material. Wrinkled bed sheets look like what they are. Professionals use all kinds of materials for backgrounds, but the easiest for a beginner is a plain, textureless wall or the seamless background paper available from most large camera and art supply stores. A medium gray works well when making portraits for publication because both light and dark hair will stand out from it.

Of course, there are exceptions to all these suggestions, and those with studio experience will recognize when these suggestions should be bypassed. But as with all the advice in this book, use it as a starting point and a point to return to when you are confused about what to do.

Making a Formal Portrait

Making a formal portrait might seem like a boring project when compared with shooting the action situations that comprise so much of modern photojournalism. But before you write off this task as something to be merely endured, let me explain why learning these techniques is so important. First, if you intend to pursue photography as a professional, you will eventually be asked to do these kinds of photos, and you will be expected to do them right. Those who plan to pursue writing, public

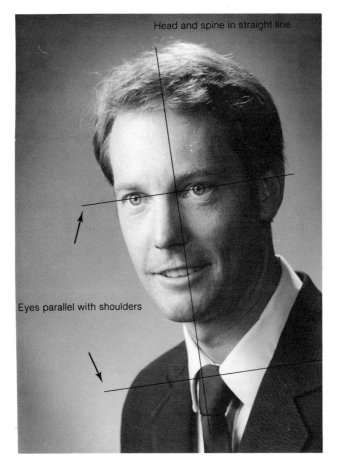

Head and spine in straight line

Eyes parallel with shoulders

Figure 11-3 When posing a person for a formal portrait, keep the head and spine in a straight line; the eyes and shoulders should be parallel. *(Randy Dotta-Dovidio)*

relations, or advertising and intend to hire a photographer when needed, should know what a well-made portrait involves. (There is nothing more embarrassing for a corporate executive than a poorly made portrait.) And finally, the lighting techniques used for the formal portrait are basic ones that can be applied to many other subjects and situations.

As you begin, keep in mind the first guideline I mentioned in the last section: Set the pose. Until the pose and camera height are determined, lighting can't be perfected.

The Pose

There are many types of poses for a portrait but the one presented here should work in almost any situation that calls for a formal presentation. You should complete your set-up with a volunteer stand-in before Mr. or Ms. Big Shot arrives. It is poor form to keep a busy executive

waiting while you fiddle with lights and cameras, and some executives won't give you but ten or fifteen minutes anyway.

Seat your subject on a low stool. If you must use a chair, use a firm one such as a typist's chair or classroom-type chair. Be sure your subject is sitting up straight and not leaning against the back of the chair. Turn the person to about a three-quarter angle to the camera as in figure 11-3. The person's head should be perpendicular to the shoulders so that a line drawn through the eyes is parallel to a line drawn through the shoulders. Have your subject lean so there is a slight tilt to the shoulders as in the illustrations. Then have your subject look straight ahead so his eyes are centered in his eye sockets. Turn his head so the ear that is away from the camera just disappears.

For a formal portrait, both men and women should wear a conservatively styled top in a plain dark color. Avoid bold plaids, checks or stripes, or necklines that would call attention to themselves. Watch for wrinkles in jackets. Common problems are for collars to ride up in the back or wrinkles to form in the sleeves. Lapels can also buckle. Pulling down on the jacket should correct these problems. (Don't ask your subject to do this because the wrinkles will just come back after he resumes the pose.) Be sure ties are straight and jackets are buttoned.

Camera Position and Choice of Lens

Now that you have set the pose, set the camera height. I prefer a straight-on camera position with the film plane parallel to the subject's face, as in figure 11-4. A slightly higher camera is sometimes used to give more emphasis to the subject's eyes, or to de-emphasize the lower part of the face due to a large, protruding, or double chin. A lower camera angle can de-emphasize a long nose or wide forehead, but I am not comfortable with this angle because it can result in emphasizing the subject's nostrils.

To prevent the unnatural distortion that a wide-angle or normal focal length lens will cause, use a lens slightly longer than normal focal length. I prefer an 85mm lens when shooting with a 35mm camera because I can stand closer to my subject and establish better rapport than possible at the distance required by a 105mm or 135mm lens. This is a personal preference, though, and these longer focal lengths are also good choices.

By the way, the cropping on the figure 11-3 is a compromise. Portrait photographers would say it is too tight, and that the face would be overpowering if enlarged to 16 × 20 or more for a display print. On the

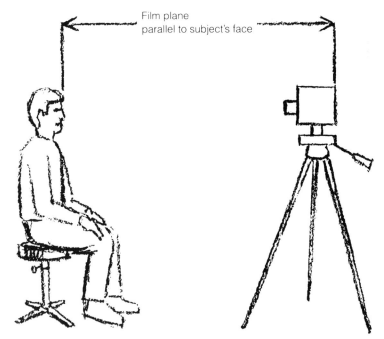

Film plane
parallel to subject's face

Figure 11–4 Adjust the camera height so the film plane is parallel to the subject's face.

other hand, many photo editors would prefer a closer crop to keep the face from being too small, particularly if the image will run small in the publication.

Lighting

First, you must decide whether to use hard light or soft light. The differences in impact created by these two types of light were covered in chapter 6. In portraiture, I think soft light is more forgiving, both for the photographer and the subject. Minor mistakes in light position or slight facial irregularities are less noticeable with soft light. Hard light creates a rugged look, which you might want for some people, but its shadows are sharply defined and must be placed with care.

Regardless of the type of light you choose there are two basic lighting arrangements for a portrait: short light and broad light. In short lighting, the main light is aimed at the side of the face away from the camera and is used when your subject has a normal-width or wide face. Broad lighting is aimed at the side of the face that is toward the camera, and is used when your subject's face is narrow. See the illustrations in figure 11–5d and 11–5e.

After you have decided which light type and style to use, place the main light. Turn off all other lights, including room lights, and set the main light high and to the side so it casts a shadow of the subject's nose that

falls downward toward the corner of the subject's mouth, as in figure 11–5a. Watch the subject's eyes. If they are deep-set and begin to get lost in eyebrow shadows, lower the main light a little. If you use broad lighting, use a cardboard flag to cut down the light on the subject's ear.

Then set the fill light. Since its job is to fill in the shadows the camera sees, put the fill light about a foot or two higher than the camera and only slightly to the side. Be sure it is on the other side of the camera from the main light. And remember, since you are producing an effect for the camera, check lighting effects only from the camera position. Look through the lens and check the background for shadows of the subject. If shadows can be seen, eliminate them by increasing the distance between the subject and the background.

The fill light should be dimmer than the main light, so back it away from the subject if necessary to reduce its intensity. A lighting ratio of 3:1 (or one and a half f-stops, see chapter 6) is about right. To measure the lighting ratio, turn off the main light and measure the fill with a light meter, then turn on the main light and measure the highlight areas. If you don't have an incident light meter, you can use a gray card as a target for your reflected meter. If you don't have a handheld meter, you'll have to take the camera off the tripod and take close-up readings as described in chapter 3.

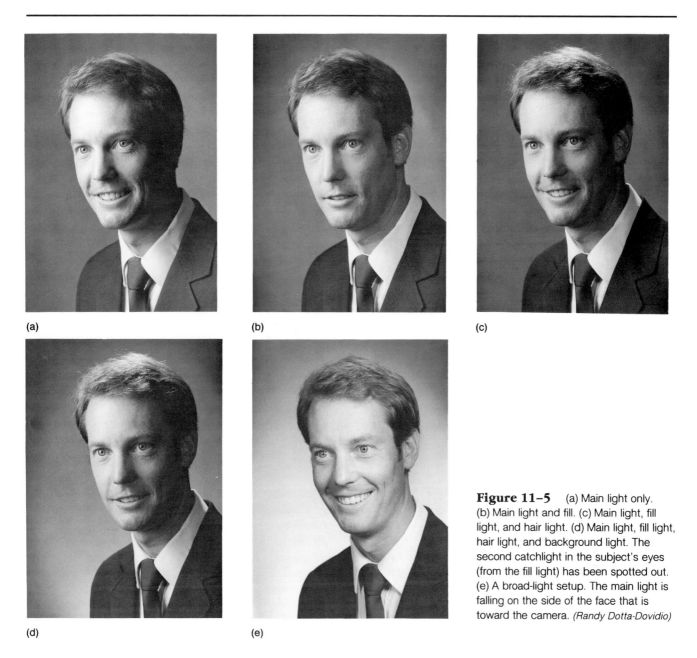

(a)

(b)

(c)

(d)

(e)

Figure 11-5 (a) Main light only. (b) Main light and fill. (c) Main light, fill light, and hair light. (d) Main light, fill light, hair light, and background light. The second catchlight in the subject's eyes (from the fill light) has been spotted out. (e) A broad-light setup. The main light is falling on the side of the face that is toward the camera. *(Randy Dotta-Dovidio)*

After these lights are set, you can add what are known as *accent lights.* Accent lights add small highlights to specific spots in a photo. An important accent is the *hair light,* which is placed above and behind the subject to create a highlight on the subject's hair and separate it from the background (fig. 11–5c). Don't make the mistake I once did and use a hair light on a bald person! Keep bald heads in shadow by using cardboard flags between the main light and the top of the subject's head to block the light. Finally, a *background* light can be added for additional background separation (fig. 11–5d).

Eyeglasses can present a lighting problem. Eyes in a portrait are important because they convey much of the person's personality, and if your subject wears eyeglasses, you may have to compromise on lighting and camera position so the eyes don't disappear in shadow. First, be sure the glasses are up against the bridge of your subject's nose. Then lower the main light so the glasses' frames don't cast a shadow across the pupils of the eyes. Reflections of lights in the glass can be reduced by having the subject tilt her head slightly, and by moving the lights slightly. Some portrait studios solve this problem by having a selection of empty frames handy.

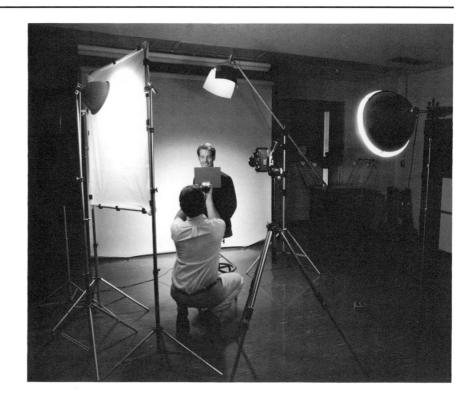

Figure 11–6 The main light at the left is being diffused by a panel made of white rip-stop nylon attached to a frame made from plastic pipe. Photographer Randy Dotta-Dividio is using a gray card as a target for his reflected light meter.

A Basic Tabletop Shot

It is risky to suggest a universal lighting set-up for small products, because each product has its own set of challenges: color and tone, shape, reflectance, and character. Use the ideas here as a starting point for experimentation.

Begin by setting up your background. Use care in selecting background material; one frequent flaw in beginners' studio work is a background that looks shabby or that competes against the concept of the photo. Although background paper is useful for a simple product shot, you'll see all sorts of background materials used in illustrations and commercial photos. If you can, try some of these: smoked glass, plastic countertop material, black velvet or velour, white translucent plastic (with light coming through the underside), flooring materials, ceramic tiles, black Plexiglas, and old barn wood. The list is endless, and a good studio photographer is always on the lookout for interesting background materials. Visit lumberyards, fabric stores, home improvement centers, and art supply stores for ideas.

After the background is ready, set your subject in place. For an overall view, use a three-quarter perspective. When setting up the scene in the viewfinder, remember to allow space in the composition for copy if necessary. Use a medium focal length telephoto lens to minimize subject distortion, and try to use a small aperture so the depth of field extends from the front edge of the product to the back edge.

Lighting

As with all lighting, set the main light first. If you need to show texture, place the light so it rakes across the subject. Food is often lit this way, the main light coming from behind and to one side of the set. If you need to show shape, place the light over the subject or to the side so it creates shadows and highlights. Avoid front light since it does not produce those all-important shadows. A way to light glassware without annoying reflections is to eliminate the traditional main and fill, use a translucent panel as a background, and aim the light through it. When glare and extraneous reflections must be eliminated in shiny metal objects, enclose the object in a tent made from thin white cloth, then aim the lights through the cloth.

Fill light is set near the camera and adjusted so the shadows have the desired brightness. If important detail must be seen, keep the shadows not more than one and a half to two stops darker than the highlights. Remember: check the lighting ratio, turn off the main light, and meter the fill light, then meter both main and fill together. Use the latter reading for your exposure settings.

Accent lights can be created with spotlights or reflectors and are added if needed to create a highlight along an edge of the subject or lighten a dark shadow. Background lights can be used to provide background separation.

Figure 11–7 The main light is coming from a large diffused source (such as the panel in figure 11–1) placed directly over the subject. The light fades off toward the rear and the background therefore fades to black. You can see a white card reflected in the front of the can, which was used to block the reflections of the photographer and his camera. *(Richard Eissler)*

Figure 11–8 The background in this shot was a piece of black Plexiglas. Background gradation was created by controlling the placement of the overhead soft light. *(Richard Eissler)*

Figure 11–9 This is where the light was placed for figures 11–7 and 11–8. Here the diffusion panel is not being used. The white card is reflecting fill light into shadows.

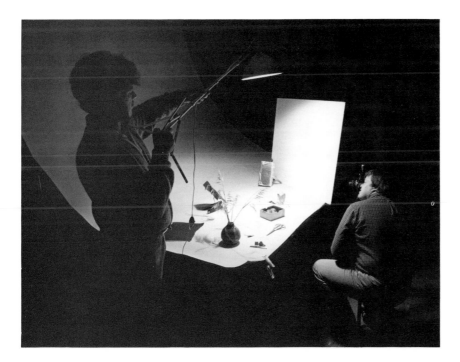

Figure 11–10 Shiny metal is colorless and can be shown only through what it reflects. Look closely at the pots and pans and you will see the pieces of white board the photographer used to create shape and control reflections. *(Richard Eissler)*

You should know by now not to fall into the trap of trying to eliminate the shadows within the subject. You can eliminate the shadows cast by the subject onto the background underneath it and thereby make the subject look suspended in space by setting the product on a piece of glass suspended between two supports. Have the background far enough from the bottom of the subject so that the shadows cast by the subject fall out of camera range. Then increase the light on the background until the reflections of the subject in the glass disappear.

Finally, bracket your exposures in one-stop intervals for black and white, one-third-stop intervals for color. If you can leave your set-up in place until you process your film, so much the better, since surprises sometimes crop up that call for a reshoot. Common problems include background defects, unnoticed shadows or reflections, and lack of sharpness, or depth of field.

When setting lights, there is one common beginner's mistake that you should avoid. It happens when working with hard light and the light on the subject isn't bright enough. You'll be tempted to move the lights closer to the subject, because that will make the subject brighter. But if you get the lights too close, say within a couple of feet, the lighting contrast—that is, the difference between the highlights and shadows—will increase and you'll have to use stronger fill light, too. And, the bright areas closest to the light source will be significantly brighter than the bright areas farthest from the light source. (Review the inverse square law of light in chapter 6.) As you move the light source closer to the subject, this effect gets stronger and more evident in the photo. The solution is to keep your lights back from the subject at least six or eight feet. If more light is needed, use a brighter light.

This problem is less severe with large soft-light sources because the light that hits the subject is actually coming from a number of different points and is spread

Figure 11–11 For an article about the IRS limiting business meal deductions, Mike Penn created this illustration. *(Michael Penn/Anchorage Daily News)*

out. Many times a studio photographer will place the soft-light panel as close to the subject as possible so the light tends to wrap itself around the subject.

Illustrative Photography

The job of an illustrative photo is to suggest, clarify, or explain. It can show the reader how something works, visually show relationships between concepts, summarize the story in a visual form, or present the subject of the story in an idealized way. The photographer can bring elements together before the lens that would never occur naturally, and can show aspects of a story that documentary images could never accomplish. Examples of successful illustrations are figures 11–11 and 11–12 and plates 15 through 18.

One important point must be made: Be sure the illustration is obviously an illustration and not a staged news picture. An illustration, through its content and execution, should be so obviously an illustration that the reader does not doubt for an instant what type of photo he or she is looking at. Illustrations that look like spontaneously shot news or feature photos might be misleading to the reader and can cause people to question the publication's credibility.

Be sure, too, that an illustration is the best approach for the story. George Wedding, a well-known photo editor, says never substitute an illustration when a good documentary photo can be made. I agree. An illustration is probably not the best approach for a serious story. I think readers prefer the real thing over artificial situations.

How to Get Ideas

A major factor in the success of an illustration is the idea, and many illustrations that fail do so because of a poor concept. Avoid the predictable. Go beyond the obvious, trite or sophomoric. Two common examples frequently found in the campus press are the alcoholism story illustrated with a silhouette of a person and a liquor bottle,

Figure 11-12 Fatigue flattens millions of people every year. One survey found fatigue to be the seventh most frequent complaint at doctor's offices. Geff Hinds started with that concept and produced this award-winning illustration. *(Geff Hinds/Tacoma News Tribune)*

Figure 11-13 This photo was made to illustrate the communication problems between teenagers and their parents. The picture won first place for editorial illustration in the 1987 Pictures of the Year competition, but some judges felt it looked too much like an actual documentary photo. *(V. Jane Windsor)*

and the final exams/all-night studying/term paper crush story illustrated with some variation of a person sitting behind a pile of textbooks holding his or her head. These kinds of photos don't tell your reader anything and are a waste of space. Consider visual approaches that symbolize rather than present literal representations of the theme or idea. An illustration should add to the story just as a good documentary photo does.

So what is the key to a good idea? Unfortunately, there is no easy way to great illustration ideas. It's hard work, but you can do some things to tip the odds of success in your favor. I am reminded of a story I once heard about a group of Japanese photo students who toured the United States. One assignment while they traveled was to make 120 different photographs of a pair of sunglasses. The instructor knew that the first thirty photos would clear away all the preconceived notions and obvious solutions. The second thirty probably would be variations on the first. By the time the students got halfway through the project, they would be generating new ideas. Well, I'm not suggesting that you come up with 120 ideas for every assignment, but I am suggesting that you think up at least a dozen. Never quit after one idea pops into your head.

When working on picture ideas, start by formulating them in terms of an overall concept or theme. This type of thinking will create a framework so when you get down to specifics, you'll be more likely to create an image whose parts work well together.

Figure 11–14 Gary Chapman and his crew set up for the illustration in plate 18. The photo was to illustrate Guillain-Barré syndrome, a neuromuscular disease. *(Gary Chapman/Louisville Courier-Journal)*

Steps in Idea Generation Read the story. This step is obvious, but experience tells me that I should remind you again.

Brainstorm. Get together with the other people involved with the story and suggest ideas. But observe one important rule: Do not criticize ideas at brainstorming sessions. If you shoot down ideas at this point, the shy people will quit contributing, and the subconscious thinking that can lead to better ideas will quit working.

Create a headline. It might be only a temporary one, but it should be a usable headline that could run with the story. The headline will help you define a concept or theme for the photo.

Use a clip file. When you see an interesting photo, clip it out and file it away. Start folders for various categories: food, fashion, product, industrial, and so on. When you need an idea, you can use these clips as inspiration.

Make sketches. Never mind if you're not an artist. Sketching your idea will help you previsualize it and recognize problems before you begin. Plan how the illustration will be used on the page. How large will it be? Will it include type? Special borders? Other elements? What display typeface will be used?

Set a schedule. It takes time to do a good illustration. You should plan on at least a day to gather all the ingredients and plan the shoot, and another day in the studio shooting.

Special Considerations: Food, Fashion

Food is harder to photograph than you might think. Because film can't capture the taste or smell of food, all you have to work with are its visual qualities. Professional photographers often hire food stylists who know how to prepare food for the eye. A photograph can take two or three days to design, set up, and complete, so stand-in food is used for set-ups so the actual items can be fresh. Cooked food must be visually perfect, and garnishes and decorations are vital parts of the scene. Fruits

Figure 11–15 This shot includes space at the top for copy. All of the elements have been carefully coordinated. (Original in color.) *(Keith Seaman)*

Figure 11–16 Strong backlight helps bring out texture and create a dramatic feeling for this beef. (Original in color.) *(Keith Seaman)*

and vegetables must be flawless—no wilt, no dents, no brown spots. Beef is often cooked a little on the rare side so it will maintain its redness. Gelatin can be made with a half a pack extra so it will stay firm for the camera.

Liquids need something extra so they aren't dead-looking in the glass. Props such as ice (pros use non-melting Lucite blocks), swizzle sticks, straws, and so on help. Sometimes a single bubble resting against the edge of the glass is enough. A drop of detergent added to the liquid will help make bubbles. To make sweat on the outside of a glass, use glycerin (from a pharmacy) mixed with water. Spray it on with an atomizer; apply large drops of pure glycerin with a toothpick. Cooking oil spread with a basting brush makes things shiny.

The props are just as important as the food. They must complement the food and should support the theme. All props should reflect the same mood: formal and elegant, down-home country, ethnic, or whatever. When shooting in color, the color of the props should be carefully coordinated, with each other as well as with

the food. Be accurate. Don't do a bread shot with a sheaf of barley (or worse, weeds) alongside the loaf when you should be using a sheaf of wheat. If you photograph wine, be sure to use the right glass (not all wine glasses are alike). And props should be either new or have that interesting patina that comes with age and use. Stuff that has seen the usual household use usually looks shabby. Import stores and junk shops are good sources for interesting props, and sometimes an antique store will rent or loan a particular piece. See plate 17 for an interesting combination of background and lighting.

Because of the attitudes we have toward our food and how it looks, food photography is probably the most difficult studio assignment. J. Bruce Baumann, photo editor of the *Pittsburgh Press* and a former judge of the Pictures of the Year competition, says too many food photographs fail because of poor concepts. Food that is poorly prepared for the camera is simply unappetizing. Humor in food photos usually fails, he says, resulting in "photographic salmonella." To test your idea, he advises, ask yourself, "Would you eat that?"

Figure 11–17 Soft side light is good for many fashion shots. *(Richard Eissler)*

Figure 11–18 Open shade works well for exterior fashion. *(Paul Rutigliano/Ros-Lynn Studios)*

Fashion: Room to Experiment

Successful fashion pictures require a good concept based on an understanding of fashion trends and the qualities of the specific garment —its lines, textures, and mood. One type of fashion photography shows the clothes in complete detail, another creates an atmosphere, a mood, a feeling of what wearing the clothes would be like.

There is no way to generalize about fashion lighting and other visual techniques, since they are as much a part of the concept as any other element. It is probably best to start with location work, learning how to control the model and integrate the setting into the photo. Many effects that would be considered defects in other genre are used here intentionally with success. Ghosting, extreme grain, high contrast, soft focus, and blur are some examples.

Important contributors to a successful photo are the models and the location. The models must be appropriate for the clothes. I can't give you a checklist for selecting models because so much of it is intuitive but, for example, some people look better in western wear than formal evening dress. Working with a professional model is a luxury that I hope you get to experience; a pro knows what's needed and how to produce it. When

professionals are not available, I suggest using dancers or actors. I find these people are more in tune with movement than most amateur models, and are only too glad to work with you. Pay them if you can, but many times they will trade their talents in return for photos.

Be sure the clothes are new, properly fitted, and ironed. Clothes that have been worn for a while show scuffs, stretches, and sags, and unless that's what you are after, the look will be amateurish. Problems with fit can be cured with temporary fixes. Tape or clothespins applied out of camera view can tighten a garment; gently crushed tissue can fill out a garment.

When directing models, I prefer to set up a scenario and let them act it out. This encourages the models to be spontaneous and to contribute ideas. Saying "hold it" can result in stiff-looking poses, so I suggest banning that term from your shooting session. Posing works better if the model is on the move and you use your sense of timing to catch the moment. This is true even for situations where the pose is to look static. The model is still making extremely subtle movements; changes in eye position or a tiny facial muscle. The model is free to move, but can sense when the two of you are onto something that is working.

During the session, give positive feedback. Let your models know that you like what they are doing for you. If there are technical problems that they can't do anything about, keep them to yourself. Never allow negativism to arise.

Summary

Working in the studio can be an exciting experience, because you are in complete control of every aspect of your image. Your thinking will take a different tack than you may be used to, because you will have to invent the photograph instead of searching for an existing arrangement.

Setting up your scene requires the same feelings for composition and design that you'd use for any photograph, so the main emphasis in learning to work in the studio is the control of light. Simple controls include blocking the light from a specific subject area by using cardboard flags, and reflecting the light into shadows with white cards, aluminum foil, and the like.

When setting up a shot, set the scene and the camera angle before you try to set lights. Then arrange the lighting as you check the effects from the camera position. Establish one main light source and keep your lighting simple, using as few lights as possible. Remember that a studio photograph should be technically perfect, so use a tripod and a fine-grain film if possible to gain maximum sharpness. Cropping should be done in the camera so grain and sharpness don't suffer because of excessive enlargement.

When making a formal portrait, set the pose first, then set the camera height, and finally, set the lights. Short lighting is used for normal to wide faces, whereas broad light is used for narrow faces. For both portraits and tabletop set-ups, soft light is more forgiving of beginners' mistakes.

Illustrations are useful in photojournalism because they can show relationships and make visual explanations that can't be photographed otherwise. But beware of deceiving your reader with illustrations that look like candidly shot news photos. Don't substitute an illustration when a good news photo can be made.

Encourage the growth of ideas by writing a headline and getting together with colleagues for a brainstorming session. Plan your illustration carefully, avoiding the obvious solution at all costs.

When shooting food, be sure the food items are as perfect as possible, and that the appropriate accessories are included. Light to show the texture of the food. For fashion, select models carefully and be sure clothes are new and well fitted. Make sure backgrounds do not detract from the clothes.

Chapter 12

The Photo Story

"My photographs at best hold only a small strength, but through them I would suggest and criticize and illuminate and try to give compassionate understanding."

—*W. Eugene Smith*

Story or Essay?

A photo story is a narrative set of pictures that work together to present a single topic. A complete photo story includes headlines and captions and a carefully coordinated page layout, all of which contribute to the message. In newspapers, photo stories are usually given major display space such as an entire page or series of pages, whereas magazines might devote many spreads to a long photo story.

To many photojournalists the photo story is the ultimate in photojournalism because it offers a chance to dig into a situation, develop a close rapport with the subjects, and display the result in the best possible manner. In some ways, a photo story is easier to produce than a single picture because all the elements of the story don't have to be fitted into a single frame, and the photographer has more time to understand the story and develop rapport. But in many other ways, the photo story is a challenge. Making sure that the pictures will work together is often challenge enough, but the photo story also requires a carefully planned approach from the first idea through the final layout.

There is also a form of picture journalism called the photo essay. In fact, some people use the terms photo essay and photo story interchangeably, but there is a difference. An essay might rely more on symbolism and subtle relationships or juxtapositions among pictures, whereas the story has a more direct progression from picture to picture. Authors Hurley and McDougall have said:

> The picture essay is more likely to argue than to narrate. It intellectualizes. It analyzes even when it presents both sides of an issue. It's more likely to be about something than someone.
>
> The picture story's visual continuity is not a characteristic of the picture essay. Unrelated in time, unconnected in story development, essay pictures do not lean on one another. Each picture is selected to make a large point; each can stand alone. If pictures in the picture story are comparable to sentences, the essay picture more closely resembles a paragraph.[1]

Not everything is easily categorized, though. Some stories have essaylike features and conversely, some essays have storylike features. As a beginner, I think you should start with photo stories, and as your narrative skills develop, move on to the more demanding essay.

The Idea

Good photo stories start with good ideas. It's self-evident that your story idea should be a visual one, but sometimes it is hard for persons with no photography experience to recognize the visual potential of an idea.

Make your own determination; don't let someone else give you a topic with a list of pictures to be shot. Too often, these lists come from persons who aren't visually oriented, and the ideas are the obvious cliches.

The first source of story ideas is your own awareness of what is going on in your community. I've mentioned this point before, but it bears repeating. Do you read a newspaper every day? Do you know the local, regional, and national issues that affect your readers? Another good source of story ideas is the one-paragraph news briefs that most papers run. Also check the want ads and the Yellow Pages, and get out into the community. Recently, one of my students was driving down an out-of-the-way street and saw someone working on an odd-looking airplane in an old warehouse. This plane turned out to be

A full page is not always available; sometimes a photo story or essay must share the page with another element. In this case, the bottom of the page was reserved for a columnist. *(Courtesy The Virginian-Pilot and The Ledger-Star)*

a rare WWII specimen that was being restored, a project that became an interesting photo story.

And one story can lead to other ideas. For example, the airplane story could lead you to the airport where you might find an eighty-year-old pilot who still holds an instructor's certificate and still flies a biplane. Another method is to take an idea and reverse it. What about the youngest pilot in your community?

Ideas also come from other publications. There is nothing wrong with borrowing an idea as long as you modify it so the product is your own work. I remember an editor who scolded me for rejecting a story idea because it had already been done by other newspapers. She said that we hadn't done the story, our readers hadn't seen it, and therefore it was still valid for us. We would be doing our own version and not copying what had been done elsewhere. So although you should still try to come up with new ideas, it's fine to borrow from time to time.

Keep an idea file. When you get a story idea, or see a story or news item that might lead to something, drop it in your file. Then when you are looking for an idea, these clips can be explored or used to spur your mind on.

Once you have an idea, write it down. Write a sample headline and a brief statement about the essence of the story. If you can't do this, the story is probably vague in your mind, too, and the resulting photos will be scattered and without direction.

About middle-aged executives who play basketball during lunch, this is the type of story that could be done in any community in one afternoon. Simple ideas are often the best. *(Courtesy The Virginian-Pilot and The Ledger-Star)*

Figure 12–1 The elements of a good photo story are evident here: a strong, dominant lead photo, continuity among the photos, and clean page design. *(Photography by Robert Cohen; Picture editing by Jim Urick; Page design by Stephen Urbanski/The Sun Tattler (Hollywood, FL))*

Evaluating a Story Idea It is vital that you examine an idea seriously before you start shooting. Some ideas might make great stories for words but weak stories for pictures; others might be totally impractical due to time or production problems.

Here are some questions to ask when evaluating your story idea:

Is the story significant? Keep in mind some of the basic news values: conflict, proximity, and the unusual. What makes this story unique? What is it about this person or event that makes it different from all the rest? Why should readers care? If you were the editor, would you publish this story?

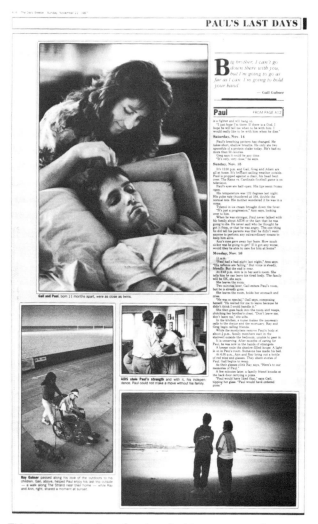

Gail and Paul, born 11 months apart, were as close as twins.

AIDS stole Paul's strength and with it, his independence. Paul could not make a move without his family.

Ray Gubser passed along his love of the outdoors to his children. Gail, above, helped Paul enjoy his last trip outside — a walk along The Strand near their home — while Ray and Ann, right, shared a moment at sunset.

This is a continuation of a story that began on another page; therefore there is no large headline. Nevertheless, there is a strong, large lead photo arranged with the other photos so the visual direction flows onto the page. *(Photos by Brad Graverson, reprinted with permission of The Daily Breeze)*

Has the story or a similar one already been covered by your publication or a direct competitor? Editors do not want to repeat themselves or what their competition has already done. If the story has been done within the last year or two, move on to the next idea. Keep in mind that this is not the same as modifying an idea from a non-competing publication.

Is the scope of the story coverable in the space and time available? You can't do the history of Western civilization on one newspaper page or in a one-afternoon shoot. A story on a hospital burn ward might be loaded with visual potential—the patients' struggles and the concern of the staff could be strong material. But the story of the whole ward is a big one, including doctors, nurses, therapists, patients, patients' families, and so on. By reducing the story to one patient's fight to return to a normal life, you have narrowed your story to something manageable.

Will the events in the story be scheduled so you can complete it in a reasonable time? If the key element in your story only happens once a month, you might find the project strung out. Long-term projects are fine as long as you know what you are getting into, but be sure that there is a definite ending in sight. And for those long-term projects, be sure the story will still be timely after it is completed.

Is the story overtly visual? Some stories lend themselves to telling with the camera, others are best told with words. A story on an accountant probably wouldn't be a good choice for telling with pictures, but you can readily envision the photos that could be made of an owner of Percheron draft horses who uses the horses to harvest their own feed. Also, some stories aren't obviously visual but could be told by a skilled photographer. I am reminded of a story one of my advanced students did on a counseling program for troubled teens. Most of the action was people talking, but this photographer had the ability to capture the subtle expressions, body language, and mood that were the visual indicators of the emotional tensions present.

Will the subject cooperate? Before you take your idea to your editor, check with your subject. It is a waste of time to consider an idea when you won't get past the subject's front door. Further, your editor's time is valuable, and shouldn't be taken up with false alarms. I recall a local foreign-born sculptor who has been the target of several photographers over the last few years. In addition to a language and cultural barrier, he's an independent sort who deals with people on his own terms. He'll let a photographer shoot for half an hour or so and then suddenly smile and say, "Enough photos. You go now. Good-bye."

Is the story something you can return to for additional shooting? Experienced photojournalists can complete some photo stories in one visit, but at first you'll need to go back and reshoot to fill in the gaps in your coverage that are bound to occur.

What technical problems will you encounter? If the lighting at the story location is weak, do you have the means to solve this problem? If flash is needed, it will be a constant reminder to your subjects of your presence. What effect will this awareness have on their behavior? Will special equipment be needed? Remote cameras, underwater gear, special lenses?

Shooting the Story

Shooting the story is not as simple as running out with your camera and snapping away. If you take this approach, you'll most likely come back with a set of photos that is little more than a collection of assorted pictures, and such collections do not make good photo stories. Don't count on being rescued by editorial salvage.

Understanding the Story

To do a comprehensive job, you should know the story better than anyone else. *National Geographic* photographers spend weeks researching a story before they even think about picking up a camera. Such detail is impractical in newspaper work, where you may have only a couple of afternoons to shoot, but you should gain as much background information as possible in the time available. This research does two things. First, it will prepare you to recognize moments and situations that need to be captured on film. Second, it is of major value in establishing rapport with your subject. This research could include a preliminary visit to your subject where you might make some photos. As you'll see in the following discussion of the two case histories, this step can be an important part of developing the story line.

After your research is complete, write out a temporary headline and short description of the story if you haven't already done so. This headline, even though it may not be the one ultimately used, becomes your guidepost when shooting. It will help you see the photos that need to be made, and it will help you avoid going off on tangents, wasting time shooting things that don't relate to the immediate story. Time and time again, I have been presented with photo story contacts that are disjointed; important pictures are missing, and there is no continuity among those taken. Without fail, the cause can be traced back to a lack of direction, direction that could have been provided by a simple headline.

TABLE 12-1 Story Idea Checklist

- Is the story significant or unique?
- Has the story already been covered by your publication or the competition?
- Is the story coverable with resources available?
- Will the scope of the story fit publication space?
- Is the story overtly visual?
- Will the subject cooperate?
- Is the story a one-time event or a continuing one?
- What technical problems can be expected?

TABLE 12-2 Sample Shooting Script

- Long shot
- Medium shot
- Close-up
- Lead photo
- Portrait
- Interaction
- Sequence
- Detail shot
- Closer

For a photo story to work, there must be some thread running through the pictures that ties them together. This thread might be the person that is your subject, or it could be the location, time, or event. Regardless of the specific device, you must maintain continuity in the content of the photos, because without it, all you'll have is a collection of assorted pictures. Working with a headline in mind is a big help, as is keeping your idea simple and limiting the number of key characters.

The Shooting Script

Once you have a headline, you can develop a shooting script, which is a more detailed list of the kinds of situations and photos that you will look for. Your script must be a flexible plan, because things often don't turn out as expected, but it will get you started and help keep you on track. Be careful of predetermining too much. Regardless of your familiarity with the story, your preconceived notions should not slant the story in an inaccurate direction. You should photograph the story, not create it.

A photographer for the long-since defunct *Look* magazine gave me the following basic shooting script, and it's still valid today.

1. *The three basic shots.* Start with the three basic shots discussed in chapter 9: long shot, medium shot, and close-up. Remember, the long shot shows the overall scene and helps the reader understand the relationships of the parts. The medium shot moves in on the action, and the close-up reveals details and emotion.

2. *Lead photo.* Next, and most important, is the lead photo. This is the shot that sums up the story and gets the largest play in the layout. Finding a strong lead photo is often the major challenge in shooting a photo story.

3. *The portrait.* This picture isn't necessarily posed, but it is a close-up of the face of the key character. It should be more than just a shot for the record; it should show this person's personality or the emotions involved in the story.

4. *Interaction.* The subject should be shown relating to other people. This is an important element in most stories and one beginners often miss. To get good interaction photos, you must be in a position where you can see what is going on. You must anticipate because these moments go by quickly.

5. *The sequence.* Not all stories will lend themselves to sequences, but if they are there, shoot them. A sequence is not necessarily a motor-drive series, but any progression through time.

6. *The detail shot.* This is an extreme close-up of a small detail. It might be a cowboy's boots outside the bunkhouse door, or his worn hands and the reins of his horse. This shot adds flavor to the story.

7. *The closer.* This is the shot that ends the story. A good closer is not necessarily the last shot taken, but is the shot with which we say good-bye. Sometimes a good story should end before every detail is told.

Of course, not all stories will have all of these shots. The lead and the closer are always necessary; the others will depend upon the situation. And although you won't necessarily shoot these photos in the order I've presented them here, you should keep reviewing your progress as you shoot to be sure you have complete coverage.

But shooting a photo story is more than going down a checklist of photos. You must go beyond the obvious description of what this person is doing. Show the reasons why and the consequences; show us the motivations. Let us see something we couldn't ordinarily see for ourselves. When you feel yourself getting emotionally involved, trust your emotions and shoot what you feel.

Subject Rapport

One of your jobs is to gain the trust and confidence of your subject so he or she will share those personal moments with you. Keep a positive attitude; never allow negative comments. Keep technical problems to yourself. And when you encounter someone whose ideas about life are opposed to yours, keep quiet. Don't engage in philosophical or political arguments. Find some point of agreement and keep conversation centered on him or her, not you.

One problem you may run into is the self-conscious poser. This person has a hard time getting used to the camera's presence and wants to make everything "look right." This is the parent who runs over to comb a child's hair, or the executive who cleans off his or her desk in anticipation of your visit. But you have to make it understood that you want to photograph them while they do what they would be doing if you weren't there. Changing things for the benefit of the camera sets up an unreal situation. You have to convince them that you will photograph with sensitivity and respect, and aren't out to do a hatchet job or embarrass anyone.

At first you can count on shooting some film just to break in your subject and get him or her used to the camera. After a while—the time varies with each person—the camera will no longer be intimidating and you can get into the core of the story. As you progress, give some positive feedback to your subjects. A few strokes aimed in their direction encourages them to continue working with you.

Sensitivity to Unspoken Signals

You also have to be sensitive to the unspoken communications from your subject. Know when to pull back and when it is time to leave. Don't wear out your welcome, and don't shoot the subject to death. And if you are doing an emotionally intense story, watch for those private moments. Some things are important to the story and must be shot. Some aren't. There's no way I can give you a checklist to recognize these situations; all you can do is shoot carefully, with sensitivity and awareness.

After you finish a shoot, never show your contacts to your subject. (The only other person who should see them is your editor.) People don't realize that you are

quite likely to make photos that don't work out, shots that catch them in an awkward moment. If your subjects see your mistakes, they might lose confidence in you and worry that the story will embarrass them. Further, this fear increases their desire to influence the editing of the story, an involvement that should be strictly prohibited. If it seems appropriate, bring some prints to the subject, some shots that you are sure they would like. One of the greatest public relations devices a photographer has is the 8 × 10 print.

Editing the Pictures and Designing the Page

Once the photos are shot, you have to edit and present them in a logical manner on the page. Don't try to include too many pictures; on a newspaper page, five or six is enough. If you have the time and resources, make some small workprints from a dozen or so of the shots you think best tell the story. These don't have to be perfect, just make quick prints so you can better see the images. Then get down to the final selection by cutting the redundancies and shots that are technically weak. Remember that visual redundancies can occur in photos that are graphically different but make the same statement. Cut out obvious cliches. And keep in mind that a straight chronology might not be the best approach; you might want to edit the pictures by theme or idea.

When laying out the page, there should be one large, dominant lead photo. Remember, this is the picture that is the peak of the story—make it the biggest picture on the page, and be sure it is significantly bigger than the others. One common mistake beginners make is sizing the lead photo too small.

Then fill in the details, using other pictures that support and explain the lead. Group the photos together, clustering the supporting photos around the lead. Sometimes your detail shot makes what I call a headline shot, a small photo that can be used near the headline as a symbol of the story. Give the headline good display too since it is the verbal counterpart to the lead photo. Don't create a Swiss-cheese look with bits of copy jumping among scattered pictures. Place the photos together and be sure the copy flows in a logical manner. Keep the white space to the outside of the layout and make sure the small spaces between photos are consistently sized. When laying out the shots, set up the page so the reader's eye flows through the pictures with the energy flow of each image. Try to keep the flow of each photo going onto the page.

Although captions are discussed in chapter 13, it's important to mention here that a good caption adds to the photo. It does *not* repeat what the viewer can see

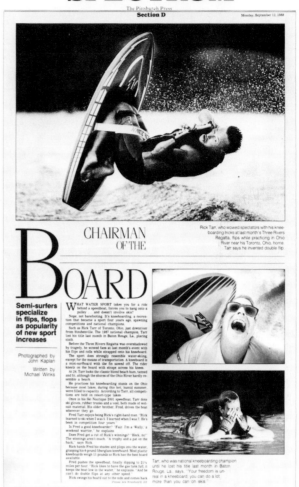

Figure 12–2 When designing photo pages, the headline type should also be considered a design element. Notice the alignment of the two cutlines. *(Photos: John Kaplan; Page design: J. Bruce Baumann/The Pittsburgh Press)*

in the photo. Keep the captions adjacent to the pictures; avoid centralized cutline blocks that force the reader's eyes to jump around on the page trying to match pictures with cutlines.

Case Histories

For all photo stories, the fundamental considerations are the same: getting a good idea, finding the images that best capture the story, and presenting them to the reader in an effective manner. To better understand how the process works, here are some case histories.

Figure 12–3 This photo story on a foster grandmother is discussed in the text. Some of the photos that were not used are in figure 12–4 a–e. *(Photos by Lisa Waddell; Picture editing by Murray Koodish; Page design by Brian Stallcop and Murray Koodish/The Memphis Commercial Appeal)*

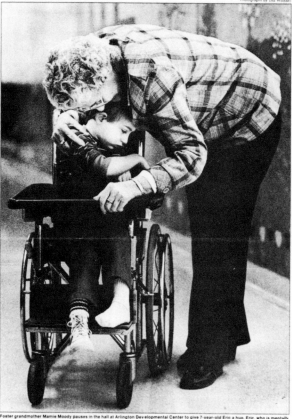

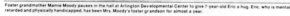
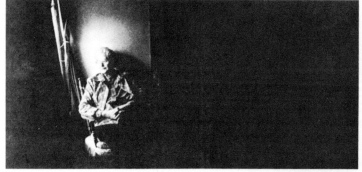

A Time for Love

The story in figure 12–3 was photographed by Lisa Waddell and edited by Murray Koodish of the Memphis *Commercial Appeal*. Figure 12–4a through 12–4e are some of the other shots that were considered for the story.

This story began with the photographer, Waddell, who was looking through magazines in the library trying to find story ideas when she came across a generic story about the Foster Grandparent Program. After suggesting the idea to her editors, she tracked down the person in charge of the local program. She was granted clearance to visit the center and made an initial trip to check out the situation and find a grandparent/child combination that would work well for the story.

(a)

(b)

(c)

(d)

(e)

Figure 12–4 The photos in this series are ones not used in the "A Time for Love" story in figure 12–3. *(Lisa Waddell/The Memphis Commercial Appeal)*

At that first visit, Waddell spent the day shooting photos of various grandparent/child couples, looking for one that would work out best for the story. Because children in such situations are protected by privacy laws, the director of the center had to get permission from the parents of any child Waddell wanted to photograph. "The challenge was to find a grandparent that was willing, plus one of the children whose parents didn't mind them being photographed," Waddell said.

One of Waddell's reasons for selecting the pair in these photos was that there was some visible interaction between the woman and the boy. Many of the children, she said, were incapable of much visible response to their foster grandparent's attention.

Although she had many pictures from that first day, neither she nor editor Koodish wanted to take such a generalized approach. Waddell said, "We had enough pictures to make a page layout, but it wouldn't have meant as much to just have a bunch of cutsie pictures of grandparents hugging, grandparents picking kids up." Koodish added, "We thought that by honing in on one relationship, we could get more dimension than by shooting a whole bunch of different people."

On four subsequent visits, Waddell concentrated on this one pair. "I was trying to get her interacting with the kid, to show that she was helping the child; and in the same way the child was helping her. I found out what activities they had during the day, and that's when I would go." She said it took several visits to get the woman used to being photographed. "It takes a while for people to trust you and go on about their life as normal."

Waddell said she was not looking for specific pictures, but wanted to concentrate on images that showed the need on both sides. "They both are at the end of the spectrum where they are in need of other people," said Waddell. One big difficulty was finding different types of situations to photograph. The children almost never leave the facility, and their awareness of their surroundings is extremely limited. "There aren't any activities that they do with the kids. It's mostly hugging and loving and touching. It was hard to get away from that one shot," Waddell said.

When it was time to edit the take, Waddell made the first selections. She made a stack of workprints, which, along with the negs, were passed to editor Koodish. He said, "I think the photographer should do the first edit on everything. The photographer was there and knows the situation. You have to trust her judgment in that respect." But Koodish also went over all the negs from the shoot to be sure nothing was missed.

At the same time, an editor must be careful about making presumptions about the story, Koodish said, so he always asks a lot of questions. As an editor, "There may be a story line that you're seeing that isn't accurate," he said. You have to talk to the photographer and the writer and be sure you understand what is going on.

"A lot of editing is very subjective," Koodish said. "One person might come up with something another person would go right by." During the editing of the story, other photographers made a few suggestions as did the director of photography.

The lead was an obvious choice from the start. Shot on the first day, it sums up the relationship and the heart of the story. Koodish sized it to run large, and then began finding photos that would both fill in the rest of the story and work well in the design of the page. Waddell liked figure 12–4c, but recognized that there was no point in using both it and the lead.

The shot of the boy on the floor was used "to show that the kid just doesn't get up and run around," said Koodish. It gives the reader an idea of the boy's condition. And although figure 12–4a is a close duplicate, Koodish said it would not have worked as well in the layout. He liked the grandmother leaning down and touching the boy, but that action was similar to the lead. To run figure 12–4a would have been somewhat redundant and presented a difficult sizing problem. By the time it was sized to fit the layout, it would have been too small to be effective. Further, the shot has more distractions around the edges than the one used.

The shot of the woman alone at home was used to show another side of the story, something that is mentioned in the text. "I shot it because that's where she would sit during the day when she didn't have anything else to do. To me, this showed that she needed the kids as much as they needed her," said Waddell. In the layout, Koodish feels it also adds a strong graphic element. "We felt that by having her isolated with the darkness, it was a dynamic shape that contrasted well with everything else. Sure, you could have cropped it, but having all the black isolates her," he said. "You can read into it what you want, but it is a moody picture because of that." He said he considered using the shot at the top of the layout, basically flopping the page design top-to-bottom, but felt the final layout was just a bit stronger.

The photo in figure 12–4b was held as a possibility until the final layout because, although it is somewhat similar in content to the lead, Koodish felt it was a clean tight shot with a simple background that could be used small if needed. "If we'd needed something 18 picas wide, we could have used it," Koodish said. Waddell said she took the picture because it was a quiet moment, and the grandmother spent hours walking the child up and down the halls, which was something he seemed to enjoy.

The long shot of the hallway, figure 12–4d, would have given the action some context, but Koodish said that scene was described in the text, and he felt it was better just to concentrate on the personal relationship.

He also said the cutlines are a vital part of the package. "They show why the pictures tie into the overall story," he said. The photographers write the cutlines, with help from the editors if needed.

Overall, Koodish said, "We could have included some of the outtakes, and made it a different story. There is no one way to do a story, and I think that's something people need to realize."

There Are 10,000 Things Worse than Being Blind

The photo story in figures 12–5 and 12–6a through 12–6e was photographed by Melissa Farlow and edited by J. Bruce Baumann of *The Pittsburgh Press.*

The idea began with Farlow. "We are expected to come up with most of the ideas . . . ," she said. "We get assignments for sports and fashion and food, but everything for feature and magazine stories, photographers contribute. We read the wires . . . we ask people to call us and we make lots of calls. Bruce has asked us to be journalists and that's what we try to do."

Farlow had been at a center for the blind and asked the staff to put her in contact with a set of blind parents. She found a couple but the husband had a rather typical role as breadwinner and didn't help out as much as Farlow had expected, so the mother became the focus of the story.

One of the challenges in this story was to keep it from being another cliche story about a handicapped person. Farlow explained that it is easy to make photos showing a person's disabilities and how that person deals with them. "I honestly thought [the mother] was different and tried to make pictures that were true to her situation and not to rely on cliches."

Farlow said she tries not to head into a story with a notion of what she is going to look for. "I think some people predict their stories and that's all they'll find. I try to go in with an open mind. My first couple of shoots are just groping, just observing. I try to tune into the subjects—how they feel and what their lives are like. Then I look for photographs that illustrate those points."

In this case, Farlow knew she had to show that the mother was blind and the kids were sighted, but beyond that, "I'm just trying to get a sense of who the people are and project that on film." After each shoot, she checked the take to see if there were gaps in that goal.

As is typical, the first visit yielded few usable photos. Farlow said the mother had planned a game with her kids for Farlow's benefit, and the house was in perfect condition. After Farlow was able to establish some rapport with her subjects, subsequent visits were more normal. In all, Farlow made about eight trips to photograph the family, trying to catch them in everyday activity around the house as well as during trips to the doctor, the beauty salon, and the amusement park.

When the shooting was complete, Farlow made contacts of all the negatives as well as workprints of her favorite shots. Some of those printed but not used are in figure 12–6a through 12–6e.

Baumann liked photo 12–6a because it was a good housework shot that included her young son being very kidlike. But Farlow didn't feel the shot worked. Farlow said, "We went back and forth between this picture and the kitchen picture," that was used in the layout. Baumann settled on the kitchen shot because, he said, "I thought it was a quicker read."

Farlow didn't like figure 12–6b, but understood that Baumann was looking for a shot that showed the mother dealing directly with one of her children in a motherly way, so she found a better one, the shot used in the lower right corner of the layout.

The log ride shot was a competitor with figure 12–6c. Farlow had originally printed 12–6c because the mother was easier to see than in the log ride, although she liked the log ride shot, too. Baumann chose the latter shot for the layout because the expressions on all the faces were better, and the mother was a part of the action instead of being the whole point of the image.

Farlow liked figure 12–6d, but realized that she was probably reading something into it that wasn't there. She said the mother could hear her son's voice, knew he was testing his limits, and went over to steady him. Farlow felt that this shot illustrated what it would be like to not always know exactly what was going on. But Baumann felt the shot was too subtle and didn't say anything about being blind.

The page layout process begins when Baumann throws the prints on the floor of his office and starts pushing them around. "I'm looking for an order, first of all. Then I put the lead picture in, and size that picture to where I think it is large enough for the information to be read. From that, I start to put the other pieces together."

Although he usually uses a lead photo that is significantly larger than the other shots, this story worked out well with one that does not obviously dominate the page. Farlow explained, "The kitchen picture reads faster, and although it may not be bigger, it appears larger."

The small shot of the three kids carrying groceries up the stairs does not include the mother, but Baumann said he felt it was important to show that she does need help.

SPECTRUM

The Pittsburgh Press

Section D

Monday, July 25, 1988

Judy Perseo has no fear of anything, even rip-roaring rides. She takes on Kennywood Park's log flume with, from front, Kimberly, Karen and Mark.

Taking the children for hair-cuts is part of Mrs. Perseo's routine. She checks length of Lisa's hair after cut by Carol Ann Revers at Personality Beauty Salon in Squirrel Hill. Son David waits his turn.

'THERE ARE 10,000 THINGS WORSE THAN BEING BLIND'

Mrs. Perseo and Kimberly work as team, with daughter pointing out scuff marks and mother doing the scrubbing

After taking taxi to shop, Mark, Karen and David carry groceries for their mother.

WHEN THE WAVES begin to break at the South Park Wave Pool, the decibel level begins to rise. People yelp and scream as they're jostled together, tossed and turned by the rollicking waves in a Felliniesque scene of water splashing and bodies glistening under a scorching hot sun and big, blue July sky.

Somehow, four bright yellow inner tubes are linked together. A mother and her three daughters are riding those inner tubes — bobbing with the waves and linked precariously hand-to-hand — while Dad and little brother watch from the pool's edge.

The girls are screeching, "Hold on, Mom!" The mother is laughing, her head pitched back gloriously.

Her name is Judy Perseo. And, she is a happy woman.

Maybe it's not the most remarkable thing, and maybe it's not the greatest achievement — but having a family to love and to care for was her one big dream. And so, this is her moment in the sun. This is her dream.

In the living room of the Perseo home in Squirrel Hill, a family portrait hangs above the fireplace. In the portrait, Judy and her husband John, both 36, are seated in front with their youngest child, David, 5, between them. Behind them stand Mark, 14, Karen, 12, Kimberly, 10 and Lisa, 8.

It is an engaging portrait. The children radiate good health and happiness, and the parents look so glad. But Judy Perseo has never seen the portrait, just as she has never seen the faces of her children.

Mrs. Perseo is blind. But she knows her children as well as any sighted

Please see Blind, D2

Photographed by Melissa Farlow

Written by Ann Butler

Mrs. Perseo chooses an outfit for David, 5

(a)

(b)

(c)

(d)

(e)

Figure 12–6 The photos in this series are some of those not used in the story in figure 12–5. The decision-making process is discussed in the text. *(Melissa Farlow/The Pittsburgh Press)*

In retrospect, Baumann thinks he should have left out the haircut picture and used figure 12–6e. "I was so adamant about this not being another blind woman story that there is no place in there when you could bet the ranch that this woman was blind," he said.

"This story doesn't have a tight story line with a beginning, middle and end," said Farlow. "It is more like an essay. There is more room for interpretation compared to others where there are certain pictures that tell a particular part of the story."

Blood, Sweat, and Gears

Here's an example of a photo story that began with a good idea, but there are some problems with the page. The editor and photographer involved have graciously agreed to share it so we can learn from some of their mistakes. The story is about a bicycle race that starts at about 300 feet above sea level and climbs some of the steepest grades in the state to a 9200-foot mountain pass. The route is 161 miles long and is about a ten-hour ride. It is a tough ride; many of those who start fail to finish.

A common approach to such a story is to concentrate on one person, but another approach would be to cover the whole event from a broader perspective. Unfortunately, the photographer took the former approach while the writer took the latter. The result is that the photos and the story don't complement each other. The reader expects the photos to show how tough this race was, but the rider the photographer concentrated on doesn't seem to be having much trouble.

Perhaps the photographer should have also taken a generalized approach. Seventy-two cyclists were involved, and it was an all-day event so there was ample time to get many pictures of exhausted riders battling the hills. The area covered is quite scenic, and there were a number of good shooting spots. Unfortunately, the photographer drove his own car, which meant he couldn't shoot as he followed riders along the road.

The good parts of the page include the large headline and a gray screen behind the whole layout that sets off the photos nicely. Also, the pictures are grouped together and the borders between them are even. Empty space is kept to the outside of the layout, and the copy is kept together as a solid block. The energy of the photos flows onto the page.

The long shot with the curved-road sign seems to be the lead, since it is the largest shot on the page, but in terms of content, this shot doesn't offer much. There is too much empty space between the sign and the rider on the road, and the dominant element in the photo becomes the sign. On the page, the shot is too small to be a lead; the photo at the lower right is almost the same size. Remember, a lead photo should dominate the other pictures. The shot of the writing on the pavement is fine and would have been a good one to use at the top of the page with the headline.

The face shot of the cyclist captures a nice expression, but the crop at the bottom cuts him off at his wrists, an awkward spot for a crop. Blowing it up to just the face would have been better.

The burn on the shot in the middle right is a bit heavy, and the photographer violated his premise by including this image of a different rider without tying it to the star character. Although the photo shows someone apparently at the end of the ride, the feeling of exhaustion doesn't come through. Although we can understand the photo at the lower right, these people are not animated—their expressions and body language are neutral. The most telling shot of the set is the one of the leg massage, even though the man's expression is hidden by the helmet.

The captions would have worked better if they had been under or beside the photos they refer to. It is difficult for a reader to relate cutlines to their photos when presented this way. Also, the captions along with the pull-out quote and the bylines make an awkward zone between the copy and the photos. The copy would have looked better if set at a wider measure and left ragged right. It would have been better to arrange the story and photos so the top of the page doesn't start out with a mass of gray type.

Summary

A photo story is a narrative series of pictures. A successful story has a lead photo that either symbolizes the entire story or captures the peak moment of the action. Other photos support the lead, explaining the details and giving additional information, and the story ends with a picture known as a closer. The photo story is slightly different from a photo essay, which is more interpretive than narrative. The pictures in a photo essay don't have the same direct continuity that is found in a photo story.

Successful photo stories start with good ideas. Of course the idea must be visual, but also be sure it is feasible considering the time and resources available. One common flaw in beginner's story ideas is trying to cover too much. Narrow your topic to one person or idea. Before you start to shoot, be sure you have done your research so you'll recognize the important moments when they arise. Write a temporary headline that can act as a guidepost, and devise a shooting script that will help you get a set of photos that will work together.

72 cyclists attempt annual Climb to Kaiser

Blood, sweat and gears

It wasn't Hell and it wasn't the Tour de France. But don't try to tell that to any of the 72 cyclists who participated in last Saturday's grueling Climb to Kaiser.

According to Virgil Classen, 48, the top Clovis finisher: "It was sheer Hell."

Classen, who finished fourth, was the first of two Clovis riders to complete this year's course. He finished the 161½ mile course which wound from Clovis' Letterman Park up to the 9,200 ft. Kaiser Pass and back in 11 hours and 20 minutes.

Bud Laraway, the other Clovis finisher, completed the course in 12 hours to capture ninth place.

But David Wilkins, 22, from Shaver Lake cycled away with it, finishing the course in 10 hours and 50 minutes, 20 minutes ahead of second place finisher Mike Bishop, 41, of Fresno.

Wilkins, a construction worker, said he has only been cycling for a year and that he has only been training seriously for the Climb to Kaiser for two months.

Ralph Tonseth, who drove a support vehicle that supplied Wilkins with fresh water bottles, said that the farthest Wilkins had ever ridden before was 78 miles and that was last week.

Tonseth said Wilkins, who is dating his daughter, began riding seriously a few months ago and joined his small Fresno cycling group, the Uno Club.

"He's a real natural," Tonseth said of Wilkins.

Not only did the riders have to complete a 161½ mile course, they had to fight with Mother Nature the whole way.

The riders woke before dawn to begin the masochistic annual ritual.

Despite the competitive spirit that was in the air at the finish, the Climb to Kaiser is a tour, not a race. The riders checked in around 5:30 a.m. and took off in pairs and small groups as the first rays of sunlight began to peek over the Sierras.

This year's Climb to Kaiser which is put on by the Fresno Cycling Club drew riders from all over California.

The course wound from Letterman Park through Watts Valley and Burrough Valley and up Old Tollhouse grade. Then, it wound past Shaver Lake, up Big Creek grade and past Huntington Lake up to Kaiser Pass. Then, following a different route, the riders returned to Clovis.

At the first rest stop, 36½ miles from the start, Jim Degraffenreid from Los Angeles arrived first at 7:36 a.m.

The first part of the course was relatively flat and Degraffenreid

flew. But it would be his first time cycling in the Sierras and local riders like Wilkins, Bishop and Classen would surpass him in the hills.

Wilkins arrived at the first rest stop second and would be in front for the rest of the tour.

Dave Torchin of Fresno and Classen arrived next.

The riders fueled up on cookies and fruit. Then they filled their water bottles and took off for the ascent up Old Tollhouse grade.

The leaders of the tour climbed Old Tollhouse to the cooler heights just as the sun's heat was starting to pulse in the valley. The 44 cyclists who finished the course would meet the sun again on the way down.

Rest stop number two was at Shaver Ranger Station.

Wilkins spun in first at 9:01 a.m. and then spun quickly out to the "Red Barn" in Shaver Lake

where his mother, Dee Wilkins, and Tonseth were waiting with some food.

Classen, a Kaiser veteran who has finished the race twice before in the top 10, arrived at the ranger station fifth at 9:14 a.m.

Classen, who climbed to Kaiser Pass in 1985 and 1987, said he has been cycling for about 20 years.

As the riders wolfed down a variety of fruits and snacks at the ranger station, one cyclist claimed that he lost four lbs. of sweat on Old Tollhouse grade. He hadn't seen anything yet.

The next stop was the lunch stop at Bear Cove Picnic Area on

Huntington Lake. To get there, the riders had to descend into Big Creek and then climb Big Creek Grade, the toughest grade of the day.

Wilkins cycled past Bear Cove at 10:55 a.m. Having had lunch in Shaver Lake, he was ready for the assault on Kaiser.

Classen reached Bear Cove at 11:05 a.m.

Rand Salas, 33, had started in Prather and caught up with Wilkins in Shaver Lake. Salas, a racer from Fresno, was not registered for the Climb to Kaiser, but he decided to tag

(See 'Climb' Pg. 10A)

'It was sheer Hell.'

—Virgil Classen

**Story by Frank Quaratiello
Photos by Ron Holman**

Upper left: Climbers were greeted by several road markings to cheer them on. **Upper right:** Virgil Classen of Clovis grins with some relief after reaching Kaiser Pass just 7 hours after he started. **Middle left:** Cyclists like Classen battled against windy roads, steep hills and motorists for over 160 miles. **Middle right:** David Wilkins, 22, of Shaver Lake left the "Climb to Kaiser" with only his bike, his shoes and the best time for the day. **Lower left:** Classen, 48, gets moral support and a leg massage from his daughter Joey at a rest stop in Bear Cove picnic area near Huntington Lake. **Lower right:** Fresno Cycling Club member Joan Ragsdale slices cantaloupe at the second rest stop while Classen gets another water refill.

Figure 12–7 This page started out with a good idea but encountered problems along the way. Some of these problems are discussed in the text. *(Clovis Independent & Tribune)*

Good rapport with your subject is also a key element in successful photo stories. At some moments, you'll need to become invisible as your subject deals with the topic at hand. At times when you feel it is appropriate to chat, keep the conversation focused on the subject, not on yourself or your technical problems. Also be sensitive to those times when you must back off and put the camera down.

When designing the photo page, look first for a strong lead photo. Play it big, being sure that all other photos are subordinate to it. Group the photos together, leaving white space toward the outside of the page and being sure the spaces between the photos are even. Group the copy as well; don't make your reader hop all over the page to follow the written half of the story.

Endnote

1. Gerald D. Hurley, and Angus McDougall, *Visual Impact in Print* (Chicago: American Publishers Press, 1971), 72. Some excellent examples of extended photo essays are Eugene Richards' *Below the Line: Living Poor in America,* and two works by Mary Ellen Mark—*Falkland Road: Prostitutes of Bombay,* and *Ward 81.* If these books aren't in your library, ask your librarian about an interlibrary loan.

Chapter 13

Photo Editing

"Photography is a potent medium of expression. Properly used it is a great power for betterment and understanding; misused, it can kindle many troublesome fires."

—W. Eugene Smith

Selecting Photos for Publication

Photo editing is the entire process of selecting photos from the photographer's take, including cropping, determining or at least influencing their use on the printed page, and preparing them for the production department. The details of graphics and page design are the subject for another book, but I will cover here the basic editing skills that you'll be expected to have as a photographer.

Actually, photo editing begins when you press the button. You should be thinking ahead as much as possible when in the field, because, as has been said before, you can't rewrite a photograph. You should bring your editor full coverage, including the three basic shots of photojournalism: long shot, medium shot, and close-up. Those of you who have had experience working on publications may have suffered the consequences of a photographer's failure to provide basic coverage. You're locked in to using either the one photo taken or none at all.

But presuming that you have a good assortment of photos to choose from, how can you be sure you have selected the best one, and what needs to be done to get it ready for print?

A large part of selecting photos is intuitive. With experience, you'll develop a feel for finding the right picture. There's no reason to ignore your gut feelings when editing photos, but the criteria listed below should also be considered.

Photographer As Editor?

There have been some rather mighty debates over whether a photographer should edit his or her own photos. On the one hand, the photographer was the person on the scene and knows what happened and which image best captures the event. But on the other hand, it is not unusual for a photographer to become subjectively involved with the photos and think an image says more than it really does. I think the best approach is for the photographer and editor to review the photos together, so each person can keep the other from falling into any traps that might exist. In practice, this approach is often difficult because the photographer might have to drop off exposed film and continue on to another assignment, or the production cycle is such that both persons aren't at the same place at the same time. In these cases, it is imperative that the photographer provide notes and detailed caption information so the editor can make the best possible decision. But regardless of the process, you should seek feedback on every shoot. If you can't participate in the editing, try to get someone to critique your shoot later.

Sorting through the Shoot

Of course, the first step in editing is to go through the shoot to see what you'll have to choose from. You'll either look at the negatives or at a contact sheet. Most newspaper photographers don't make contact sheets because they cost money and take time, but if you are a beginner you might want to make contacts since they are easier to evaluate.

Before you make decisions, you need to know the story the photos are supposed to illustrate. I've said this before, but experience tells me I need to repeat it. The photograph and the words are partners and should be selected to work together.

With an understanding of the story in mind, I usually go over a set of pictures at least twice. The first time, my eye stops at any photo that could be a possibility. When working with contacts, I'll mark these possibilities with a red grease pencil. Then I'll go back a second time to see if there are any shots that may hold some small detail or subtle message that might not have jumped out when taking the first look. Be careful when looking at the small images on a strip of negatives or a contact sheet. There is quite a difference between a photo seen at postage stamp size and what it looks like in an 8 × 10 print. A shot may look sharp but turn out fuzzy when enlarged; the impact of an image can change when printed; and more important, a good photo may escape your notice because its strong features aren't readily apparent in such a small size.

Although I've seen many persons edit without using a magnifier, I don't recommend it. Get a good loupe of about 8 power, such as the ones made by Agfa. There are many other styles, including ones with built-in lights, fancy stands, neck straps, and so on, but the Agfa loupes are inexpensive and have a nice wide field.

When looking at contacts or negs, you can judge content, composition, and a certain amount of technical quality. Don't try to make a decision on the printability of a shot when all you have in front of you is a contact sheet. Remember, the exposure used to make the contact print was the one needed to make most of the negs visible on the sheet. If there are some shots that look too light or dark on the contact, they might be entirely printable anyway. With experience, you'll be able to judge the printability of a neg just by looking at it. For tips on what to look for, review the section on negative quality in chapter 5.

Message, Graphics, and Technique

Three main points to look for when judging a photograph are message content, composition and design, and technical quality.

(a)

(b)

Figure 13–1 (a) The wasted space in the middle of this photo serves no purpose, and worse, can't be edited out. (b) Visual efficiency is greatly improved with this perspective.

When checking message content, be sure the photo is making a statement about the story and is not merely a pretty picture. Keep in mind that the message can be subtle, or possibly a counterpoint to the written part of the story. Also watch out for cliches. We discussed some cliches in chapter 9, the obvious visual solutions to routine problems. A typical cliche is one or two people passively looking at the camera, with or without background elements that relate to the story. The better choice is a photo of someone in action.

Also, be sure the photo accurately portrays the event and is not a moment out of context. Does the photo overdramatize the event? A picture at a protest rally, for example, could imply that the crowd was larger or more boisterous than it actually was.

When looking at a photo, ask: What does this photo say about this event? What does it tell us about the atmosphere of the event? Does it say enough? A common problem is *memory fault,* which is the photographer's tendency to read something into the photo that isn't really there. Be sure the photo says what you think it says. Get a second opinion.

Edward Steichen referred to good photos as being alive, so ask yourself if the photo you are considering could be called alive. Does it have impact? If the people are posing, is there a naturalness to the pose, or do they look like stuffed turkeys? Remember, the face is the primary human communicator. While many photos work well without an identifiable face, a common beginners' mistake is to make photos from outside the circle of action and capture only the backs of the key people. The result is a photo that reveals little.

Also check the shoot for photos that could be successful after cropping. It's not unusual for an image to look weak on the contact sheet yet turn into a strong photo with careful cropping.

The second point, composition and design, is often a part of the message content. But don't get caught up in the graphics of the image to the point where you overlook content. It's possible to have a beautiful photo that doesn't really tell the story, and another that gets right to the point yet isn't as well balanced and composed.

A *Look* magazine photographer I once knew said a good photo should read from ten feet. Of course, this does not mean that you should pace off exactly ten feet before looking at every photo, but it does mean that the photo should have a strong element that can be readily seen and will grab the reader's attention.

Part of composition and design is a vague-sounding concept I call visual efficiency. Visual efficiency is how the space within the frame is used. Figure 13–1a and 13–1b are examples. The intent of the photos is to show the two sheriff's deputies looking for something along the tracks. Aside from the bad background, there is a lot of space between the two men in figure 13–1a. This space is wasted. It contains no information relevant to the story, no environmental details such as location, time, other persons involved, or the nature of the incident. In figure 13–1b, although the telephoto lens helps separate the officers from the background, they are closer together and the space within the frame is more efficiently used. Wasted space in a photo is much like unnecessary words in a story. But unlike a story, extra space can't be cut from the middle of a photo.

The third point is technical quality. Is the photo sharp and well exposed? Sharp photos are a must. Once in a while you'll have a picture that isn't sharp, but the message content overrides this consideration (fig. 13–2). But these cases are rare. Look for sharp photos.

Another technical consideration is exposure. If the negative is too thin or too dense, good reproduction will be difficult if not impossible. If the image is filled with dark shadows or extreme highlights, details in these areas probably will be lost.

Awareness of Sensitive Issues

Watch carefully for things that could needlessly embarrass the subjects or the publication. Examples include folds, wrinkles or sags in clothing that reveal someone's private anatomy, or those moments when clothing has fallen aside for an instant.

Sensitive issues also include photos of grief, tragedy, violence, and the private moment. These ethical considerations are considerable and are dealt with at length in the next chapter.

Additional Criteria

When looking over the shoot, check for pairs of photos that could be used together, thereby giving the editor another option when presenting the story. When using photos in pairs, be sure that the images complement each other, *not* duplicate each other. As author Daryl R. Moen says, good uses for pairs include stories involving contrasts, times when a long shot also needs a close-up, or when a sequence best explains the action.[1]

If you decide to submit a long shot, be sure it is more than just an overall. It should make a point beyond being a wide-angle view of the scene. As with any image,

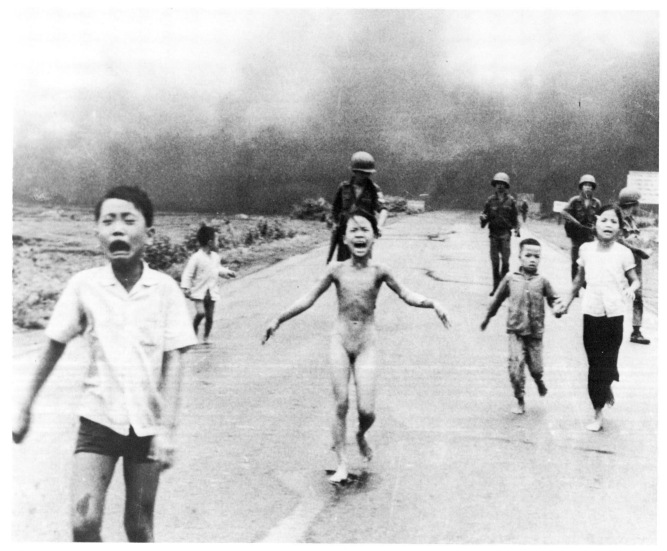

Figure 13–2 Once in a while, a photo has such overwhelming impact that its technical flaws are secondary to the message. Even though slightly out of focus, AP photographer Huynh Cong "Nick" Ut won the Pulitzer Prize in 1973 for this image of a girl running from a napalm attack in Vietnam. *(Huynh Cong "Nick" Ut/Associated Press-Wide World)*

such a photo should have impact and a dominant element that stops the reader and gives him or her solid information. One photo editor I know calls this a two-fer: two for the price of one.

Be careful when editing color photos. Don't let color seduce you into thinking the photo has more content than it really has. As I said in chapter 7, color should not become the only reason for using the shot.

Sometimes, you'll have a photo that doesn't meet very many of the criteria listed in table 13–1, yet it is still an important element of the day's news. It is important to recognize that the value of a news photo is measured heavily by the news of the day and not by its aesthetic or photographic merit alone. A good editor should ask: Does this particular photo, compared with all the other pictures available *today,* have importance?

Figure 13–3 Editors have to watch for subtle things that might offend readers or embarrass subjects. This photo was from a story on military training. Although one editor objected to the way the rope was wound around the man's crotch, the photo ran and no reader complaints were received. Would you have run the shot? *(Kory Hansen)*

TABLE 13-1 Editing Checklist

1. *Information.* Does the photo tell the story?
2. *Impact.* Will the photo grab the reader?
3. *Focal point.* Is the primary message of the photo clear and easy to see?
4. *Action.* Is something happening, or is the image static?
5. *Background.* Is it a distraction? Will there be tone mergers between subject and background?
6. *Framing.* Can it be cropped without too much image-destroying magnification?
7. *Composition and design.* Does the image use its graphic elements well? Is it visually efficient?
8. *Shadows and highlights.* Will important details in these areas reproduce in print?
9. *Sharpness.* Is the photo in focus?
10. *Ethics and decency.* Does the photo meet the standards set by the publication?

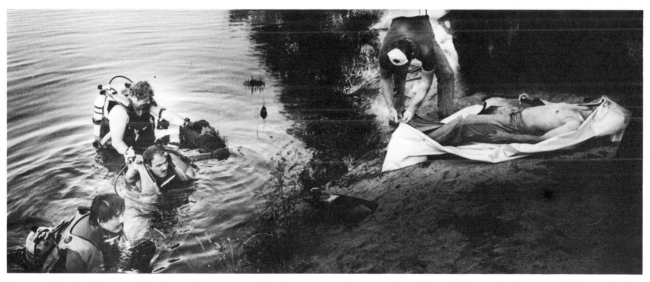

Figure 13–4 Photos of death are always a sensitive issue. Policies among newspapers vary; some will not run such photos at all, others will only if the person is not identifiable. Compare this photo with figure 14–8 on page 257. Is one photo more palatable than the other? *(Tony Olmos)*

Figure 13–5 Try editing this shoot. Consider whether one or more photos will be needed and how you would suggest their use on the page. Assume names are available for everyone photographed, and that a 6-inch story will also run. Here are the story details: The fire department in this small town has few structure fires, so they burn old buildings for training purposes. Today a house and garage that stood on the town's main street since 1910 are both being burned. The firefighters include many volunteer reserves. In the top two strips on the contact sheet on this page, the men are setting up and planning the event. In the bottom four strips, they are

burning the garage. The man in the foreground of the fifth strip is in charge of training, and the men with the hoses are trainees. The man saluting and the woman looking into the camera are not part of the story.

In the photos on this page, the men are burning the house. The close-up on the top strip is of an engineer; the men in the two frames on the right of that strip are preparing the building prior to lighting the fire. In the third strip down, the old man watching lived in the house many years ago. The men taking a break in the fourth strip are reserves.

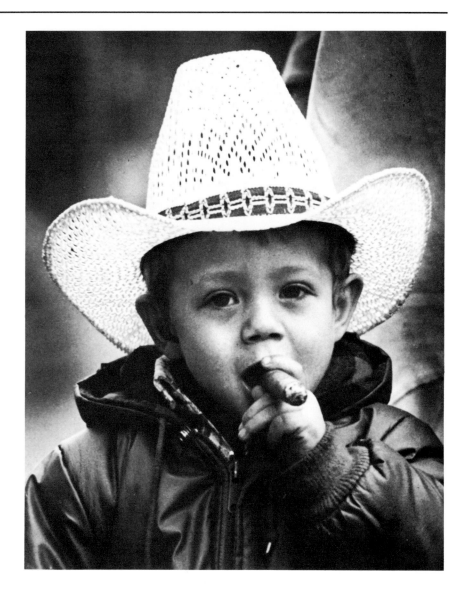

Sometimes editors are surprised by reader reaction. This photo was made during a western festival, and the paper ran it as a piece of wild art. Enraged readers accused the paper of ''irresponsible journalism'' and ''encouraging kids to smoke.'' *(Kory Hansen/Clovis Independent & Tribune)*

Sometimes a shot that will mean nothing tomorrow is important today. The shot may not have great graphic or artistic merit, and it may have little chance in photojournalism contests, but it might, in the context of that day, be the number one photo. A good news picture tells the story at that time and that place.

Cropping

Cropping, setting new boundaries for the edges of the photo, is a means of cutting out irrelevant parts of an image and emphasizing the main points. I remember reading a news editing textbook that said, ''crop ruthlessly.'' The implication was that every photo should be cropped, probably heavily. But we know better. Perhaps the author should have said, ''Crop intelligently.''

A good photographer will crop in the camera, and when that fails, will crop properly when making the print. But even then, new options may reveal themselves and photos may be cropped again after prints are made. For photos that could be cropped several ways, the decision sometimes depends upon the needs of the page design. Regardless of where or when cropping takes place, bear in mind that good cropping can either work wonders as a means of correcting flaws in the original or can destroy a well-made photograph.

The foundations for good cropping lie in composition and design. There's no need to repeat all the details of chapter 8 here although you might review that chapter with cropping in mind. Look for visual efficiency. Crop out empty space, or wasted space. Be careful, however, about destroying balance and emotional feelings created by space.

(a)

(b)

Figure 13–6 Notice how the impact of this photo is improved by cropping in to the peak action. *(Thor Swift)*

(a)

(b)

Figure 13–7 (a) Photographer Kurt Hegre only had a second to make this photograph; there was little time to crop in the camera. (b) When the shot is properly cropped it has much more impact. *(Kurt Hegre/Gilroy Dispatch)*

Crop for content. Emphasize the photo's message but at the same time, be sensitive to the subtleties of the image. Remember too, that the proportions of the camera's frame or the 8 × 10 print are not always the best proportions for the image. Don't hesitate if a tall vertical or a wide horizontal treatment is called for. A common error among beginners is forgetting to crop to correct photos that have tilted horizons. When horizons slope and telephone poles lean to one side, it looks as though the photographer was falling over when the shutter snapped. If the original frame is tilted, it's your job to straighten it out.

Cropping can sometimes salvage an otherwise weak shot. Cutting out empty foregrounds and distracting elements might make the image usable. I recall an editor who was once faced with a boring shot of four people standing in a group looking at the camera. By cropping down to the individual heads, she converted the picture into separate head shots that ran together as a four-picture package. But again, beware of cropping so much that technical quality drops.

Also, no cookie-cutter shapes, please. We are accustomed to looking at photos in rectangular formats. I once worked with a feature editor who thought it was great to give photos scalloped edges and cut them into hearts and circles. But a good editor would not turn a well-written story into a limerick, so don't destroy a good photo by cutting it into cute shapes.

There are a couple of specific don'ts in cropping. Avoid cutting off hands and feet. If you must crop these, crop way in to the middle of a limb. Also, avoid cropping so a major element just touches the edge of the frame. Either leave a little space between the element and the frame, or crop so the frame runs through the object. Things that are just touching the frame set up a visual tension that usually should be avoided in photojournalism.

Crops are easily indicated by making marks in the borders of the print, as in figure 13–8. I like to use a grease pencil so changes can be made, although grease pencil annoys process camera operators because the marks come off on the glass of the camera's copy board. Be sure to mark the print on all four borders so that the ticks line up properly on opposite sides of the print.

When the crop of a print is critical and time allows, print the shot to size and crop in the darkroom. This procedure reduces the chance for error later in the production cycle, particularly when printing facilities are at a different location and follow-ups are hard to make. These problems may be eliminated with the advent of electronic editing in which cropping, sizing, and image manipulation such as burning and dodging will be done on computer terminals. Such equipment is already being used by wire services and some newspapers, and it is not an unreasonable prediction that darkrooms will play a decreasing role in news publications of the future.

Figure 13–8 The cropping for this shot is indicated by the marks in the margins of the print. Mask the print with pieces of paper to see how the crop improves the shot.

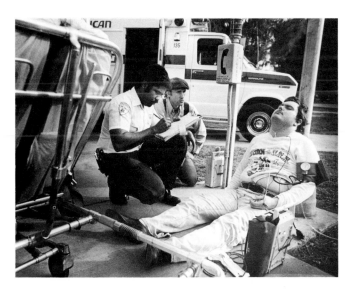

Editing also involves having a perspective on the day's news. Although this shot is both technically and graphically well done, it did not run because the incident was a routine medical aid call and of no consequence except to the victim. *(Mark Mirko)*

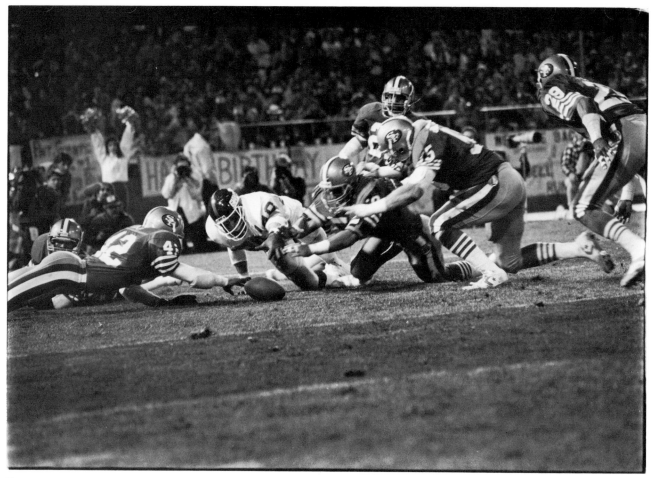

Experiment with cropping this shot. Cropping is sometimes subjective, and photographers and editors have had several lively debates about the best version. *(Rollin Banderob)*

Sizing a Photo

The print you made in the darkroom probably will not be the size needed for reproduction. Although figuring the amount of enlargement or reduction is usually the responsibility of an editor, you should know this basic skill in case of an emergency or if you are given the opportunity to design a page.

Sizing a photograph is simply a matter of figuring what percentage it will be reproduced compared to the original. You can do this easily with a pocket calculator by dividing the new width by the original width. For example, suppose your photo measures 8 inches across and the reproduction size is to be 6 inches. Enter 6 divided by 8 to get a reproduction size of 75%. You can then easily find the new depth by entering the original depth and multiplying by the percentage, which in this example is .75. Mark the back of the photo with the reproduction sizes and the percent change so the printer will know what you want.

Here's how it looks mathematically:

$$\text{Old width } \overline{)\,\text{New width}}^{\text{\% enlargement or reduction}}$$

So, in our example:

$$8\overline{)\,6}^{\text{.75 or 75\%}}$$

The Proportion Wheel

Another common method for sizing photos is by using a proportion wheel like the one in figure 13–9. This device is nothing more than a simple calculator that figures the new dimensions and the percentage of your enlargement or reduction.

Figure 13–9 A pica pole and a proportion wheel are basic tools for photo editors.

The dimensions of the original photo always go on the inner wheel; on the outer wheel will be the dimensions of the new size. For example, align the original width on the inner wheel opposite the new width on the outer wheel. Then, without changing the wheel, look along the inner wheel to find the original depth. Opposite that spot will be the new depth on the outer wheel. The percent change can be found in the window.

A common mistake is to confuse the inner and outer wheels. Do not put the width of the original on one wheel and the depth on the other. Keep the original width and depth on the inside, new sizes on the outside.

When sizing photos, always think in terms of percentages. If the reproduced width is to be 50% of the original, the depth will also be 50%. Do not make the mistake of thinking that you can trim an inch off the width and an inch off the depth and end up with the same width-to-depth proportion as the original. To take an extreme example, suppose your photo was 3 inches wide and 1 inch deep. If you took an inch off the width, reducing it to 2 inches, taking an inch off the depth

would leave it with no depth at all. What you intended to do was reduce the dimensions by one-third, or 33%, leaving the depth at about 5/16 inch.

In publications work, the *pica* is a common unit of measure. There are six picas to the inch. You'll find that measuring photos in terms of picas helps eliminate fractions of an inch. Rulers marked in picas (pica poles) are common around publications offices. Also common is measuring width in terms of columns. You might hear someone say, "Make it a four-column shot." Measurements differ among publications, so you'll need to ask about the column widths for your publication. Regardless of the measurement system used, the formula for finding the percentage is the same.

A common sizing error is to overlook the crop marks and figure the size based on the whole print. But remember, when you cropped the photo, you created a new original size and new proportions. Be sure to size the photo as cropped!

Retouching

Before submitting a print, be sure dust spots have been spotted out with spotting dye. Check chapter 5 for how-to information. Beyond spotting, retouching can help reduce flaws in a photo such as in figure 13–10. This shot suffered from a tone merger between the people in the foreground and the dark background. By carefully outlining the people with light gray, some background/foreground separation can be maintained in reproduction.

Retouching to de-emphasize objects can also make a big improvement (see fig. 13–11). You can do this by wetting a cotton pad or swab with spotting dye and rubbing it on the light area. You can also do this to a print corner that escaped burning in the darkroom. Of course, a good retoucher can do much more, such as removing facial blemishes in a portrait or enhancing details in an advertising photo. But when you go beyond minor corrections, you start getting into ethical questions about manipulating images. Electronic editing has opened the door to sophisticated, undetectable changes such as making composites, changing colors of selected items, or removing people and cloning in new backgrounds. Although this level of manipulation might be acceptable in an advertising photo, the integrity of the news photo should not be breached. The ethical questions raised by this practice will be dealt with in the next chapter. Suffice it to say here that the photographer who tampers with the honesty of the image lies to the reader. The line between improving the image and falsifying it must be carefully drawn.

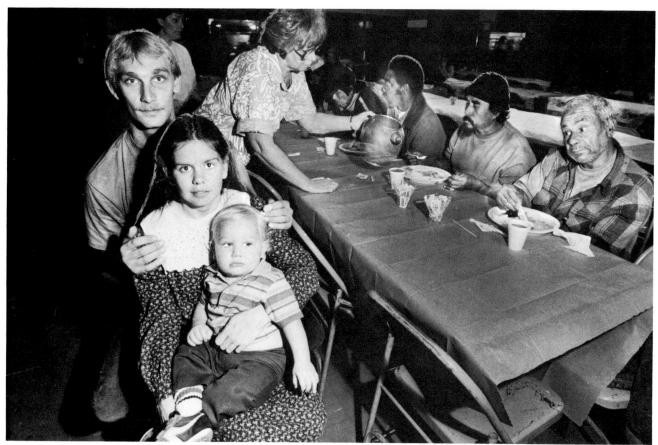

Figure 13–10 This was a difficult situation for the photographer because the dark heads of these people blended into the background. The heads were outlined slightly with light gray so they would stand out. In this book, the retouching may show, but on coarse newsprint it is imperceptible. *(John Walker/ The Fresno Bee)*

Figure 13–11 Behind the man who is looking at the car is a policeman wearing a white helmet. To prevent the helmet from being a distraction, it was darkened with a cotton swab soaked in diluted spotting dye. *(Paul Kuroda/The Fresno Bee)*

Captions

Photos and words work together, and the words of the caption are a vital part of the communications package. Words explain, clarify, and add to the image. Carefully written captions interpret the photograph, and provide information not found within the image.

There are several styles of cutlines. Sometimes a photo is used without an accompanying story and needs a cutline of several sentences. At the other extreme are name-line captions that identify only the person in the photo. Unless you are certain what type of caption your editor needs, supply every photo with a full caption. Although the extra can always be edited, information you've left out can't be fabricated.

Unfortunately, many cutlines are so poorly written that they sound like descriptions of hardware in an industrial supplies catalog. When writing this section, I looked through scores of newspaper pages seeking good examples to share. Sadly, every caption I encountered failed to qualify. One way to avoid common mistakes is to make a list of what you can't see in the photo and use this as a basis for the caption. List reasons why the pictured event is happening, pre- and postpicture events, time context, other facts not visible, quotes from the subject, names, time, date, and place.

Some tips for cutline writing:

1. *Don't repeat what is obvious in the photograph.* When writing a caption, it is terribly tempting to simply restate what you see in the image. A good caption should explain, not repeat, what the reader can see. Unfortunately, this verbal/visual redundancy happens all the time, and I have even seen editing texts that advised cutline writers to describe the photo. Why waste time and space telling a reader what can be plainly seen? *Interpret* the photo, don't describe it. Example: "Bob Jones rides his ten-speed down the new bike path in Kearney Park." We can see that this person is riding a bike down a bike path. How about: "This new bike path in Kearney Park was completed yesterday. One of the first to try it out is Bob Jones. The path is part of the city's $125,000 program to expand bike routes throughout the west side."

2. *Include story facts in your cutline, but don't repeat information that is in the headline or story.* This is a tough challenge since the head and story are often prepared separately. But the photographer should be a complete journalist and have some additional facts to contribute. Quotes from the subjects are a great way to add spice to a cutline.

3. *Never say "is pictured," or "in the photo above," or similar phrases.* Everyone knows you are referring to the picture. When naming persons, say "from left," rather than "from left to right." The former is just as effective and more efficient. Avoid overidentifying. It would be insulting to your readers to say, "President Bush, left, and his wife Barbara, right." And if you have a photo of twenty people, identify only the most important.

4. *Never say someone is "looking on."* This phrase is ridiculous. We can see that this person is watching. Identify him or her with additional facts. Instead of, "Fred Barnes adjusts the harness on his horse while Sam Pierce (left) looks on," try, "After fifty years in the saddle, adjusting a horse's harness is almost a reflex action for Fred Barnes. Ranch handyman Sam Pierce keeps the tack in good shape."

5. *Clarify ambiguities.* Why has this moment occurred? What happened before? After?

6. *Be sure facts match the photo.* More than once, I have seen an antique auto called a Model T Ford, yet the car in the photo was a Model A Ford. If you can't tell the difference and can't find out, call it "a vintage Ford." And all cattle are not cows, only the females are. I once saw a caption that referred to a cow in the photo, yet the animal was most definitely a horse!

7. *Try not to start every caption with a name.* Starting with a name can lead you into the trap of just describing the photo. More important, interesting facts are more attractive to readers than names, and a long list of names at the beginning of a caption is a sure turn-off. Imagine a photo of two forest rangers placing a radio-tracking collar on a bear. Instead of "Rangers Ted Francis (left) and Bob Holman attach a radio collar to this bear in order to track its movements," how about, "By attaching a radio collar to this 300-pound black bear, rangers Ted Francis (left) and Bob Holman can track its movements."

8. *If a photo is an old one from the file, say so.* Using old photos without telling your readers is a deception that they will soon discover.

9. *If the photo involves unusual photographic technique, mention that.* Time exposures and distortions caused by lenses are prime examples.

10. *Keep tenses logical.* Use present tense when referring to the photo, past tense when providing background information not contained in the photo. "Two Ferraris are in the center of this ball of flame. The fire gutted Mario's Classic Auto Repair on Front St. yesterday afternoon and the cars, the building, and four other exotic autos were a total loss."

11. *Keep sentences and cutlines short.* If the photo requires more than a few lines, write a story not a cutline.

12. *Try to match the mood of the photo.* A light-hearted feature would call for an entirely different approach than a wreck picture.

13. *Libel involving a photo often happens because of the cutline.* Be sure names are accurate and that the cutline relates only to the photo and its accompanying story. Don't guess. If you aren't positive about names and facts, leave them out. Never use a file photo to illustrate an unrelated story unless you have signed model releases in hand. Libel and releases are covered in chapter 15.

14. *Be careful when writing gag cutlines to circulate around the office.* From time to time these escape with embarrassing and possibly legally troublesome consequences.

As Wilson Hicks said, "The camera can go just so far. Words go the rest of the way." Although it is easy to fall into the trap of dashing out a caption at the last minute, your careful efforts with the visual part of your message deserve more than a carelessly crafted companion. Well-written captions make good photos better.

This necessarily brief introduction to photo editing must end here, the point at which the photograph leaves the photographer's hands. If you're interested in page layout and design, which is a growing specialty in journalism, consider joining the Society of Newspaper Design. Their address is in the Appendix.

Summary

Photo editing actually starts when the photo is taken. A good photojournalist thinks ahead and tries to provide the editor with a variety of images and options. Most photographers prefer to edit their own work since they were on the scene and know which shot best represents the story. However, it is possible to be mislead and think a photo contains more than it really does. Two-person editing is the best solution, where the photographer and an editor review the work together.

When sorting through the shoot, go over the material at least twice, looking carefully for photos with information, impact, strong focal points, action, clean backgrounds, good framing, strong composition, and sharp focus. Keep in mind that the impact of an image will change when it is enlarged. Be careful when dealing with sensitive issues. Use photos of tragedy, violence, and grief only after deciding they don't cross ethical boundaries.

Remember that a single photo isn't the only way to present the story. Sometimes two or even three photos working together will do a more complete job. When you see this possibility, be sure to point it out to the page editors.

Cropping is to the photographer what copyediting is to the writer. It is a way to improve upon the original product by correcting errors and eliminating distractions. Cropping should begin in the camera when the photo is made, but you'll also have a chance when making the print and when preparing the print for reproduction. Crop with care, removing empty foregrounds and peripheral distractions, but do not hack away thoughtlessly. Be sure to look for tilted horizons. Make crop marks in the borders of the print so the printer will know what you want.

After the photo is cropped, it must be sized. This step is usually done by figuring the new size as a percentage of the original. Simply divide the old width into the new width to get the percent of change.

Pictures and captions are allies in communication. The words should explain and interpret, not describe, the photo. The most common error, visual/verbal redundancy, can be avoided with only a little more effort than it takes to write a poor caption. Include facts and, if possible, a quote in your captions. Never say "is pictured," or "looks on." Keep tenses logical, and double-check facts. Be sure the facts in the cutline are consistent with the facts in the photo.

Endnote

1. Daryl R. Moen, *Newspaper Layout and Design* (Ames, Iowa: Iowa State University Press, 1984), 83.

Part IV
Beyond the Camera

English class, Krczonow, Poland, December 16, 1989. *(Stephen J. Pringle)*

Chapter 14

Ethics

Outline

*"On his individual assignments,
he cannot dodge an ethical
question on the grounds that the
boss, not he, edits the paper."*

—*Gerald Gross,*
Responsibility of the Press

"Shoot first—edit later."

—*Anonymous*

No Easy Answers

If you are looking for firm answers to ethical problems, you won't find them here. If you are expecting a checklist at the end of this chapter, you will be disappointed. And you may come away from these pages with more questions than when you started, for the ethics of journalism simply can't be summarized on a neat, wallet-sized card. Sometimes what we are here to do—inform the public—seems to be at odds with what needs to be done in a specific case. And the next day, a slightly different case will require a slightly different handling.

While reading this chapter, keep in mind that there is no special level of ethics that reserves itself for photojournalism. The ethics of this business are, at the fundamental level, no different than any other ethics. Some thinkers would reduce the questions I will raise here to a matter of motives and consequences. In looking for answers, they would ask you to examine your motives and the consequences of your actions. Obviously, if both motives and consequences are good, or bad, the answers are easy to find. But it is the other combinations that cause problems. Bad motives that result in good consequences is a possibility, although we like to think of journalists acting with wholesome intent. And, of course, we can also get into discussions about whether a particular motive is good or bad.

But what about the combination of good motives with bad, or at least questionable, consequences? I think most of the issues in this chapter fall into this category, and you'll have a chance to wrestle with this problem when you try to decide for yourself how you would handle the situations discussed.

Freedom and Responsibility

Unfortunately, we don't have space in these pages for a long discussion about the importance of information to a democracy, but it is important to remember that freedom includes responsibility. Many people don't trust the press, and this thought when combined with the fact that some in the legal community do not view the First Amendment as an absolute,[1] should remind us all that freedom of the press exists only as an attitude. In the case of the photo of the drowning victim discussed later in this chapter, one reader thought "The photograph reaches the height of insensitivity and oversteps the principles of freedom of the press." Although there are both legal and perhaps social limits to the First Amendment, if this kind of attitude were to expand, the press, and consequently the free flow of ideas, could be more restricted than is healthy for our society.

Conflicts of Interest

First, let's look at the problem of maintaining objectivity in the face of the personal, ideological or commercial relationships you will develop with people you are likely to cover. Personal relationships can put a strain on everyone if your friend becomes involved in a negative story. You then find yourself having to balance friendship obligations with professional ones. Obviously, I'm not suggesting that you abandon all your friendships, but when the situation arises, you will be faced with a conflict.

Also, there are people who will cultivate your favor. Suppose, for example, the press relations manager for the local sports team regularly gives you a free ride on the team airplane, or a sidelines pass even though you aren't covering the game, or even a box seat. Is there a hidden quid pro quo in his generosity? What kind of pressure would you feel if that person became involved in a negative story? Perhaps, as you read this, you can say that it would not affect your decisions, but how do you know that there wouldn't be some subconscious effects? Imagine this comment from the PR manager after involvement in a minor traffic accident: "We've been friends for a long time, and I hope you'll respect that by not running that photo." If your answer is dependent upon the news value of the incident, suppose the accident resulted in a couple of moderate, but typical, injuries.

Emotional Involvement

Sooner or later, you'll also have to face the problem of emotional involvement with your subjects. The most likely situation is on longer stories, ones that keep you in contact with the subject for weeks or months. As you get to know these people, your objectivity may diminish.

Frankly, I don't think it is possible for a photojournalist to be entirely objective, nor is it possible to make good photos without some involvement with your subject. I don't think people go into this business unless they care about what they are doing and who they are dealing with. And caring itself puts a person beyond pure objectivity. It then becomes a matter of limits—at what point does your involvement begin to have adverse effects on your images? (This is one of the reasons why it is important to have someone else help edit your photos. Your personal involvement may cause you to see something in the image that isn't really there.)

Political and Business Involvement

This kind of relationship can include conflicts such as those between your after-hours work with a political group and your coverage of issues that concern that

group. Although you might try to prevent your feelings from influencing your photos, those who know you may think your work is biased, and that impression could be as big a problem as any overtly slanted point of view.

Another potential problem is created when you take freelance assignments from local businesses. Can you keep that from influencing your coverage of these businesses as news subjects, and will the reading public understand your relationship?

Professional Conflicts

Two other conflicts of interest come up from time to time. The first one is getting in the way of someone else's shot. If a photographer realizes that taking a certain vantage point will give her a better shot but at the same time spoil everyone else's, what should she do—shoot alongside everyone else or take the spot?

To me, the second conflict is not an issue: at an emergency should the photographer take pictures or try to help the victims? It is not unusual for a photojournalist to get to the scene before emergency personnel, and in such a case, basic human decency requires that you help. One rescue worker said, "A good rule of thumb might be that if anyone is there helping and you can do no more than anyone else, record the event. But if no one is there, you must step in to help, as a human being first, a journalist second."[2]

Unpublished Photos

Because the photo is so often the most accurate record, sooner or later you will be asked by lawyers or police for copies of pictures you have made at an accident or crime scene. On the surface, there might be no problem in giving out photos of a routine traffic accident, but before you do, consider the implications.

On the one hand, if you had photos that could prove someone's guilt or innocence, perhaps you should make those photos available. But if you do, aren't you compromising journalistic independence by becoming directly involved in the story? How could you maintain objectivity if you got caught up in a dispute between, say, two neighbors, both of whom were asking you for photos taken from the other side of the fence?

And if you made it a practice to hand out (or sell) accident photos, would the line be drawn there? Suppose you photographed a labor picket line that turned violent. Should the police have access to your pictures to identify and bring charges against the picketers? Does your role as a journalist include being an arm of law enforcement? If so, how could you continue to cover union activities if you were viewed by the union as a source of trouble?

Suppose your photos were of a protest rally during which no laws were broken, yet the police wanted the pictures for an unspecified investigation? There have been numerous cases of police abuse of civil rights. How would people react to you if they suspected you were an informant?

I recall a case where the Ku Klux Klan held a rally, complete with robes and cross burning. Photographers were welcome at the rally, and a photo was run in the paper. Some time later, an organization that opposes the Klan requested copies of all photos taken at that event. Would you send the photos? If the event had been an equal rights rally and the request was from the Klan, would your response be different?

It's a Matter of Trust

Some people have no fears, but others don't want to deal with you. They don't want to share themselves with the reading public, or they simply don't trust your motives. Perhaps they have something to hide (that may or may not have anything to do with the story you are working on). How can you get them to trust you if they have a nagging suspicion that you will share whatever you see, hear or photograph with the police—or their ex-spouse's lawyer? Your sources should be able to trust you. Information shared in confidence should remain confidential, and your subjects should know that you are working for a news publication and not for the police.

In regard to releasing unpublished photos, the policy at many papers is to provide a copy of the photo that appeared in the newspaper, but nothing else. Some publications destroy all unprinted negs after a couple of weeks, a practice that prevents negs from being subpoenaed. Yet other publications will provide any pictures taken to anyone who can pay for the prints.

Pictures that Lie

The camera never lies—usually. But the fact that it can distort what appears in front of its lens is a matter of serious concern. If, through however well-meaning efforts, the honesty of the photograph is lost, the photojournalist's credibility will be damaged.

The problems begin when you press the button. If a quote can be taken out of context, so can a moment of time. You can catch someone blinking or yawning and make him or her look like a moron or a fool. You can use a wide-angle lens and distort facial features; light can change shape and influence mood. And instead of making things look worse, you can use photographic techniques to make things look better than they really are.

Figure 14–1 Burning down the background is a common technique, but at what point does it falsify reality? In this case, there is an umpire standing immediately behind these two players, but the photographer darkened the image so only the players could be seen. You can see part of the umpire's leg between the two players. *(Glenn Moore)*

You may also face a problem when the photos don't match the tone of the story. Suppose the subject was in a good mood during the interview, and two-thirds of the photos show that, yet the overall story is downbeat. The list goes on and on.

Perhaps it's a matter of understanding objectivity, subjectivity, and honesty. Because the decision to push the button is a subjective one, it must be made with honest intent, the goal being to present to the reader as accurate a representation of what was there as possible. Catching the subject with mouth open may be purely objective, because that is what happened during that 1/125 second when the button was pushed. In that regard, the photo is honest. But if it makes the person look like a fool when in fact this person is not, the image has failed. Because we cannot present our photos in the context of time, the burden lies with the photographer to decide upon the picture that best represents a composite of the moments.

The Altered Image

What about the photo that needs dodging and burning? In contrast to the wide sensitivity of the eye, camera and film are limited, and sometimes the image needs darkroom help in order to match what we saw at the scene.

Look at the picture in figure 14–1. The photographer thought the darkroom treatment was necessary to enhance the image and that the techniques used were no different from those used by a reporter who decides which quotes to use. But at some point, normal enhancements end and distortion begins.

Figure 14–2 The photographers were part of the scene and photographer Rick Rickman decided that they had become part of the story. But would it be ethical for an editor to crop in to just the woman and the baby? Would it have been ethical for Rickman to use a telephoto lens to present just those two people? *(Rick Rickman/The Orange County Register)*

One photographer put the question into perspective this way: "The use of dodging tools, ferricyanide [a chemical bleach that lightens areas], and burned-down areas of a print are okay to do, but with limitations. I'll do all three to a print if it will help the reader see what I saw. I won't go out of my way to take backgrounds completely out or make the photo look distorted by using 'The Hands of God.' "[3]

Cropping and Composites

Cropping can distort, too. Imagine the photo in figure 14–2 cropped down to just the woman and the little girl. There were many photographers and reporters on hand to cover the story but if they were cropped out, would the resulting image misrepresent the scene?

Other distortions include obvious fakes such as the composite images made by pasting several photos together. This type of fraud is not done by any reputable journalist. But there are times when you might be tempted to try an April Fool's joke. A doctored photo of the dome of the state capitol being blown off by legislative hot air could be initially taken for real by readers who don't recognize your sense of humor and who expect the news to stick to facts.

Perhaps, however, a feature story needs an illustration. You'll have to decide how far to go when creating such images. The picture in figure 14–3 is about a drought, and if you look closely, you'll notice that the moon is much larger than it ought to be. The story was not breaking news, and the photographer thought the moon would enhance the photo. Some photojournalists feel that these machinations are fine as long as they are explained in the caption.

Similar questions can be asked when a photo would work much better in the page design if the subject was facing in the opposite direction. It is a simple matter to make a print with the negative flopped upside down in the enlarger. If there is nothing in the background, such as street signs, that would appear reversed and thus look odd, is it permissible to flop the image? After all, the photographer could have taken the shot from the other side.

Figure 14–3 If you look closely, you will notice that the terrain was shot with a wide-angle lens. Such a lens could not produce a large moon in the background. The moon was printed from a separate negative. Is it ethical to manipulate photos in this way, even if readers are warned in the cutline? *(Robert DeGiulio/Statesman Journal)*

Digital Retouching

Computers have opened the door for a new means of ethical transgression. Whereas altering a photo with X-acto knives and airbrushes requires a conscious effort that involves time, planning and talent, computerized image processing has made it easy for photos to be changed by anyone in the production chain, from editors to prepress technicians. Some of these people may not understand or respect the special requirements of the journalistic image.

After a photograph has been scanned by a computer, objects can be added or deleted, changed in color or moved about within the frame with a degree of perfection that is undetectable. These features are frequently used by art directors in preparing advertising photos, but some of these options have been used to change photos intended for editorial (nonadvertising) use.[4]

Two well-known examples are the covers from the *Day in the Life* series of books and the covers of two issues of *National Geographic* magazine. In February and April 1982, *National Geographic* used digital retouching to alter pictures to better fit the cover format. In one case, the pyramids of Egypt were moved slightly in relation to other elements in the photo. The other cover was a portrait of a soldier. In the photographer's take, one frame had the best expression but not all of the soldier's hat, so the next frame, which had all of the hat, was spliced in. The magazine's photo director said he had no problems with these changes because they could have been done by the photographer on the scene.[5] But the manipulations created quite a stir in the industry, and in a letter to this author, senior assistant editor W. Alan Royce said the alteration "was done experimentally when the technology was first available to us, and is not consistent with our present policy regarding electronic manipulation of photographs and illustrations."

However, a different viewpoint is expressed by Rick Smolan, co-director of *Day in the Life* series of books. Several cover photos are digitally altered. For example, the photo in figure 14–4 was originally a horizontal image, but to make it fit on the cover of the book, the horseman and the tree were moved closer together and the moon was enlarged. Smolan said, "We feel that anything that makes the picture stronger but doesn't change the journalistic integrity of the photographs is fine. . . . It seems silly not to use the technology that's out there to make what you're doing strong."[6] But another photo editor said that changing photos digitally is "ethically, morally, and journalistically horrible."[7]

Another concern is changes made by well-meaning but misguided computer technicians. At *The Register* in Santa Ana, California, swimming pool water that had been dyed red was changed to blue because the engravers thought swimming pool water was always blue.[8] And the *New York Times Magazine* once discovered that an aesthetically inclined printing technician had added some shrubbery to the background of a photo.[9]

Figure 14–4 Many of the covers for the *Day in the Life of* books have been digitally enhanced. For this one, the moon was enlarged and the horseman and the tree were moved closer together. *(Cover photo by Frans Lanting)*

As I write this book, digital photo processing equipment is relatively new and available at only a few newspapers. But photos can be digitized and electronically retouched with personal computers, and the low-end technology is racing to meet the high-end machines as the prices of both come down. It is not unlikely, then, that you will soon deal with electronically processed images, and the possibilities for use and abuse of this technology should be carefully considered.

Is changing a photo merely a form of editing, as a writer edits a story, or is it a falsification of facts? Keep in mind the following statement by Hal Buell of The Associated Press:

When it comes to news pictures, I vote for the "no tampering" position. No tampering, not at all, of any kind, not even a little bit. . . . When you set up an atmosphere of acceptance, you first tamper with the meaningless picture, the one where it really doesn't make any difference. Take a background out of fashion or [add] a little extra color in a food picture. Then with minor details in a news picture. Remove a black background or maybe an annoying shadow. Then what? I don't know because we aren't there but I can see the danger.[10]

Posing

But so much of our work is done by arranging the photo before the shutter is pressed, not after-the-fact as in the example just presented. To what extent does posing a photo create a false situation? Consider the questions raised in the following discussion among a newspaper editor and several photojournalists. An editor had assigned a photographer to cover basketball fans leaving for a state tournament where the local high school team would play. The photographer turned in a photo of cheerleaders tying decorations onto cars. The editor said:

We weren't too happy with the picture because we wanted to convey some of the excitement. I suggested to the photographer that perhaps he could get a bunch of the kids together in a group and have them waving their hands in a big *V* or yelling and screaming, basically just saying to them, "Be yourself, kids," and shoot the picture.

The photographer was upset about this, because he felt it was a posed picture and people weren't doing anything. They were just sort of standing around and he felt that it was wrong to take that kind of picture. We didn't think so. But since then, we've heard some reactions from other photographers who felt you shouldn't do that sort of thing.

One photojournalist explained why this situation was a breach of ethics:

Would you ask your writer to go to that same event and get names of the people that are going on that trip and then have the writer make up quotes? . . . That's where it turns. . . . The subjects know that's a phony picture. Then the photographer goes to another assignment and the next day, the next month, and so on, and all those subjects know those are phony situations. Can the public put their trust in your paper? Do you lose credibility by having this untruth perpetuated each day?

Then the discussion was given an overall perspective from another expert:

What is a posed picture? Many of the subjects who are in our pictures pose themselves for us. . . . Sometimes we pose pictures. I think that it's very important that the reader understand what the situation is because basically we don't want to fool the reader. . . .

Sometimes in a caption we can explain that we organized these people to have this picture taken in a certain way. Or in the style of the photograph, it is so obviously posed that no reader is fooled into thinking that this was a real event.

I think there's no ultimate answer as to when you pose or when you don't. It's a whole series of situations, but you have to keep in mind that what you present to the reader has to be honest.[11]

Re-creations and Controlled Candids

But what about using models for photos that are intended as illustrations but look like documentations of reality? In one case, *Parade* magazine used models in photos on the cover of an issue containing a story on teen prostitution.[12] The photos looked like they were taken of women on the street soliciting customers. The faces were not recognizable, and the shots looked like they were taken candidly on the street with a telephoto lens. In two of the three photos on the cover, the girls were professional models. The maker of the third photo said that image was of an actual solicitation.

The magazine said they used models to avoid legal problems if a real prostitute was somehow identifiable in the photos. They also said an explanation had been planned to run with the photo credits on an inside page, but was inadvertently dropped. One photographer who used a model didn't see any problem with the practice. He said it was done all the time by all magazines and that legal problems were an important concern.[13]

But, in a related discussion on posing, one widely respected photojournalist said, "You cannot rely on a caption to correct the ills of a misleading photograph. . . . If you don't want to perpetuate the practice, the answer is simple: don't."[14]

What, then, about the photographer who arrives a few minutes late and asks the subjects to reenact the event? This situation is no different from the posed photos just discussed. The event is over, and it would be deceiving to present the images as real.

Consider, however, the technique used by some of the best-known photographers in the history of the medium, that of asking the subjects to do what they would normally do, but arranging it for the benefit of the camera. Wilson Hicks, an editor of *Life* magazine during its rise to dominance in the world of American photojournalism, described how W. Eugene Smith used the technique in shooting his famous "Spanish Village" essay:

> By explaining to the villagers that he wished to tell who they were and what they did in the most interesting possible manner, and to draw the full import and most suggestive meanings from their actions and appearances, Smith made actors of them, but actors in a drama held strictly to the facts. For the camera they enacted consciously what they theretofore had done unconsciously; they did what they were used to doing better than they were used to doing it. In re-creating an actuality, Smith gave to it more power and beauty than it had had originally.[15]

Smith believed the procedure was entirely ethical. He said, "If to direct is to translate the substance and spirit of the actuality more effectively, then it's thoroughly ethical. If, however, the actuality is perverted for the purpose of making a more dramatic picture, the photographer has indulged in an unwarranted 'poetic license.' This is a common type of distortion."[16]

But contemporary photographers are less comfortable with this technique, and those who aim their lenses into this gray area risk crossing a critical line between honesty and falsehood. Several photographers have been fired when their editors believed the line had been crossed.[17] In one case, a photographer made pictures of giant pandas that were supposedly in the wilds of China. In reality, the bears were in a two-acre pen at a research center in China's Wuyipeng province. In an explanation to readers, the managing editor of the magazine said the pandas really were wild and, "Isn't that the way a panda in the wild would look? Yes, probably. Isn't that the kind of terrain in which a wild panda would be found? Yes. So what's the difference?" The difference, he said, is in being honest with the reader.[18]

Photojournalist Sam Abell said, "[P]hotojournalism derives its strength from its reputation for the unconstructed photographs. When that's changed with your altering . . . you're changing the basic structure of admittedly a very small but important branch of photography. It lives by its ethics."[19]

Grief, Suffering, Violence, and the Private Moment

A police officer is killed on duty and the press attends the funeral. A child drowns in a lake, the parents react to seeing the body, and a photographer records the moment. A woman falls to her death from a tall building. The cameras are there. Should they be used? Is this event history, or are we intruding? Do the victims have a right to suffer in private, and if so, when do the readers' need to know override those of the individual? Is there a difference between the person who voluntarily enters the spotlight and those who are unwillingly forced there by fate? And does the volunteer surrender everything, or should he be permitted to choose what will be revealed? (Or do we consort with him in revealing only that for which he has sought attention?)

This area is perhaps the most controversial and sensitive of photojournalism ethics, and I doubt that any consensus will ever be drawn. Perhaps the photo of tragedy has more impact than words because the photo leaves so little to the imagination. With words, the reader has a choice to create a mental picture or not—an imaginary image that is under the reader's control. He or she

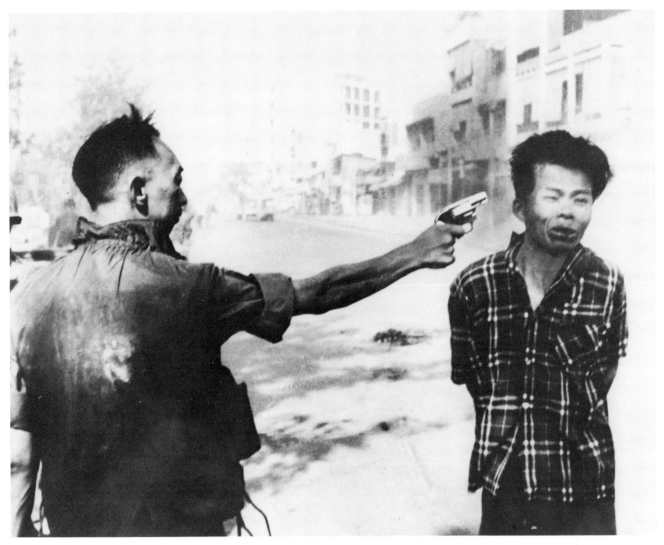

Figure 14–5 Associated Press photographer Eddie Adams won the Pulitzer Prize in 1969 for this photo of street justice in Vietnam. While the use of the picture did not cause a great ethical debate, it raised many questions about the government the U.S. was defending. *(Eddie Adams/AP-Wide World)*

can pick and choose which elements comprise that picture and can stop creating when the image reaches the limit of tolerance. But the photograph forces an image upon the reader, one which he or she cannot control. Its presence on the page is almost impossible to ignore, and its reality can be overwhelming.

By discussing a few of the questions here, perhaps those instances where the line is crossed can be reduced. When a decision is made, it should be a carefully reasoned decision, based not on the needs of the moment nor on an impulsive reaction to a dramatic image, but on careful consideration of the value of the photograph as news, and the consequences of its use—its effects on the subjects of the photo, the readers, and the credibility and reputation of the publication.

In some cases, there is little professional dissent about the use of such a news photo. When the event or the image is of such magnitude that it affects many readers, editors generally agree that the photo should run in spite of possible negative reader reaction. For example, the photo in figure 14–5, was made in 1968 during the Tet Offensive in Vietnam. It was a peak moment in the history of that war, and publication of the photo changed many attitudes. Although some readers may have found it difficult to look at, the image symbolizes the horrors of that war. But what of the scene with less global impact?

Figure 14–6 In January 1987, Pennsylvania State Treasurer R. Budd Dwyer called a press conference the day before he was to be sentenced on charges of bribery and corruption. These photos of his public suicide raised many questions. *((a): Gary Miller-AP/Wide World Photos; (b-e): Paul Vathis-AP/Wide World Photos)*

(a)

(b)

(c)

The following sections are three case histories. The first involves a public official and a locally significant story with a bizarre and tragic conclusion. The second was a major event that took the life of a person who was not otherwise in the news, and the third would not have been more than a one-paragraph news brief if the photographer had not been there.

Dwyer Suicide

In January 1987, R. Budd Dwyer, treasurer of the state of Pennsylvania, stood convicted of bribery, mail fraud and racketeering. On the day before he was to be sentenced, he called a press conference and, in front of TV cameras, still photographers and reporters, he pulled a .357 magnum revolver from a manila envelope and shot himself in the head.[20]

The Dwyer suicide quickly became a story centered on the media and the use of the photos: Could anyone at the press conference have prevented his suicide? Should it have been photographed? And should the photos have been used?

A series of the Dwyer suicide taken by AP photographers Gary Miller and Paul Vathis is reproduced in figure 14–6a through 14–6e. UPI also had a similar series, and other still and video photographers were on the scene.

When Dwyer first pulled out the gun, no one knew exactly what was coming. Some thought he was just fooling around; others thought he would use the gun on them. Those present said to stop his suicide was impossible. Only fifteen seconds elapsed from the time he revealed the gun until he pulled the trigger, and by the time everyone realized what was going to happen, there wasn't time to think. As one video photographer said, "I really didn't think about the situation until it was over and we were out in the hallway. . . . I've been in the business eight and a half years and it was all reflex action." And from photographer Vathis, who made the pictures in figure 14–6b through 14–6e, "Nothing went through my mind except to keep shooting."

(d)

(e)

But there was time to put the camera down and turn away. Should the photographers have allowed themselves to become involved in Dwyer's final act? One photojournalist called this type of situation a "publicity crime." More commonly involving murder, terrorism, hostage taking or kidnapping, "The publicity crime is a perfect example of how we are used. . . . On one hand we have an obligation to report the crime, but on the other hand we have a nagging suspicion we may become accomplices."[21]

And what about the photographer's private ethics? Does he or she owe an employer photographs of every assignment regardless of personal standards?

Use of the Photos Many newspapers used pictures from the series in figure 14–6 or similar shots from UPI. Three different surveys showed that most papers used photo (a), but from one-fourth to one-third of the papers also used pictures (c), (d), or (e).[22]

Of course, the main argument in favor of using at least one photo was the event itself. One photo editor said Dwyer "chose the time, place, and circumstance. . . . We're not in the business of not reporting. We were obligated to pass it on to the public."

Another editor said, "The reasons on which to base a decision . . . should be the quality of the pictures (which was very good) and the news value of the event. Most of the ethical questions that might have come into play, such as privacy and fairness, simply didn't apply."

Another viewpoint was this: "Photos are more powerful than words. More personal. And potentially more offensive. But our job is not to avoid offending readers. Our job is to touch, teach, and help our readers and to show and explain to them what is happening in the world. You don't touch people or affect their behavior with mug shots and pictures of sunsets. . . . [T]he best pictures, the ones that do move us and make us stop and feel human emotions, are often controversial."

One argument that can be used on both sides of the question is that the photos might motivate others. Would this event give someone else a similar idea? But the opposite is also a possibility. One woman called a TV station that ran the entire video footage and said: "I have often considered the taking of my own life as a means of solving my problems. But I feel strongly now that I have an alternative."

A pragmatic argument for not using the pictures is based on news values. Dwyer was a state official unknown outside the immediate area, and his case was of little consequence elsewhere. That he turned a press conference into a public suicide raised his story to a different level, but in the context of the day's news in, for example, California, many other stories competed for space in the paper. Public suicide is certainly news, but do the readers need to see the details to understand the event?

In a different vein, the ombudsman for the *Kansas City Star* said that the paper "wouldn't assign a photographer to cover someone blowing his head off, so why should we publish those same photographs just because a photographer happened to be there?"

Another editor, whose paper did not use any of the controversial photos, said, "We did not want to offend the sensibilities of our readers. We were concerned about Dwyer's children, his wife, his relatives, and friends. Our readers tell us they don't want to see pictures like that."

It is ironic to note that, on the same day, photos of victims of street violence in the Philippines were used by many papers without dissent or reader objection. How does the Dwyer story, or any other local or national story, fall into a different category than something from a war-torn country halfway around the world? Such photos are still violent. The dead and dying are graphically shown. So why does it matter that one is distant and another is close?

Mt. St. Helens Victim

I think most editors would agree that an event involving a well-known person, such as the assassination of a world leader, must be presented to the readers. However, here is a case involving a major news story but an unknown victim.

On a Sunday morning in May 1980, Mount St. Helens, near the Washington-Oregon border, erupted. All day, news agencies flocked to the scene as the peak continued to belch smoke and ash. Most of the photos of the mountain were taken from great distances; other photos were of local townspeople coping with the massive amounts of ash that rained down on their communities.

The peak had been rumbling for weeks, and both before and after the eruption many people had been treating the spot as a tourist attraction, sneaking past police lines. Searchers were looking for victims, but at first it was too dangerous to get too close. The day after the eruption, George Wedding, shooting for the *San Jose Mercury News,* made the photo in figure 14–7. "It was," he said, "the first photo that brought home strongly that people died up there."[23] The photo ran in many newspapers, including one seen by the boy's grandfather. Until then, the child had been listed as unidentified, and the family did not know the fate of the boy, or his father and brother, whose bodies were in the cab of the truck.

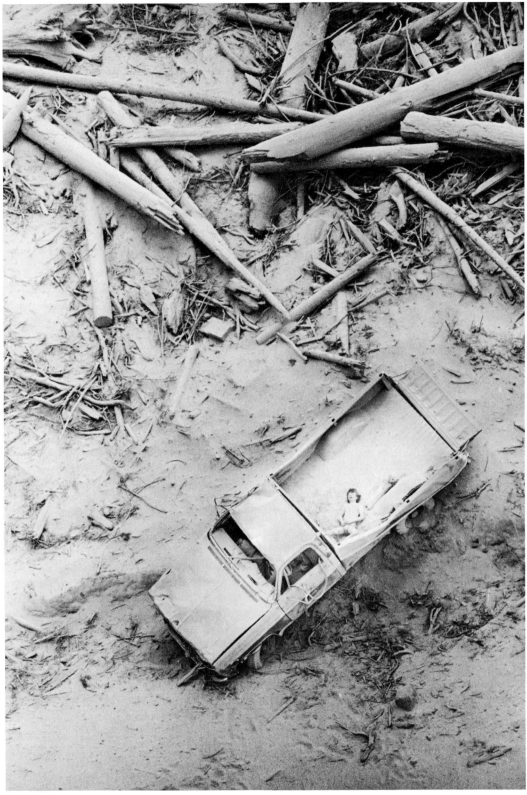

Figure 14–7 George Wedding made this photo of a victim of the 1980 eruption of Mt. St. Helens in southern Washington state. *(George Wedding/San Jose Mercury-News)*

After running the picture, the *Seattle Times* received 150 complaints about its use of the photo. The *Portland Oregonian* also had about 150 calls and letters, and Wedding's own paper had about thirty-five complaints.

Some persons argue that the use of such photos is an intrusion upon the privacy and dignity of death and that the trauma to the family is unwarranted. An editor at *The Seattle Times* who opposed using the shot said, "I would not have run it. I know it reflects the horror of what happened, but I think we offend more people than we impress."[24]

But other editors at the *Times* felt publication was a must. "I think we had to run the picture," one said. "It made me uncomfortable, especially wrestling with the inevitable conclusion that family members might well identify the victim. But we are chronicling an incredible event, and are publishing history. The photograph in question likely will be the picture—or one of the pictures—used in the years ahead when the awesome fury of the eruption is detailed. Thousands of words about gas velocities, air temperatures, and ash falls don't begin to tell the story of the violence and instant death as that one picture."[25]

The Photographer Responds Keep in mind the quotes at the beginning of this chapter as you read the thoughts of George Wedding as he expressed them several years after the incident:

> I think any good news photographer would have made that picture. Maybe a lot of them would have chosen not to transmit it or publish it. Maybe if I had it to do over again, I might have made that decision myself. I don't know. . . .
>
> I don't believe that it's a photographer's job to go out and blindly machine gun pictures of everything that he sees and leave it solely up to an editor in an air-conditioned office isolated from the outside world.
>
> I don't agree with body pictures. Ninety-nine times out of one hundred I would not run body pictures in my newspaper if I were an editor. I think they have the final decision. But I'm the person out in the field and I'm the person to make the first decision.
>
> In some stories, if I don't want an editor to see a picture, I just don't take the picture. If an editor never sees it, it never sees publication. . . .
>
> [I]t wasn't really fair to that family to publish those pictures without contacting them, without giving the authorities time to identify the body. . . . And it wasn't fair to the family to read about their child's death in the newspaper. . . .
>
> [But s]ome say it would have been unfair to withhold that kind of information in light of the enormous impact the story had. . . . The photo helped capture the essence of the story of Mount St. Helens.[26]

Bakersfield Drowning

Although I hope you will never have to cover major tragedies such as those just discussed, it is not unlikely that eventually you will have to confront the kinds of decisions made in this case. The story might be a funeral, fire, traffic accident, or victims of a violent crime. You will have to make your own decisions about what to shoot, and you will return to the newspaper office with pictures that will not change the course of world events and may not have local significance beyond the day's news. Yet they might be honest, dramatic images that capture a moment of life in your town. And you will have to weigh the reporting of the news against sensitivities of the subjects, their families and your readers.

The photo in question is reproduced in figure 14–8. Here is photographer John Harte's account of the event:

> [W]hen I pulled up to the lake, I was jarred by one of the eeriest sights I've seen. Nestled between two trees, a team of men were wading through the water, locked arm in arm. They were searching the 3-foot-deep waters for a body.
>
> On shore, gathered around a picnic table, a group of people nervously watched. Some were weeping. It didn't take much to tell they were the missing boy's family. I used a Nikkor 180 on an FM2 to record the scenes of the rescue workers and the family hoping against the odds. I also had my F3, with a 24mm. I photographed those scenes for about 15 minutes, trying to be as unobtrusive to the family as possible.
>
> Then it happened, and a scene of hysteria spread like a wildfire. The little boy's body was found and a rescue worker came over to tell the family. As the boy's tiny body was placed in a bag, the mother collapsed in tears. Then the entire family went into hysterics. People were screaming and being carried off all around me. It took a few minutes for things to settle down. The mother was taken away in a car, and the hysteria of the remaining family and friends had turned to quiet sobs and soft spoken words of comfort.
>
> From a photojournalist's standpoint, as sickening as this sounds, I was satisfied with what I had shot. There was the search, the reaction and the removing of the body. I figured that was probably it. I watched as the bag containing the body of Edward Romero was carried to a waiting sheriff's vehicle. As is common practice, it would be placed in the back of the car until the coroner arrived to pick it up. But Elroy Romero, Edward's father, wouldn't let it be that way. He wanted to see his boy right then and there. He wanted to hold him, to kiss him, to say good-bye. It was an intensely personal moment in the darkest of his life. He demanded that the bag be opened so he could view the body of his son.
>
> When I saw the bag placed on the ground, instead of in the car, I moved toward it. A sheriff's lieutenant pointed a finger and demanded, "I don't want any pictures taken of this!" I kept moving forward. The only

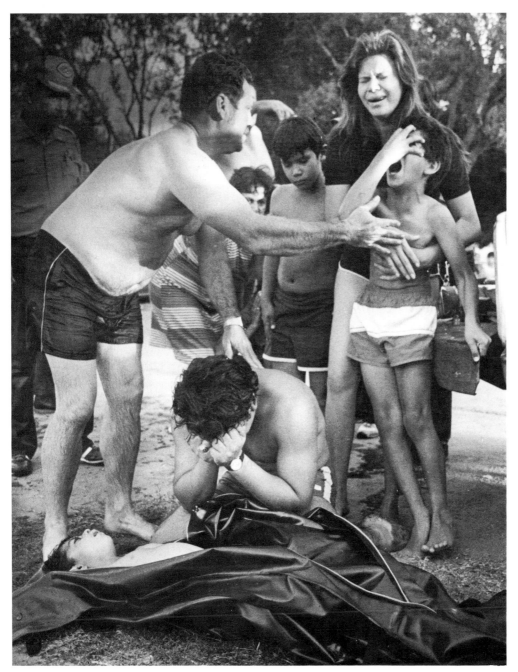

Figure 14–8 A local boy drowned in a park lake, and John Harte of the *Bakersfield Californian* took this picture. *(John Harte/Bakersfield Californian)*

other cameraman on the scene, from one of the TV stations, complied and backed off. I saw it unfolding—the bag being unzipped, the father on his knees. The lieutenant again yelled "No pictures!" but this was a get-at-any-cost picture. They would have to arrest me to keep me from taking this picture. I was about ten feet from the scene when a deputy spread his arms in front of me and said "No." In one motion I identified myself and ducked under his outstretched arms. I expected to be grabbed from behind, but I was left alone to take my pictures. . . .

I took the pictures from a distance of about three to five feet with the F3 and 24mm lens at 2.8 and 1/250. In all, I took eight frames of that scene. At first there was just Elroy Romero and Edward. I photographed him touching the boy's face. As he picked the boy up and hugged him, a young boy believed to be Edward's older brother raced up, saw the body and screamed in horror. At the same time, Elroy buried his face in his hands and rescue worker Joe Colbert reached to comfort them both. It was the picture of that instant that would run in the *Californian* the next morning.[27]

Readers React The reaction from readers was quick and strong. The *Californian* received more than four hundred phone calls, five hundred letters, about eighty subscription cancellations and a bomb threat. Comments included words such as insensitive, invasion of privacy, poor taste, yellow journalism, and sensationalism. Here are some quotes from letters received by the paper:

"This was and should have been a private moment. . . ."

". . . I realized your newspaper has no concept of news versus sick."

"Most of the caring people in Bakersfield can understand and relate to the grief of the family without that picture."

"I am outraged at this latest episode of tasteless journalism. The stories involved may be newsworthy, but the photos aren't."

"That picture will remain in my mind, as well as in the minds of countless other people, forever."

"What happened to human decency? Some emotions are intimate and should not be used to sell newspapers."

"The photograph reaches the height of insensitivity and oversteps the principles of freedom of the press."[28]

In a memo to newsroom staff, managing editor Bob Bentley said, "There are many lessons that can be learned from this specific incident. . . . I think the greatest one is stark validation of what readers—and former ones—are saying . . . : *That the news media is seriously out of touch with our audiences,* and it is costing us dearly and perilously in respect, support, and credibility. . . . [I]t concerns me greatly that we can think we are so right and they can think we are so wrong."[29]

Editor Bentley wrote a column explaining that the decision to print the picture was a mistake and apologizing to readers who were offended. But photographer Harte said there were three drownings that day, and drownings were a problem in that community. Perhaps printing these kinds of pictures might cause others to be more cautious. Harte said:

> I do not agree with the apology. If there is something to be sorry for, it's that a young boy drowned. But we shouldn't be sorry we ran the picture. We'll never know if any lives were saved because a parent took extra precautions after being shocked by this picture. But if just one life was saved, if one family was spared the agony that the Romeros suffered, then the picture was worth it. I can't agree with Bentley's comment that "[T]he obvious disadvantages of publishing the picture far outweigh any possible benefits."

How does Harte feel about taking the picture?

I feel guilty. On one hand I was excited about getting that kind of picture. But it came at the expense of a family that lost a son. I didn't sleep that first night. Now I feel a lot better about it. I'm sorry Edward died, but I'm sure the picture did some good somewhere.

Would he have trouble taking the same type of picture again? "None whatsoever."

The Photographer's Decisions

You might not be comfortable with John Harte's decisions. Should you shoot first and edit later, or do you have some responsibilities on the scene? Is there a reason for running a photo beyond its shock value—is the wreck or drowning picture effective in preventing such things from happening? Should we play the role of the doctor, administering foul-tasting medicine to our readers because we have decided it will be good for them in the long run?

One commentator said, "It is wrong as a general principle for one human being (an assignment editor, perhaps, or a news director) to say to another human being (a camera operator in the field): 'You get the pictures; we'll decide whether to use them.' "[30]

But the other view could be summarized thusly:

> It is difficult for me to understand the lack of comprehension of many photographers as to just what the job of a news photographer is. Basically he/she is at any event as the extended eye, through the media, of the public.
>
> The goal is simplicity itself—to show exactly what is going on in front of the lens from a neutral viewpoint. In short, to get an unbiased picture of anything and everything that happens, good, bad or indifferent, regardless of mitigating excuses.
>
> . . . The split-second at the taking of the picture is not the moment to think if it will be used. Nor are all the psychological hoopla, philosophical ramblings and personal hangups relevant or necessary.
>
> What is necessary at the precise time is well-composed, sharp, correctly exposed interpretive images of exactly what is going on. That's what the photographer is there for, nothing else.
>
> Seldom is the wisdom of exhibiting the resultant pictures up to the photographer. At a subsequent time, in a supposedly calmer period of reasoning, the wisdom of running what had been taken can be discussed and judged by an allegedly broader and wiser group of evaluators of which, if one is lucky, the photographer will have a voice.[31]

One Photographer's Guidelines

Here are some questions photojournalist Garry Bryant asks himself when faced with difficult situations:

1. I have to determine if the private moment of pain and suffering I find myself watching needs to be seen. Should this moment become public? If so, does it tell the story or part of the story of this event?

2. Are the people involved in such shambles over the moment that being photographed will send them into greater trauma?

3. Am I at a distance trying to be as unobtrusive as possible?

4. Am I acting with compassion and sensitivity?[32]

Summary

We have had space here to examine only a few of the issues and a few of the questions such issues raise, but I hope it is evident that there are no clear-cut answers. The real world is full of variables that make broad statements of what is right difficult to follow. On the one hand, it would be easy to deal with conflicts of interest by avoiding those situations that lead to them, but it is impossible to be a photojournalist without getting involved in your community.

And it would be easy to say that no one wants to read about the tragedies, so they shouldn't be printed. But that would be a form of censorship that is not appropriate in our society.

Part of the professional goal of most photojournalists is to be honest and sensitive, but the force that pushes them is revealed in the quote from Lewis Hine that opened chapter 1: "There were two things I wanted to do. I wanted to show the things that had to be corrected. I wanted to show the things that had to be appreciated." The question of whether some of those things should be shared, and who should decide, will probably never be satisfactorily answered. But you will have to set your own standards, ones that are realistic, carefully thought out, and that you can live with.

Endnotes

1. For example, in describing University of San Diego law professor Bernard Siegan, a Reagan nominee to the 9th U.S. Circuit Court of Appeals, *The Fresno Bee* said in an editorial, "Thus, he argues, the First Amendment . . . free speech protections only bar Congress, not the president, from imposing censorship." "Another Bork?," *The Fresno Bee,* 6 January 1988.

2. Michael J. Okoniewski, "Photograph or Help?" (letter), *News Photographer,* July 1983, 20.

3. Jose Luis Villegas, "Two Different Things" (letter), *News Photographer,* August 1987, 66.

4. According to an article in *Photo District News,* such alterations are not unusual in TV news. The magazine quoted one TV source as saying that artists are under heavy deadline pressure and "do it as fast as possible and worry about the consequences later." May 1987, 20.

5. Shiela Reaves, "Digital Retouching: Is There a Place for It in Newspaper Photography?," *Journal of Mass Media Ethics,* no. 2 (Spring/ Summer 1987): 46.

6. "Make a Good Picture Better: Turn Horizontal to Vertical," *News Photographer,* January 1987, 25.

7. Jack Corn, quoted by Reaves, "Digital Retouching," 46.

8. Tom Hubbard, "AP Photo Chief, AEJMC Professors Discuss Ethics, Electronic Pictures at Convention," *News Photographer,* January 1987, 33.

9. Stewart Brand, Kevin Kelly, and Jay Kinney, "Digital Retouching: The End of Photography as Evidence of Anything," *Whole Earth Review,* July 1985, 46.

10. Hubbard, "AP Photo Chief," 33.

11. "Discussion Topic: To Pose or Not," *News Photographer,* January 1987, 41.

12. *Parade,* 20 July 1986.

13. Betsy Brill, "Town Protests Staged Picture, 'Hooker Image,' " *News Photographer,* September 1986, 4.

14. Jack Corn, quoted in "Discussion Topic: To Pose or Not," *News Photographer,* January 1987, 41.

15. For a complete discussion of this and its use by *Life* magazine photographers, see Wilson Hicks, *Words and Pictures: An Introduction to Photojournalism* (New York: Harper & Bros., 1952), 128ff. The "Spanish Village" essay ran in *Life* on April 9, 1951.

16. Hicks, *Words and Pictures,* 130.

17. Jim Gordon, "Foot Artwork Ends Career," *News Photographer,* November 1981, 32ff. Also see accompanying sidebars.

18. "Panda Pictures Are Fraud, Geo Says," *News Photographer,* November 1981, 36.

19. "Discussion Topic," *News Photographer,* January 1987, 40.

20. A thorough discussion of this story can be found in *News Photographer,* May 1987, 20–39. All of the material and quotes presented here are based on or are directly from that report.

21. Mark Godfrey, "Ethics, Responsibility and Integrity," *News Photographer,* November 1974, 11.

22. Two of the surveys, reported on p. 22, 34, and 35 of the May 1987 *News Photographer,* did not indicate whether the AP or UPI photos were used, but since both series were almost identical, the illustrations here will serve to indicate the shots discussed.

23. "All a Big Game," *News Photographer,* August 1980, 12.

24. William H. Kitts, quoted by Don Brazier, "Unforgettable but Unpleasant Photograph," *APME News,* July 1980, 11.

25. James C. Heckman, quoted by Brazier, Ibid.

26. "George: National, R-10 Newspaper Photographer of the Year George Wedding," *News Photographer,* January 1982, 17.

27. From a written account provided to the author by photographer John Harte.

28. These quotes were excerpted from letters printed in the 2 August 1985 edition of *The Bakersfield Californian.*

29. Internal memorandum, *The Bakersfield Californian,* dated July 31, 1985.

30. David Dick, quoted in "No Ethical Justification," *News Photographer,* May 1987, 29.

31. Harvey Weber, "The Extended Eye" (letter), *News Photographer,* August 1987, 68.

32. Garry Bryant, "Ten-fifty P.I.: Emotion and the Photographer's Role," *Journal of Mass Media Ethics* 2, no. 2, (Spring/Summer 1987): 34.

Chapter 15

The Legal Limits
by John Zelezny[*]

Outline

"Congress shall make no law respecting an establishment of religion, or prohibiting the free exercise thereof; or abridging the freedom of speech, or of the press; or the right of the people peaceably to assemble, and to petition the Government for a redress of grievances."

—First Amendment,
U.S. Constitution

*Copyright © 1990 by John Zelezny. The author is a member of The State Bar of California and an assistant professor of journalism at California State University, Fresno.

The First Amendment: Not Unlimited

In your effort to meet deadlines, capture telling images, and achieve technical precision, it is easy to overlook the law. Yet legal rules do apply to many aspects of photojournalism, and a working knowledge of these rules is another mark of the true professional. Legal standards are sometimes subtle and complicated. But there is plenty of incentive to learn at least the basics, because legal oversights can mean personal hassles, public embarrassment, and serious financial liability for you and your employer.

Like everyone else, photojournalists are protected from government interference by the First Amendment to the U.S. Constitution, which states: "Congress shall make no law . . . abridging the freedom of speech, or of the press. . . ." But the courts have said this amendment is not absolute. So despite the amendment, there are some laws that restrict your activities, as well as some that protect them. In this chapter, we'll cover the most relevant of these laws.

Please remember, however, that what follows is a general overview; it is not a detailed presentation of your state's laws. Some national uniformity is achieved by the U.S. Supreme Court's First Amendment interpretations, but considerable diversity remains. The specific legal rules in your area might be different from a neighboring state's, or from the national norm. For the legal details of your jurisdiction, contact a state press association or your employer's attorney.

Access to the News

In some cases the threshold question is whether you may even gain access to newsworthy places—the house where a homicide occurred, the industrial yard where drums of toxic chemicals have been dumped illegally, or perhaps a military testing site. And on this question the First Amendment is usually impotent. With limited exceptions, the First Amendment is not interpreted to guarantee you access to information or places. As Chief Justice Burger wrote in 1978: "There is an undoubted right to gather news 'from any source by means within the law,' . . . but that affords no basis for the claim that the First Amendment compels others—private persons or governments—to supply information."[1] In other words, the First Amendment works defensively, as a shield against government suppression, but not offensively, as a battering ram to open doors to the newsgathering process. It does not, for example, make you immune to the law of trespass.

Private Property and Trespass

Trespass is the unconsented intrusion upon property that is in the rightful custody of others. For the photographer, this typically means wandering through private land or structures where permission—either express or implied—does not exist. Trespass can occur at the moment of entry, when you hop the fence, for example. Or, if you originally had permission, trespass could occur later—if you exceed the scope of consent, or if consent is revoked and you fail to leave.

For example, suppose you entered a restaurant during its regular business hours. There is no trespass, because under what the law recognizes as custom and usage, there is implied consent for the public to enter. But the implied consent would not extend to all purposes, such as your roaming through the restaurant to photograph patrons. Furthermore, the restaurant management could end any claim of implied consent by expressly asking you to leave. Now should you linger, trespass will occur.[2]

News photographers have run into legal trouble by assuming that the right of police or other emergency personnel to enter property also implies consent for the news media to follow. Courts usually reject this contention. In fact, even the express consent of police or fire officials may be insufficient, as a 1986 ruling in *Miller v. NBC* illustrates.[3]

A television camera crew, working on a minidocumentary about paramedics, obtained consent to accompany a unit of Los Angeles Fire Department paramedics and film all aspects of their work. The unit was called to a private residence, and the camera crew followed—right into the bedroom, where a man lay on the floor, dying of a heart attack. TV crew members stayed to film the resuscitation efforts, but they never sought consent to enter from the one person, under the circumstances, who could give it. That person was the victim's wife, who anxiously waited in another room of the apartment and realized only later that a television crew had been present. The California Court of Appeal held that she could pursue a trespass claim against the TV station.

The Florida Supreme Court reached a different result ten years earlier, holding that no trespass occurred when a *Florida Times-Union* photographer accompanied fire and police officials into a burned-out house without the owners' consent.[4] One distinguishing feature, however, is that in this case the owners of the house were out of town at the time of the fire, so consent of the authorities was the best the photographer could obtain. Indeed, the authorities in this situation could be viewed as the temporary custodians of the property, legally able to authorize others' presence. Whether most courts would actually follow this reasoning, however, is uncertain.

Trespass is a *tort,* a civil wrong for which the injured party may collect damages in court. It need not be shown that you entered the property with any mischievous or malicious intent. If a trespass is willful, though, it can sometimes constitute a *crime* as well as a tort. A crime is an act punishable by the government. State statutes specify a variety of criminal trespass situations, such as refusing to leave clearly posted or fenced lands after being so asked.

Figure 15-1 In Florida, a photographer accompanied officials into a burned-out house and made this picture. The mother of the fire victim learned of her daughter's death by seeing the published photo and sued the paper for trespassing. In this case, the courts held that no trespass had occurred. *(Bill Cranford/Florida Times-Union)*

A final note about trespass: Suppose you have wandered onto the back lot of a manufacturing plant to photograph dangerous storage tanks. The foreman approaches and says, "You're trespassing. Hand over your film." Are you legally bound to comply? No. The mere act of civil trespass does not give the property occupant authority to seize your film or equipment, though this is often presumed. The legal remedy for trespass is through the courts. Confiscation of your film by force or threat would be in turn a violation of your property rights. The rule can be different, however, if your actions amount to a crime and officials are seizing your film as evidence. More about that later.

Accident, Crime, and Disaster Scenes

Even in the most public of places, there are times when police or other authorities may close areas in the interest of public safety. Typical examples are traffic collisions,

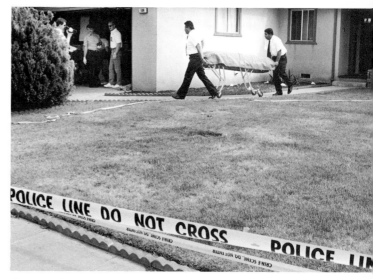

Figure 15-2 If the police declare an area a crime scene, you will have to stay behind the lines. *(Ron Holman/The Clovis Independent)*

chemical spills, scenes of violent crime, or areas damaged by earthquake, storm, or fire. Unauthorized persons who enter these enclosed sites may be arrested and prosecuted for misdemeanors.

Of course, it is just such newsworthy areas that you'll want access to as a photojournalist. And fortunately, news people are granted access rather routinely. Some law enforcement agencies issue standing press passes to employed news people—something you should inquire about before a newsworthy calamity strikes. These passes serve as a handy form of identification for the agency, and letting credentialed photographers past the barricades is common policy. But in most cases this practice, which you may come to take for granted, is not required by law. So even with a pass there are times when you might be held behind the lines with the general public—a humbling and frustrating experience.

In California a unique statute specifically allows news people to cross police lines, but even that statute is interpreted narrowly. A court in 1986 said the statute was meant to allow news people to assume the risk of injury and enter sites that were closed solely for public safety. But if authorities believe media access will impede emergency operations, or if the closure is related to investigation of a crime, then no media privilege exists. For example, the court upheld the conviction of a TV news cameraman who disobeyed police orders and entered an airline crash site where officers were investigating a possible criminal cause.[5]

If authorities at a calamity scene do order you to stay away, don't expect an on-the-spot argument to prove fruitful. In fact, if you force a confrontation you could be arrested and prosecuted for interference with a police officer, even if your presence was consistent with prevailing

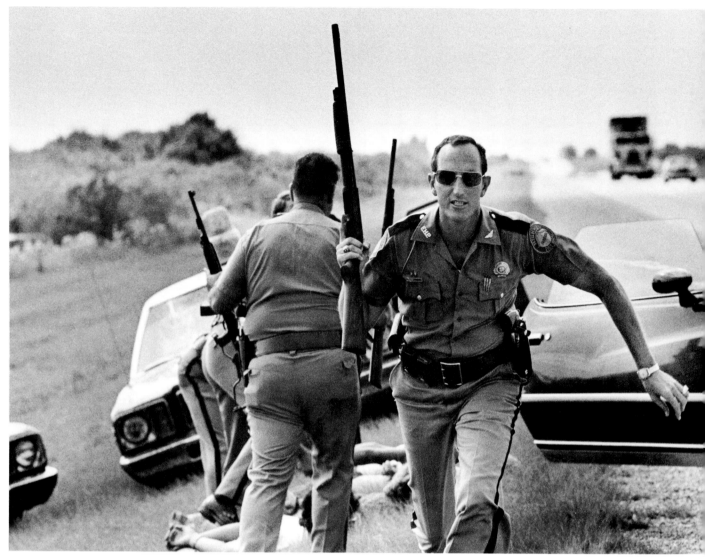

Figure 15–3 In 1978 *Palm Beach Post* photographers Ken Steinhoff and C. J. Walker were hassled by this Florida Highway Patrol officer at the scene of the arrest of some robbery suspects. The Patrol later apologized and adopted a media rights policy. *(Ken Steinhoff/The Palm Beach Post)*

policy. Courts are likely to give deference to the judgment of police officers in emergency situations.[6] If you believe an officer is unreasonably or even illegally standing in the way of your job, ask to speak to a superior officer, or avoid the impeding individual and find another vantage point. File a complaint later. For the benefit of your long-term working relationship, set up a media/law enforcement meeting where both sides can discuss problems and agree to some guidelines.

Government Property and Proceedings

Government property—military bases, prisons, power plants, and so on—exist for a public purpose, but that does not mean they must be open to the public, or to you. Entry can be limited to that which serves the property's purpose, and the laws of civil and criminal trespass apply.

There is, however, a significant difference between government-controlled property and purely private property. For the most part, possessors of private property may invite or exclude whomever they wish. But government, once it does open property or proceedings to the general public, cannot single out the press for exclusion. Nor may it admit the news media generally but exclude a particular photographer or media organization because of unhappiness with its past coverage. Courts have ruled that such government discrimination violates the First Amendment.[7]

Meetings If it is access to a government meeting you desire, then the law swings more forcefully to your aid. The federal government and all fifty states have enacted open-meetings statutes that require government deliberations to be open to the public.

The federal law, called the *Sunshine Act,* requires most federal regulatory agencies and commissions to provide advance public notice of their meetings and then to conduct these meetings openly. There are exceptions, of course. Three of the more important ones are discussions of national security matters, personnel matters, and criminal investigations.

State open-meeting laws vary greatly and can be quite complicated, covering local government bodies (such as school boards, planning commissions, and city councils), state agencies, and even the legislatures themselves. Like the federal law, the states also allow executive, or closed, sessions for specified topics of deliberation.

If you find yourself shut out of a government meeting, don't just presume the agency has legal authority to do so. Contact your employer's lawyer. Open-meetings violations occur frequently, especially with small, local-government bodies that may be ill-informed of the open meetings requirements. Often one call from a lawyer is enough to prompt the proper open-door policy.

Courts Finally, what about courtroom proceedings? Open-meeting laws do not cover the courts. But they don't need to. This is the one place where the First Amendment is interpreted to guarantee public access.

In 1980 the U.S. Supreme Court ruled that the public (and press) has a First Amendment right to attend criminal trials. This ruling, contrary to the general principle that the First Amendment does not guarantee access, was based on the tradition of open criminal trials at the time the amendment was adopted. According to Chief Justice Burger, this tradition suggests constitutional intent that trials remain open.[8] Therefore, you and the public may be locked out of a criminal trial only if truly essential to protect the defendant from legal prejudice—a very rare circumstance.

In 1986 the Supreme Court extended First Amendment access to preliminary hearings in criminal cases, at least in states with a tradition of public access to such hearings.[9] And some jurisdictions have extended First Amendment access to civil trials as well as criminal ones.[10]

Taking the Photo

Now suppose you've legally gained access to the newsworthy location. Do you have a legal right to do what you came to do—to take photos? In most cases the answer is yes. Consider the accident scene, for example. If you're in an area that is open to observers, police do not have the authority to single you out and order, "No photos!" Overzealous or overprotective officials often make such commands. But the general legal rule is that whatever and whomever the public is free to see, you are free to photograph, and officials cannot act as on-site censors.

There are some occasions, however, when the very act of photographing can be legally prohibited.

Courtrooms

For the best illustration of instances when photographing can be legally prohibited, we need only pick up where we left off—in the courtroom. Courts have long perceived a clash between journalistic coverage and a defendant's constitutional right to a fair trial. And traditionally photography has been the facet of journalism that courts have abhorred the most.

Television and still photography have been considered distracting to juries, intimidating to witnesses, and generally disruptive of courtroom decorum. For decades most court systems across the nation maintained strict bans on the use of cameras. The U.S. Supreme Court first confronted the issue in 1965. A man had been convicted of large-scale fraud in Texas, and despite the defendant's objections the trial judge permitted the proceedings to be televised. (Texas was one of just two states that allowed televised trials at the time.) The U.S. Supreme Court overturned the conviction, ruling that the use of TV cameras had contaminated the ideal of due process.[11]

But in the years that followed news organizations lobbied vigorously for the use of cameras, and in the mid-1970s the tide began to turn; courts began to experiment. In 1981 the Supreme Court faced the issue again, this time ruling that the presence of cameras does not inherently render a trial unfair.[12] The ruling further opened the door for experimentation with cameras.

Today a vast majority of states have abandoned the strict prohibition on cameras in the courtroom. But some limits remain; the new rules seek a balance between your legitimate photographic needs and the parties' rights to dignified proceedings. For example, the statutes and court rules typically give wide discretion to the judges. Frequently the rules require you to get approval in advance from the presiding judge. And in proceedings with extraordinary media interest you may be required to enter into a pooling arrangement with other news organizations—a situation where one photographer is admitted and shares the pictures with all the others. Your state's court rules might also prohibit close-up photography of jurors and the use of motorized drives or flash.

But although state courts are often allowing the presence of cameras, the federal court system remains opposed. Rule 53 of the Federal Rules of Criminal Procedure precludes federal judges from allowing photos during court proceedings. That is why network news broadcasts often resort to sketches of courtroom action.

Figure 15–4 State courts have generally opened their doors to photography, provided permission is obtained in advance. Federal courts remain off-limits to photographers. *(Steve Hanks/Lewiston Morning Tribune)*

Private Property

When you are admitted to privately owned property or a privately sponsored event, you do not necessarily gain the right to photograph. The people in control may specify that your presence is subject to certain limitations. Perhaps it's a sign at the entrance of a Las Vegas stage production: NO CAMERAS ALLOWED. Or maybe it's the fine print on your ticket to a figure skating exhibition: NO FLASH PHOTOGRAPHY.

The private sponsors of art, entertainment, and sporting events have something to sell, and they may package and sell their products almost any way they wish. Restrictions on photography are usually intended to prevent distractions to other patrons or to maximize marketing opportunities. For example, promoters of a skating exhibition might wish to sell exclusive photography rights to a leading sports magazine, which means prohibiting photography by all others.

Since the law regards entertainment as a product, the fact that it might also be newsworthy does not change the rules of proprietary control. If you accept admission to such an event, you have implicitly agreed to the stated restrictions, and this agreement is binding. In New York a statute even provides that theaters may temporarily confiscate photographic equipment from persons admitted to live theater shows unless they have written permission to photograph.[13]

Copyright

Another property interest is *copyright,* the exclusive right to control the reproduction and distribution of creative works. As a photographer, the copyright law

works to your economic benefit by preventing others from pirating your images (see chapter 16). But the law works both ways. If you use your camera to reproduce others' copyrighted works without permission, then you risk liability for copyright infringement. The federal copyright law does, however, provide an important exception to the original creator's broad control. It's called *fair use,* the limited use of the copyrighted work for certain socially desirable purposes.[14] Let's consider a real-life example to help sort through these rules.

A graphic arts company owned the copyright of a piece of art titled *Ronbo.* It was a photograph that superimposed President Ronald Reagan's face on a muscular body firing a machine gun—a pose intended to mimic the title character from the movie *Rambo.* The graphics company sold this image in the form of posters. In 1986 a newspaper photographically reproduced the *Ronbo* poster across a full page in order to illustrate a news story on the "Reaganization" of American cinema. This was done without the copyright holder's authorization. So, is this a copyright infringement? The answer is yes, unless the fair-use exception can come to the newspaper's rescue.

The federal copyright law says, "the fair use of a copyrighted work, including such use by reproduction in copies . . . for purposes such as criticism, comment, *news reporting,* teaching, scholarship, or research, is not an infringement of copyright" (emphasis added). Was the newspaper in the clear? The reproduction was for a news reporting purpose, so this factor weighed in favor of fair use. But the purpose of the use is only the first consideration in a four-part test that courts use to determine fair use. The other factors are the nature of the copyrighted work, the substantiality of the portion used, and the effect on the market.

As to the nature of the work, it was creative. Creative, imaginative works are generally entitled to more protection than works that are purely informational. Therefore, this factor weighed against fair use. And as to the substantiality of the portion used, the entire work was reproduced. So this factor also weighed against fair use. Finally, would the newspaper's reproduction have a negative effect on the copyright holder's market for its poster? The court concluded that the newspaper reproduced *Ronbo* so prominently that the copy would likely reduce demand for the original poster. So the final factor also worked against the newspaper, and the court held that the photographic copy was not fair use, making the paper subject to liability for copyright infringement.[15] If the newspaper had reproduced *Ronbo* in a significantly smaller size, or as just a background element in a photo with other content, then the fair-use privilege probably would have applied.

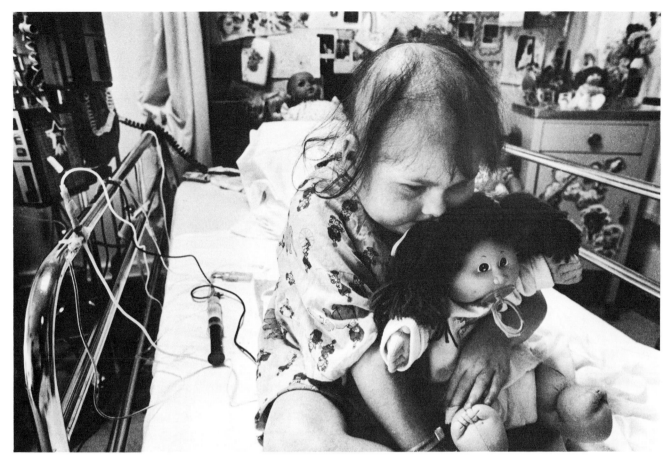

Figure 15–5 Photographer Sarah Fawcett could not have photographed this young leukemia victim without the consent of her parents. Photographing anyone in a hospital without his or her permission could be considered an invasion of privacy. *(Sarah Fawcett)*

Invasion of Privacy

Among the more complicated legal barriers that you face today is invasion of privacy—a relatively young area of law. Although trespass, libel and copyright law have been with us since colonial times, the invasion-of-privacy concept was first proposed in 1890 by legal scholars reacting to the affronts of gossip-oriented newspapers in the yellow journalism era. Courts and legislatures began developing the law in the early 1900s, but its evolution is far from complete.

To understand invasion of privacy, you must note that it is developing four distinct branches: intrusion, appropriation, public disclosure of private facts, and false light. The first of these, intrusion, occurs in the news-gathering process, and the others occur upon publication.

Intrusion

You will commit an invasion of privacy of the *intrusion* type if you invade a person's physical seclusion in a manner that would be highly offensive to reasonable people. Ordinarily, this means peering into a private residence or some other enclosed place where a person is entitled to believe he or she is safe from unwanted observation. A claim of intrusion is sometimes joined with a claim of trespass. For example, in the previously discussed case of *Miller v. NBC,* the TV crew entered a private residence to film paramedics in action. The court ruled that in addition to trespass, the wife could sue the TV station for intrusion. "Reasonable people," the court wrote, "could regard the NBC camera crew's intrusion into Dave Miller's bedroom at a time of vulnerability and confusion occasioned by his seizure as 'highly offensive' conduct."[16]

But you can also commit this civil wrong by snooping around with a 1000mm lens, even though you aren't trespassing. Remember the key question: Is your subject in a place where he or she can reasonably expect privacy? In a house, probably yes. But in other settings, rarely.

Figure 15–6 You would have no problem using a photo such as this for any purpose since there is nothing in the image that can be identified. *(Tony Olmos)*

Consider this case from the state of Washington: A television station was pursuing a story about a pharmacist who was facing criminal charges. A cameraman walked up to the exterior window of the pharmacy during closed hours and filmed the pharmacist talking on the phone inside. The court held there could be no claim of intrusion and explained: "It is not contended that the film recorded anything other than that which any passerby would have seen. . . . The filming was accomplished without ruse or subterfuge."[17]

Though the case decisions thus far do not supply solid guidelines, there are some places other than residences where photography would be risky. Most notably, you should refrain from photographing patients in hospital rooms or ambulances unless you have their clear consent.

Commercial Appropriation

The second branch of invasion of privacy is *appropriation,* sometimes called misappropriation or infringement of the right of publicity. It is the unauthorized use of a person's name or likeness for a commercial purpose. And although the other areas of privacy law are being defined by judges and juries, many states have specific statutes relating to commercial appropriation. It is a law that protects private individuals as well as those of celebrity status.

Here's the typical scenario: You take a handsome, close-up photo of a college track star clearing the hurdles. You then provide the photo to the display advertising department at your newspaper, without the athlete's consent, and it is used prominently in an advertisement for a brand of running shoes. Sure, some track stars probably would be flattered. But others might feel exploited or embarrassed, and they would have grounds to sue.

You will be safe from an appropriation claim if the individual in a photo is not readily identifiable—an anonymous figure in a crowd, for example. Nor will appropriation occur if a photo is used purely in a news context. Only when used in a commercial context will you need to have consent. Courts have consistently upheld this critical distinction, though it is not always an easy one to make.

Use of a photo is not classified as commercial simply because the medium itself is operated for a profit, as most newspapers are. There must be a direct link created between the person in the photo and the promotion of a specific product or service. Appropriation laws exist to protect persons from unwilling, implied endorsements and to give individuals control over the commercial marketing of their own likenesses.

How about self-promotions by the news media? Even here, if the individual in a photo is only incidental to the promotion, courts have held the media immune from appropriation lawsuits. A 1986 Oregon case illustrates this point. A television news cameraman photographed an auto accident scene, including footage of a victim who was bleeding and receiving emergency medical treatment. The videotape did not appear on the news program, but it was used some time later—in a promotional spot for an upcoming special report on emergency care. The accident victim sued for appropriation, claiming his likeness was used without consent for the TV station's own commercial advantage. But the Supreme Court of Oregon ruled in favor of the station. Although the footage was used for a commercial purpose, the victim's appearance was merely incidental to that purpose, the court said. The promotion did not imply that the victim endorsed the forthcoming program about emergency care, and "the identity of the accident victim was immaterial," the court said.[18]

So, the basis for appropriation lawsuits is not simply an individual's unauthorized presence in a photo that serves a promotional role. There also must be a link between the promotion and the individual's personal attributes—looks, position, name, reputation. It is the exploitation of these personal attributes that the individual has the legal right in commercial settings to control, or to be compensated for.

There are times, though, when you might photograph persons for integral use in advertisements or other trade or promotional materials. And sometimes you won't even know how your photos ultimately will be used. In these instances you must protect against appropriation lawsuits by obtaining the consent of your photographic subjects.

Model Releases In some states the appropriation laws say valid photographic consent must be in writing, and that's a prudent idea in any event. Your photo kit should contain *model releases* or *photo consent forms* so you'll be prepared on the spot. A typical release form is shown in figure 15–7.

To play it safe, you should obtain signed releases whenever your photos might be used in other than hard-news contexts. Many magazines and book publishers require a signed release before they will publish your work. Courts have not been entirely predictable in deciding whether the pictures in magazines and books appeared in a news context or a commercial context. For example, in New York a black teenager won an appropriation lawsuit against the publisher of a book about getting into college. The teen was not a subject of the book, but her picture was used on the cover to help boost sales to minorities. This was deemed a commercial use under the state's appropriation statute. The publisher was unaware that the freelancer who took the photo never obtained a written release.[19]

A few things to remember about consent: First, persons under eighteen years old, minors, may be deemed incapable of giving valid consent, so make sure a parent or guardian signs the release form on the minor's behalf. Second, when consent is given gratuitously, not in exchange for money or something else of value, then the consent may legally be withdrawn at any time prior to publication. Gratuitous consent is not a binding contract, and you must honor a subject's change of mind. Finally, even though a release may be worded very broadly, courts sometimes hold that reasonable limitations are implied. For example, the release might be deemed invalid after the passage of many years. Or it might not cover drastic alterations to the photo.

What if you have a good photo you'd like to market, but you were not able to get a release? You can protect yourself by communicating this to the purchaser and

Figure 15–7 Any time you suspect that a photo might be used outside of a news context, get a model release such as this one.

perhaps stamping the back of the photo: "Not to be used for advertising or trade purposes. No model release available." This action will help assure that the photo is used properly, and in any event, that you sold it only for a legal use. If the photo is misused at some point, the legal liability will then have to fall elsewhere.

Publication of Private Facts

Mention invasion of privacy and it is this third branch—unwarranted publicity about private life—that often comes to people's minds. You may indeed be sued if you

- publish private facts,
- of a highly embarrassing or offensive nature,
- without a newsworthy purpose.

This law threatens American precepts about freedom of the press by allowing you to be sued for the dissemination of truthful information. In practice, though,

successful lawsuits against the media have been infrequent. Let's take a closer look at the elements of this law.

You can be liable only if the publicized information had been truly private. That is, prior to your publication the information had been guarded and not generally available to the public. Therefore, events that occur in a public place may almost always be published without worry of a lawsuit. In a 1976 case, *Neff v. Time, Inc.*, a photographer for *Sports Illustrated* photographed a group of Pittsburgh Steelers fans who were hamming it up atop a dugout prior to a football game at Cleveland. From thirty pictures of the group, the magazine published one to illustrate an article titled "A Strange Kind of Love," about the Steelers' rowdy fans. The photo, however, clearly showed one of the fans with his trousers fly open, and that fan, Neff, sued for publication of private facts. Though the photo was not anatomically revealing, the federal court acknowledged that the magazine deliberately exhibited Neff in an embarrassing manner. But this condition wasn't enough. The court denied his claim because the photo simply did not reveal private facts. Neff's behavior was observable by the general public, and he had even taunted the photographer to take pictures. The court wrote: "A photograph taken at a public event which everyone present could see, with the knowledge and implied consent of the subject, is not a matter concerning a private fact."[20]

This rule that photos of public scenes cannot be deemed privacy invasions is frequently stated in court opinions and is well worth remembering. Still, there can be exceptions. For example, contrast the Neff case with the often-cited 1964 case of *Daily Times Democrat v. Graham.*[21] Flora Graham and her two sons went through the fun house at a county fair, unaware of what to expect. As she exited, Mrs. Graham's dress was blown up by air jets beneath the fun house platform. And as fate would have it, a newspaper photographer captured this moment on film. A few days later the picture appeared on the front page, showing Mrs. Graham exposed from the waist down, except for her underwear. The Supreme Court of Alabama upheld an invasion-of-privacy judgment for Mrs. Graham even though it acknowledged she had been part of a public scene. Unlike the Neff situation, Mrs. Graham's embarrassing predicament was instantaneous and nonvolitional. The court wrote: "To hold that one who is involuntarily and instantaneously enmeshed in an embarrassing pose forfeits her right of privacy merely because she happened at the moment to be part of a public scene would be illogical, wrong, and unjust."

Now let's look at the second element of this law. Even if you reveal truly private information, you won't face legal trouble unless the revelation is highly offensive to prevailing notions of decency. For example, a person may have kept his pet dog under wraps—a guarded secret even from close friends. Yet, to publish a photo of the ugly dog would not normally be the sort of publication that offends a community's sensibilities regarding privacy. Areas of revelation that are likely to be considered offensive include sexual matters, unusual physical disorders, and mental disorders.

Finally, and perhaps most important, private-facts claims are limited to revelations that are not newsworthy. You might publish information that is both private and highly embarrassing, but if it's reasonably connected with a newsworthy event, you're safe. This newsworthiness defense is a legal acknowledgment of the public's legitimate right to know. So, what is the legal definition of newsworthy? As you can imagine, this has been a tough problem for the courts, and the articulated newsworthiness tests vary from state to state. Generally, though, courts avoid the quagmire of strict definitions by simply asking juries to consider whether the published information is in line with customary news-media content. What will not be considered newsworthy is sensational material published for its own sake—material published not because it will help enlighten, but precisely because it is offbeat and embarrassing in itself. In the fun house case, for example, the picture of indecent exposure was characterized as a mere curiosity piece, published specifically for its embarrassing quality, rather than a legitimate complement to the write-up on the state fair. Some modern courts would likely reach a different conclusion. As for public figures—sports heros, movie stars and the like—a greater portion of their lives may be within the scope of legitimate public concern. Courts have frequently stated, though, that even public figures are entitled to keep some information of their domestic activities and sexual relations private.

False Light

The final branch of invasion-of-privacy law, *false light,* will be raised if you represent someone in a false and highly offensive manner before the public. This civil wrong is similar to libel (treated in the next section), except that false-light claims aim to compensate people for their personal embarrassment and anguish, not necessarily for damage to reputation. It is common for a claim of false-light invasion of privacy to accompany a claim for libel.

The false-light problem typically arises when a story or cutline falsely implies disturbing facts about individuals in an accompanying photo. You should take care to assure that your pictures, including file photos of the average person on the street, are not used in a distorted or fictitious context.

A classic 1952 case serves well to illustrate. A magazine photographer had taken a candid photo of a couple seated in an ice cream parlor at the Los Angeles Farmers'

Figure 15–8 As part of a story about this dancer, the picture itself is usable, since everyone knew the photographer was making photos for publication, but you could face a false-light claim if your cutline made untrue statements about the behavior of the individuals in the photo. *(Gary Kazanjian)*

Market. The photo depicted them in an affectionate pose, sitting side by side and cheek to cheek. So far so good. But the photo of this happily married couple was used to illustrate an article segment about the "wrong" kind of love. The photo caption read: "Publicized as glamorous, desirable, 'love at first sight' is a bad risk." And in the article, love at first sight was said to be based solely on sexual attraction, a short-lived type of love sure to be followed by divorce. The couple sued for invasion of privacy, and an appellate court ruled the claim was sufficiently sound to go before a jury. The court wrote: "It is apparent from the article and caption under the picture, that they are depicted as persons whose only interest in each other is sex, a characterization that may be said to impinge seriously upon their sensibilities."[22]

Privacy law has not yet evolved to the point where you can confidently predict exactly where courts will draw the lines in such cases. But you're free to use photos of persons on the street to illustrate news stories as long as you don't take the liberty of linking these anonymous people to specific, shameful characteristics. For example, it would be fine to run a picture of a man looking in a department store window to illustrate a story about the habits of holiday shoppers. But that photo should not be paired with a caption about compulsive shoplifters.

You should get into the prudent habit of writing and affixing accurate captions to your own photos before forwarding to editors or freelance markets. This step reduces the chances of photos being used out of context. And if photos do eventually appear in a distorted manner, then you personally will not have to share in the liability because you will not be among those at fault.

Privacy in Perspective

Together these four branches of privacy invasion can be intimidating. But they needn't be. The vast majority of your photos will be taken in public places, will be of legitimate public interest and presumably will be published in an accurate context. Such photos cannot be the basis for privacy claims, even if the depicted persons are enraged by your work for one reason or another. Also, some states do not recognize all four branches of invasion of privacy. As of 1986 the Ohio courts, for instance, had specifically declined to recognize claims for false light. And if you need further solace at this point, keep in mind that privacy claims against the media are infrequent and in most cases successfully defended.

You should, however, examine all the circumstances carefully when you encounter the warning situations: shooting individuals in private, vulnerable, and highly demeaning settings; using photos in commercial messages; and the careless linking of photos to factually unrelated stories or cutlines. And even in these situations, you can often publish without fear by simply taking the necessary precautions, such as obtaining written consent.

Libel

Libel is a legal wrong recognized throughout the history of this country. It is the printed form of defamation, the wrongful injury to a reputation. Claims are usually based on verbal accusations—of professional incompetence, criminal acts, immoral behavior and so on—that are not true. So what does this have to do with you as a photojournalist?

Figure 15–9 These two girls were photographed trying to keep warm while watching a softball game. There is no invasion of privacy if the photo is used in a news context, such as a story about the weather or the game. However, if you wanted to use the photo for an advertisement, you must have model releases. *(Lane Turner)*

As with false-light invasion of privacy, libel in the photographic context is usually generated by an ill-fitting cutline or disparaging context. For example, suppose a newspaper composes a story about emergency-room (ER) physicians who show up to work under the influence of alcohol. To illustrate this story, an editor asks you to provide a photo of an ER physician—any ER physician—working on a patient. This situation should signal trouble. If the cutline or overall context of the photo could be interpreted to mean that this particular doctor comes to work drunk, then it could be devastating to his reputation, and this can be the basis for a libel lawsuit.

Though very rare in practice, it is also possible for a picture alone to be libelous. Cropping or creative darkroom modifications could create a photo that conveys a false and defamatory image—even without an accompanying cutline or story. Such would be the case if you blended two photographs, one of a local banker and one of an organized-crime figure, to make it look like the two men were conversing on a secluded park bench.

Figure 15–10 This portrait accompanied a story about this young graffiti artist. There is no libel as long as the cutline states the facts. If the photo is used with a story about vandals spraying obscenities on walls all over town, the caption and photo together could constitute libel. *(Mike Penn)*

As you probably suspect by now, there are several elements to the law of libel. For the photographed complainant to win in court, he must show all of the following:

1. *That your work contains a defamatory message,* alleged facts that would tend to harm a person's esteem in the eyes of others.

2. *That your work was published.* This criterion is met when the newspaper hits the stands, but publication can occur even before that, when you show the harmful depiction to co-workers or personal acquaintances.

3. *That the person was identified in connection with this defamatory communication.* Identification can be accomplished by a cutline description, the visual image, or a combination of the two.

4. *That the defamatory portrayal is false.* If the message of your photo/caption is substantially true, there can be no libel.

5. *That you were at fault.* It is not considered libel if the untruthful publication was simply an honest mistake. This fault requirement is a First Amendment standard mandated by the U.S. Supreme Court. It is intended to assure you some breathing space for the inevitable factual errors that can occur despite your best efforts. Public persons, such as government officials and celebrities, must show that you published with *actual malice,* with knowledge of the message's falsity or with reckless disregard for the truth. In many states private persons are allowed to recover on a lesser showing of fault, mere negligence on your part.

Acquisition by Authorities

Now let's examine those instances when government officials might seek to acquire the fruits of your labor. For example, suppose the police request your film because it would aid them in a criminal investigation. You might be quite willing to comply, but then again, you might not. The news media sometimes resist such requests because of significant inconvenience or to avoid becoming arms of police agencies, in effect or in perception. By what methods and for what purposes can government agencies demand or confiscate your work?

Search Warrants and Subpoenas

In 1971 police were called to remove demonstrators who had seized the administrative offices at Stanford University Hospital. When police forcibly entered a hallway they were attacked and beaten by some demonstrators armed with sticks and clubs. The *Stanford Daily* soon published photos of the demonstration, and police believed this student newspaper had additional photos that would help identify the perpetrators of the criminal assault. So the police decided to obtain the additional photos in the most direct manner possible; they showed up at the *Daily* office with a search warrant and proceeded to search the photo labs, file cabinets, desks, and wastepaper baskets. They found nothing that had not already been published.

The *Daily,* however, sued the police chief and other officials, claiming that the search violated the paper's First Amendment rights. The search process, argued the *Daily,* is physically disruptive, intimidating to the news staff, and a threat to the cultivation of confidential sources. The case eventually reached the U.S. Supreme Court, where the students lost. The court held that as long as a search warrant is supported by probable cause to believe that evidence of a crime will be found, then a search is acceptable. Nothing in the Constitution gives the press a special privilege to avoid this process, the court said.[23]

Some states and Congress, however, accepted the notion that the press should be protected against the intrusiveness of police searches and that news organizations' materials should be requested by subpoena instead. Congress, in the Privacy Protection Act of 1980,[24] provided the protection that the Supreme Court would not. The federal statute prohibits newsroom searches and seizures of documentary materials, including photographs and film. Exceptions apply when the photographer himself is suspected of the crime, or when a search is deemed necessary to avert destruction of the materials or to prevent death or serious injury to a person. But in the absence of one of these exceptions, law enforcement personnel must utilize a subpoena rather than a search warrant to obtain photographic evidence from news organizations.

From the standpoint of the press, the *subpoena* is a preferable procedure to deal with. It is a court-backed order that the news organization turn over specified materials, or copies of those materials. The subpoena allows a number of days to respond, so it is less disruptive to a news production schedule. Also, the newspaper has time to consult an attorney and may decide to appear in court to resist the subpoena.

Shield Laws

Though subpoenas are considered preferable to warrants for search and seizure, news professionals have long argued that they should have a far-reaching privilege to decline subpoena demands as well. The crux of this argument is that journalists, if they are to pursue investigative-type stories and cultivate reluctant sources, must be free to keep some information confidential. And it is argued that it would be too easy for authorities to exploit news organizations by routinely serving subpoenas to obtain negatives or notes related to crime scenes or even civil litigation.

Here again, many legislatures have been persuaded by these arguments and have concluded that in the long run society's need for information is best served by protecting news people from forced disclosure of information and other products of their work. So, slightly more than half of the states have enacted *shield laws.* These laws grant news personnel the privilege to decline investigatory or evidentiary requests by the justice system.

Find out if your state has a shield law. If it does, look closely at its provisions. The strength and breadth of shield laws vary greatly. Some things to look for: Exactly what is privileged from disclosure? Is it any and all information and materials accumulated while on the job, including prints and negatives? Or is it something much narrower, such as the identities of sources? Does the privilege extend in all instances, whether or not you originally obtained the sought-after information through a confidential relationship? Does it apply to you if you work as a freelancer, or only if you're employed by a news organization?

On-the-Spot Confiscation

Another aspect of this acquisition problem remains all too common: on-the-spot decisions to seize film and equipment, without a warrant. Since search and seizure of journalistic work, even with a proper warrant, is rarely allowed under the federal statute, seizure without a warrant should be even less acceptable. And in fact that is the law. But the problem tends to crop up in emergency situations, when officials may be on edge and decisions are made too quickly.

Figure 15–11 While covering a protest rally in San Francisco, photographer Michael Rondou was arrested because his credentials were three months out of date. More common than an arrest is an attempt by police to confiscate film and equipment on the spot. However, this is almost never permissible under the First and Fourth Amendments to the Constitution. *(Mike Maloney/San Francisco Chronicle)*

For example, on a May morning in 1985, police were engaged in a violent attempt to evict from a Philadelphia rowhouse the members of a radical, heavily armed group called MOVE. The riotous scene was closed to onlookers, but Greg Lanier, a photographer for *The Philadelphia Inquirer,* paid "rent" to secure a vantage point in a house across the street. When police spotted Lanier they decided to evacuate the premises. But, for reasons uncertain, they also body-searched Lanier and confiscated all of his film, cameras, and other equipment. To his credit, Lanier phoned his newspaper, rather than staying to protest. By midafternoon the *Inquirer* obtained a court order forcing police to return the film and equipment. The order also prohibited police from "seizing without a warrant any film, camera . . . or other news-gathering material absent exigent circumstances and probable cause to believe that such employee has committed or is committing a criminal offense to which the materials relate."

This is essentially the standard required by the federal privacy protection statute and the Fourth Amendment to the U.S. Constitution. What it means is that government officials cannot confiscate your work or property, even temporarily, for purposes of reprisal or to keep you from covering a story. And even when your work is sought as criminal evidence, an on-the-spot seizure would virtually be limited to an instance when you are committing a serious crime and, because of your fleeting actions, police have no time to get a written warrant.

Summary

Though there is always a danger in oversimplifying or generalizing the law, it is helpful to restate legal rules in terms of some working principles to help you in the field. From this chapter we can construct some general guidelines:

1. In areas wide open to the public, such as streets, sidewalks, parks, and airport lobbies, you can photograph whatever and whomever is within public view, even if people object.
2. In privately run facilities for the general public, such as sporting arenas, markets, and office and hotel lobbies, you can photograph freely unless management objects or states restrictions, which you must honor immediately.
3. In government facilities with restricted uses, such as courtrooms, offices, prisons, and military installations, photographing may be subject to prior permission or to specified restrictions.
4. Within areas intended for privacy, such as residences, physician offices, and hospital rooms, you should take pictures only with permission of the person controlling the property and the person to be photographed.
5. Regardless of where you take the photo, it should not be published in a nonnews or distorted and objectionable context unless you have the individual's written consent.

Of course, we've seen there are lots of exceptions to these general rules, as well as factual situations that are hard to categorize. Although you are guaranteed much freedom under the First Amendment, our increasingly litigious society nevertheless presents legal pitfalls. When in doubt, talk with an editor or attorney who has experience with the laws of your state.

Endnotes

1. *Houchins v. KQED, Inc.,* 438 U.S. 1 (1978).
2. See *Le Mistral, Inc. v. CBS,* 402 N.Y.S.2d 815 (1978), where a television station was held liable for trespass.
3. *Miller v. NBC,* 187 Cal.App.3d 1463 (1986).
4. *Florida Publishing Co. v. Fletcher,* 340 So.2d 914 (1976).
5. *Leiserson v. City of San Diego,* 229 Cal.Rptr. 22 (1986).
6. See *State v. Lashinsky,* 404 A.2d 1121 (1979), where New Jersey's Supreme Court upheld the conviction of a press pass-carrying photographer for arguing with a state trooper at the scene of a fatal automobile accident.
7. For example, see *Borreca v. Fasi,* 369 F.Supp 906 (1974), where a federal trial court ruled the mayor of Honolulu could not exclude a particular news reporter from his press conferences.
8. *Richmond Newspapers v. Virginia,* 448 U.S. 555 (1980).
9. *Press-Enterprise v. Superior Court of California,* 106 S.Ct. 2735 (1986).
10. See *Publicker Industries v. Cohen,* 733 F.2d 1059 (1984).
11. *Estes v. Texas,* 381 U.S. 532 (1965).
12. *Chandler v. Florida,* 449 U.S. 560 (1981).
13. New York Arts and Cultural Affairs Code sec. 31.01.
14. 17 U.S.C. sec. 107.
15. *Update Art, Inc. v. Maariv Israel Newspaper, Inc.,* 635 F.Supp. 228 (1986).
16. *Miller v. NBC,* 187 Cal.App.3d 1463, 1484 (1986).
17. *Mark v. King Broadcasting,* 618 P.2d 512, 519 (1980).
18. *Anderson v. Fisher Broadcasting Co.,* 712 P.2d 803 (Or. 1986).
19. *Spellman v. Simon & Schuster,* 3 Med L. Rptr. 2406 (1978).
20. *Neff v. Time, Inc.,* 406 F.Supp. 858 (1976).
21. *Daily Times Democrat v. Graham,* 162 So.2d 474 (1964).
22. *Gill v. Curtis Publishing Co.,* 38 C2d 273 (1952).
23. *Zurcher v. Stanford Daily,* 436 U.S. 547 (1978).
24. 42 U.S.C. sec. 2000aa.

Chapter 16

Education and Careers

Outline

*Photojournalism isn't making
pictures for yourself or your ego.
It is making pictures for the
reader/viewer. Photographers
who understand this move ahead
very fast.*

—Rich Clarkson

Your Education

A college degree is a requirement for employment at many newspapers. Studying journalism gives you a background in the field and a ground-zero starting point on the staff of a campus publication. This experience will more than likely be the source of material for your first portfolio.

Education also helps you learn to think critically and analytically, and broaden your perspective on people and the world. Remember the story from chapter 9 about the young photographer who asked the old-timer how the old-timer got such great pictures—the old-timer said, "F/8 and be there." But there is little room in this business for someone who is nothing more than a button pusher.

Broadening Your Knowledge

It is tempting to take all the photo classes you can possibly fit into your schedule. When you're excited about the medium, it is hard to resist all those interesting courses. Many schools offer a dozen or more, and in a couple of extremes, it is possible to take as much as sixty or seventy units of photography.[1] Although this route might be reasonable for someone headed for other areas of professional photography, beware of isolating yourself from classes that broaden your overall background. As a photojournalist, you will come in contact with all kinds of people and situations. The best photos come from photographers who have confidence and a broad perspective on the world. The well-rounded photographer understands the issues of the day, the subject and the audience, and can use the technical tools needed to capture the message. I urge you to talk with your academic adviser about a strong liberal arts program, including classes such as history, literature, art, sociology, psychology, anthropology, and so on. Explore some of the classic issues of our cultures. Give serious thought to a second or even a third language.

Further, I firmly believe that being a visual reporter is not enough—you must be a complete journalist. Writing skills are just as important as skill with the camera. If you are in a program that requires only one writing course, talk with your adviser about taking at least a second-semester class. I believe there is no better way to learn to organize thoughts and information than by learning to write news. And the skills you learn will make you more valuable to prospective employers.

Plan too for the future. Right now, shooting might be the most exciting thing in your life, but you cannot guarantee where your career will take you. Put a variety of things in your educational savings bank. Fifteen years from now you might want to make a withdrawal.

The Photojournalist's Personality

In today's market, the photojournalist must be intellectually aware, technically skilled, and physically strong. Most good photojournalists are patient, stubborn, imaginative, tireless, quick thinking, decisive, curious, diplomatic, and assertive, yet not offensively aggressive. They are good politicians and psychologists, have a love of people and work, have a broad range of interests, an ability to anticipate events, and an understanding of what readers want and need. A good photojournalist is willing to take risks and knows when and how far to push.

Give careful thought to your own traits. If you are uncomfortable approaching strangers and making photos of them, or if you prefer photographing scenes and objects, perhaps photojournalism is not the best area of photography for you. This business is intensely competitive. The slow or indecisive photographer will be left behind; pictures made by the ignorant will be empty, and the timid and withdrawn will be in constant turmoil over dealing with new people and situations on a daily basis.

Building a Portfolio

One of the greatest problems for the beginning photojournalist is that first portfolio—what to include and how to arrange it. There is no magic formula; the content should show what you do best. To say there should be five news photos, five sports photos, and so on is just not appropriate for every photographer. With that in mind, below are some points to consider as you assemble this important sales tool.

First, edit carefully. Go through all your work, carefully watching for the strong image that might have been overlooked. Second, and this is important, have another photojournalist look over your first selects with you. You'll need this help to avoid including a photo that you are subjectively involved with. We all have favorite images that have personal meaning but aren't strong enough for a portfolio.

What kind of pictures should you include? Try to show some versatility. The traditional categories are news, feature, photo story, sports, and illustration, but don't try to fill all these categories unless the images are strong. If you are weak in sports, for example, don't include sports shots just to show that you went to a few games.

Careful Editing

How many pictures should you include? There is no magic number—about twenty seems common. But one photo editor said the best way to say that you have only nineteen good photos is to include a weak twentieth.

Figure 16–1 This is a page of slides from photographer Lane Turner's portfolio. It contains a selection of news, sports, and feature photos. A second page (not shown) consists of photo stories.

Show only your best work, no excuses, no exceptions. If you have to explain a photo, then it isn't telling its own story and should be eliminated.

On the other hand, if you have a number of pictures that are portfolio quality, you can tailor your portfolio for each publication you apply to. If the publication has extensive sports coverage, include more sports. If color illustrations are used frequently in their paper, show more of those. Beware, however, of presenting a false impression of your capabilities. If you should be hired because of a misleading portfolio, both you and your employer will be unhappy, and you'll soon be looking for another job.

Color is increasingly important for the graduating student or beginning professional, but color must be edited just as carefully as black and white. Never include color just for the sake of including color. Be sure there is strong message content in those color shots and that they are technically flawless.

Have some contact sheets from recent work available, too. Many editors like to see how you handle the camera and how you cover an assignment.

Finally, it should be obvious that your print quality must be tops. A common flaw I see in beginners' portfolios is inconsistent printing. All your prints should be as close to each other in contrast and density as possible, carefully burned and dodged where needed, and spotted to perfection. Use the same brand of print paper throughout so the image tones are consistent.

Portfolio Cliches

The photos on the following list are those that appear frequently in collegiate portfolios. Although you might be personally attached to a picture of this type, remember that the people who look at your work probably have seen hundreds of other collegiate portfolios and want someone who is not just a carbon copy of the pack. If you have an example of a cliche that is the best ever made, by all means, use it. But if there is the slightest doubt, pull it out.

- Kids playing in sprinklers
- Second-base slides
- Levitated football players
- Basketball jumping-under-the-basket shots
- Sunsets, silhouettes, babies, and flowers
- Most shots of celebrities
- Rock musicians performing (and most other performance photos)
- People (particularly children) holding protest signs
- Photos from your trip to Europe
- Any photo that depends solely on a special photographic technique
- Color shots that aren't strong communicators

Feedback

An excellent way to get feedback on your portfolio is to take it to professional conferences and ask the pros for a critique. Many of the seminars sponsored by groups such as the National Press Photographers Association and the Society for Newspaper Design include portfolio critiques. (Addresses for these groups are in the Appendix.) Judging photographs is quite subjective, and you'll probably get some conflicting comments, so try to get at least a half dozen critiques before coming to any conclusions about your work.

Keep your portfolio up to date. There is an old saying: you're only as good as your last assignment. Although an old picture can still be a good picture, the photo editor wants to know what you can do for him or her *today*. If you discover that most of your portfolio is more than a year old, perhaps you need to step back and see how you are progressing.

Physical Format

The physical format of your portfolio is less important than the images, but there are some customs in photojournalism that you would be wise to follow. Print portfolios are usually printed on 11 × 14-inch paper and mounted on 11 × 14-inch black mat boards. This size is large enough to show off your work yet small enough for someone to handle while sitting at a desk. I haven't heard any photo editors object to 8 × 10s, but this size is uncommon. Avoid larger prints or those oversize multi-ring portfolio binders. Editors want

Figure 16–2 Get as much feedback on your work as you can. Take your portfolio to events such as the NPPA's Flying Short Course and ask the editors and photographers in attendance for their opinions. *(Jim Gordon/News Photographer)*

to see a neat presentation, but they are unlikely to be impressed by fancy cases or special mounts and mats. Mount the prints neatly, carefully trimming the mount tissue so it doesn't show. Use a black felt-tip marker to darken the edges of the mount board. Overmats, which are second layers of mat board with cut-out windows, are common in the art field but not generally used in photojournalism.

Photo stories are usually presented on three 11 × 14-inch boards hinged together with black tape so they open like a book. Give the layout on the boards the same care you would a page in a publication.

If you have an entire newspaper page you want to include, a neat way to keep torn, yellowed newsprint out of your portfolio is to photograph the page and make a print. Keep grain to a minimum by using a 35mm fine-grain film such as T-Max 100 or Technical Pan, or a larger format such as 120 or 4 × 5.

I don't recommend that you show clips when prints can be made. Clips are rarely your work alone, but include editor's decisions about selection, cropping, and size. Also, newspaper reproduction is never capable of the quality of a print.

A nice way to present prints is in a fiber print case that can also double as a shipping container. You should be able to get such cases at art supply stores. Old print-paper boxes are not recommended.

Figure 16–3 Prints should be mounted on 11 × 14-inch boards. This photo story has been mounted on three boards hinged with black tape. *(Photo story: Mark Mirko)*

Slide portfolios are becoming common, particularly when applying for internships and in other situations when a portfolio must be mailed. See the Appendix for details on how to make portfolio slides. To present your slides, use plastic slide pages. Try to find stiff ones that can be held up to the light without flopping over. As an alternative, you can get black mat boards that are die-cut to hold slides. These make a handsome presentation when showing your work in person, but they add bulk to a mailed shipment; therefore, if the application instructions call for plastic pages, don't use die-cut black boards.

Be sure the slide mounts are clean and neatly labeled. When applying by mail, include a cover letter and caption sheet, numbering the slides to match the captions on the sheet. The captions must be prepared with as much care as the photos.

Organize the slides on the pages, grouping similar types of shots in the same row. Use a second page for photo stories, and a separate slide for each shot in the story.

Internships

An internship gives you the chance to get practical training that is not available in school. Many newspapers offer these short-term spots during the summer, although some internships are also available during the school year. Internships typically run from six weeks to three or four months, and pay varies from none to the equivalent of the paper's starting salary.

To qualify for an internship, you should have had some experience on a campus publication. And although you'll be looking forward to learning from the experience, most papers expect you to be able to handle assignments as one of the regular staffers. They won't have time to show you how to process film or make a print under deadline pressure.

The time to start looking for an internship is in the late fall and early winter. Contact the photo directors or managing editors at the papers you'd like to work for, and check

with the National Press Photographers Association for the internship list they sometimes have available for student members. When applying, be sure to follow the application instructions. Prepare a resume or cover letter and limit it to one page. Present the facts, and avoid getting carried away with philosophical essays on the meaning of photojournalism.

Internships are quite competitive, so apply for a number of them at the same time. If you use a one-at-a-time technique, deadlines will pass and you may eliminate other good opportunities by waiting for a particular photo editor to make a decision.

If you are asked to appear for an interview, you should be familiar with the paper before you arrive. Get some back issues and examine its style. For the interview, dress like the professional that you are, and try to anticipate some questions you will be asked. The easy ones will be about your background. Tougher ones include why you want the internship and what do you expect to get out of it.

While on the internship, take advantage of every possible chance to learn. Plan on putting in many more hours than you are scheduled for, and try to observe what happens in other departments of the paper. Get as many staffers to critique your work as possible. If a formal evaluation isn't offered by about the halfway point, ask for one.

Job Hunting

There are less than eighteen hundred daily newspapers nationwide, and there is considerable competition for the few jobs available. Therefore, be prepared to apply to dozens of publications and to move away from your hometown area if necessary.

Many jobs are not advertised, but are filled through word of mouth. One way to get into the information network is to join the professional organizations listed in the

Figure 16–4 Photojournalism is a highly competitive field. There are relatively few jobs, and there is little room for the slow or timid photographer. *(Judy Griesedieck/ San Jose Mercury-News)*

Appendix and get involved in their activities. Attend professional conferences, not only to learn, but also to show your portfolio and develop professional contacts. Sometimes these groups have job referral services, but don't rely on these alone.

Stringing

Stringing is a form of freelancing. The name stems from the early days when freelance writers were paid by the column inch, and total inches were tallied by tying knots in a piece of string.

Stringers are used when a publication needs extra help during busy times or vacation periods. Your work as a part-timer can demonstrate your talents to the editors and possibly lead to a full-time spot. I have one friend who was a stringer for the Associated Press and carried a belt pager so the photo desk could reach him at any time. They called him often, and when a full-time slot opened, he was hired.

Realistic Goals

Perhaps you aspire to a staff position at *Time, Sports Illustrated, National Geographic,* or a major newspaper. Although that goal is worthwhile, it is more likely that your first job will be at a small newspaper such as a community weekly or small daily. There, you'll be expected to shoot everything from Dog of the Week to the Cub Scout jamboree. The pay won't compare with the major publications, but you'll probably have a certain kind of freedom that tends to disappear as the size of the publication grows.

More than likely, you'll be able to come up with a story idea and carry it all the way through, including writing, laying out the page, and even paginating it on the computer or pasting it up in the backshop.

As you gain experience, you'll move to larger publications with better pay and benefits and more opportunities to shoot major events. There will be more resources such as equipment, lab technicians, and budgets for travel and logistical support. The trade-off, though, is less control over your images.

There is certainly nothing wrong with aiming for the top, but keep in mind the advantages and disadvantages of both large and small publications, and don't automatically forsake the latter at the beginning of your career.

By the way, when you land a job or internship, be sure you have a written understanding at the beginning about the ownership of your negatives. Try to work out something so the negs will revert to you after the paper is done with them. Your pictures represent your professional history, and you shouldn't let them sit in a file for a few years only to end up in the trash. If the paper insists on keeping the material, ask for a written agreement giving you access in order to make prints for your own use.

Office Politics

There are a couple of things you might want to keep in mind on your first job. In school, you may be used to having your work run the way you want it to and being able to approach the editor directly and argue about a point. But professional reality is often quite different. As the new kid on the block, you'll be watched closely and you might have less freedom to express your opinion than you have been used to. When an editor asks you to shoot a photo that you think is a cliche, don't argue or try to be a camera hot-shot. Shoot the photo and then try one your own way. Be aware of the chain of command and move cautiously within it. Don't bypass your immediate supervisor unless the issue is worth risking your job for. Also, there are sometimes two different structures, the official one and the unofficial one. You might be perceived as a threat by some of the old-timers, so be prepared to prove yourself through the quality of your work.

Most important, choose your battles. Don't fight for every shot. Some of your pictures will be butchered and some of your good ideas will be rejected. Unfortunately, that's one of the frustrations of the business. If you come on like you are always right and they are always wrong, you'll be ignored and labeled a complainer and a hothead.

Freelancing

Freelancing is one of the toughest routes for the photojournalist to follow. If you choose this route, you must be a business person as well as a photographer, and you will probably spend more time on the business side of photography than with your camera.

One common misconception is that all you have to do is send your portfolio to major magazines and wait for them to call with an assignment. Nothing could be farther from reality. Magazine editors have already dealt with a hundred photographers whose skills are proven, and editors are unlikely to call on an unknown photojournalist. But there is a way to get on the preferred list.

Robert Gilka, former director of photography for *National Geographic,* has said that we are up to our necks in photographers but only up to our ankles in ideas. And therein lies the key to success as a freelancer. If you can come up with good ideas that editors can use, you'll eventually sell those ideas and the pictures that illustrate them.

Start by researching the publications you want to shoot for to see what types of stories they cover. Look at at least one years' worth of issues. Then find something they haven't covered and suggest it to the editor.

Querying the Editor

When you have an idea you think would be of interest to a publication, send a query letter. Catch the editor's attention with the first sentence, and briefly outline the story. Consider writing the first paragraph of the letter as you would the lead of the story. Send a couple of photos if they are available.

Most editors are weighed down with mail, so don't burden this person with more than a half dozen prints. Be sure to provide a stamped, self-addressed envelope for a reply and the return of your prints. Don't forget this important detail, since editors are not bound by either ethics or law to return unsolicited material.

Magazines take some time to answer; six to eight weeks is about normal. While waiting, keep working on other ideas for other magazines. Freelancing is a lot like going fishing. You'll have to throw a lot of bait into the water, and you'll get a few nibbles. Once in a while you'll get a strike. But unlike fishing, don't throw one hook in at a time and then sit in the boat waiting while the line floats downstream. Treat ideas as a bulk commodity. Try to come up with a few story ideas every day. Not all will be salable, but the exercise will leave you with a good collection at the end of each week. Only a few of those have to be workable.

Also, the enterprising freelancer considers all possible markets for photos, including greeting cards, posters, product packaging, books, and audiovisual productions. The list is almost endless. Consult the freelance market guides listed in the bibliography.

If you get an assignment, meet the agreed-upon deadline. Pack your work securely, but don't make the container impossible to open. All photos must have caption information, including names for recognizable people. In some cases, you will need model releases. Keep releases in your file. See chapter 15 for details on releases.

Payment and Rights

Most publications pay freelancers when the material is published, but everything is negotiable and you might work out a different arrangement. Be sure you have a written understanding about payment and rights to the material before agreeing to the assignment. One organization that has worked hard in this area is the American Society of Magazine Photographers. ASMP publishes *Professional Business Practices in Photography,* a useful guide that includes suggested legal forms and a thorough discussion of common business practices. Their address is listed in the Appendix.

Publications usually pay in one of two ways: per day of shooting or per page of printed material. This is known as the *day/space* rate. Photographers and editors should agree on both day and space rates and, ideally, the photographer should be paid by whichever method is highest. For example, suppose the day rate is $500 per day, and the space rate is $500 per page. If you worked one day but the editor used two pages of photos, you'd get $1000, the rate for the two pages used. If the editor used only a half page of photos, you'd get $500, the rate for one day of shooting.

As a freelancer, you should never sell photos. Rent the rights to use them. Photographs often have lives far beyond their original use and can continue to earn money for you over the years. When you grant usage rights to a publication, be sure the editor understands what rights are involved. The ASMP has useful forms available for this purpose in their book. The common rights granted are "one-time rights," which means the publication can use the photo once in a particular issue. Additional uses must be paid for.

The business of freelance photography is a complicated one filled with perils for the uninitiated. Unfortunately, there is not space here for a detailed discussion of rights, rates, and business practices. If you want to become a freelance photographer, get a copy of the ASMP book as well as some of the other business-oriented books listed in the bibliography.

Copyright

Federal copyright laws protect your work from being used without your permission. If you copyright your work, you can control its use and collect the profits you deserve. On the other hand, if you publish a photo without copyright, it becomes public property for anyone to use. If you are on the staff of a publication, the work you produce is owned by your employer; but all the work you do as a freelancer can be copyrighted in your name.

To copyright your work, it must bear a copyright notice like this:

Copyright © by [photographer's name], 19___
All Rights Reserved

In the blank for the year, insert the year the work was created or first published. The term of a copyright is your lifetime plus fifty years. You can have a rubber stamp made with small type so the notice will fit on 35mm slide mounts.

This notice is adequate protection in most cases, but in order to collect statutory damages if your copyright is violated, you must also register your copyright with the government. You can get the necessary forms from the Register of Copyrights, Library of Congress, Washington, DC 20559.

The Big Story

If you suddenly found yourself at the scene of a major story—a large-scale disaster for example—what would you do with the photos you took? If you marketed them properly, they could be quite profitable, but if you didn't, you could end up with some nice photos that go no farther than your portfolio.

Here's a case history: In 1983 there was a strong earthquake in California's central valley, and the business district of the small town of Coalinga was destroyed. The quake struck in late afternoon, and several of my advanced students raced to the scene (possibly setting a new speed record for motorcycles in the process . . . !). They were able to shoot about four rolls of color shots before the sun went down. To the best of our knowledge, this was the only color shot that first afternoon.

The photographers called a major news magazine, and the unprocessed film was sent there by air for the editors to develop and examine. The magazine paid the photographers a small fee for this privilege. But the earthquake happened on a Monday and the magazine's deadline was Thursday. The editors sat on the pictures until the Thursday deadline and decided not to use any of the shots. By then, all other potential customers' needs had been filled by other photographers, and the story became history.

The students' mistake was in sending the photos to the wrong spot. By sitting on the shots until the story was dead, the magazine kept them out of competitors' hands. But if the students had sent the photos to an agency like those described in chapter 1, the shots would have been offered to many outlets instead of one, and the international marketing expertise of the agency could have brought more profit to the students. One of my former students did just that after the 1989 San Francisco earthquake and made over $10,000 from the pictures.

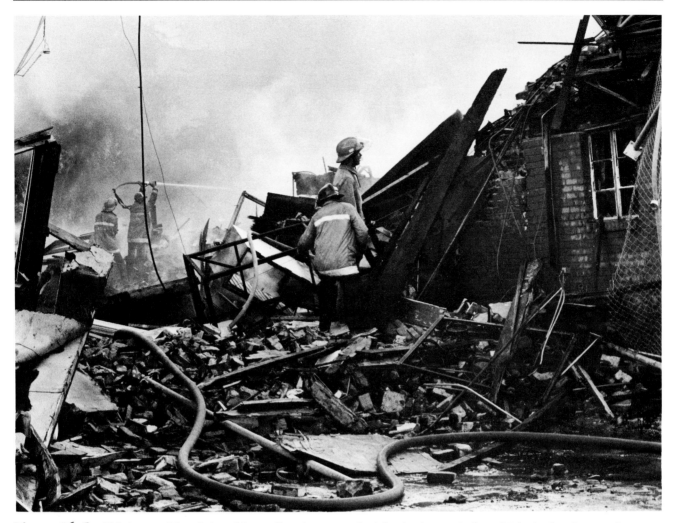

Figure 16–5 This is one of the photos of the earthquake mentioned in the text. Unfortunately, no sales were made from the take due to a marketing mistake by the photographer. *(Al Grillo)*

You'd be wise to keep a list of such agencies in your wallet just in case. Most agencies are in New York; check your local library for the Manhattan Yellow Pages and contact some of the agencies listed for information.

On stories with only local impact, call your newspaper's city or photo desk and tell them what you have. Time is of the essence. Go straight to a telephone—do not process your film first. Keep in mind typical newspaper deadlines. Most morning papers make a preliminary decision on news photos by late afternoon of the previous day. The front page is usually planned by 6:00 P.M. or so, and unless your shot is a major story, it will probably be too late to consider after that. (Afternoon papers make their final decisions around noon.) As the day moves into evening, the magnitude of the event must increase for it to warrant a change in the paper's decisions, but make no presumptions. Give them the chance to decide. Before delivering the film, be sure you have an understanding about the rights sold, the payment, and the credit line.

Photo Agencies

As mentioned in chapter 1, there are photo agencies that deal with freelancers for assignments and stock photos. Agencies match clients' needs with photographers' talents or act as sales brokers for material already produced by the photographers. Some agencies emphasize breaking news; others concentrate on in-depth coverage or single photos that are not bound to a time element. Because the agency handles the business end—sales, billing, filing, and so on—the photographer can spend more time making pictures. Further, the agency usually has access to a large number of clients and markets that the photographer could never reach on his or her own. On the other hand, the agency takes about half of the proceeds as its commission, so the photographer must keep producing a volume of material in order to profit.

(a)

(b)

(c)

Figure 16–6 If the photographer has obtained model releases, photographs such as these have potential as stock images because they could be used in many contexts. There is little to date them or tie them to a specific event. *((a): Don LeBaron; (b): Lane Turner; (c): Tony Olmos)*

One of the biggest letdowns to me when I started in photography was the realization that the stock business deals in photos almost as a bulk commodity. The ten terrific photos I had struggled to make, and was so proud of, were insignificant in the shadow of a picture file of three million. To succeed with a stock agency, you need to submit new material on a regular basis and think in terms of building up several thousand photos before any significant income will be realized. If your agency sells a photo for $150 and takes a typical 50 percent commission, you won't pay much rent with the remaining $75. I don't want to discourage you from this avenue, but I do want you to have a realistic idea of what it takes to succeed.

Summary

To be successful as a photojournalist, you must be more than a photographer. Technique is necessary, but many people have that and aren't good photojournalists. You need confidence and a broad perspective on the world, and you must be sensitive and perceptive. Expand your interests into as many areas as you can. Don't just hang around with other photographers, but get out into your community. Read. The daily newspaper is a must, but so are the interpretive journals that provide depth and perspective on events, and so is the literature that explores the fundamental questions of life.

Take a good look in the mirror. Photojournalism requires certain personality traits; curiosity, tenacity, and an ability to deal with people are high on the list. If you aren't comfortable approaching strangers with your camera, then perhaps photojournalism isn't the photographic specialty for you.

As you grow, get feedback from others on your work. Being a photojournalist is a lot like being an athlete or a musician. You must practice every day.

Your portfolio represents your talents. Of course it should contain only your best images, but it should be flawless in technique and presentation as well. The exact format isn't as important as the photos themselves, but if you have to make excuses or explanations, then an overhaul is necessary.

A vital part of your training is an internship where you can work under real conditions and get feedback on your work. We used to call it OJT (on-the-job training). Start applying for summer spots in early winter by contacting the papers you'd like to work for.

Your first job probably will be on a small paper where you'll be able to refine your skills and exercise considerable control over your work. Frustration about the misuse of your work goes with the territory, so be sensitive to the office politics and avoid rolling out the heavy artillery for every problem.

If you are tempted to try freelancing, be forewarned that this is a tough route to follow. In the beginning, assignments for major magazines will be the exception, not the rule. You'll need as good a business sense as a photographic one and probably some other source of income until you are established.

Endnote

1. A computerized list of photography programs and courses offered in the U.S. is being compiled by Prof. Howard Le Vant at Rochester Institute of Technology, 1 Lomb Memorial Drive, Rochester, NY, 14623. Your instructor can contact Professor Le Vant for information.

Chapter 17

A Brief History of Photojournalism

*by Beverly M. Bethune**

Outline

"The question is not what to picture nor what camera to use. Every phase of our time and our surroundings has vital significance and any camera in good repair is an adequate instrument. The job is to know enough about the subject matter to find its significance in itself and in relation to its surroundings, its time, and its function."

—Roy Stryker

*The author is an associate professor of journalism and mass communication at the University of Georgia.

Establishing Roles in the Nineteenth Century

Among the earliest portrayals of a photographer in literature was that of Holgrave in *The House of Seven Gables,* a novel written by Nathaniel Hawthorne in 1851. In this grave and earnest young daguerreotypist was Hawthorne's vision of the man of the future, a blending of scientist and artist, of technical and creative skills. "I make pictures out of sunshine," Holgrave said.

Today's photojournalists have fulfilled Hawthorne's vision and extended it to include not only the roles of scientist and artist, but also of documentarian and journalist. They have an understanding of the physical sciences—chemistry and the physics of light and optics. They bring to their work the creative eye of the artist, often in split-second situations. They document life on this planet, exploring to its farthest reaches, showing vast audiences social and environmental conditions. And they are journalists, recording the happenings, both large and small, of the age. Few other professions demand that their practitioners perform such a multiplicity of roles.

Although photography is only some 150 years old— and photojournalism is younger still—its history is rich in significant people and events. To cover such a history adequately in the space allotted here is impossible. At best, we can present only a few highlights and urge interested readers to seek more detailed information elsewhere.

Capturing the Image

The invention of photography drew on the observations, dreams, inventions, and failures of many persons across centuries. Ancient Greeks understood that light rays passing through a tiny pinhole would form an image. In his study of optics in the tenth century, Arab mathematician Alhazen of Bazra observed inverted images of outdoor scenes on the walls of darkened tents. The images were created by light entering through small holes in the tent walls.

These darkened tents or rooms were called "cameras obscura," or "dark chambers," and by the Renaissance they were well known. Leonardo da Vinci produced a drawing of a camera obscura in his notebooks. Artists and draftsmen used the device as a tool, tracing the image produced on the wall.

At first the camera was actually a room, a portable room one could erect quickly wherever it was needed. But it soon shrank to a more practical size, first as a sedan chair and then as a two-foot box with a lens on one end and a sheet of frosted glass on the other. With this small box, the image cast on the glass by the lens could be seen outside the camera.

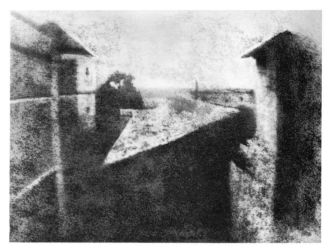

Figure 17–1 Niépce's earliest existing photograph, made in 1826. *(Gernsheim Collection, Harry Ransom Humanities Research Center, University of Texas at Austin)*

Of course the image made in the camera obscura was not permanent, merely an upside-down projection of the world beyond the lens, and increasing demand for a lasting and replicable image spurred both artists and scientists to work on the problem.

One was a Frenchman, Joseph Nicéphore Niépce, who would become the first person to fix an image permanently. A gentleman inventor, Niépce became interested in lithography but could not draw, so he began to experiment to see if he could obtain views photographically.

By the early 1820s he had found a method to make a permanent image obtained from his camera obscura. He coated a light-sensitive bitumen mixture onto a glass, pewter, or copper plate and exposed it for eight hours to a scene in his camera. Where light struck the plate, the mixture hardened. When the exposure was finished, Niépce washed the plate in lavender oil, which removed the soft, unexposed (and still light-sensitive) mixture and left the hardened image, a relief negative.

The only surviving picture made by Niépce is dated 1826. There is some evidence, however, that this was not his first success; he may have made some permanent photographs as early as 1822.

Although Niépce was always a poor businessman and in need of money, he kept the details of the process secret. So in 1826, when he received a letter from Louis Daguerre asking about Niépce's experiments and telling about his own, Niépce at first responded warily. Daguerre was a Paris artist and entrepreneur, already famous for his creation of the Paris Diorama, a vast building containing enormous paintings so real that visitors sometimes thought they were structures inside the building.

Money problems and illness overtook Niépce, however, and after three years of cautious correspondence with Daguerre, he agreed to a partnership, Niépce contributing his invention and Daguerre contributing a still experimental camera obscura, as well as his youth and entrepreneurship. Niépce died in 1833 before he could reap any reward for his work.

Daguerre, on the other hand, made a fortune. He worked on Niépce's invention until he had perfected a process which he modestly named the daguerreotype. Announcement of the process in 1839 created a sensation. The day after the announcement, Daguerre published a seventy-nine-page manual explaining the process, and the edition sold out in a few days. Within a year it had been translated into many languages and printed in all the capitals of Europe and in New York City. Daguerre's greatest contribution to photography—perhaps even greater than his perfection of Niépce's invention—may have been this swift, worldwide dissemination of information on the new science of photography.

The beauty of the daguerreotype and Daguerre's skill at marketing it distracted the public from its most obvious weakness: It could not be replicated. It was an Englishman, William Henry Fox Talbot, who laid the true foundation for modern photography with his invention of the paper negative from which multiple prints could be made. Viewers of a single image could then be increased exponentially.

Fox Talbot announced his negative-positive process in 1839 only days after Daguerre's preliminary report had been released. Most of the public was already so enthralled by the daguerreotype that they virtually ignored the paper negative. Of those who did take notice, many felt the process was inferior, that the image from the negative was unacceptably soft.

Neither of the initial photographic processes had a long life. In 1851, British sculptor and photographer Frederick Scott Archer invented the collodion wet-plate process, which replaced the daguerreotype and the paper negative and was the reigning photographic process for more than thirty years. In addition to shortening exposure time to several seconds, it produced on glass plates photographs of fine detail and great tonal beauty.

Putting the Processes to Use

As soon as the new photographic processes were announced, scientists and artists everywhere began to use and perfect them, adapting the technology to their interests and skills. Among the first Americans to use the daguerreotype process was Samuel F. B. Morse, a New York University professor and inventor of the telegraph. Morse not only made daguerreotypes, but he also taught the process to others, including Mathew B. Brady, who then opened his own studio where he made portraits of many well-known Americans. Brady would go on to greater fame as a Civil War photographer.

With improvements to lenses and the daguerreotype process, portraiture became a principal direction of photography. Answering a long-felt need for cheaper portraits than those done in oils by the painters of the day, there were eighty-six portrait galleries in New York City by 1853.

The first painter to adopt Fox Talbot's process was David Octavius Hill, a Scotsman, assisted by Robert Adamson. The two set out to photograph all 450 delegates who had attended the convention at which the Free Church of Scotland was founded. They later transferred these images to one large oil painting, a work never completed.

French author and caricaturist Gaspard Felix Tournachon, known as Nadar, became a master of the collodion wet-plate process and made portraits of most of the intelligentsia of Paris. Using the same process, Julia Margaret Cameron made dynamic photographs of her illustrious friends in England. The work of these and other early portraitists bring to life for us the people of this era.

In addition to portraiture, photographers made images of landscapes and architecture. They produced photographs of their travels to faraway, exotic places. A group of artists, both professional and amateur, developed a pictorial photography in the romantic tradition. Conflicting views from this diversity of direction spawned a debate on the merits of photography as art that would last a century.

Documentarians and Journalists

The term *documentary photography* is vague and defies precise definition. The *Life Library of Photography* calls it "a depiction of the real world by a photographer whose intent is to communicate something of importance—to make a comment—that will be understood by the viewer."

That is a modern definition, but modern documentary evolved over a century and had its roots in early photographers as recorders. They recorded both the familiar—family, friends, and community—and the unfamiliar—distant, and exotic places, and events. The camera preserved the family history and brought the world into the home. It saw more than the human eye, which tends to see selectively, and, to the nineteenth century mind, the camera's documents were literal recordings of truth.

Photographic documentation of news events occurred as early as 1842, and from the beginning, newspapers were interested in publishing such photographs.

Figure 17–2 Dead Confederate sharpshooter at the foot of Little Round Top, by Alexander Gardner. *(Alexander Gardner/From the collections of the Library of Congress)*

Unfortunately, there was no method of transferring the image directly to the printed page until the last quarter of the nineteenth century, so newspapers employed "sketch artists" to copy photographs onto wooden or metal plates for reproduction. By midcentury some newspapers frequently published pictures such as railroad wrecks, burning buildings, parades, and other events. The photographer had become a journalist, visually documenting the occurrences of the time for publication.

News photographs for home viewing could be produced by means other than newspapers, however. In the 1850s a binocular camera was invented for making stereo pictures, and few homes were without a stereoscope and slides for viewing. Factories capable of producing thousands of stereographs a day were in operation, some commissioning photographers to shoot news events as well as the usual views of landscapes and architecture.

Cartes-de-viste, small photographs the size of a standard visiting card, were also immensely popular. They were made by a camera with four lenses, capable of producing eight small photographs on a single plate. Although these photographs were portraits, they frequently were of persons involved in the news and could be mass produced. Within a week after Confederate troops under P.G.T. Beauregard attacked Fort Sumter, for example, E. & H.T. Anthony Co. in New York was printing and distributing daily more than a thousand cartes-de-viste of the Union commander at the fort.

It was a newspaper, however, that published the first battlefield photographs, made by British photographer Roger Fenton. In 1855 Fenton arrived in Balaclava with official credentials to cover the Crimean War. With him were an aide, all his photographic supplies, cameras, four horses, and a wagon which would be his darkroom. When he returned to England months later, he had more than three hundred negatives of battlefield scenes and

Figure 17–3 Ruins of Richmond, Virginia, from the Brady Collection. Mathew Brady and his staff made thousands of photographs of the war, the bulk of which were sold to the government when Brady was strapped by the financial panic in 1873. *(The Brady Collection/National Archives)*

Figure 17–4 Photography also documented the westward expansion. Timothy O'Sullivan made this shot of the ruins at Canyon De Chelle in New Mexico in 1873. *(Timothy O'Sullivan/ From the National Archives)*

portraits. *The Illustrated London News* published wood engravings made from the most interesting of these, and exhibitions of the prints were held in London and Paris.

Fenton may not have been the first to document a war. Daguerreotypes are said to have been made in the Mexican War in 1846, but none has been found, and Fenton is the first battlefield photographer whose work is known.

The Civil War in America was recorded by many photographers, the most famous of whom was Mathew Brady, already well known as a portraitist. He had made a portrait of Abraham Lincoln that was the president's favorite, and at the outbreak of the war, Brady called on his favor to ask for federal funds to cover the conflict. Although President Lincoln refused, he did give Brady the world's first press pass: "Pass Brady—A. Lincoln," signed on the back of Brady's business card.

After losing his equipment and almost losing his life at the first Battle of Bull Run, Brady left photographing the rest of the war to his assistants: Alexander Gardner, George Barnard, Timothy O'Sullivan, and others. In all, they took some seven thousand photographs, many of which appeared in newspapers as wood engravings and lithograph illustrations with the credit line: "From a photograph by Mathew Brady."

War was not the only subject for the early documentarians. Gardner and O'Sullivan and other Civil War photographers documented the westward expansion in the latter part of the century. Artist-photographer William Henry Jackson photographed throughout the West,

taking the first photographs of the Yellowstone area. He made a catalog of twelve Yellowstone images, then hand-printed enough of the catalogs to put one copy on the desk of every U.S. senator. The purpose was to persuade Congress to set aside the Yellowstone area as the country's first national park.

Emergence of the Photojournalist

Although in the late nineteenth century the stage seemed set for photojournalists, their appearance on the scene awaited several inventions. First was the invention of dry film. The collodion wet-plate process had shackled photographers to their darkrooms because the plate had to be kept wet with the highly volatile collodion mixture in order to be light-sensitive. So even in the field, photographers had to have their darkrooms at hand—hence the large wagon that followed Fenton, Brady, Jackson, and other working photographers over mountains, deserts, and battlefields. The slow exposure times of the plates required a camera on a tripod and precluded action photographs.

Then in 1871, English physician Richard Leach Maddox invented a dry plate process using a gelatin emulsion, and in 1878 another Englishman, Charles Bennett, improved the process to allow exposure times of 1/25 second. The wet plate was obsolete, the traveling darkroom was discarded, and the tripod could be optional. Photographers' shots were limited only by the number of plates they could carry, and they did not even have to process their own film.

The second invention that made the photojournalist possible was George Eastman's 1889 invention of flexible, transparent film. This invention made it feasible to roll up a large piece of film in a camera and make a number of exposures on a single strip.

Both inventions gave photographers speed and mobility, necessary attributes of photojournalism. The third invention put the photographer's work directly on the printed page without the helping hand of the artist. This was the halftone process, so called because it produces middle tones between black and white. The photograph is copied through a screen that breaks the image into dots on an engraving plate: large dots produce the shadow areas of the photograph, small dots produce the highlight areas and a variety of in-between-sized dots produce the "halftones" of gray.

The process was the invention of photo-mechanical expert Stephen Horgan, who worked for the *New York Daily Graphic*. In 1873, on the last page of the December 2 issue of the *Graphic*, there appeared a picture of an imposing building. On another page of the issue an announcement said: "On the last page will be found a picture of Steinway Hall, . . . It is worthy of inspection, too, as being the first picture ever printed in a newspaper directly from a photograph. There has been here no intervention of artist or engraver, but the picture is transferred directly from a negative by means of our own patented process of 'granulated photography.' "

In spite of the significance of the new process, it was years before it came into general use. The union of woodcutter artists was strongly opposed to photo-mechanical methods. Editors, proud of the artistry of their woodcut illustrations, refused to consider the process. In 1893, when Horgan was working for the *New York Herald*, he suggested to owner James Gordon Bennett, Jr., that they print some halftones. The suggestion got him fired.

Horgan then moved to the *New York Tribune*, and by 1897, the *Tribune's* high-speed presses were the first in the country to use the halftone process regularly. By 1910, the process was in widespread use. The scientist/artist/documentarian could now also be a journalist.

Speed, mobility, and direct connection to the press now brought the various roles of the photographer together to create the twentieth century photojournalist.

Transition Years

In the late nineteenth century, the United States was in the early Progressive era, a period of deep cultural crisis, brought about by accelerated urban and industrial growth, by the disappearance of the frontier, and by a flood tide of European immigrants. Millions of people were crowded into city tenements unfit for human habitation. Children everywhere—some only a few years old—were working in mines, fields, and mills. Crime, disease, and death were rampant.

Social Documentary

The time was ripe for the social reformers who formed the backbone of the Progressive movement, and journalists were among the reformers. In fact, historian Richard Hofstadter says, "To an extraordinary degree the work of the Progressive movement rested upon its journalism. The fundamental critical achievement of American Progressivism was the business of exposure, and journalism was the chief occupational source of its creative writers. It is hardly an exaggeration to say that the Progressive mind was characteristically a journalistic mind and that its characteristic contribution was that of the socially responsible reporter-reformer."

One such reporter-reformer was Danish immigrant Jacob Riis, whose police beat for the *New York Sun* and *The Evening Sun* exposed him to urban poverty. His writings as a reporter, magazine writer, and author of several books became a pulpit from which he preached housing reform with an evangelical zeal.

Riis is generally credited with being the first American to use photography as a tool for social reform. With the invention of flash powder in 1887, which allowed him to take photographs at night and in other low-light conditions, he and a group of photographer friends began touring Manhattan's slums, usually after dark. At considerable risk to their lives from startled and irate subjects, they took photographs inside tenements, flophouses, cafes, and saloons. Later, when Riis's friends tired of the adventure, he bought his own camera and made the photographs himself.

Riis was a poor writer, often criticized by his contemporaries, and, by his own admission, a poor photographer. He said in his autobiography, "I am downright sorry to confess here that I am no good at all as a photographer, for I would like to be." The impact of both his writings and his photographs, then, must lie in their subject matter, immensely powerful and often poignant records of living conditions in New York City.

The photographs were copied by an artist at the *Sun* for reproduction in the newspaper (which did not use halftones until 1900), made into lantern slides to accompany Riis's lectures before philanthropic groups, and reproduced in his books.

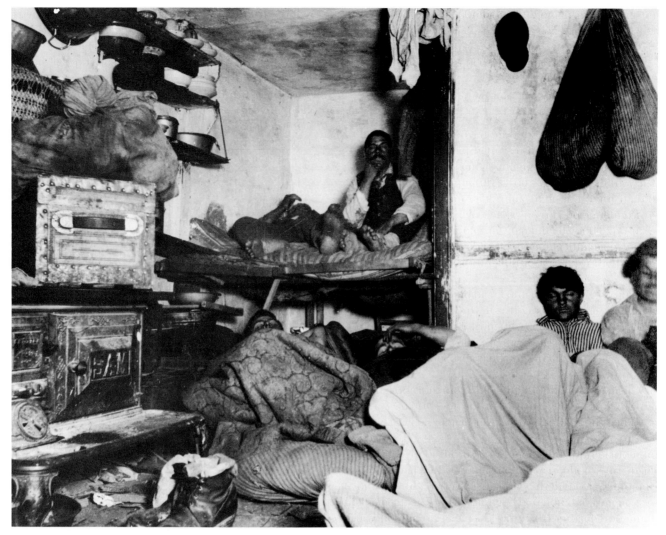

Figure 17–5 Lodgers in a crowded Bayard Street tenement, by Jacob Riis. Riis is generally credited with being the first American to use photography as a tool for social reform. *(Jacob Riis/Museum of the City of New York)*

Theodore Roosevelt, soon to become New York City police commissioner, was so impressed by Riis's 1890 book, *How the Other Half Lives,* he left a message at Riis's home, saying, "I have read your book, and I have come to help." Later, as police commissioner, he joined Riis on fact-finding nocturnal forays into the slums, and he and others mounted a reform campaign that cracked down on some of the worst abuses. They tore down tenements, built parks and playgrounds, and supplied clean water to the city. In time Riis would be called the "Emancipator of the Slums," and Roosevelt would name him "New York's most useful citizen."

When Riis felt he had enough photographs to suit his purpose, he stopped making them. Thus his reputation as a photographer rests on 412 glass plate negatives, only about 250 of which most likely were made by Riis, and all of which were made between 1887 and 1898. From Riis's death in 1914, the negatives were stored in the attics of the family's homes until they were discovered in 1945 and 1946 after persistent investigation by photographer Alexander Alland. Alland restored the negatives and made exhibition prints from them. The collection is housed at the Museum of the City of New York.

Since publication of Riis's photographs, his renown as a photographer has been growing steadily, in spite of his own estimate of his ability. He probably will be remembered far more as the photographer who gave birth to social documentary photography than as the author of reform books.

Social documentary achieved greater aesthetic heights with its second principal practitioner, Lewis Hine, who brought a photographer's eye and skill to the genre. As a sociologist, he also brought an association with social science and academia, a relationship which would be found frequently in social documentary.

Figure 17–6 A social reformer with a camera, Lewis Hine made photos such as this of immigrant families. He also turned his camera on working children (see figure 1–1), and his photographs helped the passage of child labor laws. *(Lewis Hine, from the International Museum of Photography at George Eastman House)*

Like Riis, Hine began his photography as an adjunct to his other interests. He was teaching sociology at the Ethical Culture School in New York City in 1903 when his superintendent gave him a camera and suggested he use it in his teaching. He taught himself how to use the equipment and began photographing immigrants arriving at Ellis Island as well as black and other slum dwellers in New York and Washington, D.C.

Hine's name is often coupled with Riis's, for although much younger than Riis, Hine was a contemporary in the reporter's later years. No evidence has been found that they knew each other. However, Hine, with his sociology background, certainly must have been familiar with and influenced by Riis's work, much of which had already been published by the time Hine began to photograph.

The two also had a common meeting ground in the New York Charities Organization Society (COS), a charitable group of which Riis was a member. The COS published a weekly newsletter called *Charities,* later *Charities and The Commons,* and Riis served on its publication committee. When Hine left teaching in 1908 to devote full time to his photography, *Charities* hired him as its staff photographer.

Hine was with the magazine when the staff made the Pittsburgh Survey, a pioneering undertaking of immense scope, which analyzed social conditions in that city. The survey was published as a series of articles and photographs in several issues of the magazine. Almost one hundred Hine photographs appear with the survey report.

Hine's work with children led him to a staff photographer position with the National Child Labor Committee, a group lobbying strongly for effective child labor laws. For thirteen years, as he traveled across the nation, Hine made vivid and eloquent pictures of children—starving and exploited children working everywhere: New England cotton mills, Southern cotton mills, Baltimore canneries, California canneries, Colorado beet fields, Southern cotton fields, New York tenement sweatshops, and Pennsylvania coal mines. Many historians credit Hine's photographs with a major share of the committee's success in child labor reform.

During World War I Hine recorded the war work of the American Red Cross in Europe, and after the war he photographed men at work in various settings, including construction of the Empire State Building. He also documented a Tennessee Valley Authority project for governmental agencies and worked briefly for the Works Progress Administration in 1936.

But the world of the Progressive reformer was long past by then, and work was increasingly hard to find. Hine died in great poverty and obscurity in 1940. His negatives were left to the New York City Photo League, who gave the collection to George Eastman House in Rochester, New York when the group disbanded.

The social documentary photography of Riis and Hine was photography with a purpose, photography that sought to persuade an audience to make much-needed social changes. It was a noble legacy to the twentieth-century photojournalist.

Women Become Photographers

Few women entered the field of photography before the 1880s. The bulky, heavy equipment and the complexity of the wet-plate process combined with intense social pressures to discourage most women's interest. Those who were active usually followed in the tradition of Constance Fox Talbot, learning photography from their husbands and acting as their assistants.

However, the invention of dry plates, roll film, and smaller cameras—the same inventions that made possible the modern photojournalist—made photography accessible to all and attracted women in particular.

Photography became an acceptable activity, within limits, for women. Taking family snapshots—smiling babies, gatherings of friends, and family occasions—connected photography to the domestic scene and the domain of women. Darkrooms and studios could be maintained at home. The camera was seen by society as one of the few mechanical devices a woman was capable of operating.

Early on George Eastman saw in the nation's women a vast market potential, and he stressed the simplicity of the Kodak camera. Advertising in women's magazines, he aimed his message at the middle class woman with her new-found leisure bought by the Industrial Age. The "Kodak girl," wholesome and all-American, photographing everywhere, was featured in the advertisements and stretched the still-Victorian society's definition of "lady-like" behavior.

At the turn of the century several thousand women were working as professional photographers. A central figure among them was the first woman press photographer, Frances B. Johnston. The only daughter of wealthy, supportive parents in Washington, D.C., Johnston studied art in Paris and afterward worked as an illustrator for a Washington newspaper.

She was among the early illustrators who recognized that photography would play a significant role in journalism. She wrote to George Eastman to ask him to recommend a camera suitable for press photography, and he sent her one of his recently marketed Kodaks. After studying photography under the photography director at the Smithsonian Institution, she was ready to launch her career in the early 1890s.

Johnston began by using her distant relationship to President Grover Cleveland's wife to gain access to the White House, and from there she became the unofficial White House photographer, photographing not only Cleveland, but also four other presidents and their families. As the Washington photography representative of the newly formed Bain News Service, she shot the elite of Washington as well as special events, such as the opening of expositions and the signing of treaties. In 1899 she photographed aboard Admiral Dewey's flagship as it returned triumphantly from the Philippines.

Johnston also documented American life as she saw it, photographing in mines, factories, rural areas, and schools for blacks and Indians. These were not the disturbing photographs of the Riis and Hine social documentary tradition, however. Rather, they reflected the eye of the middle class Victorian/Progressive female of the time.

Always supportive of other women, Johnston wrote articles urging women to become photographers and corresponded with the many professionals and amateurs who wrote to her seeking advice and reassurance. In 1900 she organized an exhibition of photographs by twenty-eight American women for the International Photographic Congress of the Paris Exhibition. The show established the significance of women's work as photographers.

Figure 17-7 The Secret Service and the children of Theodore Roosevelt, by Frances Johnston, the unofficial White House photographer and first woman press photographer. *(Frances B. Johnston/From the collections of the Library of Congress)*

Also active in these years was Jessie Tarbox Beals. A Massachusetts school teacher, Beals bought a camera for $1.75 and began to use it to work for tenement reform and for prevention of cruelty to animals. For a brief time (1902–1904), she was a staff photographer for the *Buffalo Inquirer & Courier* in New York state before she became a freelancer. Her work was published in New York City newspapers and national magazines.

Jimmy Hare

In 1889, a colorful English photographer named Jimmy Hare arrived in America. He would become the first of the twentieth century's great war photographers and would establish the stereotype of the swashbuckling male photojournalist/adventurer that exists today.

Hare photographed in New York for *The Illustrated American,* a publication that regularly used halftones as early as 1896. Shortly after he left the *American,* the battleship Maine blew up in Havana harbor, and he immediately signed on with *Collier's* magazine as a special correspondent to cover the subsequent Spanish-American War.

Hare shot the wreckage of the Maine, Teddy Roosevelt and his Rough Riders, and battlefields all over Cuba. He used a light, hand-held, folding camera, and twelve-exposure roll film, giving him greater speed and mobility than his colleagues who were still using heavy 5 × 7-inch cameras. During his long association with *Collier's,* Hare also covered the Russo-Japanese War, the Mexican Revolution, the First Balkan War, and World War I.

He is also known for the first published photograph of an airplane in flight. The Wright brothers adamantly refused to allow witnesses to their flight experiments long after the first successful flight in 1903. So in 1908 Hare and a group of reporters went to North Carolina, located the stretch of beach at Kitty Hawk where the tests were going on and waited in the bushes. When, to their amazement, the observers finally saw an airplane take off, Hare was able to get two quick shots, later published in *Collier's.*

National Geographic

Literally thousands of magazines, appealing to both general and specialized audiences, came and went in the latter part of the nineteenth century. Many offered opportunities for the emerging photojournalists.

Among the specialized magazines was *National Geographic,* founded in 1888 by the National Geographic Society to disseminate geographic knowledge. Early issues were stuffy and overly scientific, scaring away more readers than they attracted. Eleven years later the society was deeply in debt, and the magazine was on the verge of bankruptcy. Then the society's president, inventor Alexander Graham Bell, hired his future son-in-law, Gilbert H. Grosvenor, to rescue the operations.

Grosvenor would lead the society and the magazine for sixty-six years. He turned the *Geographic* into a publication supported by member-subscribers, gave it a popular approach to science, and most important in photojournalism history, made it into a picture magazine over the opposition of many of its scientist members.

He chose the halftone process so he could run a larger number of photographs, which by 1908 made up more than half the magazine's pages. In 1910 the *Geographic* had its own photo lab and began to pioneer the use of color photographs, made at first by the Lumiere Autochrome process.

The 1920s

The decades around the turn of the century created the modern photojournalist, and from the 1920s onward, it was time for the photojournalist to grow, to broaden, and to polish skills acquired over a century.

The Battle of the Tabloids

The frivolity of the Jazz Age masked deep social and economic problems, some unsolved from the nineteenth century, others created by a change in morals and a search for new directions.

The publications of the nation were a part of that mask, particularly with their photojournalism. Newspapers became as preoccupied with sex, crime, and entertainment as the rest of the nation was. Prohibition brought rumrunners, speakeasy operators, and gangsters into the spotlight, and they made terrific copy and pictures. So did the new Hollywood stars Rudolph Valentino, Fatty Arbuckle, Clara Bow, sports stars such as Jack Dempsey, Bobby Jones, and Babe Ruth, and celebrities like Charles Lindbergh.

A new kind of newspaper was born to provide this kind of journalism, the tabloid. Its smaller size, which made it easier to read on the subways, its extreme sensationalism, giant headlines and lavish use of pictures were characteristic of the tabloid.

The first of these in America was the *New York Illustrated Daily News,* which found its circulation among the immigrant and poorly educated American-born population of New York City. It was put on newsstands where only foreign language papers had sold before, and its pictures sold the paper to those who could not read the English words.

In 1924 the *News* had the largest circulation in the United States. That same year it was challenged by two new tabs, the *New York Daily Mirror* and the *New York Daily Graphic*. The *Graphic* quickly became the most notorious. Its reporters wrote first person stories to be signed by persons in the news, and the stories carried such lurid headlines as "He Beat Me—I Love Him" and "Boys Foil Death Chair; Mothers Weep as Governor Halts Execution; Would Have Kicked Off With a Grin." It was the *Graphic* that invented the "Composograph," a faked picture of what the editors believed had taken place.

There were tabloid stories and photos of a Broadway producer giving a party featuring a nude dancing girl in a bathtub of champagne, of the murder of a preacher and a singer in his choir, and of a wealthy real estate man ("Daddy") and his fifteen-year-old bride ("Peaches") frolicking on a bed with Daddy saying, "Woof, woof, I'm a goof!"

These photos were topped by another murder case in which an art editor was killed by his wife and her corset salesman lover. The night before the execution of the wife, Ruth Snyder, in the electric chair, the *Graphic* advertised: "Don't fail to read tomorrow's *Graphic*. An installment that thrills and stuns! . . . A woman's final thoughts just before she is clutched in the deadly snare that sears and burns and FRIES AND KILLS!"

But it was the *News* that scooped them all. Photographers, though not reporters, were banned from the execution scene, so the *News* brought in *Chicago Tribune* photographer Tom Howard, who would be unknown to local authorities and news people. Posing as

Figure 17–8 *Chicago Tribune* photographer Tom Howard strapped a camera to his ankle and went to the execution of murderess Ruth Snyder posing as a reporter. When the electricity was turned on, he carefully pulled up his pant leg and made this exposure. *(N.Y. Daily News Photo)*

a writer, he strapped a miniature camera to his ankle and ran a cable release up the inside of his trouser leg to his pocket. Just as the electric current hit Snyder's body, he casually lifted his trouser leg just enough to expose the lens and make his shot. The photograph covered the front page of the *News* the next day and created a sensation.

The tabloids were actually few in number, but all were sensational to some degree. It is a measure of their impact that the Snyder photograph would become a symbol of the journalism of the 1920s.

New Tools

Two improvements in equipment in the 1920s would make photojournalists' jobs easier. Most American newspaper photographers in the 1920s were using the 4 × 5-inch Speed Graphic camera, a medium-sized camera with a folding front and bellows, and film carried in a

holder, two shots to the holder. It was a bulky, heavy camera but was considered an improvement over the tripod-mounted, 5 × 7-inch glass plate cameras prevalent among the earliest photojournalists.

However, in Germany, two new cameras were developed that eventually would revolutionize photojournalism: the Leica and the Ermanox. Oscar Barnack, a scientist with the optical firm of E. Leitz, invented the Leica in 1913. It was a high-quality small camera that used a roll of 35mm movie film, and had a film-advance system similar to that of a movie camera, and a lens that could be focused. World War I interrupted large-scale production of the Leica, but it was marketed in 1923. It was not the first 35mm camera on the market, but it was the first successful one.

The same year the Leica was introduced to the public, so was the Ermanox. It was a small, old-fashioned glass plate camera that had the fastest lens in the world at the time, f/2 and later f/1.8.

The small size of both cameras further advanced the mobility of photojournalists and enabled them to shoot less obtrusively. With the high-speed lens of the Ermanox, photographs could be made indoors without flash in available light. Photographs could be more natural as subjects, unaware of the camera, went about their usual business. The way was cleared for modern documentary style.

Another 1920s improvement was the invention of the flash bulb. Flash powder, which had been invented in the late 1800s, had been a continuing hazard for early photojournalists. The powder was poured into a flash pan and ignited, causing a cloud of smoke that made a second photograph impossible and left photographer and subject gasping for air. Photographers frequently suffered burns and injuries; at least one lost a hand from the exploding powder.

So, in spite of the fact that flash bulbs added bulk to the photographer's bag, they were clean and safe and welcome. Many photojournalists became expert in creating dramatic images with multiple lights.

German Magazines

Also developing in Germany, in addition to new photographic tools, was a new and robust photojournalism that would profoundly affect the development of photojournalism in America. These were the picture magazines, and their photographers were among the first to use the new cameras.

In 1928 the magazine with the largest circulation in the world was the *Berliner Illustrirte Zeitung*, noted for the quality and journalistic impact of its photographs. One technique of editor Kurt Korff and publishing director Kurt Szafranski was to create a primitive

photo essay, a group of photos on one topic. But although each photograph might have been strong, frequently there was not a cohesive visual effect in the layout.

The technique was somewhat an outgrowth of the Sunday rotogravure pages begun by the *New York Times* in 1914. Grouping most of the best photos together on one page and using the special rotogravure process to print them gave the *Times,* and later the other newspapers that adopted the process, better reproduction. Most of the photographs on the picture page were unrelated, however.

In an effort to compete with the Berlin magazine, the *Munchner Illustrierte Presse,* a publication with a much smaller circulation, hired Stefan Lorant as a Berlin editor. Lorant stole away many of the *Zeitung's* best photographers and assigned topics to them individually, allowing them to generate their own ideas but also suggesting some himself.

This approach resulted in the publication of stories shot entirely by one photographer. The pictures were published simply and naturally, without cropping them into fancy shapes or using other layout gimmicks. There was a lead photo, run large, and several smaller photos arranged for maximum unity and effect—a photo story resembling those of the 1980s.

Lorant's success in attracting good photographers and in producing good photo stories was reflected in the burgeoning circulation of the magazine.

The photographers drawn to Berlin by these and other magazines represent an honor roll of photojournalists: Felix Man, Wolfgang Weber, Martin Munkacsi, Alfred Eisenstaedt, Robert Capa, Fritz Goro, Andre Kertesz, and the Gidal brothers, Tim and Georg, were among them. Most would soon flee Nazi Germany. Some would end up in the United States, where they played major roles in developing American picture magazines.

One photographer who did not survive the war was Erich Salomon, known as "the father of candid photography." He was a forty-two-year-old German lawyer in 1928 when he purchased an Ermanox with a fast lens, hid it in a briefcase and secretly took photographs at a sensational murder trial. The photos sold so well that he became a freelance photographer.

Salomon specialized in photographing dignitaries and heads of state, trying to show their human qualities by catching them at unguarded moments in meetings and social functions. He was not always welcome at these gatherings, and he developed a number of ploys to get past the guards and to get his photographs once he was inside. He carried his camera in an arm sling or hollowed-out books or a flower pot. Once he made a hole in the crown of his derby hat for his lens and carried his camera there. At formal diplomatic meetings he wore a dinner jacket or white tie and tails, like the participants. An urbane man, speaking several languages, he blended in with his subjects. He often stood several feet from his camera, using a long cable release and waiting for the candid moment.

Finally, his presence at state functions became customary, leading the French premier Aristide Briand to say that no one would believe a meeting was important unless Salomon photographed it.

In 1929 Salomon went to the United States on assignment for William Randolph Hearst. Pleased with Salomon's work, Hearst ordered fifty Ermanoxes sent over from Germany for his photographers. But Hearst found out it was the man, not the camera, that made the picture. Salomon used an Ermanox until 1932, when he bought a Leica and a telephoto lens.

Although Salomon was a Jew, he refused to leave Germany until it was almost too late. He finally sought refuge in the Netherlands during World War II but was betrayed by a Dutch Nazi. He and all his family, except one son, Peter Hunter-Salomon, were killed at Auschwitz. To the world, he left a legacy of remarkable photography. To future photojournalists, he left a new method of photo reportage.

The 1930s

Few decades have ended with such an abrupt change as did the 1920s. For most of 1929 America was prosperous, optimistic, and wildly carefree. By early 1930 the nation had plunged into an economic depression, abject poverty, and despair. Two years later thirty-four million men, women, and children—28 percent of the population—were without any income whatsoever. On the road were approximately two million persons, "dispossessed sharecroppers, foreclosed farmers abandoning farm land parched by three summers of drought; ragged bands of youths who had graduated from school and could not find jobs—members of what was called the 'locked out' generation," writes historian William Manchester.

Newspaper Photojournalism in the 1930s
Yet throughout the hard days of the Depression, newspapers thrived and grew fat and complacent. The tabloids grew considerably more sober. Newspaper photojournalism stagnated.

On most newspapers the photo staff worked directly under the city editor, who rarely had any training in visual communication. His lack of expertise showed in the photos he chose and the way his selections were displayed, usually in one or two columns unless it was a sensational photo. Assignments were nearly always routine, most often the "grip-and-grin" shots of award presentations or mug shots. Strong news photos were trophies, won in the dog-eat-dog world of the street, where attacks on photographers had become a serious problem.

Considered merely technicians since the days of the newspaper sketch artist, photographers were the second-class citizens of the news operation. They had little or no formal education to help them forge ahead in the world of word people.

To make matters worse, in 1937, following the sensational trial of Bruno Hauptmann for the kidnapping and murder of Charles Lindbergh's young son, photographers were banned from the nation's courtrooms by Canon 35 of the American Bar Association's Canons of Judicial Ethics.

Photographers, reporters, and famous writers from around the world attended the Hauptmann trial in great numbers, and the sheer size of the press, in addition to their lurid stories, helped to create the impression of a "Roman holiday." But it was the photographers who were accused of wild and obtrusive behavior and flagrant invasion of privacy. Although these charges would later prove false, the damage was done, and the ABA's ruling stood for decades, as did the image of the press photographer.

The establishment of the Associated Press Wirephoto network in 1935 and the United Press Telephoto network in 1936 brought additional photos to newspaper pages, enabling the publications to present photos of breaking news from many distant locations. However, this new source of photos also made newspapers less dependent on their own photographers. Frequently local photo coverage suffered.

American Picture Magazines
While newspaper photojournalism was languishing, magazine photojournalism came to the forefront, where it would remain for decades.

In November 1936, Henry Luce's Time, Inc., published the first issue of *Life,* a weekly picture magazine, and it was an instant, enormous success. In the first three years of the magazine, the printers were never able to produce enough copies to meet the demand.

Initially the magazine was patterned similar to the German picture magazines, in particular the *Berliner Illustrirte Zeitung,* whose editors Kurt Korff and Kurt Szafranski had left Germany and acted as consultants for the new publication. Wilson Hicks of the Associated Press was later hired as picture editor, and he immediately set his own stamp on the organization.

To the original staff of photographers—Margaret Bourke-White, who had photographed for *Fortune* magazine; Alfred Eisenstaedt, one of the early German magazine photographers; and Peter Stackpole, and Thomas McAvoy—he added, by 1941, forty more. Most of the best-known photojournalists of the era would work at some time for *Life,* including Gordon Parks, W. Eugene Smith, Eliot Elisofon, Robert Capa, David Douglas Duncan, and many others.

Hicks established a working operation that is still used by almost all magazines that produce photo essays. Although the essay was the cooperative work of several people—editors and writers—each essay was usually assigned to one photographer and the final product was that photographer's vision. Using this system, *Life* brought the photo essay to its finest form.

In 1937 *Look* magazine was born, but in the beginning there was not much resemblance to *Life,* except that both published pictures. *Look* was initially a cheesecake, Hollywood gossip magazine. Eventually, however, it improved editorially and by the mid-1950s was out-pacing *Life* in its presentation.

The influence of the picture magazines, especially *Life,* on photojournalism was considerable. Working for *Life* became the highest goal for almost every photojournalist in the late 1930s.

Yet as *Life* began publication, another group of photographers had gathered who would equally influence photojournalism and define modern social documentary photography.

The Farm Security Administration

Under President Roosevelt's New Deal administration, the Resettlement Administration, later renamed the Farm Security Administration (FSA), was established within the Department of Agriculture to provide for the rehabilitation of hundreds of thousands of destitute farm families who were victims of both the economic depression and the natural disasters of drought and dust storms.

One of the first actions of the new agency was to create the largest information staff the nation's capital had ever seen, all to keep the general public informed about the problems so many people were facing.

Heading the photographic procurement section was Columbia University economics instructor Roy Stryker. As a graduate student, Stryker had met Lewis Hine, whose techniques had fascinated him. He brought many of Hine's ideas and approaches to the FSA. Although not a photographer himself, he would prove to be a genius in selecting and guiding talent.

The first person he hired was his own undergraduate teaching assistant, whose principal interest was physics. This was Arthur Rothstein, who set up the lab for the FSA and then became one of its most important photographers.

Other photographers who worked for the FSA during its existence were Walker Evans, John Vachon, Carl Mydans, Dorothea Lange, Russell Lee, Ben Shahn, Theodor Jung, Paul Carter, Marion Post Wolcott, Jack Delano, John Collier, Jr., and Arthur Siegel. They would

Figure 17–10 *Life*'s first cover. *(Margaret Bourke-White/Life Magazine © 1936 Time Inc.)*

become famous for their photographs of rural and small-town America, the sharecropper in the South, the Okie immigrant in California, dust storms in the Midwest, and farming conditions everywhere.

Dorothea Lange was one of the most significant photographers of the group, and she was the one to whom the others often turned for advice and opinions. She documented the westward trek of migrant workers driven from their land in the dust bowl of the Midwest to the squalid transient camps in California. John Steinbeck wrote *The Grapes of Wrath* after seeing Lange's photographs, and the movie made from the novel often imitates her images.

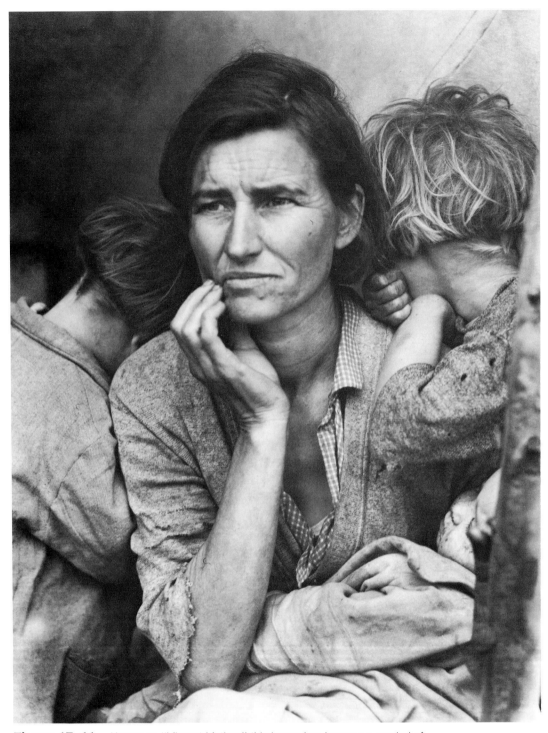

Figure 17–11 Known as "Migrant Mother," this image has become a symbol of the Great Depression. Dorothea Lange photographed the woman and her children in California's Central Valley in 1936. *(Dorothea Lange/From the collections of the Library of Congress)*

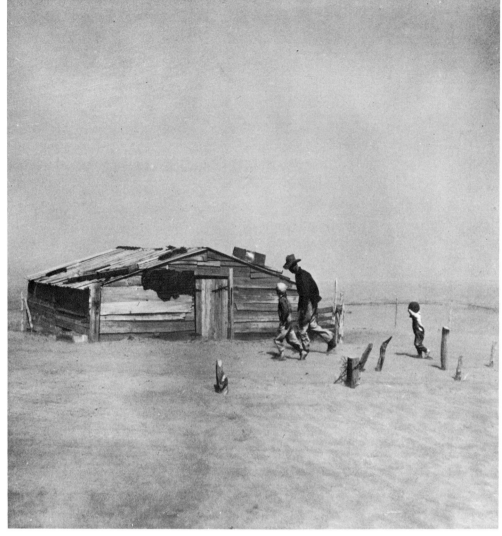

Figure 17–12 "Dust Storm, Cimarron County, 1936." While Dorothea Lange's photo on the facing page stood for the human consequences of the Depression, this photo by Arthur Rothstein symbolized the devastation of the land. *(Arthur Rothstein/ From the collections of the Library of Congress)*

Her photograph of a migrant mother may be the best-known photograph in the world. It is closely rivaled by Arthur Rothstein's photograph of a farmer and his two sons in an Oklahoma dust storm.

In all, the FSA photographers made 270,000 negatives. FSA photos were reproduced in thousands of newspapers and magazines in the 1930s and had much to do with the public's acceptance of the New Deal farm programs. The first documentary photographs to be known by that name, they set the standards for modern social documentary photography in their simplicity and stark, poignant realism. They increased knowledge of public facts, but they also sharpened those facts with feeling and sensitized the intellect about actual life. Beyond reportage, they became works of art, prized for image as well as message. They significantly influenced succeeding generations of documentary photographers.

War

World War II brought a halt to economic depression in the United States and a new impetus to photojournalism. Roy Stryker wanted to send his entire FSA team to Europe. Instead, they were incorporated into the Office of Strategic Services, which would later become the Central Intelligence Agency.

However, there were many other photographers who would roam both theaters of the war, some still unknown, but others already famous. Margaret Bourke-White was the only foreign photographer in Russia in the spring and summer of 1941 when the Germans attacked Moscow. After Pearl Harbor she was accredited as an official U.S. Air Force photographer, and she followed the war from North Africa to Italy and finally to

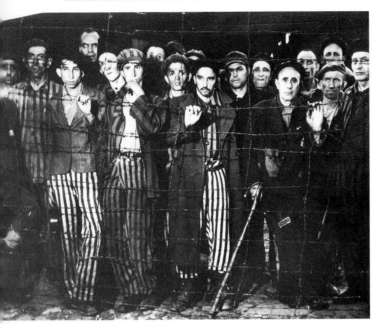

Figure 17–13 Liberation of Buchenwald, by Margaret Bourke-White. *(Margaret Bourke-White/Life Magazine © Time Inc.)*

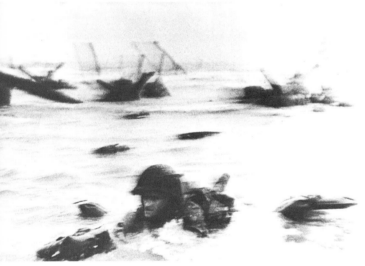

Figure 17–14 Robert Capa made this photo of the D-Day landing on Normandy in World War II. The blurriness seems to emphasize the tension of the landing. *(Robert Capa/Magnum)*

Germany. At the close of the war she made stark and horrifying photographs in the liberated Nazi concentration camps.

In 1950 she went to Korea to another war. On her last night there she stayed in a tiny mountain village that, unknown to her, was in the midst of an encephalitis epidemic. Not long afterward she discovered she had Parkinson's disease, a degenerative ailment that turns muscles and joints rigid. It may have been the result of that stay in the Korean village. From the mid-1950s until her death in 1971, photography had to be largely put aside.

Robert Capa, who had begun his career on German picture magazines, photographed as a Paris-based freelancer during the Spanish Civil War. Working for *Life* after America entered World War II, he covered most of the important invasions and campaigns of that war. He was at Normandy's Omaha Beach on D-day, scene of one of the bloodiest landings of the invasion. He shot hundreds of pictures there, most of which were lost in a processing accident.

In 1954 Capa was killed in French Indochina when he stepped on a land mine. He was the first American correspondent killed in that conflict, which would later become the Vietnam War.

Another important photographer was noted French photojournalist, documentary filmmaker and artist Henri Cartier-Bresson who was captured near the beginning of World War II and imprisoned by the Germans for three years. He finally escaped to work in the Paris underground and, when France was liberated, to organize French photographers' coverage of the Nazi retreat. Cartier-Bresson's concept of "the decisive moment," the instant within a scene "at which the elements in motion are in balance," became a standard for photojournalists.

Probably the leading photojournalist of this century, W. Eugene Smith, first made his name with his World War II photography for *Life* magazine. He was so seriously wounded at Okinawa in the Pacific that he thought he would never be able to photograph again. But he did recover, and after the war he went on to make photo essays for *Life* that took the essay form to its highest expression. Much of Smith's reputation today rests on five essays he shot for *Life:* "Country Doctor," "Great Britain," "Nurse Midwife," "Spanish Village," and "A Man of Mercy" (the story of Dr. Albert Schweitzer). These powerful essays speak eloquently of Smith's sensitivity and compassion for his subjects.

Smith insisted on having complete control over the layout and captions of his work in order to preserve his own concept. It was an insistence in conflict with *Life's* normal procedure, and Smith broke from the magazine. He shot two more major essays, one on the city of Pittsburgh and, much later, one on Minamata, a Japanese

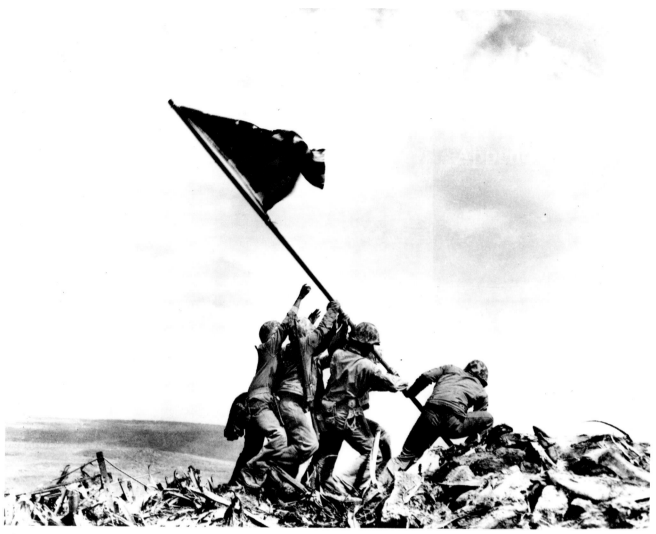

Figure 17-15 In what has become one of the most famous war photos of all time, Joe Rosenthal caught these men raising the flag over Mt. Suribachi on Iwo Jima during World War II. *(Joe Rosenthal/AP-Wide World)*

fishing village whose inhabitants were poisoned by mercury waste from a nearby chemical plant. At Minamata he almost lost his life again, this time when thugs hired by the chemical company severely beat him. Until his death in 1978, his health continued to decline, and he did very little shooting.

Smith's intense commitment and perfectionism and his efforts to "illuminate and try to give compassionate understanding" with his photographs are hallmarks of his work and have inspired many contemporary photojournalists.

However, it was David Douglas Duncan whose name became almost synonymous with war photography. Duncan covered three wars: World War II in the Pacific as a Marine photographer, and the Korean and Vietnam Wars as a *Life* photographer. As he photographed each one, his attitude toward the horrors of military conflict

evolved. His World War II photographs emphasized military operations, whereas his later images more and more often portrayed suffering and death. In *I Protest!,* a collection of his Vietnam photographs made at Khe Sanh, he wrote, "I'm just a veteran combat photographer and foreign correspondent who cares intensely about my country and the role we are playing. . . . And I want to shout loud and clear protest at what has happened at Khe Sanh and in all of Vietnam."

Duncan, of course, was not alone in his protest of the Vietnam War. Indeed, since Roger Fenton first photographed Crimean War battlefields, the reality of photographs increasingly weakened the public's romantic notion of war as the Grand Adventure. When television joined photojournalism in bringing the senseless obscenity of war into the family living room, the notion was put to rest forever.

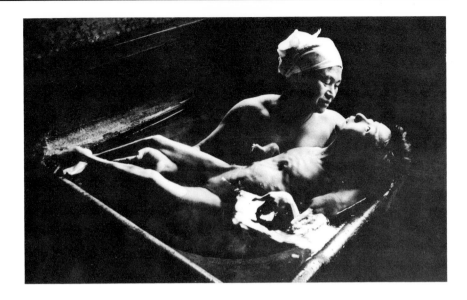

Figure 17–16 "Tomoko in Her Bath," from the photo essay Minamata, by W. Eugene Smith and Aileen Smith. *(W. Eugene Smith/Black Star)*

Troubled Decades

In the 1950s, the 35mm camera came into almost universal use among magazine photojournalists. The day of the Speed Graphic, whose photos were typified by the harshly lit night scenes of Arthur Fellig (the New York City freelance newspaper photographer known as "Weegee") was essentially over.

The smaller 35mm cameras with their roll film made photojournalists more mobile. The invention of portable electronic flash units did away with the changing of flash bulbs after every shot. Tri-X film, first at a speed of 200, later boosted to 400, added more opportunities to use available light. New and improved color films made some color commonplace in magazines.

In spite of these added advantages, there were very few fresh approaches to photojournalism in the 1950s. Most of the creativity was in television in the hands of Edward R. Murrow and Fred Friendly.

Magazines were as fat, prosperous, and complacent as newspapers had been earlier. Working for *Life,* with its unlimited expense accounts, worldwide assignments, and vast readership, remained the highest goal of almost all photojournalists, and they looked to magazines for their inspiration.

Magazines Weaken

In the 1960s, the magazine world came apart. Virtually every national magazine was in financial trouble, caused principally by competition with television for the national advertising dollar. One by one, the weakest magazines folded. Those that remained cut page sizes and numbers along with budgets. They sold out or merged.

Magazine photojournalists were forced to turn to other work. Some became commercial photographers. Others, like Gordon Parks, turned to filmmaking. Still others, like W. Eugene Smith with his Minamata photographs, turned to books as a medium for their work.

And yet another group, who came to be called the "New Photojournalists," took their inspiration from art photography, abandoning traditional photojournalism values such as "the decisive moment," and emphasizing personal vision.

This "snapshot aesthetic" had its roots in the work of Robert Frank, published as a book called *The Americans.* Frank was a Swiss fashion photographer who used his 1955 Guggenheim Fellowship to travel the United States, taking hundreds of photographs. He made the images randomly, seemingly unplanned, and they showed Americans of the 1950s isolated from each other, empty and humorless—not at all the way Americans thought of themselves.

Unable to get his work published in the United States, Frank had it published in France in 1958. Later, when it was finally published in this country, it was hailed by some as the best single volume of contemporary documentary photography.

The influence of Frank began to show strongly by the mid-sixties in the work of Diane Arbus, Lee Friedlander, and Garry Winogrand, the so-called "social landscape" photographers, and in the early seventies in the work of Annie Liebovitz, chief photographer of *The Rolling Stone* magazine.

Was Photojournalism Dead?

In 1972 at President Nixon's directive, Gifford Hampshire, formerly on *National Geographic's* illustrations staff, began Project Documerica. Like the FSA almost forty years before, Documerica had a mission, this time to document the environment. Professional photojournalists, drawn from all over the nation for short-term assignments, shot thousands of 35mm color transparencies. But in two years the project died from lack of funds and interest from both the federal government and the public.

In the early seventies *Life* and *Look* ceased publication. A later attempt to revive *Look* failed quickly. *Life* returned in the late seventies as a monthly, but critics called it "soft," and it lacked the news emphasis and the sparkle of the old *Life,* as did the new gossipy *People* magazine.

In an essay accompanying a 1978 photo exhibition at the Museum of Modern Art in New York, director of photography John Szarkowski announced that photojournalism was dead.

Photojournalism Revived

Of course, photojournalism was not dead. It was alive and well and living in newspapers across the country.

The disappearance of strong magazine photojournalism may have been the best thing that ever happened to newspaper photographers. Without the mecca of magazines to monopolize their dreams and without the magazine photojournalist to worship and imitate, newspaper photographers at last were forced to focus on what was essentially the only outlet left to them, the newspaper.

Slowly, newspaper photojournalism began to improve. The shift to offset printing improved reproduction quality, which in turn, helped motivate newspaper photographers. More photos were run, and more of them had significant story-telling content and "moment." They were displayed better and cropped more sensibly. Frequently an entire page was devoted to a grouping of photographs that told a single story—the photo story or essay, done so well by W. Eugene Smith and others for magazines, now honed and adapted to the newspaper page.

One such story was Brian Lanker's childbirth story "The Moment of Life: An Experience Shared." When Lanker, at that time a *Topeka Capital-Journal* photojournalist, won the 1973 Pulitzer Prize for this story, editors began to realize that photo stories on "sensitive" topics like childbirth were not just acceptable but welcome. Lanker's thoughtfulness, good taste, and great emotional rapport with his subjects strengthened the photo story and opened the door for photographers to cover other stories previously considered too "delicate" for the newspaper reader.

Newspapers such as the *San Jose Mercury-News,* *The Courier-Journal* of Louisville, the *Miami Herald,* the *Seattle Times,* and the *Orange County Register* became known for their excellent photographic coverage, and they were the new goals for young photojournalists. And photography directors such as Brian Lanker's mentor, Rich Clarkson, for many years at the *Topeka Capital-Journal,* became known for their ability to train and nurture new talent.

Photojournalists themselves changed. They began to seek equal treatment as professionals and to be regarded as visual journalists whose contributions to the product had as much value as any other element. Slowly, they began to shed some of their "second-class citizen" image. They began to feel and be an essential part of the news organization.

These changes did not take place entirely as a result of the death of the picture magazines, however significant that event was. There were several other causes of a more vigorous photojournalism, not the least of which was the National Press Photographers Association (NPPA). Founded in 1946 to improve press photography and the image of the press photographer, the NPPA saw its influence spread far beyond its membership as the group took up First Amendment and ethical questions. By the late 1980s, the NPPA had more than eight thousand members, an extensive educational program, and a series of noted publications, and had funded studies on such issues as health hazards in the darkroom and the coming electronic era.

Another factor in the new status of newspaper photojournalism was the increasing number of college graduates in the ranks. Since their degrees matched those of reporters, these new photojournalists expected to be treated as equal members of the news team. Aware there could be life after street shooting, many saw their own organizations as a place to move up. And many did—to photo editor, graphics editor, or the higher editorial positions of the paper.

Greater emphasis on the visual image throughout society also gave more impact to photojournalism. Competition with *USA Today* and with television put greater stress on all the visual aspects of newspapers.

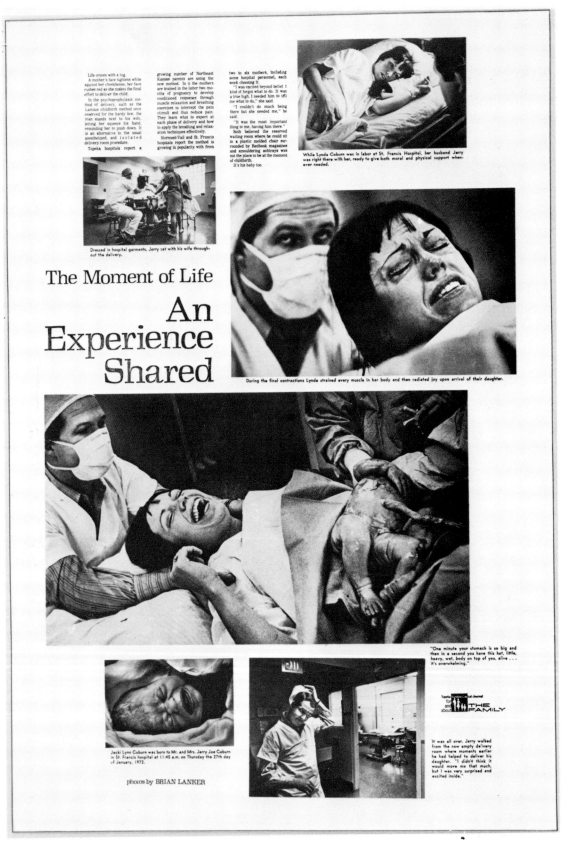

Figure 17–17 This page of photos by Brian Lanker won the Pulitzer Prize in 1973 and marked a turning point for subject matter thought appropriate for newspaper pages. *(Brian Lanker/ Topeka Capital-Journal)*

There was a new concern for visual literacy in colleges and universities, spurred by support from the Association for Education in Journalism and Mass Communication. The popular success of the photograph as art gave all photography more prestige. The International Center of Photography, founded in New York City by Cornell Capa in memory of his brother, Robert, provided photojournalism an international home, including a museum, a gallery, a school for photojournalists, and a gathering place for documentary photographers from all over the world.

A growing number of photo agencies gave photojournalists additional outlets for their work, either by acting primarily as photographers' representatives to generate assignments for them or by acting primarily as a library of stock photographs.

Black Star is among the oldest of the photographers' representatives, established in New York City in 1935 by three German emigres who had been connected to the German picture magazines of the 1920s. American picture magazines were already on the drawing boards, and Black Star's founders had access to European photographers and photographs they knew would be in demand. In the late 1980s Black Star had a staff of photographers working exclusively under contract for the agency and also a considerable number of stringer photographers located around the world.

Another long-time organization, Magnum, was begun as a cooperative agency in 1947 by Robert Capa and a small group of war photographer friends. In banding together, they hoped to obtain higher fees for their photographs and retention of their negatives. The agency remained a cooperative through the years but accepted some work from nonmembers.

More recently on the scene was Contact Press Images, a small but significant agency with an emphasis on comprehensive, in-depth stories. It was founded in 1976 by Robert Pledge and David Burnett, both formerly with the French agency, Gamma. Pledge had been a magazine editor in France and ran Gamma's New York office. Burnett had spent eighteen months covering the Vietnam War before becoming a Gamma photographer. Although Contact was comprised of only a handful of photographers, it won more awards than any other agency of its size.

In addition to these and other agencies, grants from organizations and institutions were a source of support for photojournalists that allowed them time to develop their ideas in depth. For example, April Saul spent months covering Hmong refugees from Laos as they were relocated about the United States. For seven years, Herman LeRoy Emmet spent part of each year living with and photographing a family of migrant farm workers. Mary Ellen Mark photographed the lives of prostitutes in the brothels of Bombay and women in a mental institution, both projects requiring considerable time. All three photojournalists were able to involve themselves in long-term stories because of their grant support.

What's Next?

Photojournalists moved into the last decade of the twentieth century far better equipped than any of their profession before them. Using lightweight cameras, they continued to make pictures from sunshine, but they also made pictures from electronic light and, with incredibly fast film, they even made pictures from almost no light at all. Matrix metering guaranteed good exposures, and motor drives capable of advancing film many frames per second could capture all the action for the photographer.

Images also could be recorded on tiny CCD (charged coupled device) chips in still video cameras and transmitted electronically from the scene of a story to a computerized picture desk at the newspaper, where they could be enhanced and laid out directly on a newspaper page.

In addition, the readership for photojournalism was more visually sophisticated than ever before, and the boundaries of subject matter for photographs had been expanded.

Yet state-of-the-art equipment and appreciation did not automatically equal excellence in photojournalism. Some critics observed that the strength of photojournalism images was waning. They noted a sameness to the photographs, a lack of original approach, too much emulation among the photographers. Color photography came under special fire: too much "color for color's sake" in newspaper photography, they said. Some believed the integrity of the documentary photograph was endangered by the glitzy, "perfect" photographic illustration with which it often had to compete.

Observers at the 1987 Pictures of the Year Contest, the national annual photojournalism competition, called the spot news entries "generally poor" and felt there was "a diminished treatment of social issues." They recommended a return to the basic concepts of photojournalism—truthful, honest, objective reporting—and a concern for informing readers, not winning contests.

In getting back to basics, the photojournalists of the future will need to examine these and other questions. In doing so, they might consider W. Eugene Smith's words: "My beliefs, my camera, and some film—these were the weapons of my good intentions." They have been the weapons of concerned photographers since photography began.

Epilogue

Toward the Electronic Newspaper

*by Michael L. Morse**

"The illiterate of the future will be ignorant of the use of camera and pen alike."

—*László Moholy-Nagy, 1936*

Outline

*The author is a professor of journalism at Western Kentucky University.

Streamlining the Process

Photography has long been a stone around the neck of the newspaper industry. Words can quickly be communicated, set in type, and brought to the printed page, but it seems the photographs are always the last ingredient to arrive. The primary problem, of course, is the way the material is gathered. Newspaper reporters can write a story in the office by simply making phone calls and reporting others' impressions of an event, but photographers must be physically present to record their images. It is time consuming to go to the scene, return, process chemical-based film, edit, and make prints. But by switching to electronic cameras and other new image-processing technology, much of this wasted time can be saved, and images can be brought to print almost as quickly as written stories. The goal for many newspapers is to bring the written word, graphics, and still images together on the page via a computer screen in a completely electronic format, which is then ready for the platemaker or the printing press. That process is called *pagination.*

Years ago, the introduction of video display terminals (VDTs) revolutionized the way type is handled in the production of newspapers. Now news photography is caught up in the electronic revolution. The key words of electronic photography are *electronic imaging, pixel editing,* and *pagination.* Electronic imaging means taking photos with cameras that use electronic chips instead of film to record the image. Pixel editing means using computer terminals to perform corrections such as dodging, burning, cropping, and so on that ordinarily would be done in the traditional darkroom. Pagination is the electronic assembly of the page with all its type, photos, and graphics before it is sent to production.

Electronic Photojournalism

There are essentially two ways electronics can speed up the process of taking photographs and preparing them for publication. One way still relies on the same chemical-based film we have been using for years, but it includes new devices that allow us to transmit the image from the news location back to the newspaper where it can be edited electronically and inserted into a pagination computer. No darkroom printing is required.

The second method relies entirely on new technology. Images are taken with an electronic camera called a *still video camera.* This camera is similar to the familiar video camcorders in popular use, except, instead of capturing moving images, it records still shots on small computer disks. Because the picture is recorded as electronic data, chemical processing is not needed and the image can be quickly and easily transmitted back to the newspaper via telephone lines.

Still Video—The Electronic Camera

Perhaps the primary difficulty with making news deadlines lies with our current chemical-based technology. Not only must the photographer go to the scene and return, but there is also considerable delay while the chemical-based film is processed and printed. If the film is processed on location, one of the biggest obstacles the photographer faces is simply to find a suitable location to develop and edit the film. Still video can alleviate this problem since no processing is required. Still video has more potential than any invention in the history of photography to move us forward as news gatherers and away from being technicians.

How Still Video Works

Still video (SV) cameras record images on magnetic media such as computer disks instead of light-sensitive film. The operation of SV cameras is fairly simple to grasp. The light, focused by a lens, goes through a shutter and strikes an electronic chip called a CCD or *charged coupled device.* This chip may be thought of as a substitute for the film used in a conventional camera. The chip is like an incredibly small yet organized group of photo cells. In fact, if magnified greatly it might look like a solar cell array used to generate electricity. The individual light-sensitive cells are arranged in rows and columns and each cell has a specific location on the chip. The cells produce the so-called pixels or picture elements that, when recombined in the original pattern, compose the photograph.

When an image is focused on the chip, each cell records its individual light level, much as silver grains do in ordinary film. After the picture is taken, another electronic chip downloads and processes all the information about various light levels on the CCD, reconstructs the original pattern and records this information on a track on a 2-inch floppy computer disk or electronic memory chip contained in the camera back. This action is quite a technical feat, as a typical CCD chip contains over 400,000 individual photo cells or pixels. (Kodak has manufactured one that has 1.4 million pixels, but it is prohibitively expensive at this point and does not record color.)

Once recorded as electronic information, the image can be manipulated any way one desires, much as a computer program handles word processing or graphics. More important, it can be transmitted via phone lines, and, best of all, no darkroom or chemicals are needed.

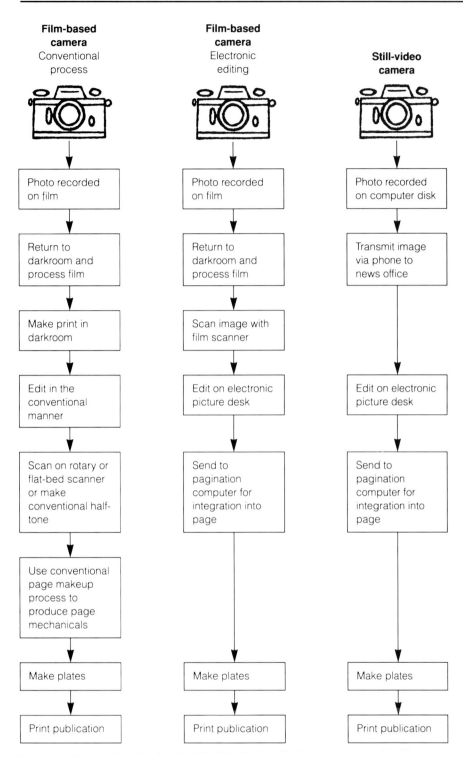

Film-based camera
Conventional process

Photo recorded on film

↓

Return to darkroom and process film

↓

Make print in darkroom

↓

Edit in the conventional manner

↓

Scan on rotary or flat-bed scanner or make conventional half-tone

↓

Use conventional page makeup process to produce page mechanicals

↓

Make plates

↓

Print publication

Film-based camera
Electronic editing

Photo recorded on film

↓

Return to darkroom and process film

↓

Scan image with film scanner

↓

Edit on electronic picture desk

↓

Send to pagination computer for integration into page

↓

Make plates

↓

Print publication

Still-video camera

Photo recorded on computer disk

↓

Transmit image via phone to news office

↓

Edit on electronic picture desk

↓

Send to pagination computer for integration into page

↓

Make plates

↓

Print publication

This chart is a rough guide to the steps in the production process under various systems. As publications move toward the electronic processing of images, production is streamlined.

(a)

(b)

Figure E–1 (a) Still video cameras have been used when deadlines are tight and image quality is a secondary consideration. As the electronic chips are improved, it is predicted that these cameras will play an increasing role in news photography. (b) The Canon still video transmitter RT-611, a companion to the camera in (a). *(Courtesy Canon U.S.A., Inc.)*

Since the image is highly flexible electronic data, we can do much to it with little effort. For example, the cameras shoot in color and provide automatic color balance to match the lighting conditions. If necessary, color can be corrected electronically with little effort. And, as has been mentioned before, the electronic data of the image can be transmitted through phone lines or via satellite back to the paper for editing and insertion on the page. Suddenly photographs can be available almost as quickly as printed information.

A side benefit is that the photographer carries less equipment. Because the CCD chip that senses and records the image is smaller than a 35mm frame, lenses become effectively longer and faster on these cameras. For example, on the Canon still video camera all lenses become equivalent to four times the marked focal length. A normal 50mm lens becomes equivalent to a 200mm. Lenses also gain in maximum speed. Canon offers three lenses for its camera that are equivalent to a range from 24mm to 600mm, f/1.2 to f/2.8, yet they are small enough to put in a coat pocket. Here is a comparison chart showing how lenses on still video cameras compare to lenses on regular 35mm cameras:

SV camera		Standard 35mm camera
6mm	=	24mm
50mm	=	200mm
180mm	=	720mm

You can see how smaller lenses could be a big advantage when covering fast-changing events. Slip a few of the small 2-inch disks into your shirt pocket, a couple of lenses into your coat, and you can cover most anything. Gone are the days of wandering around like a pack mule with one shoulder permanently lower than the other. Gone are the very real back problems associated with carrying all those long lenses and accessories.

Here is a summary of some of still video's advantages:

1. No chemical processing required; image instantly usable.
2. Shoots up to fifty shots per disk.
3. Can shoot up to ten images per second.
4. Has shutter speeds up to 1/2000 second.
5. Most versions shoot color.
6. Electronic sensors automatically balance the color to neutral.
7. Lighter equipment means greater mobility for the photographer.

The Resolution Problem

The main limitation with current SV equipment is its resolution. Resolution can be thought of as the degree of sharpness and clarity of the image. Even at 400,000 pixels, the overall resolution of the SV photograph is not high. The output looks a bit coarse and fuzzy and is somewhat below what most newspapers would like for good quality reproduction. Remember, a typical 35mm film frame by comparison contains the equivalent of eighteen million pixels.

<div align="center">A field A frame</div>

Figure E–2 The current still video recording format includes two modes, field and frame. Two fields make one frame. The frame mode has higher resolution but requires more space on the storage disk.

On the other hand, we sometimes don't use the entire film frame and such cropping reduces the quality of any image. Also, the quality of newspaper printing methods limits how much of that eighteen million-pixel resolution we can really use. The 65- to 100-line screen used by most newspapers to produce halftones isn't exactly high resolution, so much of the quality provided by film is lost in the translation anyway. Most experts say a million or more pixels would be enough to produce acceptable results for newspaper work.

Part of the resolution problem facing SV has to do with the way the image is recorded on the disk, and perhaps with the disk itself. In May 1984 manufacturers of electronic equipment met and decided on a recording format for still video. This standardization helped eliminate problems with incompatible formats, such as the war between Beta and VHS video that has gone on for years. In still video everyone's equipment is interchangeable to the extent that the disk will play or print with any manufacturer's equipment.

However, the universal format selected, NTSC (National Television Standards Committee), is actually of rather poor resolution in this application. It is the same format used for television signals and videotape recording in the United States. The picture is literally painted on the screen by an electron beam in an interlaced pattern. The complete picture is composed of two complete screen scans called *fields*. One field is painted on in a series of lines, one line at a time, then another field is painted on between the lines of the first scan. Two fields make one *frame,* or a complete picture. The entire process takes about 1/30 second. Some SV cameras can record images in either the lower resolution *field mode* or higher resolution *frame mode.* In the field mode, fifty images can be recorded on the 2-inch disk whereas only twenty-five images will fit on the disk in the frame mode. This rather low resolution works well for TV since the picture is changing rapidly and the screen is large and viewed at a distance, but on a 3 × 5-inch still video print, the rough texture is apparent. This recording format limits obtaining the resolution needed for reproduction in newspapers.

Nevertheless, publications have experimented with still video and have published photos that otherwise could not have been obtained. *USA Today,* for example, uses still video cameras when deadlines are too tight to allow for film processing. The results are a bit fuzzy, but viewable. At President George Bush's inauguration in 1989, Associated Press photographer Ron Edmonds made a photo of the swearing-in with an SV camera (fig. E–4), and the image was on its way to newspapers within forty seconds. See also figure E–3 and plates 20 and 21.

To get better resolution, the chip needs more and smaller pixels. More pixels per unit of area is like having finer grain. Current models of SV, although tolerable under some circumstances, don't have grain as fine as we need.

Numerous ideas have been proposed to solve these resolution problems. The 2-inch disk won't hold enough information at higher resolutions to produce the twenty-five- or fifty-frame storage currently offered, so it has been suggested that a small belt pack containing a larger-capacity disk or other memory device be used in professional models. Of course, more pixels per unit area in the chip is most desirable as is going to a higher-resolution recording format. A high-definition TV format that would double the scan lines is being discussed in that industry as this book goes to press. Manufacturers are working on these problems, and we simply will have to use current technology as best we can until improvements are made.

Figure E–3 Due to tight deadlines, this NCAA championship game, played in Seattle in April, 1989, was photographed by *USA TODAY* photographer Tim Dillon with a Sony SV camera. Many editors do not object to the slight loss of sharpness if the only other option is no photo at all. *(Tim Dillon/USA TODAY; Copyright 1989 USA TODAY)*

Figure E–4 (a) Associated Press photographer Ron Edmonds used an electronic camera to make this photo of President Bush being sworn into office. Edmonds then transmitted the photo directly from the camera platform and the image was on its way to users in less than a minute. *(Ron Edmonds/Associated Press)* (b) Edmonds transmits the photo in (a) seconds after the image was made. The electronic camera is to the right on the tripod behind Edmonds; the black box he is operating is the transmitter. *(Chick Harrity/Associated Press)*

(a)

(b)

Remember that current models are the early generations of this new technology, and are quite amazing in view of that fact. One should also realize still video is not being developed solely for the news photographer. It has enormous applications and uses in other areas such as law enforcement, real estate, and medicine. In fact we are probably one of the smaller potential users of still video.

Is Film-Based Technology Dead?

It is unlikely that conventional film will become obsolete. Considering the enormous resolution of film and the rather questionable resolution still video is likely to have in the near future, it seems more likely the two technologies will coexist for many years to come. Still video is a new tool that will shine in some applications and falter in others. In fact Kodak, which is experimenting with still video, believes still video may never reach a level of resolution to compete with film in high-quality applications. Film itself is being improved constantly. Large reproductions such as full-page photos, even in newspapers, clearly will remain better when shot on large-format, silver-based photographic film. (Even 35mm film, with its eighteen-million pixel equivalent, is weak under the high-quality demands of some magazine work.)

Image-Processing Devices

The ultimate goal, electronic pagination, requires that all the page elements—stories, headlines, graphics, and photos—be composed of electronic data so the main pagination computer can assemble these elements and print out the page. When photos made on conventional film are to be used, they must be converted into information usable by the pagination equipment. This can be done with portable scanner/transmitters designed for use in the field, or with larger permanently installed machines that offer more options to the user. Once the image is digitized, it can be cropped, enhanced, and altered with additional computerized equipment at electronic picture desks or image manipulation stations.

Portable Film Scanner/Transmitters

Film scanner/transmitters are devices that read a photographic negative and send the image over phone lines without requiring a print. Of course, the Associated Press and United Press International print transmitters have been available for some years, but they only transmit from prints that have been made in photographic darkrooms. Film transmitters are compact and transmit very high-quality digital images from color negatives, color transparencies, and black-and-white film. These devices literally scan the film bit by bit and record the various

Figure E–5 The Leafax transmitter is currently used by the Associated Press and its member newspapers to transmit an image directly from a black-and-white or color negative. The negative is placed in a slot that is hidden by the monitor in this view. The photo can then be cropped and captioned before transmission.

Figure E–6 This is the scanner at the *San Jose Mercury-News*. The original transparency is placed on the drum at the left. The operator can exercise considerable control over the color balance of the final image by manipulating the controls on the panel at the bottom. The lithographic film, from which the printing plates are made, is exposed in the chamber at the far right.

tones as electronic data and transmit that data to other locations over ordinary phone lines. One very popular unit is the Leafax 35, invented by electronics guru Robert Caspe and now marketed by Associated Press. The Leafax is a briefcase-sized unit with a 3½-inch color monitor for editing. It weighs only twenty-six pounds and can transmit over regular phone lines. Other companies such as Hasselblad and Nikon also offer film transmitters.

Production Scanners

Production scanners are computer-controlled devices that read the various tones of a print or film image and translate those tones into electronic data. Unlike the portable units just discussed, these machines offer versatile control of the output, enabling the operator to make color and contrast adjustments to precisely match the needs of the press used to print the publication.

These scanners come in two styles, rotary drum and flatbed. The names of both units are based on how they scan images. In rotary units, the photograph is attached to a spinning drum where it is scanned by a light-sensitive recording device. The flatbed scanner looks more like a copy machine, and the print or negative lies flat while it is digitized. Scanners can process black-and-white or color and are especially valuable to papers that are capable of producing high-quality color. Because of the high level of control possible, these machines have done much to improve color in newspapers and magazines.

The Electronic Picture Desk

Once we have an electronic image, whether from still video or from electronic transmitters or scanners, we can edit and manipulate it so it later can be integrated into the overall page layout. Devices called *electronic picture desks* (offered by many different sources, such as Crosfield Electronics, Associated Press, Reuters, Agence France Presse, and others) allow us to handle the picture much as we handle type. The electronic picture desk, sometimes referred to as an electronic darkroom, is simply a computer work station where digitized images are displayed and may be altered on a computer screen. Images can be displayed on the screen either singly or in groups for comparison. They can be cropped, rotated, lightened or darkened, or even sharpened. After such manipulation, they are sent directly into the paper's pagination system. Most electronic picture desks are relatively small—about the size of a personal computer. Work is underway to develop programs to turn small computers such as the Apple Macintosh and the IBM PC into picture desks. These devices will become more and more versatile as computer technology evolves and program software becomes more sophisticated.

In any case, the electronic photo desk is fast becoming a standard item at most newspapers. The Associated Press is placing its AP Leaf Electronic Picture Desk in all its 950 member papers. Wire photos will be delivered via satellite to the photo desks, increasing speed and quality.

The use of the electronic picture desk will increase the demand for competent photo editors. It also will assign a much more significant role to those photo editors, since the photographer will more often still be in the field shooting while the editing process takes place. Strong lines of internal communication will also be necessary to maintain the integrity of the image.

Image Manipulators

Once pictures, type, and graphics are in digital form, powerful mainframe computer systems called image manipulators or pagination computers are used by many newspapers to complete the pagination process. These devices can be used to lay out the page (stories, headlines, photographs, and graphic images) and then print out a completed page negative or positive that is used to make plates for the printing press. No manual layout or stripping of photographs is needed.

Also available is software that allows image manipulation (and page layout) to be performed on a personal computer such as the Macintosh and then be transmitted to more powerful mainframe computers where a high-resolution copy is made from the basic page geometry drawn on the Mac.

An interesting aspect of image manipulators is that they are so powerful they can literally take a photograph apart bit by bit and reassemble it any way the operator desires. Of course, we have always been able to do a certain amount of that in the darkroom or by processes like airbrushing, but electronic devices allow us to do almost endless changes faster, slicker, and with hardly a sign that changes have been made. We can bring several photographs together into one. We can remove parts of a photograph, fill in or clone parts of an image, change colors, and even sharpen edges. This ability is both an asset and a curse. It's an asset in that it allows us to do high-quality retouching of photos and to produce fully paginated layouts on a screen. It is a curse in that it presents many ethical problems. In advertising photography manipulation seems the rule. However, when one tampers with news photos, the truth can be easily lost. There have been a number of well-known instances in the last few years where publications acquired image manipulators and used them to distort the truth of photos.

Beyond the question of ethics, commercial photographers are quite concerned about how their business will be affected. They are afraid they will lose business when clients use image manipulators to make new photos out of old ones by combining photos into composites without payment to the original photographers. Indeed, it might be possible for a company to build up an image bank of photographs of its product that could be manipulated into new photographs. Thus, new photographs might not be needed except on the occasion of new products. The increased use of image manipulators, particularly in the newspaper environment, presents many new questions to the professional.

Summary

The world of electronic technology has finally caught up with news photography, and most forward-thinking editors and publishers will try to remain competitive in today's marketplace. With the myriad of media competing for the same audience, a newspaper must find ways to put out a high-quality product cheaper and faster than ever before. The idea of turning all input into electronic data as quickly as possible can streamline the process greatly. All the devices discussed—still video, electronic picture desks, scanners, transmitters, and image manipulators—form a part of the pagination process. Considering the flexibility that electronic equipment presents over mechanical equipment, it seems clear these new devices will alter considerably the way news photographers conduct their everyday business.

Figure E–7 The Associated Press is installing these Leaf Picture Desks at its member newspapers. Color photos are delivered in three minutes and black-and-white photos in one minute. The old equipment took about eight minutes to transmit black-and-white photos and twenty-four minutes to transmit color photos. The new computer system is also capable of storing four hundred images, which can be cropped, sized, and sent to various output devices. At the terminal is Brian Horton, Lazer photo director of the Associated Press. *(Photo courtesy Associated Press)*

In a sense, these machines are a double-edged sword that requires new skills and understanding to handle. However, these changes may alleviate much of the tedious busywork that photojournalists have been doing for years and allow those who truly want to be communicators to put more of their efforts into the rightful pursuit of journalism. One famous quote admonishes photographers to "get out of the darkroom and into the newsroom." Perhaps this new technology will enable that to happen.

Figure E–8 As a demonstration, *San Jose Mercury-News* artist Bruce Maxwell created this montage. The photo is an assembly made from the parts in (b). The image was flopped left-to-right and the sign was returned to its original orientation. The names on the sign were changed, and the heads of Jesse Jackson, George Bush, and Ronald Reagan were spliced in. Finally, Michael Dukakis's watch was switched so it would be on the correct arm. All the work was done electronically; no hard copy ever existed. *(San Jose Mercury-News)*

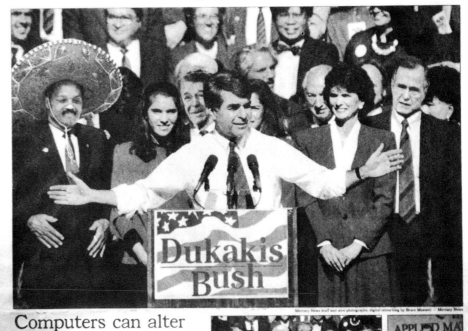

Science & Medicine

What's wrong with this picture?

Computers can alter photographs in a snap

(a)

The large picture above is a fraud. Using the Mercury News digital retouching system, we combined the four smaller staff and wire photos above and at left into one. For more on how it was done, see Page 2C.

(b)

Appendix

Section 1

Processing Time/Temperature Charts for Common Black-and-White Films

The processing times listed here are only recommendations. Your specific conditions may require adjustments. Always process a test roll before trying these times with important film.

TABLE A-1 Tri-X (ISO 400)– Development Time in Minutes

Developer	65° F	68° F	70° F	72° F	75° F
HC-110 (A)	4¼	3¾	3¼	3	2½
HC-110 (B)	8½	7½	6½	6	5
D-76	9	8	7½	6½	5½
D-76 1:1	11	10	9½	9	8
T-Max	7	6	6	5¾	5½

TABLE A-2 T-Max 100 (ISO 100)– Development Time in Minutes

Developer	65° F	68° F	70° F	72° F	75° F
T-Max	NR	8	7½	7	6½
D-76	10½	9	8	7	6
D-76 1:1	14½	12	11	10	8½
HC-110 (B)	8	7	6½	6	5

TABLE A-3 T-Max 400 (ISO 100)– Development Time in Minutes

Developer	65° F	68° F	70° F	72° F	75° F
T-Max	NR	7	6½	6½	6
D-76	9	8	7	6½	5½
D-76 1:1	14½	12½	11	10	9
HC-110 (B)	6½	6	5½	5	4½

TABLE A-4 Ilford HP5 (ISO 400)– Development Time in Minutes

Developer	Dilution	68° F	75° F
D-76	None	7	4¾
D-76	1:1	12	8
HC-110	A	6	4
Acufine	None	5	3½

Section 2

Push Processing

Push processing is a common technique that involves shooting film at a speed rating higher than its recommended rating, and then compensating somewhat for the resulting underexposure by special development. It is a useful and common technique for getting pictures in low-light conditions.

I have placed this information in the Appendix because explaining this technique to beginning photographers is somewhat like putting a first-time driver in a Ferarri Testarossa. I do not think that those of you who are just learning exposure and development should try this method until you are confident with the normal routine. The best prints come from properly exposed and processed film. There is always some compromise with quality when departing from standard procedures.

A typical case for push processing would be at a night or indoor sporting event where the existing light is too low for the shutter speed and aperture combination you want to use. For example, suppose you were using ISO 400 film and your meter recommended an exposure of 1/60 at f/2.8. This shutter speed is way too slow for sports action.

To solve this problem, set your light meter for a film speed of 1600. Because each doubling of film speed equals a difference in exposure of one f-stop, you can now shoot at 1/250 at 2.8. Here's how it might look if you laid this information out in a chart:

Suggested exposure at: ISO 400 = 1/60 @ 2.8
ISO 800 = 1/125 @ 2.8
ISO 1600 = 1/250 @ 2.8

At an ISO of 1600, your meter would then recommend an exposure of 1/250 at 2.8. If your lens opened to f/2, you could use 1/500 at f/2. Check your exposure ruler (see chapter 3) if you are confused by these equivalent exposures.

TABLE A-5 Push Processing Times for Tri-X Film

Film Speed	Developer	Time and Temperature
400	D-76	8 min. at 68° F
	HC-110 (Dil. B)	7½ min. at 68° F
800	D-76	12 min. at 68° F
1600	Acufine	10 min. at 68° F
	Acufine	6½–7 min. at 75° F[a]
	Edwal FG-7	9½ min. at 68° F[b]
	T-Max	8½ min. at 75° F
2400	Acufine	8 min. at 75° F[c]
3200	Edwal FG-7	12 min. at 75° F[b]
	HC 110R	8 min. at 70° F[d]
	T-Max	10½ min. at 75° F

Experiment with different processing times. Increased agitation will increase contrast and can help improve negs made under flat lighting conditions such as classrooms. For high-contrast scenes such as concert lighting, reduce agitation.

[a]Agitate at beginning and halfway point only.

[b]Mix FG-7 1 oz. concentrate to 15 oz. water and add 1 oz. sodium sulfite.

[c]Agitate at beginning only.

[d]Mix 1 oz. HC 110R (replenisher) with 15 oz. water and add 1 oz. sodium sulfite.

TABLE A-6 Push Processing Times for T-Max 400 Film

Film Speed	Developer	Time and Temperature
400	T-Max	6 min. at 75° F
	D-76	8 min. at 68° F
	HC-110	6 min. at 68° F
800	T-Max	6 min. at 75° F
	D-76	8 min. at 68° F
	HC-110 (Dil. B)	6 min. at 68° F
1600	T-Max	8 min. at 75° F
	D-76	10½ min. at 68° F
	HC-110 (Dil. B)	8½ min. at 68° F
3200	T-Max	9½ min. at 75° F

TABLE A-7 Push Processing Times for Fuji Neopan 1600 Film

Film Speed	Developer	Time at 75° F
1600	D-76	5 min.
	HC-110 (Dil. B)	5 min.
	T-Max	3½ min.
3200	D-76	10 min.
	T-Max	7½ min.

TABLE A-8 Push Processing Times for Kodak T-Max P3200 Film

Film Speed	Developer	Time at 75° F	Time at 85° F
1600	T-Max	7 min.	5 min.
	D-76	8½ min.	5½ min.
	HC-110	6 min.	4½ min.
3200	T-Max	9½ min.	6½ min.
	D-76	11 min.	7½ min.
	HC-110	7½ min.	5¾ min.
6400	T-Max	11 min.	8 min.
	D-76	12½ min.	9 min.
	HC-110	9½ min.	6¾ min.
12,500	T-Max	12½ min.	9 min.

In effect, you are lying to your light meter by telling it you have faster film. The photos that result are underexposed. In the case of a 1600 setting with 400-speed film, your photos will be two f-stops underexposed. This underexposure can then be compensated for somewhat by extending the development time or by using special developers. (Fixing and washing times remain the same as for normally processed film.) Included in this section are processing charts for various film and exposure combinations.

As I mentioned above, however, push processing includes a trade-off in image quality. Shadows usually suffer, becoming dark and lacking in detail. Overall negative contrast is usually affected also. (If your negatives are generally too contrasty, reduce the processing time; if too flat, increase the time.) These drawbacks are sometimes minimal, sometimes serious, depending upon the individual circumstances. Extremes of ISO pushing, lighting contrast in the original scene, and development technique will result in lowered image quality. In photojournalism this poorer quality is acceptable when the only other option is no pictures.

TABLE A-9	Push Processing for Color Films at 100° F Processing Temperature		
Film	**Stops Pushed**	**ISO**	**First Developer Increase**
E-6	1	2x normal	2 min.
(transparency)	2	4x normal	4 min.
C-41	1	2x normal	30 sec.
(negative)	2	4x normal	1 min.

The relatively new 1600- and 3200-speed films will reduce the need for push processing in many situations, but photographers are always stretching the limits of the technology. Kodak's P3200 black-and-white film can be pushed an equivalent of two stops to an astonishing ISO of 12,500 with results that are acceptable to many photojournalists.

One more caution. Every photojournalist has his or her favorite formula, and you will undoubtedly encounter advice that runs counter to that given here. As with any special technique, experiment before using any of these suggestions on an important assignment.

Push Processing Color Films

On the whole, push processing color films results in a greater loss of quality than a similar push in black and white. Grain increases and color saturation decreases. Further, some color shifts can occur that can be difficult to correct in the final reproduction. Push processing C-41 and E-6 process films is done by extending the first developer time. All other steps remain the same. Kodachrome films can be push processed only by labs equipped to do so; I do not recommend pushing Kodachrome except in an emergency. Check the labs that advertise in the *Photo District News* (listed in the periodicals section of the bibliography) for this service.

Section 3

How to Make Portfolio Slides

Most portfolios are now presented in the form of slides. Slides are far easier to ship and handle, and much less expensive to make than a set of 11 × 14 mounted prints. You should, however, have a print portfolio on hand for in-person interviews.

In black and white, slides should be made only from top-quality prints. Eight-by-ten-inch prints work well, but there is no reason not to use any other convenient

size. Be sure the prints are the best quality you can produce; the slides will not hide any defects. All the prints should be consistent in their contrast and density, and properly spotted. They need not be mounted.

The standard copying set-up is shown in figure A-1. Set the lights so they are at about a 45° angle to the print. Either flood or flash will work, but be sure there is no reflection from the print surface into the camera's lens. You might have to turn out the room lights and make a cardboard mask to keep the camera's own image from reflecting back from the print surface. You can either tack the print to the wall, keeping the camera perpendicular to it, or set the print on a table and aim the camera down. (If your prints are unmounted, you may need to set a piece of clean glass over the print to hold it flat.) In either case, the lights should be at the same angle relative to the print. I prefer the vertical arrangement, attaching the camera to an enlarger using a photographic C-clamp that includes a ball-head. This set-up makes it easy to crop by raising or lowering the enlarger until the image fills the frame. Be sure the camera is exactly perpendicular to the print.

Take a meter reading with an incident meter, holding it at the print position. Try to use an exposure combination that will allow you to stop your lens down a few stops, where it will be at its sharpest. F/8 is a good aperture to aim for. Use a cable release so the camera will not wiggle during the exposure. If possible, use a macro lens (*not* a macro zoom) which is less prone to distortion.

Any color slide film will do, but be sure its color balance is appropriate for the lights you use. Remember, if you use photofloods, you'll need either a tungsten-balanced film or an 80B blue filter over your lens to correct the color. I'd suggest a tungsten-balanced film such as Kodachrome 40, Ektachrome 50, or Fujichrome 64 RTP.

There is also a means of making slides using Kodak's T-Max 100 black-and-white film processed in special chemicals. This reversal processing kit has just been introduced and although we were not able to test the process thoroughly before this book went to press, first results look promising.

Until our tests are complete, we prefer to use a special Kodak black-and-white film made for copying medical X-rays. Called Rapid Process Copy Film 2064, it is a direct-reversal film that yields positive images with normal processing. The maximum black (technically known as D-max) is very high, and the film is capable of capturing all the subtleties and brilliance of the original. Unfortunately, this material is very slow, with an ISO of about .06. Our exposures with 500-watt photofloods range from 15 to 30 seconds at f/4, but I think

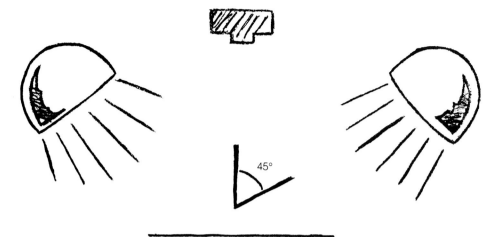

Figure A–1 When copying prints to make portfolio slides, set up two lights equidistant from the copy and at 45-degree angles. Be sure the light is spread evenly across the copy.

the superior results are worth the wait. The film can be processed in DK-50 at 75° F for about ten minutes, or in Dektol at 85° F for about five minutes. I prefer the results from DK-50 but this developer is a little harder to get than the common Dektol. Most camera store personnel are not aware of this film and won't find it in their catalogs since it is a rather special item. If they can't order it for you, call the Kodak hot line, (800)242-2424, and ask for the name of a dealer who can. The catalog number for the 150-foot roll is 174–6031. Be sure to run a test before shooting too many copies. Exposure affects the whites; processing affects the blacks. If your whites are muddy, increase the exposure. If the blacks are weak, increase development. Use a water bath to keep processing temperature constant. After processing, the slides can be cropped or masked with quarter-inch black border tape from a graphic arts supplier.

For copying color, I think the best solution is to send the work out. The time you'll spend trying to get good color copies is usually not worth any lab fees that could be saved. Color negs can be converted to slides, although your cropping options are limited. You can also have a print made and then make slides from that. Original transparencies can be duped at a rather low cost. Never send out originals in a portfolio since a loss could be catastrophic. If you have access to a slide duplicator, you can crop your dupes yourself.

Section 4

Popular Films for Photojournalists

Making a list of films for photojournalism is a risky proposition. Ten or fifteen years ago, such a list would have been easy. In black and white, Kodak's Tri-X was the standard, whereas color work was usually done on Kodachrome 25 or Ektachrome 64.

Today, there are many films to choose from, and there is little consensus as to which films are best. New color films are being introduced more frequently than in past years and some of the emulsions discussed here will certainly have been improved upon or superseded by the time you read this book. For this reason, I have decided not to include a detailed listing of films. Check with local newspaper photographers to see what is currently popular.

Selecting films can be rather personal, too, and I'll no doubt upset some photographers whose favorite films I have neglected. Some consumer photo magazines regularly run articles comparing films, but frankly, I think it is more important to worry about picture content. If your pictures are good, it won't matter what film you use.

Nevertheless, the pros tend to gravitate to certain brands. In black and white, Tri-X remains a standard. This film will take a tremendous amount of abuse and can be exposed at speeds ranging from 50 to 2400 or more and

still yield a usable print. The T-Max films from Kodak are praised by some, condemned by others. Those that like them say the grain is finer, a questionable value considering newspaper reproduction. Others criticize the highlight rendition as being too dense. This problem may be just a matter of learning to expose and process the film properly.

There is no question that the T-Max P3200, called "Magic-X" during its trial introduction, is a fabulous film for low-light situations. It is reported to maintain excellent shadow separation when pushed.

Fuji's Neopan 1600 is not as well known, but some who have tried it say it also does well in low-light situations.

Slow-speed black-and-white films (less than ISO 400) are rarely used simply because so many news situations require faster films. Those of you with a fine-arts background may cringe at this idea, but in the news business, grain is secondary to getting the picture. Further, reducing the types of film used makes it easier to react by reflex when the going gets fast and furious.

Many color films are available. For negative work, Kodak's Kodacolor 400, and Ektapress films (at speeds of 100, 400, and 1600) are popular, as are Fuji's Fujicolor Super HG 400 and Super HR II 1600. Transparency films frequently used include Fuji's Fujichrome 100, 400, and 1600. Magazine photographers also like Kodachrome 25, 64, and 200. Many photographers consider Kodachrome 25 to be the best color film ever made. It is virtually grainless, and its color quality is a standard against which many other films are measured. Of course, its slow speed and special processing eliminate it from consideration for deadline news.

Section 5

Reclaiming Silver from Fixer

The silver that conventional photography depends upon for its light-sensitive emulsions is a nonrenewable natural resource. A gallon of used fixer can contain as much as one ounce of recoverable silver that should not be dumped down the drain.

There are a number of ways to salvage the silver that is removed from processed film and paper by the fixer. Commercial labs use either a metallic replacement cartridge or an electrolytic device. In the first method, the cartridges are filled with fine steel wool. Silver-bearing solutions are fed through the cartridges and the steel wool dissolves into the solution causing the silver to precipitate out as a sludge in the bottom of the canister. Exhausted canisters are then sent to a refiner for credit. Eastman Kodak offers cartridges and a method of crediting labs for silver returned in used cartridges.

The second method uses a system that involves an electric charge that flows between two electrodes immersed in the solution. The silver plates out on one of the electrodes in an almost pure form. This system is more sensitive to the condition of the chemicals than the metallic replacement cartridges, and it is used by large labs where conditions can be monitored.

In larger cities, there are companies that will collect used fixer and pay a fee for the silver recovered. The drawbacks to this option are that a significant volume is needed before any worthwhile return is realized and you must store the used material until you have enough to reclaim. Recyclers will not come out to collect just a few gallons.

I have found a simple silver recovery system that is effective for quantities as small as one quart of used fixer. Just save the used fixer in a plastic tank and when the tank is about full, add a small amount of powdered zinc and stir. The zinc goes into the solution and the silver ends up at the bottom of the tank as a black sludge. Add a teaspoon or so of zinc per five-gallon batch, stir and wait a day for the sludge to settle. A crude test for remaining silver is to dip a shiny penny halfway into the solution. If the penny comes out looking silvery, there is still silver to be reclaimed. A more accurate test can be made with Kodak silver estimating papers, which are dipped into the solution and compared with the color chart provided with the papers. When the test shows no more silver to be recovered, the solution is carefully siphoned off and the sludge is dried. Dry sludge is saved until several pounds have accumulated. Then it is sent to a refiner.

Section 6

Professional Organizations

National Press Photographers Association, 3200 Croasdaile Dr., Suite 306, Durham, NC 27705; phone (800)289–6772. This premier organization for news photographers publishes the monthly magazine *The News Photographer* and offers numerous seminars, portfolio critiques, and an AV library; sponsors student chapters and a job information bank; and co-sponsors the Pictures of the Year competition and the resulting annual, *The Best of Photojournalism.* Student memberships available.

American Society of Magazine Photographers, 419 Park Ave. S, 10th Floor, New York, NY 10016; phone (212)889–9144. Publishes the useful guide, *Professional Business Practices in Photography,* and offers many services to members in the area of the business of photography. This organization also works to protect the freelance photographer's right to control the ownership and use of his or her work. Student memberships available.

Professional Photographers of America, 1090 Executive Way, Des Plaines, IL 60018; phone (312)299–8161. Primarily oriented toward studio photographers, but there are membership categories for many areas of specialization. Also conducts training seminars and publishes a monthly magazine.

Advertising Photographers of America, 45 E. 20th St., New York, NY 10010; phone (212)807–0399. The name implies their orientation, but many freelance photojournalists also do commercial photography and might benefit from membership.

Society of Newspaper Design, The Newspaper Center, Box 17290, Dulles International Airport, Washington, D.C. 20041; phone (703)620–1083. For designers and graphic artists. The SND publishes a journal and an annual compilation of its contest winners. The annual is a good source for layout ideas. Student memberships available.

Bibliography

Adams, Ansel. *Artificial Light Photography*. Boston: New York Graphic Society, 1966.
———. *Camera and Lens*. Boston: New York Graphic Society, 1970.
———. *Natural Light Photography*. Boston: New York Graphic Society, 1965.
———. *The Negative*. Boston: New York Graphic Society, 1981.
———. *The Print*. Boston: New York Graphic Society, 1983.
Adams, William Howard. *Atget's Gardens*. Garden City, N.Y.: Doubleday, 1979.
Ahlers, Arvel. *Where and How to Sell Your Photographs*. 8th ed. Garden City, N.Y.: Amphoto, 1977.
The American Image: Photographs from the National Archives, 1860–1960. New York: Random House, 1979.
American Society of Magazine Photographers. *Professional Business Practices in Photography*. New York: American Society of Magazine Photographers, 1986.
August Sander. The Aperture History of Photography Series. Millerton, N.Y.: Aperture, 1977.

Bayer, Jonathan. *Reading Photographs: Understanding the Aesthetics of Photography*. New York: Pantheon Books, 1977.
Ben Shahn, Photographer. Intro. by Margaret R. Weiss. New York: Da Capo, 1972.
The Best of Life. New York: Time-Life Books, 1973.
Bourke-White, Margaret. *The Photographs of Margaret Bourke-White*. Edited by Sean Callahan. Greenwich, Conn.: New York Graphic Society, 1972.
Bowden, Robert. *Get That Picture*. Garden City, N.Y.: Amphoto, 1978.

Brooke, James T. *A Viewer's Guide to Looking at Photographs*. Wilmette, Ill.: The Aurelian Press, 1977.
Brown, Theodore M. *Margaret Bourke-White: Photojournalist*. Ithaca, N.Y.: Cornell University Press, 1972.
Buell, Hal, and Saul Pett. *The Instant It Happened*. New York: Associated Press, 1975.

Callahan, Sean, and Gerald Astor. *Photographing Sports: John Zimmerman, Mark Kauffman and Neil Leifer*. Dobbs Ferry, N.Y.: Morgan & Morgan, 1975.
Capa, Robert. *Images of War*. New York: Grossman Publishers, 1964.
Carroll, John S. *Photographic Lab Handbook*. New York: Amphoto, 1976.
Cartier-Bresson, Henri. *The Decisive Moment*. New York: Simon & Schuster, 1952.
Cavallo, Robert M., and Stuart Kahan. *Photography: What's the Law?* New York: Crown Publishers, 1976.
Chernoff, George, and Hershel B. Sarbin. *Photography and the Law*. 5th ed. Garden City, N.Y.: Amphoto, 1975.
Clements, Ben, and David Rosenfeld. *Photographic Composition*. New York: Van Nostrand Reinhold Company, 1979.
Coleman, A.D. *Light Readings: A Photography Critic's Writings, 1968–1978*. New York: Oxford University Press, 1979.
Cookman, Claude. *A Voice Is Born*. Durham, N.C.: The National Press Photographers Association, 1985.
Coote, Jack H. *Monochrome Darkroom Practice: A Manual of Black-and-White Processing and Printing*. Boston: Focal Press, 1983.

Craven, George. *Object and Image: An Introduction to Photography.* Englewood Cliffs, N.J.: Prentice-Hall, 1975.

Davidson, Bruce. *East 100th Street.* Cambridge, Mass.: Harvard University Press, 1970.
———. *Subway.* Millerton, N.Y.: Aperture, 1986.
Davis, Phil. *Photography.* 3d ed. Dubuque, Ia: William C. Brown, 1986.
Diane Arbus. Millerton, N.Y.: Aperture, 1972.
DuBois, William W., and Barbara J. Hodik. *A Guide to Photographic Design.* Englewood Cliffs, N.J.: Prentice-Hall, 1983.
Duncan, David Douglas. *Self Portrait: U.S.A.* New York: Harry N. Abrams, 1969.
———. *This Is War!* New York: Bantam, 1967.

Edey, Maitland. *Great Photographic Essays from Life.* Boston: New York Graphic Society, 1978.
Edom, Clifton C. *Photojournalism: Principles and Practices.* 2d ed. Dubuque, Ia: Wm. C. Brown, 1980.
Eidenier, Connie Wright, ed. *1988 Photographer's Market.* Cincinnati: Writer's Digest Books, 1987.
Eisenstaedt, Alfred. *The Eye of Eisenstaedt.* New York: Viking Press, 1969.
———. *Witness to Our Time.* New York: Viking Press, 1966.
Erich Salomon. The Aperture History of Photography Series. Millerton, N.Y.: Aperture, 1978.
Erwitt, Elliott. *Photographs and Anti-Photographs.* Greenwich, Conn.: New York Graphic Society, 1972.

Evans, Harold. *Pictures on a Page: Photo-Journalism, Graphics and Picture Editing.* New York: Holt, Rinehart and Winston, 1978.
Evans, Walker, and James Agee. *Let Us Now Praise Famous Men.* Boston: Houghton Mifflin, 1960 (expanded version of 1941 ed.).

Faber, John. *Great News Photos and the Stories Behind Them.* 2d ed. New York: Dover, 1978.
Farber, Robert. *Professional Fashion Photography.* Garden City, N.Y.: Amphoto, 1978.
Feinberg, Milton. *Techniques of Photojournalism.* New York: John Wiley & Sons, 1970.
Feininger, Andreas. *The Complete Photographer.* Englewood Cliffs, N.J.: Prentice-Hall, 1966.
———. *The Creative Photographer.* Englewood Cliffs, N.J.: Prentice-Hall, 1975.
———. *Photography.* Englewood Cliffs, N.J.: Prentice-Hall, 1969.
———. *Principles of Composition in Photography.* Garden City, N.Y.: Amphoto, 1978.
———. *Successful Color Photography.* Englewood Cliffs, N.J.: Prentice-Hall, 1969.
Focal Encyclopedia of Photography. New York: McGraw-Hill, 1975.
Frank, Robert. *The Americans.* Intro. by Jack Kerouac. New York: Aperture, 1969.
Freedman, Jill. *Circus Days.* New York: Harmony Books, 1975.
Fuso, Paul, and Will McBride. *Photo Essay.* Text by Tom Moran. Los Angeles: Alskog/Petersen Publishing Company, 1974.

Garcia, Mario R. *Contemporary Newspaper Design: A Structural Approach.* 2d. ed. Englewood Cliffs, N.J.: 1987.

Gardner's Photographic Sketch Book of the Civil War. New York: Dover, 1959 (reprint of 1866 ed.).
Gernsheim, Helmut. *A Concise History of Photography.* New York: Grosset & Dunlap, 1965.
———. *The History of Photography.* New York: McGraw-Hill, 1970.
Gidal, Tim N. *Modern Photojournalism: Origin and Evolution, 1910–1933.* New York: Macmillan, 1973.

Haas, Ernst. *The Creation.* New York: Viking Press, 1971.
Halsman, Philippe. *Halsman on the Creation of Photographic Ideas.* New York: Ziff-Davis, 1961.
Hattersley, Ralph. *Discover Your Self Through Photography.* Dobbs Ferry, N.Y.: Morgan & Morgan, 1970.
Henri Cartier-Bresson. The Aperture History of Photography Series. Millerton, N.Y.: Aperture, 1976.
Heyman, Ken, and John Durniak. *The Right Picture.* New York: Amphoto, 1986.
Hicks, Wilson. *Words and Pictures: An Introduction to Photojournalism.* New York: Harper & Bros., 1952.
Hine, Lewis. *America and Lewis Hine: Photographs 1904–1940.* Millerton, N.Y.: Aperture, 1977.
———. *Men at Work: Lewis W. Hine Photographic Studies of Modern Men and Machines.* New York: Dover, 1977.
Hodgson, Pat. *Early War Photographs.* Boston: New York Graphic Society, 1974.
Horan, James D. *Mathew Brady, Historian with a Camera.* New York: Crown Publishers, 1955.
Horrell, C. William. *A Survey: College Instruction in Photography* (Publication T-17). Rochester, N.Y.: Eastman Kodak Company, 1983.

Hoy, Frank P. *Photojournalism: The Visual Approach*. Englewood Cliffs, N.J.: Prentice-Hall, 1986.

Hurley, F. Jack. *Russell Lee Photographer*. Dobbs Ferry, N.Y.: Morgan & Morgan, 1978.

Hurley, Gerald D., and Angus McDougall. *Visual Impact in Print*. Chicago: American Publishers Press, 1971.

Jacobs, Lou, Jr. *Free-Lance Magazine Photography*. New York: Hastings House, 1970.

Johnson, William S., ed. *W. Eugene Smith: Master of the Photographic Essay*. New York: Aperture, 1981.

Jury, Dan, and Mark Jury. *Gramp*. New York: Grossman, 1976.

Kalish, Stanley E., and Clifton C. Edom. *Picture Editing*. New York: Rinehart, 1951.

Kane, Art, and John Oppy. *Art Kane: The Persuasive Image*. New York: Alskog/Thomas Y. Crowell, 1975.

Kennerly, David Hume. *Shooter*. New York: Newsweek Books, 1980.

Kobre, Kenneth. *Photojournalism: The Professionals' Approach*. Somerville, Mass.: Curtin & London, 1980.

Lange, Dorothea, and Paul S. Taylor. *An American Exodus*. New Haven and New York: Yale University Press, 1969.

Leekley, Sheryle, and John Leekley. *Moments: The Pulitzer Prize Photographs*. New York: Crown, 1978.

Life Library of Photography. New York: Time-Life Books, 1970–1975.

Lynn, Bob, ed. *The Best of Photojournalism/13*. Durham, N.C.: National Press Photographers Association, 1988.

Lyons, Nathan, ed. *Photographers on Photography*. Englewood Cliffs, N.J.: Prentice-Hall, 1966.

McCullin, Donald. *Is Anyone Taking Any Notice?* Cambridge: M.I.T. Press, 1973.

McDarrah, Fred W., ed. *Photography Market Place*. Ann Arbor, Michigan: R. R. Bowker, 1977.

MacDougall, Curtis D. *News Pictures Fit to Print . . . Or Are They?* Stillwater, Okla.: Journalistic Services, 1971.

Mante, Harald. *Photo Design: Picture Composition for Black-and-White Photography*. New York: Van Nostrand Reinhold, 1977.

Marcus, Adrianne. *Photojournalism: Mary Ellen Mark and Annie Leibovitz*. Los Angeles: Alskog/Petersen Publishing Company, 1974.

Mark, Mary Ellen. *Ward 81*. New York: Simon & Schuster, 1979.

Meltzer, Milton. *Dorothea Lange: A Photographer's Life*. New York: Farrar, Straus & Giroux, 1978.

Meredith, Roy. *Mathew B. Brady: Mr. Lincoln's Camera Man*. New York: Dover, 1974.

Moen, Daryl R. *Newspaper Layout and Design*. Ames: Iowa State University Press, 1984.

Morse, Michael L., ed. *The Electronic Revolution in News Photography*. Durham, N.C.: National Press Photographers Association, 1987.

Nadler, Bob. *The Color Printing Manual*. New York: Amphoto, 1978.

Nelson, Roy Paul. *Publication Design*. Dubuque, Ia: Wm. C. Brown, 1972.

Newhall, Beaumont. *The History of Photography: From 1839 to the Present Day*. New York: New York Graphic Society, 1982.

Newhall, Nancy, ed. *The Daybooks of Edward Weston, Vol. I and Vol. II*. Millerton, N.Y.: Aperture, 1973.

Newman, Arnold. *One Mind's Eye*. Boston: Little, Brown, 1974.

O'Neal, Hank, ed. *A Vision Shared: A Classic Portrait of America and Its People, 1935–43*. New York: St. Martin's Press, 1976.

Owens, Bill. *Documentary Photography*. Danbury, N.H.: Addison House, 1978.

———. *Suburbia*. San Francisco: Straight Arrow Books, 1973.

———. *Working: I Do It for the Money*. New York: Simon & Schuster, 1977.

Photographic Literature and *Photographic Literature 1960–1970*. Edited by Albert Boni. Dobbs Ferry, N.Y.: Morgan & Morgan, 1962 and 1972.

Picker, Fred. *The Zone VI Workshop*. White Plains, N.Y.: Zone VI Studios, 1972.

Pollack, Peter. *The Picture History of Photography*. New York: Abrams, 1970.

Recovering Silver from Photographic Materials. Rochester, N.Y.: Eastman Kodak, 1979.

Richards, Eugene. *Below the Line: Living Poor in America*. Mount Vernon, N.Y.: Consumers Union, 1987.

Richardson, Jim. *High School: U.S.A.* New York: St. Martin's Press, 1979.

Riis, Jacob A. *How the Other Half Lives*. New York: Dover, 1971 (reprint of the 1901 ed.).

Robert Frank. The Aperture History of Photography Series. Millerton, N.Y.: Aperture, 1976.

Rothstein, Arthur. *The American West in the Thirties*. New York: Dover, 1981.

———. *The Depression Years as Photographed by Arthur Rothstein*. New York: Dover, 1978.

———. *Photojournalism*. 4th ed. Garden City, N.Y.: Amphoto, 1979.

Russell Lee, Photographer. Dobbs Ferry, N.Y.: Morgan & Morgan, 1978.

Sahadi, Lou, and Mickey Palmer. *The Complete Book of Sports Photography*. New York: Amphoto, 1982.

San Francisco Chronicle. *Through Our Eyes: The 20th Century as Seen by the San Francisco Chronicle*. San Francisco: Chronicle Publishing Company, 1987.

Schuneman, R. Smith, ed. *Photographic Communication: Principles, Problems and Challenges of Photojournalism*. New York: Hastings House, 1972.

Shaman, Harvey. *The View Camera: Operations and Techniques*. Garden City, N.Y.: Amphoto, 1977.

Shay, Arthur. *Sports Photography: How to Take Great Action Shots*. Chicago: Contemporary Books, 1981.

Shulman, Julius. *The Photography of Architecture and Design*. New York: Watson-Guptill, 1977.

Smith, W. Eugene. *Minamata*. New York: Holt, Rinehart and Winston, 1975.

————. *W. Eugene Smith: His Photographs and Notes*. Millerton, N.Y.: Aperture, 1969.

Sontag, Susan. *On Photography*. New York: Farrar, Straus & Giroux, 1978.

Steichen, Edward. *The Family of Man*. New York: Museum of Modern Art and Simon & Schuster, 1955.

————. *A Life in Photography*. New York: Doubleday, 1963.

Stroebel, Leslie. *View Camera Technique*. 5th ed. Stoneham, Mass: Focal Press, 1986.

Szarkowski, John. *From the Picture Press*. New York: Museum of Modern Art, 1973.

————. *Looking at Photographs*. New York: Museum of Modern Art and Greenwich, Conn: New York Graphic Society, 1973.

Taft, Robert. *Photography and the American Scene*. New York: Dover, 1938.

Theisen, Earl. *Photographic Approach to People*. New York: Amphoto, 1966.

Turner, Richard. *Focus on Sports: Photographing Action*. Garden City, N.Y.: Amphoto, 1975.

Turnley, David C. *Why Are They Weeping? South Africans under Apartheid*. New York: Stewart, Tabori & Chang, 1988.

Walker Evans. New York: Museum of Modern Art, 1971.

Walker Evans at Work. New York: Harper & Row, 1982.

Walker Evans: Photographs for the Farm Security Administration, 1935–1938. New York: Da Capo Press, 1976.

Ward, John L. *The Criticism of Photography as Art: The Photographs of Jerry Uelsmann*. Gainesville: University of Florida Press, 1970.

Weegee, Arthur Fellig. *Weegee's People*. New York: Duell, Sloan & Pearce and Essential Books, 1946.

Weinberg, Adam D. *On the Line: The New Color Photojournalism*. Minneapolis: Walker Art Center, 1986.

White, Jan V. *Editing by Design: Word and Picture Communication for Editors and Designers*. New York: R. R. Bowker, 1974.

White, Minor, Richard Zakia, and Peter Lorenz. *The New Zone System Manual*. Dobbs Ferry, N.Y.: Morgan & Morgan, 1976.

Whiting, John. *Photography Is a Language*. New York: Ziff-Davis, 1946.

Zakia, Richard. *Perception and Photography*. Rochester, N.Y.: Light Impressions, 1979.

Zakia, Richard D., and Hollis N. Todd. *Color Primer I & II*. Dobbs Ferry, N.Y.: Morgan & Morgan, 1974.

Photographic Periodicals

American Photo; 1515 Broadway, New York, NY 10036. This magazine concentrates on photographers and their work.

Aperture; Aperture, Inc., Elm St., Millerton, NY 12546. A quarterly covering all areas of photography; prides itself on quality reproduction.

The News Photographer; National Press Photographers Association, 3200 Croasdaile Dr., Suite 306, Durham, NC 27705. Covers the news photography scene. Subscription is included with membership in the NPPA.

Petersen's Photographic Magazine; 8490 Sunset Blvd., Los Angeles, CA 90069. Concentrates on equipment and techniques.

Photo District News; 49 E. 21st St., New York, NY 10010. An excellent publication covering the business of commercial and freelance editorial photography.

Photographer's Forum; 614 Santa Barbara St., Santa Barbara, CA 93101. A high-quality vehicle for the work of emerging photographers.

Popular Photography; Ziff-Davis Publishing Co., 1 Park Ave., New York, NY 10016. Concentrates on equipment and techniques.

Pro Imaging Systems; PTN Publishing Co., 210 Crossways Park Dr., Woodbury, NY 11797. Primarily intended for industrial photographers.

The Rangefinder; Box 1703, Santa Monica, CA 90406. Primarily devoted to the business concerns of portrait and wedding photographers.

Studio Light; Eastman Kodak Co., 343 State St., Rochester, NY 14650. Semiannual. Interviews with professionals; impressive reproduction of top-quality work.

Index